The
Man
Who
Unleashed
The Birds

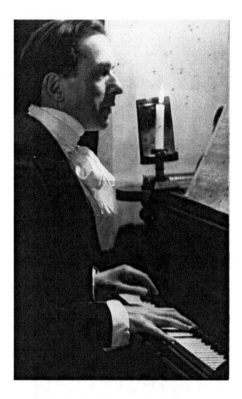

Frank Baker

"I can hardly wait to tell you that I sat up late last night, and lay in bed late this morning, in order to finish your *Birds*. I have been absolutely fascinated. I had imagined, God knows why, that it was some sort of thriller, certainly not this really superb psychological, one might say metaphysical, drama. It's far deeper stuff than mine, and now I realise to the full how bitter you must have felt when there was all this stuff about the film in the papers, and how the idea was taken from a story of mine. What I cannot understand is why your story did not awaken an instant clamour in everyone, and why it didn't become the book of the moment and be snapped up for film rights then and there."

Daphne du Maurier (writing to Frank Baker)

The Man
Who Unleashed
The Birds

Frank Baker & his Circle

PAUL NEWMAN

Abraxas Editions & DGR Books

CONTENTS –

ACKNOWLEDGEMENTS

First I would like to thank the 'Q' Memorial Fund for their grant towards researching and gathering material for this book. Roger Tomlinson, an expert on FB, was unfailingly obliging, providing books, letters and advice. Such help has been matched by the generous cooperation of FB's children, Josie, Jonathan and Llewellyn, who made available their father's letters, notebooks and diaries, inestimably important primary sources. Jonathan patiently went through these pages making notes, corrections and fascinating additions: hence the present work is greatly indebted to his knowledge and diligence. Josie also supplied letters, diaries, documents and details, unflaggingly responding to my enquiries, and Llewellyn provided additional memories. I would like also to thank the sculptor and author, A.R. Lamb and his wife, Jennifer, for their generosity and the special effort they made to ensure I met the surviving friends and acquaintances of Frank Baker, several of whom are still living in Mevagissey, notably Bernard Moss the ceramicist and his wife, Maureen, also an artist, who recounted stories of their early years in the fishing port. Paul Miskin supplied intriguing memories of his father, Lionel, and of John Layard's approach to psychoanalysis. Especially obliging was Richard Savage, son of D.S. Savage, who copied letters and essays in order that I should be able to consult them as well as providing information on E.S. Hill and never failing to respond to my enquiries. His brother, Edward, kindly loaned me his magnificent family album packed with relevant images. Photographer and author, Dr John Crook, traced a couple of portraits of William Holden Hutton and also extracted a relevant chapter from his history of choir schools. Andrew Lanyon, artist and author, sent me his fine study of Lionel Miskin, recalling the man and his milieu. Martin Val Baker was immensely helpful, providing photographs from the DVB archive. Film buff and Hitchcock expert, Ken Mogg, allowed me to quote from his brilliant 'Notes' on *The Birds*; he also drew attention to Michael Walker's memory of the film of *Lease of Life*. Author and critic, Roger Dobson, let me include his apt and enlightening response to *I Follow but Myself* and Christian Browning, son of Daphne du Maurier, kindly checked the letters relating to his mother. Finally my measureless gratitude to my friend, Lee Cooper, director of DGR Books, for patiently proof-reading the manuscript and discovering errors that have now been (hopefully) eliminated.

INTRODUCTION

Colin Wilson cites a group of Russian intellectuals who are lounging, drinking heavily and smoking while deeply engaged in argument. One gets up, ready to leave. "You can't go yet," his friends complain. "We haven't decided whether God exists or not."

This was a vital metaphysical issue in 19th century Russia and Britain, persisting into the 20th century as religion came increasingly under the assaults of the Rationalists, Logical Positivists and exponents of the New Physics. Presently it has revived yet again with Richard Dawkins' massive study *The God Delusion*. Even if there was an erosion of belief during the 1950s – Bishop Robinson's *Honest to God* was a rather sombre rallying cry – religion was still considered a major issue. Representatives of the church, nuns, monks and bishops, appeared on television discussion programmes, whether the issue was crime and punishment, taking the marriage vow, birth control or the implications of rising consumerism. In particular, whenever sexuality cropped up, almost *inevitably* a priest or nun was on the board, the producers assuming carnal innocence would ensure an angle that was novel and unbiased.

Nowadays, of course, religion is still a major issue. Its most passionate advocates, who literally believe it to death, are Muslim terrorists who not only embrace the existence of Allah but seek to impose their translation of His will in acts of reprisal. Christians have not demonstrated this sort of passion since they themselves were crusading against the Muslims.

I draw attention to this because, in certain respects, Frank Baker might be classed as a religious novelist or a novelist who placed God in the forefront of his fictional investigations. Whether the world conforms to Bishop Berkeley's premise – that the realm of matter has no validity beyond the Maker's conception – is a major theme in *The Downs So Free*. Similarly religion dominates *Teresa* – how compatible is middle-class respectability with God's will? Even his horror novel *The Birds* hints that man has spiritually lost his way; so does *My Friend the Enemy* and *Talk of the Devil*, the latter uneasily poised between psychological and theological accountability. The treatment may be slightly facetious as in *Sweet Chariot* or prolonged and pondered as in *Lease of Life*. In discussion with the American critic, Everett Bleiler, Kathleen Lloyd, FB's wife and most sympathetic literary critic, observed:

"Now to the way you picture Frank Baker as a person. It seems necessary to digress and say something of our lives and put his religious and philosophical development in perspective – if his thought about time and eternity and his obsession with Catholic dogma and symbolism express the themes and meanings

at the heart of his work, it is his love of people, his strong emotional ties and his life-experience (in the visible tangible material world) that give his work vitality and make his characters live. I blame myself that I did not say more about Frank as a person in my previous letter. But I was shocked to laughter when he came over as an impoverished Jesus freak."

This is sound. Frank Baker is definitely not a "Jesus freak", but he could be classed as a 'religious novelist'. So could Dostoevsky – although he is clearly far more than that. Ignoring Muriel Spark, who might be regarded as a latecomer, arguably the two most publicised British 'Catholic Novelists' of the 20th century are Evelyn Waugh and Graham Greene, the first a splendid, self-parodying poseur with a fierce respect for tradition underscored by an anarchic glee that embraces black slapstick and cannibalism; the second a lover of sleaze, heat and tropical swelter who wrote novels where sins are heaped up and cosmetically applied to doomed souls to make the story more wickedly appealing.

Where Greene happily trod the mires of politics, guilt and sexuality, Frank Baker was also interested in these themes, but thought that they were forces so strong that they could bury a whole man and his conscience. Perhaps it was his constant awareness of the importance of the more quiet, sustaining things – family, friendship, art and communal celebration – that made him reluctant to descend too deeply into the corruption of which he was aware, but to portray instead decent, innocent, kindly, lonely people like Amy Carr or a type of pernickety male eccentric many would prefer to draw away from.

Frank Baker, while fascinated by evil, seldom crosses the threshold and presents a thoroughly hateful character, save perhaps in *My Friend the Enemy* when he is exorcising a painful early memory. His attitude may be contrasted with that of his contemporary, Gerald Kersh, whose metier is a luscious, blistering contempt for mankind:

The greatest consolation of the degraded human being is the fact that there are others in the same mire. The lower you descend, the intenser grows your yearning for standardisation. The drunkard loves to see others get drunk; the prostitute would like to see all the other women in the world on the streets. There is no satisfaction quite so deep and evil as that of a man who can say: 'Aha, now we're all in the same stew!' With what joyous melancholy, with how delicious a thrill of self-pity the out-of-work man sees the unemployment figures rise! 'Be exactly my size; no bigger, and no smaller,' says the dwarf; 'Damn your eyes!' whispers the blind man; 'Comrades!' yells the Communist.

(Night and the City)

In his version of *Punch*, Frank Baker demonstrates this need to drag someone down. It also surfaces in *Talk of the Devil*, but generally he favours the 'Holy Fool' above the 'Conscious Corrupter'. Hence, although his first novel has a monstrous villain – a Jack the Ripper equivalent – generally his works are more concerned with Goodness than Badness and there is often reconciliation and hope at the end.

The cream of his *oeuvre* celebrate life's craziness shot through with tragedy, beauty and nostalgia. Later works portray the attrition and narrowing of choice caused by old age and are flecked by failure and regret. Old maids, louche young men, failed musicians and crusty, preposterous eccentrics are his preferred type. The society he portrays appears to have more social cohesion than today's and yet he frequently rails against its blunders and inadequacies. The darker books use thriller formats and show a world where good and evil persist in an uneasy balance. Within him personally, of course, there was a darkness, a shame, only hinted at in his stories, so that his *alter egos* – say, for instance, Philip Hayes, in *Talk of the Devil* and Maurice Hilliar in *Before I Go Hence* – are not like the questing, harassed, angry soul who occasionally breaks out in the private letters.

To those who see Frank Baker as principally a fantasy novelist, the foregoing may appear a little pompous or pedantic. Strictly speaking, he only wrote two fantasies, *Miss Hargreaves* and *Sweet Chariot*, the social satire element in *The Birds* placing it nearer science fiction or dystopian vision. The other novels tend to be quiet, understated works, notable for their effective characterisation and scene-setting, punctuated by two incursions into thriller territory, neither of which proved a commercial success. The fantasy label simply stuck to FB because his most esteemed work, *Miss Hargreaves*, was incorrigibly zany and light-headed.

Another point is that his characters are not the usual hybrids or jigsaw of characteristics. In his fiction Frank Baker constantly recycles people he knew in life. His mother is used, his father, his grandmother, his aunt and many of his friends. Sometimes he does not bother to alter their first names. Tansy, the heroine of his first novel, was based on a Cornish girl of Frank's acquaintance and many other characters had living models. It is a point of curiosity that modest people, who whittle their lives away in quiet corners, are often unaware of the stories in which they are portrayed, even when they are stocked in their local libraries. This kind of liberty can get one into trouble today, especially if the target is rich and can secure a good lawyer. Fortunately for Frank Baker he never provoked any of his living models unlike, for instance, Sven Berlin whose portrayal of Arthur Caddick as a bibulous poet in his novel *The Dark Monarch* resulted in the payment of heavy damages and the imprint being pulped.

The obvious question: Why revive the work of Frank Baker? The reply would be that here is a classic novelist, noted in his day as an accomplished

weaver of natural and supernatural fiction, who tackled themes of originality and also wrote one of the very best of modern autobiographies, but is presently disregarded. This book is written to redress the balance and urge a reprint of his more important works. Along with telling his life story, I have given space to summaries and extracts from his novels, diaries, reviews and letters. With the exception of *Miss Hargreaves*, his works are out of print, so I have tried to compensate for this unavailability.

It is belittling to attach to anyone a banner of significance they might consider irrelevant or subsidiary to their life's work. I have called this present biography *The Man Who Unleashed the Birds*, blatantly enlisting the leverage of the Hitchcock film whose genesis FB challenged when it created such an impact. Were he not an almost-forgotten author, such a strategy would not be necessary. But in view of the striking coincidence of Daphne du Maurier publishing in 1952 a title and concept identical to a narrative he had composed many years earlier and, in addition, annexing all the praise and publicity when the project was turned into a film, it seems a justifiable strapline to brandish, especially as it provoked in him so much anguish and self-analysis. The pain and perceived failure of his literary striving was epitomised in that incident which, more fortuitously, triggered a paperback reprint of his version of *The Birds*.

Another detail that requires explaining is the subtitle *Frank Baker and his Circle*. Why not merely Frank Baker? The reason is that FB was a genial man whose life possessed a strong social context, even when trying 'to get away from it all'. Regularly he kept in touch with and warmly supported his friends. They were vital components in his psychological make-up; to omit them would be to exclude a gripping literary and artistic dimension. Hence I have shaded in their characters and attitudes, so that standing together they make up a legion of the lost or, more hopefully, the about-to-be-rediscovered. If this sounds abject, I should emphasise most are not really *that* lost: W.S. Graham is acknowledged as an international poet of the first rank; Lionel Miskin's work is gradually coming to the fore; Denys Val Baker's autobiographies are still popular; Derek Savage, who locked horns with Orwell in debate, was a firebrand in his day, but is now neglected and John Raynor's songs are seldom honoured by recital. Certainly they are figures of weight and substance with lively minds who deserve to be revived and re-appraised.

In putting together this profile, I have adopted a 'collage' approach, quoting reviews, blurbs and letters. As more and more contemporary knowledge accrues in academic disciplines, there is less and less space for it in people's minds. Hence facets of literary history get buried or forgotten. Thirty years ago, students would instantly identify the type of book Stella Gibbons parodied in *Cold Comfort Farm* and pick out the 'time play' genre of the 1920s, but I can no longer take this for granted.

Hence I may supply more than a tighter design would warrant. Analyses of the various books may inhibit narrative impulsion or hold up the 'action' (if one dare employ so thrilling a noun in the context of lit. crit.) but essentially a novelist's life is spent staring blearily composing over a desk or hammering a keyboard like a pugilistic pianist. What he routinely does is organise characters and themes into a story. The rest of his activities, whether boozing, adventuring or gloomily veering into insanity, are of peripheral import.

I should also add that several chapters in this book are heavily dependent on FB's autobiographical ventures, *I Follow but Myself* and *The Call of Cornwall*. Often I take out a paragraph or two, using quote marks as indicators. I do not invariably adhere to this rule. There are occasions when I either quote verbatim or summarise or 'thin out' his prose, often retaining phrases and abbreviating. This is a liberty, for he is a superb communicator, a polished stylist, in his own right. But as my intentions are necessarily different, I have to wreak a little violence here and there. Besides published sources, there are words, phrases and extracts taken from notes or private letters, usually appearing in quotes but not invariably. Strictly speaking, to acknowledge a source, one should always use quotes or markers, but they can be aesthetically irritating if they pepper the text too thickly and, if the phrase be commonplace, simply banal. What all this amounts to is that, in places, I have been a bit cavalier with the fusion and extraction of texts and sources. For this, I apologise to anyone who thinks I might have gone about things in a better way.

LONDON

To throw away the key and walk away," is a famous poem of Auden's juvenilia. A phrase hinting at the bohemian's desire to break free of what his elders might call 'responsibility' or all those things people consider one should attend to rather than one's own needs. And that is what Frank Baker did at a crucial stage of his development, walked out of one life into another and never regretted it. He was a person born to express himself, either in music or prose. To be forced to do anything else – to live a life dictated by others – was an anathema. And so, at the age of thirty, he walked out on it all and came to Cornwall, hoping that the gesture would lead to the full definition of himself as a man and artist. It was probably the most important decision he made – a veritable leap of faith, undertaken not on behalf of God, but for the purpose of self-discovery.

From what did he walk away? The simple answer would seem the reach of an over-anxious, protective mother – for he was an only child – and the ever-looming spectre of menial drudgery that did not draw upon his creative talents. But there were skeletons he left behind too. Nothing truly shocking or terrible, but private matters, conflicts, that needed an open space in which he would not be troubled by those who knew too much, were too curious or wanted to ask of him things that would make him impatient with them. There were qualities deriving from his inner nature that both drove him into hiding and out again to seek the world of books, theatre and entertainment which he was to portray, with varying shades of convincingness, in his own writing.

Nearly thirty years after he was born, securely esconced in Cornwall and saluted as a promising novelist, he started to write his autobiography in a large red-bound notebook, dated Michaelmas 1937, purchased from a purveyor of office equipment in Penzance. With chronological thoroughness, he starts assembling memories that he anchors to places – Alexandra Palace, Eagle House, Stafford Grammar, Winchester Choir School – he regarded as stepping-stones in his personal journey. Beginning by invoking Chesterton's autobiography, he asks why should he attempt to portray his life and outlook. His reflections ramble around points of uncertainty and then he states that, to the best of his knowledge, he was born in a flat high above a draper's shop near the ponderous mausoleum of Alexandra Palace in North London, 22nd May 1908:

"I don't remember that birth. I wish I had. I sometimes think that if we could remember clearly the actual moment of our birth, could sense the fears and the joys of the mother who gave us life: could see quite clearly the strip of ceiling, the patch of sunlight on the wall, the fly at the window, the hand of one who assisted at the delivery, in any of these thing which must first have happened to

us, we should have a totally different attitude to life. But 'sometimes to think' is dangerous; it smacks of old ladies who suddenly get interested in beauty, in spiritualism or moral theology. When I ponder the matter of birth I find myself asking why, in Heaven's name, am I writing this autobiography anyhow? And it is a question that cannot be sidetracked, though it certainly should have been out of courtesy to the reader in a foreword, and since I want them to read this, I am going to put it under the Alexandra Palace and hope for the best."

Here he is circling round the point. A writer sets such things down to celebrate or advertise himself, just as an actor does when he goes on stage. He wants to charm, intellectually engage and draw in the reader, but there are things in a man's life that are not charming or even pleasant, that engender pain, distress, embarrassment, like the Wilde trials in which a way of life was exposed and blatantly condemned, a way of life of which FB was aware and had briefly explored.

Being born in Hornsey, Frank classified his background as "shabby suburban" but he had antecedents that inspired and fascinated him, in particular his maternal grandfather who had been a musician, the organist at the BBC's Alexandra Palace, a gift young Frank inherited and developed throughout his life, moving between literature and music, writing and singing.

His own father, Edgar Baker, was a marine insurance salesman, orthodox and education-conscious. Frank recalls a small, dapper, handsome fellow with exquisitely waved hair, long eye-lashes and a permanent aura of meticulous cleanliness. A natural athlete, good at cricket and swimming as well as being a skilful pianist, he had perfectly shaped, "totally unworkmanlike" hands that were incapable of rising to the challenge of untying a knot.

Frank's mother was called Lillian and he indelibly connected her with the "airy, fairy Lillian" of some frivolous poem that had been inscribed in his mother's autograph book. Her character in no way resembled the poetic Lillian, but Baker imagined that she had been a handsome, dark young woman, with "a very pronounced Jewish air in her facial expression..." But he is unable to provide any evidence of his mother's Jewish ancestry. It is a projection of his own that he hopes will turn out to be true, though he admits that the thought would probably scandalise both his parents.

Slight of build, slim, with silky brown hair, Frank appears to have been a slightly quaint, attractive child, too sensitive and imaginative for his rather droll parents, but a stimulating companion for intelligent, artistic adults who were able to respond to his needs, recognise his musical and literary gifts and point his talents in a direction where they might find fulfilment.

"One person in the background remains wrapped in mystery. This is mother's father, a man I never saw and she rarely saw. He seems to have left his life quite early in mother's life. He was called Robert Price and he spent much of his time

out of England. I don't know what he did. I found an old photograph of him and several others, grouped outside a tent somewhere near Cairo. I know he spent a lot of time in Spain. I know that whenever I say to my mother, "O Lord, I wish I could get out of England!" she says, "You take after father." And I am pretty sure that I do, just as I take after my father's mother – a lady whom he must have [handled] with some care, a paradoxical character is she."

It was his father's sister, Beatrice, who opened the door of the world for him, offering warmer, broader horizons – France, Spain and Italy – than the staid Hornsey residence in which his parents observed their stultifying routines. While he loved his mother and father, Frank was contemptuous of what he saw as their limited, provincial outlook and inability to grasp his artistic aspirations. Later he grasped that they were ordinary, decent people who brought him up well and tried to allow for his special needs. It was then he acknowledged that it was he – the child who cried for the moon – who made unfair demands on them rather than the other way round.

If he felt detached from his parents, finding them "not quite human" in those early years, he adored his nurse, although he remembered nothing about her thirty years later save that she wore a big hat. At school young Frank turned out to be a bright pupil, effortlessly mastering reading and writing, yet he was never happy there. He stood apart from other children, lacking their rough and tumble boisterousness. Sensitive, delicate and on the small side, he did not remember being bullied but was miserable there. Briefly he went to a "dreadful" school in Crouch End as a weekly boarder from which he twice ran away.

High Street, Hornsey, in Victoria's reign, with the church in the background – a familiar sight to the young FB.

14

The onset of the Great War caused upheavals in the Baker family. In 1917 Frank's father was called over to France to serve in the Royal Army Service Corps. Frank and his mother moved to Stafford to live with Aunt Betty and her husband, Reggie, who was a veterinary surgeon. Frank took a shine to his aunt and came to associate her with the admirable figure of Betsey Trotwood in *David Copperfield*. Aunt Betty lightened his spirits and understood his needs. Her conversation was more risqué than his mother's; she referred to the *Folies Bergère* with its lovely naked ladies, introducing the notion that eroticism could be liberating and exciting rather than bedevilled by shame. 'Thou Shalt Sample It And Make Up Thine Own Mind' was her philosophy rather than 'Thou Shalt Not'.

By contrast, Reggie comes over as ogreishly prankish, bluff and high-spirited on the surface but underneath deeply troubled and capable of doing malevolent, disturbing things, like slipping a dead dog's bloody tail into Frank's bed in order to make a man out of him and intimidating him with tales of fuming, savage stallions after he'd heard the boy was scared of horses. Swearing with fervour and flaunting his lack of sensitivity, he decided a little honest terror never did a lad any harm and prodded his weak points. But much of this bluff resilience was a front and eventually the devils took possession of Uncle Reggie who ended up a bankrupt drunk, leaving Aunt Betty no spare cash to support her mother, Teresa, who went to live in a nunnery known as The Little Sisters of the Poor. Generations later, Frank was to write one of his best-known novels *Teresa* about this animated if occasionally tiresome lady who, side by side with alcoholic sprees, enjoyed a rich spiritual life.

WINCHESTER CATHEDRAL CHOIR SCHOOL

The end of the Great War marked the return of Edgar Baker to his family and the next phase of Frank's education. In view of his son's musical aptitude, Edgar sent him to Winchester Cathedral Choir School (not, as he was always anxious to point out, the ancient public school in that city) until he was sixteen. Commonly known as Colebrook House, the school was in a large 16th century building that had a facelift in the reign of Queen Anne. While there, Frank was one of a group of boys entertained by the vivid and rather impressive Dean, William Holden Hutton, a noted literary figure of the period, who read the boys ghost stories in his study in the evenings: a taste for supernatural fiction stayed with Frank all his life and became a feature of his own books.

The Dean liked little boys and was not beyond expressing his affection by embracing them or offering them a holiday, the type of liberty that would provoke rumour and allegation today, but might be overlooked in Edwardian times when there was a large choice of boarding schools and schoolmasters were entrusted with responsibilities that went beyond classroom instruction. Frank remembered

how the kindly, distinguished Dean treated them as individuals and adults, holding grand tea parties when he would entertain them with stories and joyfully play master of ceremonies.

The Dean did not patronise but treated his pupils as equals, providing lavish feasts for them that included small quantities of wine. Dressed in silver buckled shoes rising to black silk stockings and knee breeches, he would address them as they sat demurely in their Eton suits at the high table while he mixed the salad with his fingers, tearing shreds of the lettuce and dressing them in olive oil while sharing some curious or amusing anecdote concerning an eminent person of his acquaintance.

After dinner, they'd be ushered into the magnificent drawing-room with its Venetian mirror and portrait of Archbishop Laud, and it was in this room the Dean would read the boys ghost stories from Edgar Allan Poe, Sheridan Le Fanu and M.R. James. Usually, when he had his listeners captivated, there was a juncture where he would break off, saying, "What's that? Listen." His enthralled pupils would hear a sinister scratching noise getting louder and louder and the Dean would turn an alarmed look on his audience. "Is any of you boys making that noise?" The tension increased until someone glimpsed that the noise was coming from the concealed nails of the Dean's left hand scraping against the broad band of stiff buckram that he wore around his waist.

FB remained always grateful to the Dean who literally loved young boys, "a pleasure which he even went so far as to advertise". This was allied to another unfortunate predilection: a High Church flamboyance that introduced Eucharistic vestments into the Cathedral and dared to wear a cope at his own installation. Like other ecclesiastical outcasts with whom he was to become acquainted, the Dean was teetering dangerously towards Anglo-Catholicism at a time when Middle Church was in ascendance.

What the Dean seemed less conscious of was that he was leaving himself open to gossip and rumour. He would invite pairs of choirboys to stay at the Deanery and feed and entertain them. Generally they enjoyed it, but some of those in charge thought the reputation of the Cathedral School was being threatened by his antics, especially when he took one personable boy with him to spend a weekend at a hotel in Bournemouth. Finally the pupils of the Choir School were called into the Chapter House and interviewed by one of the canons on their relationship with the Dean. Frank was among those. Did the Dean ever try to touch him? Did he visit him at night in bed? Did he ever kiss him? Frank replied that he'd put his arm around his shoulder and wished him goodnight while he was in bed, but never kissed him. However, the boy who went to Bournemouth with Holden Hutton answered differently: yes, the Dean *had* kissed him.

This disclosure resulted in a secret meeting with the Dean and the canons wherein they told him that he must cease inviting choirboys to the Deanery or

else resign. The Dean agreed to the former and from thenceforth curbed his expression of natural affection for young males.

When Frank left the Choir School and tried his hand at writing, he sent a batch of his shorter pieces to the Dean who read them carefully. They included "a flowery analysis of Ralph Williams's *Pastoral Symphony*", a parody of Rupert Brooke's *Grantchester*, a sonnet to Sybil Thorndike in the form of an anagram, a ghost story called 'Spring Song' and a poem about St Catherine's Hill, Winchester. By then the Dean was a very sick man, a victim of chronic asthma, and yet he would evaluate the stories carefully and thoroughly, never mocking the subject matter or the fact they were derivative, merely commenting on the manner of the telling, knowing that technique must be uppermost in the mind of a writer who chooses the shorter form.

So anxious was young Frank to renew his friendship with the Dean that he persisted in writing letters to him. He wanted to meet up with his old mentor who did at last invite him to stay at the Deanery. This was taking a great risk after the scandal of the Bournemouth incident, but Holden Hutton sensed he was dying and might as well extend his encouragement to an ex-pupil who needed it. So he took Frank in, discussing with him poetry and literature, giving him advice on how to market his work and telling him that he must learn to stoically accept the dreaded rejection slip. It later occurred to Frank that this kindly man, a celebrated author and theologian, had listened patiently while he read to him his immature effusions, his poems, songs and short stories, while he had not once taken the trouble to study any of the Dean's vigorously written and widely admired titles on history and biography. Such is the selfishness of youth.

<center>*</center>

On leaving Choir School, there was no opportunity for Frank to go to university. Instead, with the help of his father, he obtained work as a clerk for the London Assurance Company. The work turned out to be arduous and monotonous and he found himself disliking several of his colleagues. One of them, the chief underwriter, he got to hate so much that he later awarded him a scathing lampoon. Five long years he spent in the office, from 1924 to 1929, growing more desperate and claustrophobic as each long day unfurled. He felt his youth was being consumed by the jaws of metropolitan commerce and that he might never get out of it. This anger and resentment he integrated convincingly in sections of his 1936 novel *The Birds*:

I worked in a room called the underwriting room, the place where the main business of the marine department was conducted. There were about twenty of us in that room; I, the youngest, called junior-clerk. Amongst other duties, I had to copy what were known as declaration policies into large registers. I cannot remember many details of that labour and God forbid I should weary you with them.

Initially he was conscientious in writing out the documents, but as time went by he realised that they were never looked at. So he began to copy in a more reckless, illegible way, convinced it mattered to no one. Finally he decided to take revenge on behalf of the youthful clerks before him who'd been chained to the wheel of such monotony, taking "bundle after bundle of ancient claim documents in long yellow envelopes, foreign registers from branches all over the world, account books and ledgers – all written by hands long ago dead – and thrusting them into the great furnace that heated the water pipes all over the building.

This blatant rebellion did not behove well for his future as an underwriter. Not long after, to his parents' dismay, Frank jacked in his job with London Assurance. The reason was that an offer had come from a former contact, the ex-Precentor of Winchester Cathedral, now the chaplain at St Nicolas's College, Chislehurst. Frank was invited to go and live there, working as his assistant secretary and also taking on the position of organist at St Sepulchre's Church, Holborn, where the chaplain was vicar. To Frank this was a chance in a million, a golden door, but not so to his affronted parents who were unable to understand how he could throw aside a "good safe job with a pension at the end". True, ideally Frank would have preferred to attend Oxford University – his father had been a boy chorister at Magdalen – but short of that, the newly formed School of English Church Music, only recently given the archiepiscopal blessing by Canterbury, with Sir Sydney Nicholson as its Head, and situated in a splendid house in Kent, was too good to be missed. So, overriding his parents' concern and submitting his resignation to the Underwriter "in a proud letter, I went like a lamb to a slaughter I could not have dreamt was waiting for me. I had never been so full of confidence in my future."

ONLY A ROSE

Frank was delighted with his new job as organist and assistant secretary and proved good at it, getting on with both the boys and teachers and making new friends and acquaintances. He took to Chislehurst with its pond, caves, woodland and attractive environs and, being on the outskirts of London, he was able to visit his parents and attend concerts and religious festivals in the city.

By then, having worked in an office alongside a variety of social types, he was slightly more knowledgeable and worldly wise. Although still young and relatively callow, his reading and grasp of art and music had broadened. Less comfortably, he was aware he had sexual leanings apart from those of other young men who appeared exclusively interested in the opposite sex. His knowledge of such matters had increased through certain associations, one in particular being meeting up with Alfred Rose, an odd, middle-aged man of flexible sexuality who picked up seventeen-year-old Frank during an Ascension Day service at St Paul's Cathedral.

Aged seventeen, he had been over a year working with London Assurance and was taking time off for his lunch-break, when he was approached by this creepily intriguing middle-aged man with his bat ears, flared sensuous nostrils and soft, insinuative voice that Frank identified with that of the Devil. Rose's opening gambit was well-calculated. "Not very fussy about their clothes, are they?" he said. This put-down pleased Frank no end – his Winchester choirboy background had been governed by the significance of ritual detail. "No, they aren't," he responded. "They shouldn't be wearing copes, should they?"

Rose invited Frank back to his small, warm, compact flat in Chancery Lane. He was flattered by the intense personal attention Rose gave him and found himself talking fluently and with frankness to his new friend. Hence he became a regular visitor to this clerically inclined mystery man who combined a hint of scholar and satyr. Before long, quite a close friendship formed, and with it came a sense of slightly embarrassed obligation on Frank's part. In his autobiography, he portrays Rose as a Monseigneur or priest without portfolio. To the general reader, he comes across as one of those vaguely attractive 'wicked' or defrocked clerics like the Reverend Montague Summers who wrote books on Gothic literature, diabolism and witchcraft. But Rose was palpably a less consequential figure although he boasted among his friends and acquaintances Lord Alfred Douglas, Nancy Cunard, Lord Birkenhead, Sir Landon Ronald and the Archbishop of Canterbury. He also had regular recourse to an important-looking bureau with many cards and drawers, hinting at doing government work demanding precision and secrecy. This may have been Frank, of course, projecting his own conjectures upon the consequential air Rose adopted when he retired to that piece of

furniture, for he never declared outright that he was doing this or that. Frank decided that he was probably doing small clerical chores to bring in extra money but with a ritual gravity and ponderous concentration that made them seem grander.

Whatever shields and ruses the older man adopted to keep his pupil in thrall, the bond was genuine. It may have been an odd, awkward partnership, but it worked for a while. Rose was a poetry lover who maintained a spicy library, including the original, lavishly illustrated edition of *My Life and Loves* by Frank Harris. Frank sensed the old man had the knowledge to ease his way into the mysteries of life and literature. Their conversations were close and intimate, for he quieted Frank's fears about exploring his own body, the sin of Onan, with a noble, commonsense oration: "Don't think about it all the time. But when you have to do it, do it without regrets. Millions and millions have done it before you, millions and millions will do it after you. If man was made in God's image be sure that the genital organs have their proper place in this image…"

Rose possessed a full Loeb library of classics and, more to the point, his God appeared to have liberal views. Frank later found out he had been a monk at an Anglican Benedictine community on Caldy Island that had been broken up by the church hierarchy. Apparently Rose was involved in a conspiracy to steal a medieval church manuscript. The scandal had left him bitter about the church but enthusiastic about sympathetic souls like Lord Alfred Douglas, a sonneteer of excellence as well as the instrument of Oscar Wilde's downfall.

A tiny, telling glimpse of Rose's hidden life was revealed when Frank visited him one day. He was surprised – almost alarmed – by Rose introducing him to a pair of "completely natural and rather hoydenish girls", apparently his daughters, the youngest of whom, aged about twelve, was prevailed upon by their father to do a little "parlour trick", namely recite the Lord's Prayer backwards in Latin, ending with 'Noster Pater'. "I knew nothing whatsoever," Frank commented, " of all the vapid idiocies…which go to make a black mass…yet I see Rose's complacent smile as she strung out words which had thus been divested of meaning."

One occasion, when Frank was staying at his flat for the night, he started to undress, intending to sleep on the sofa, when Rose wandered back in murmuring some lines from a book he was holding, not looking directly at Frank but wholly conscious of him. He completed the quotation then wandered out and down the passage, stopped, yawned and slightly turned. A pause, during which Frank's embarrassed tension rose considerably, and Rose remarked: "Why not sleep here? Plenty of room."

From where he stood, Frank was able to take in the full impact of his companion's superb masculine credentials. "I could see", he recalled, "his beaked nose and the tufts of black hair in his flared nostrils. Impeccably clean, the sheets of the well-made bed were turned down, and he reclined on the counterpane.

There was indeed plenty of room for two; it was a perfectly sensible and courteous invitation. Yet I felt as though his heart was beating inside mine, and my temples throbbed. It was an agonizing moment. Finally, I broke the silence. *Oh, no thanks, Mr Rose. I like the sofa...got used to it...*"

In retrospect, Frank felt he had been ungracious not to go along with Rose's request. "Perhaps nothing lay behind it," he conceded, "and if anything did I might have been able to give him something he needed. In my refusal to share his bed I must have hurt him more deeply than ever he could have hurt me. But youth is selfish; age must suffer its intolerance."

THE PRICE OF FRIENDSHIP

Because of their differences in age and, more importantly, suspicion arising in the minds of his slightly stuffy parents whenever he mentioned this odd, churchy friend of his, who actually *encouraged* him in his writing rather than recommended safer, more conventional work, Frank gradually detached himself from Alfred Rose, finally completing the break by not turning up at a meeting they had arranged. However, it transpired he had severed a vital lifeline, for the problems affecting Frank penetrated to the core of his psychological and physical makeup. They required a special language, an ability to discuss openly and honestly a young man's sexual and emotional inheritance. His parents, through no fault of theirs, were unable to encompass these matters. So far as they were concerned, desires and emotions were things that needed to be tethered rather than released. Even the pains and pressures a normal young man or woman might have to undergo during adolescence were not easily broached in Edwardian households. Unfortunately, in Frank's case, the difficulty was intensified by a bisexuality that could only be shared through friends like John Raynor whom he had befriended at the Church School of Music.

Through this hitherto suppressed part forcing its way through, in less than a year of taking up his position at Chislehurst, Frank found himself sacked for a crime that not only had he not committed but of whose nature he was ignorant: sodomy. Back then, the word possessed a biblical horror and sublimity that it has forfeited today when, providing no law has been breached, police no longer arrest boys and boys for acting as if they were girls and boys unless there is strong evidence of coercion.

Frank had formed a friendship with a fourteen-year-old resident chorister of Chislehurst called Roger. He showed much affection towards Frank who returned it, almost regarding him as a younger brother. An uncomplicated, very happy boy, pleasantly mischievous if not intellectual, he was a fine young actor, too, securing the chief role in Sydney Nicholson's opera for boys, *The Boy Bishop,* performed on St Nicholas's Day, 6 December. Roger gloried in the role which, in point of fact, drew him and Frank, who was also involved in the production, together. "We began to behave like conspirators," he wrote, "sending

21

sentimental little notes to one another, and meeting in places which were out of bounds for the boys. I recollect a tea-shop in Bromley; and there were the woods near the choir school where one evening we made a bonfire. The warden (Nicholson) discovered this; so did the chaplain. Together they decided that my intentions were suspect. I was sent for and questioned by both of them."

Frank was asked to explain his actions. What was he getting up to with Roger? The word 'buggery' was thrown at him for the first time. Up until now, he had only known the word 'bugger' as an expletive and not as a sexual specialisation. A sense of guilt arose that scalded him to the centre of his being. He felt he had contaminated Roger and yet, as his accusers had only let fall hints and aspersions, he could hardly defend himself. A choking, voiceless anguish arose – from thenceforth, Frank was strictly forbidden to have any contact with Roger or to talk to any of the boys. Against this Frank and Roger secretly rebelled, meeting several times despite the ban. They were discovered and Frank was dismissed. The Warden of the school sent a letter to his father warning: "Unless Frank can get a grip of himself I shudder to think what will become of him."

This letter Frank took to Rose, telling him the whole sordid story, how he had been dismissed without any kind of appeal; also, more sensationally, how a governor of the school had offered him £500 and the fare to Rhodesia on condition that he never, by raising the matter publicly, damage the reputation of the establishment. This not only left him out of work but unable to get a character reference from his last employers, London Assurance. His parents had practically disowned him, believing a crumb of truth lay behind the accusation. The situation was apparently hopeless, but Rose was enthralled, not in a morbid way, but in the way of one who had previously encountered the hypocrisies and social timidities of the Anglo-Catholic establishment:

"Good God!" he exclaimed. "You have a case as clear as daylight. They will put the boy in the witness box of course; but there is not one answer he can make to any question which could go against you. The letters will be seen by any jury for the innocent and touching missives they are. Of course you'll need a very clever counsel. There are very high damages here, very high indeed, my dear Frank! You have nothing whatever to fear. You have only to tell the truth, as you have told me, as you have written it in that excellent statement I asked you to compose. No, nothing to worry about! This can indeed be the making of you. Rhodesia! Ha!" His lips tightened; he gave his most cunning chuckle. "And this offer made to you in a *letter!* God, what fools! What dolts! A clear case of criminal blackmail, no less."

Frank was heartened and terrified by this stirring battlecry. Rose was spoiling for a fight, but he was less impassioned. It may have been the eve of his sexual Agincourt, when he should ride forth and smite down his accusers, but he

preferred the whole thing to be played down rather than broadcast from the rooftops. Yes, he *should* but *did he really want to*? For in spite of Rose's oratory, something made him hang back. He did not want to immerse himself in such deep legal waters as he was being urged to enter. The publicity would be extraordinarily embarrassing and he might never live it down. What about Roger – did that rather jolly young man want to be turned into an object of scandal? The prospect of accusing his persecutors of blackmail was truly audacious and he asked Rose whether it was really possible.

"Is it *possible*", he snapped, "that you don't see the danger you are to these people? Don't you realise you are like a bomb? Touch you off, let you explode, and the whole rotten bag of ecclesiastical tricks will be blown sky high! Do you think Cosmo Gordon Lang is going to want *this* story fluttering round the dovecotes of the Church Assembly? His pet School of Music, under the patronage of Queen Mary, exposed as being responsible for the criminal dismissal of one of their young employees: moreover, one who as a chorister at Winchester gave his first confidences in the *confessional* to a priest who is now the chaplain of this unholy dunghill! And this same priest amongst those concerned in a vicious smear campaign against that distinguished Fellow of St John's College, Oxford, Regius Professor of History, Dr Hutton, Dean of Winchester. And now, what happens? This young man, chucked out with a filthy indelible brand on his good name becomes the victim of blackmail by one of the governors of the School who offers him £500 – oh, my God! It's too good!" He threw up his hands, then rubbed them together, chuckled and purred, patted me on the back, then set to again, with the glint of war in his eyes. "Five *hundred* pounds! This is worth every cent of five thousand, and you will get not a penny less, *and* your name will be cleared."

Thus it went on, week after week of dauntless talk, while Frank held out in the sad little Stroud Green flat, to which he had retreated during this period of duress, decorated with its few keepsakes and books, short stories and poems, all written out in thick exercise books. He was like the scolded child in the Coventry Patmore poem who arranged his pathetic little creative bulwarks around him to keep at bay the wolves of the world.

 Repeatedly he visited Rose who each time assured him all he would have to do is wait until the details were assembled and they were ready to launch an attack. One thing was totally essential, he was told, that he must not leave London, but be on the spot, ready for the next move.

 Eventually, in a seedy office in Blackfriars, he met the barrister friend of Rose's. This legal beaver made Frank twitch, so grubby and bug-infested did he appear with his greasy hands and faded gown spotted with mildew. Frank listened politely but he was weary of London and his own indiscretions. All the time he heard this off-putting fellow outlining the legal position he was dreaming of the

holiday he had taken from London Assurance, in the far west of England, and he thought of a cottage he had seen, solitary and tranquil, deep in the fastness of the Kenidzhak Valley. It was this he longed for rather than strife and legal wrangle in the gloomy halls and courts of the metropolis.

So, with his savings of about twenty pounds, his books and clothes, he took the road to Cornwall, not telling Rose but later writing to him, saying that he did not care whether his accusers blackened his name or not. Frank did not wish to prolong contact with them even in the interests of establishing his innocence.

Replies came back from Rose, accusing him of cowardice, of lacking the courage to even defend his own character, whereupon Frank told him that he did not want to endanger Roger's name by further publicity and attention.

Rose wrote back, taking up the points, but this time Frank did not answer. Never again did he see his old mentor although he was thoughtful enough to send back his copy of *My Life and Loves* which he had been keeping on extended loan. The belated correspondence ended as Frank entered a new phase. Years later, indirectly, he found out that Rose had died. But he never forgot that rebellious, errant priest, his learning, eloquence, courage and pedantry, and especially that pertinent, uncomfortably apt phrase with which he had once rebuked him: "Frank Baker – *A man whom God hath made to mar himself.*" Was there more than a hint there that his supple eloquence, his ability to express himself in music, words and images, was merely the result of his being a flawed and incomplete person?

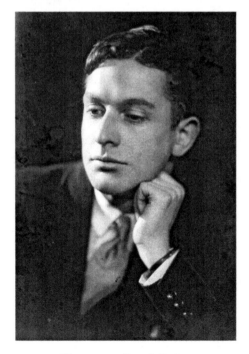
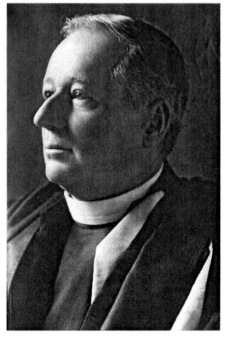

The young Frank Baker. Dean William Holden Hutton.

LAND'S END

In 1930, after five years in an underwriting room and one in a school for church organists, Frank settled at Land's End where it was still possible to live on a pound a week. Though the social strata into which he had born partially precluded him, he might have stayed on in London and, through his combination of personal attractiveness, musical and literary talent, inveigled himself among the upper class fauna of the "bright young things", sharing their whimsicality, drunkenness and sartorial surrealism. But even if he had been especially conscious of them, something in him would have rejected their party-going evangelism and fatalistic hedonism in favour of Cornwall. The duchy had always seemed to him a dream, a sanctuary, a spiritual rock, and now, after the horror of the false accusation, the threat of scandal and exposure, he wanted to leave the world of cities, schools, head teachers and lecherous ex-priests and give full expression to his creative nature:

I might have pretended to my parents, and to a loyal friend, John Raynor, a student at the College, who always stood by me, that I only intended to go to Cornwall for a holiday... But in my heart I knew that I was putting London and all my background forever away from me. I was going to write. I would earn my daily bread by the only job which might still be open to me as a church organist. But, above all, from now onwards I was going to live as I wished to live, never again to any pattern of behaviour laid down by anyone else.

Of all parts of the duchy, he preferred the Penwith Peninsula with its heathery moors, gaunt skies and atmosphere of stubborn resilience that on sunny days transformed into a realm of dazzling rock, blue water and narrow, steep-sided valleys. The air was crystalline and pure; local produce and fresh fish were cheap and plentiful and the people curious but friendly. What's more, the phoenix of contemporary English literature, D.H. Lawrence, who had not long passed away, had stayed at Tregerthen, leaving behind the swift, incisive impressions of a natural prose colourist allied to bittersweet memories of friendship, harassment and betrayal. At that time, although Lawrence had secured a select bunch of admirers – notably Aldous Huxley, Richard Aldington, Hilda Dolittle, Compton Mackenzie, Peter Warlock, Cecil Gray and E.M. Forster – he had not yet received a powerful academic boost from the likes of F.R. Leavis.

Earlier, in 1927 or 1928, Frank had visited the Kenidzhak Valley, in the company of his schoolboy friend, John Raynor. It was a place that never failed to make him wax lyrical and he was to recall his early impressions in an article in the Cornish Review:

At last I came to the gate and swung it aside. Down came the smell of stock, sensuously opening out to me in the spring flowering of the hillside. The warm moist air of the flower-filled night surged into me and drew me also deep into its living centre. I was an operative part now of all this, I said, as I climbed the last bit of steep path past the almost invisible beds of bulb flowers. I paused by the well, listening to the blackbird singing wildly from the stone hedge at the bottom, an outpouring of ecstatic song which touched the strings of my heart and called out to music there.

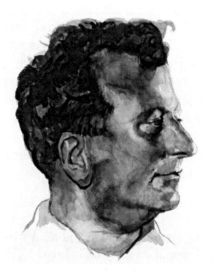

John Raynor, FB's oldest friend who stayed with him during his early years in Cornwall.

Frank's first home was half way up the side of a lonely, entrancing valley. It had a sloping garden and a little wooden gate with the words 'Edge of Beyond' painted on it. The cottage was attached to another of the same size that had been occupied by an old couple who had died. Hence Frank was left alone in this mysterious place, save for his neighbour, Maxie Uzielli, a well-established local whom he was soon to befriend. Maxie had green fingers and planted her garden with rows of beautiful bulbs. This placed her in a permanent war of attrition with the massive, voracious and elastically agile slugs that were a feature of the locality.

Thrilled at achieving independence, Frank got down to work in his solitary setting. Quickly he struck lucky, selling an article to the *Radio Times* that he followed by two more pieces that were accepted. What gave him particular pleasure was the publication of a story of his in the *English Review*, a periodical formerly edited by Ford Madox Ford who, apart from being a distinguished novelist himself, had discovered D.H. Lawrence and collaborated with Conrad on a venture. Editorship had by now passed over to a lesser light, yet there was still prestige attached to appearing in its pages.

For the meantime, he needed a steady source of cash to sustain his frugal way of life. This was supplied by Canon Thomas Taylor (1938 – 1938), Vicar of St Just. Known as "the poor man's lawyer" for his readiness to provide help and advice to his flock, his bardic title was 'Gwas Ust' (Servant of St. Just) but he

was also an ecclesiastical historian, having written a learned study of Celtic Christianity, a history of St Michael's Mount and a hagiography, *The Life of St Samson of Dol*. To relieve his sedentary side, he went fly-fishing. When Frank appeared on the scene, he was angling for an organist – offering the skimpy bait of twenty-six pounds a year. Frank asked whether the sum might be doubled, fifty-two pounds a year. The white-haired Canon shook his head but then smiled: "I will put it to the Parochial Church Council."

Frank's daringness paid off. He was taken on for one pound a week for two Sunday services and a single choir practice. He wondered whether the Parochial Council had footed the bill or was it really the decency of Canon Taylor, paying the extra twenty-six pounds out of his own income? The solicitous Canon Taylor also took Frank by bus from Penzance over to St Hilary to see a Corpus Christi procession, "a glory of copes along an avenue of ash trees." There Frank was introduced to Father Bernard Walke whose knightly pacifism and love of donkeys made him think of Don Quixote.

A BIT OF OLD BAROQUE

At St Hilary, FB also met Walke's friend, Filson Young (1876-1938), an overlooked figure today but prominent in the Edwardian age and between the wars. Author, journalist, pioneer motorist, sailor, broadcaster and literary all-rounder, Filson was in addition a musician, playing the organ (badly in FB's rashly expressed opinion) at the Corpus Christi celebration and making his presence vividly felt. He visited Cornwall not only because his mistress, the artist Dod Procter lived there, but in a professional capacity too. As an adviser for BBC Radio, he had to arrange the broadcasting of Ber Walke's nativity plays that by now had achieved national popularity. After their first transmission in 1926, Lord Reith phoned the vicarage and told Walke how both he and Ramsay Macdonald had listened together and been deeply affected, and from then on they became annual events.

It was Filson's job to technically oversee the St Hilary broadcast, making sure the rough, warm Cornish voices were transmitted faithfully. Frank was introduced to this "broken-off bit of old Baroque", as Mary Butts dubbed him, who was then in his early forties, a big, sprawling man who tended to intimidate with his slightly bullying and inevitably superior expertise. "When I think of him," Frank recalled, "I invariably see The Dong with the Luminous Nose, moving slowly in a melancholy and slightly menacing pocket of air, borne down by the burden of his own personality and longing to prowl out of it; and the nose, if not actually luminous, pointing quiveringly out from his large red face; an embarrassment yet a consolation to him."

Frank and Filson were both skilful organists. Filson remarked on Frank's playing, correcting him occasionally, while Frank seemed to be more reticent in his criticism, save on that first occasion during the Corpus Christi service when

he referred to "the terrible music" produced by Filson. The latter got his own back, not maliciously, but merely in the interests of keeping up the standard. "Your playing's too fussy, too personal," he remarked to Frank after hearing his playing of the Mass at St Hilary. "Nobody wants to hear Frank Baker enjoying himself when they're singing mass at Credo. What they do need is a strong, solid accompaniment." Put out at first, Frank was forced to admit Filson was right, for when he omitted the embellishments, the singing *did* get better.

When Frank met him, Filson had already cut a flare-path through the main events of the century. He had driven fast cars, mastered boats and planes, reported on the Boer War, reported sensational trials and enraged Sir Arthur Conan Doyle who accused him of 'bad manners' after he had exposed a fraudulent medium at a séance to which he had been invited. Filson dryly took up the manners point, saying he was not aware the affair was a 'tea party' – an opportunity to titter and delicately ingratiate – but an opportunity to test supernatural phenomena.

BIRDMAN

Less blusteringly consequential than Filson was another man Frank met through Walke – a tall, lean, young doctor with fiercely staring dark brown eyes, who was suffering from consumption. Slightly chilly and clipped in manner, he was a staunch Anglican who regularly attended Walke's services as had his late mother, an elderly lady who, at her express wish, had been buried at St Hilary. Kept in tolerably high spirits by an ever-attendant chauffeur and elderly nurse, Miss Backhouse, with whom he lived near Newlyn in a big, spacious house called *Katoomba*, he had private means and was called Robert Walmsley. Ber and Annie liked to host this intense, slightly isolated individual. Robert knew he was dying but was determined to spend his last days studying and observing his primary obsession. He was a Birdman in excelsis and loved to watch the waders and rare visitors that gathered in the Hayle estuary, the Marazion marshes and elsewhere. These creatures meant more to him than any human and he was amassing notes on his encounters with them.

Frank was not drawn to him initially, for Walmsley then struck him as aloof, vaguely off-putting and prone to break into maniacal cackles. This he found disquieting while admiring his dignity and lordly bearing. Usually Robert dressed in a severe dark blue suit with a stiff white high collar and immaculately polished black shoes. When friends of Ber assembled in the rectory after Mass, he kept back from the rest, standing near the bay window so that he could take in the view of the garden. One day, when Frank and the others were talking, they heard Robert break into a fiendish frenzy of laughter. The commotion was so intense that they could not initially locate its origin. But they traced his gaze down to a large blackbird in the garden.

"Mad people," observed Robert. "Clearly mad. Maniacal. Observe the eyes."

Frank stared at the hectic flush on Robert's cheeks and the searing fanaticism in his eyes and realised there was a man gripped by an otherworldly hunger.

Later, when Robert had driven off, he remarked to Walke. "But it's birds he laughs at. It always has been birds."

Bernard corrected him. "People – for *birds are people* to Walmsley."

The conversation was interrupted by the door opening and the return of Robert.

"Redwings!" he snapped. "Many. Very early. Eating the berries on a thorn in the avenue. Come now if you wish to see them."

Coats were quickly flung on shoulders as the company hurried out and down the road with Robert beckoning them on, but by the time they reached the tree the birds had literally flown. "You were too late," Robert said. "But they will stay. The weather up-country is too hard. But you must look for them. Don't mistake them for thrushes. The red is under the wing, sometimes on the breast, like blood – look for large eyebrows."

MAKING FRIENDS: MARCUS TIPPET & EDWARD GARNETT

In the Kenidzhak Valley Frank began and completed his first novel, making use of characters he encountered in and around the area. Lawrentian, he called this first book, *The Twisted Tree*. Like *Women in Love*, it explored a mother-son relationship that reached a tragic climax. The Cornish heroine is called Tansy and, by way of an affair with an unstable artist, she gives birth to a boy, David. She loves him fiercely but he develops traits that she judges as evil. "I drew without caution or care," he recalled, "from the people I found immediately round me, hardly even troubling to disguise them. This is something I would not dare to do today. I do not think the Harry family at the farm ever realised I had used them in this manner and, in fact, I never got to know the family well. I scratched the surface of their lives, no more. It was a very different family who revealed to me the richness, the full-blooded creative force which fires the Cornish character."

He is referring to the local family whom he got to know best of all, almost intimately, the Tippets. Just as the Hockings of Zennor took the young D.H. Lawrence to their heart, Frank was offered the kindness and hospitality of the Tippets who lived near Kenidzhak, in the neighbouring Cott Valley. Herbert, the father, was a former engineer, strong, tanned and quietly authoritative; Emily the mother was a miller's daughter, capacious, excitable and fired with emotion. Three of their grown-up children had already emigrated leaving five presently at home: Gertrude, Hiram, Marcus, Pat and Mercia (upon whom Tansy in *The Twisted Tree* was modelled). To Frank, they seemed a bright, open, casual family, refreshingly different from the middle-class staidness of his upbringing. The

house they lived in was not big enough to contain all the children by day, so they ran wild in the fields and lanes. Frank took to this family, their dialect and attitudes, their rows, silences and sense of humour. He intuited that, in addition to being his friends, they were literary material, characters he might choose to recreate in his fiction.

Not only did the Tippets ply him with stories and local gossip, they fed him wonderful local food: pasties, apple-pie, heavy cake, saffron buns, bread and butter, jam, pickle, and cheese. This was served on a big mahogany table while from the kitchen coils of woodsmoke drifted and dispersed around the workaday banter. Sometimes a game of cards might follow. The white cloth on the table was whisked away, revealing a plane of gleaming wood over which the players would dispute and celebrate their hands. Favourite games were rummy, solo whist, sevens-up and nap. Possibly to this big, bustling, engaging family Frank appeared a lost soul, a young man living all on his own in a remote cottage, spending most hours of the day dreaming up stories – what sort of a living was that? And, indeed, sometimes, after spending a long evening in their company, he might feel disconsolate tramping home alone, the darkness filling the sky and the night owls calling.

One sticky, foggy evening, beads of drizzling smothering the window panes, Frank left the Tippets and set off back to Boscean. It was past midnight and he had to cross a field of bullocks. The jumpy behaviour of the cattle made him nervous and Marcus Tippet, the younger brother, noticed this and offered to accompany him back to his cottage. A friendly conversation lit up the tramp back to Frank's place, and quickly a bond was formed, a communion of two young men who both felt a little on the outside of things. Marcus admired Frank's natural literary skills and Frank admired Marcus's superior practicality. It occurred to them both that they could pool their skills and make each other happy. While Frank wrote books, Marcus could plant bulbs, put up shelves, paint and mend walls. He even made a platform for the little Bord piano Frank had received as a gift from his musician friend, Christopher Fleming, an old friend from Chislehurst days.

Marcus confided to Frank that he was tired of living at home – he needed to get away from his animated and curious family. Living among so many, there was no space in which to expand or peacefully reflect. Frank promptly offered him a room in his cottage. They both agreed that they got on well and were fond of each other. Living together would solve a lot of problems and they set about re-designing the house, painting and furnishing the rooms individually. The partnership proved a great success for Frank, for it was in this home he made with Marcus, this tight, cosy cottage, not only was he to achieve a sense of security, but to entertain a luminary of the London literary scene who was to nurture his talent in a selfless, generous way: head editor of Jonathan Cape, Edward Garnett. By all accounts Garnett was a big shaggy, genial bear of a fellow, who had his

peppery moments and shows of temper. Nevertheless Frank's evocation suggests one of those bizarre beings encountered in Gothic fiction:

The great, pale, harvest moon face; the pouched owl eyes under the thin spectacles; the mop of thick white hair, still curly and with the vestige of a middle parting; the heavy overstooping shoulders; the floppy tweed suit draped over six shaggy feet of his large frame – all this I saw getting slowly out of an ancient motor-car and coming towards the shaky iron gate of my cottage in Penwith at about five-thirty of a summer afternoon in 1933.

Edward Garnett had established himself as a formidably astute editor and skilful midwife for any young, promising novelist. He had helped revise and overhaul the novels of Joseph Conrad, D. H. Lawrence and Mary Webb. (Less fortuitously, he turned down James Joyce's *Portrait of the Artist as a Young Man* while promoting the works of John Galsworthy.) So when Frank learned that Garnett liked Cornwall – was happy to be put up by him and Marcus – he was naturally overjoyed and anxious to meet him.

The introduction had come to Frank through friends who lived nearby, George and Ruth Manning-Sanders. He was a painter and she was a poet. The couple lived at Sennen, seven miles distant, and George knew Garnett well and suggested that he should get in touch with him on Frank's behalf. This he did, saying the Boscean cottage would make a perfect, economical holiday retreat. Garnett sent a brief note to Frank – yes, he'd be delighted to holiday in Cornwall for a week; his secretary, Miss Heath, would accompany him. George Manning-Sanders laid down one essential condition: Frank had to keep quiet about being a writer or else Garnett would think he'd been lured to the cottage under false pretences. "Let him discover for himself," said George, "that you are writing your first novel and would welcome advice." So Frank hid his second-hand Corona typewriter, his writing paper, notebooks and other evidence of literary guilt. But as he was not able to dispose of his book collection, he did wonder whether Garnett did actually catch on without saying.

Garnett and his secretary, Miss Heath, turned out ideal guests, courteous and warm, but Garnett, unlike Miss Heath who approved of everything, had little rituals that demanded respect and attention from others, notably he liked to address his audience with a bottle of wine and the appropriate glasses placed nearby. The manner of Garnett's after-dinner talk was to launch an anecdote or reflection, sweeping steadily towards a conclusion, but then, in order to masterfully stretch the thread of tension, he'd pause, reach for the bottle in a casual manner, always eyeing the audience, drag it across to the rim of the glass, and then, before pouring, complete the sentence. Not until he had finished would he offer glasses of wine to the rest of the company. It was a most impressive technique and Frank had been told by George Manning-Sanders that it was his duty to place the wine within easy reach of Garnett, so that he could smoothly

negotiate this little ritual. One evening, the table prepared, the bottle and glasses in place, Frank did just that, realising it was not all that difficult. When the moment came and Garnett, in full dramatic flow, paused and reached for the wine which Frank extended towards him, the tilted neck of the bottle refused to let out a drop, however much Garnett groaned and shook it, wrecking the effect of his rolling delivery. So the whole oratorical balloon popped, being upstaged by a cork which Frank had forgotten to draw.

If that minor matter gave Garnett cause for resentment, a girl on the scene provided adequate compensation, a friend of Frank's called Molly whom Garnett was happy to flirt with and impress with his worldly wisdom. During all this gabbling bonhomie, Frank kept to his word, never once hinting to Garnett or Miss Heath that it was his intention to become a writer. But Frank guessed they had already found out through Molly or the impressive collection of books that filled the shelves. For it was not long after Garnett's return to London that the first letter arrived for Frank from Pond Place, Chelsea, dated 25 August 1933.

Dear Baker,
We arrived safely, and naturally the litany of praise we have been singing over your cottage and you and Marcus has been enriched by strophes and ante-strophes over Miss Molly and Miss Molly's eyes.
I want to send Marcus a little gift. Those marvellous sandwiches have had a cumulative effect and his kindness to us has penetrated even deeper. But I don't know what to send him. Perhaps you could find out if he needs anything (& what do earth gods and the Spirit of the Place need?) & let me know.
Miss Heath joins in wafting and invoking blessings on your head.

Marcus was delighted by such courtesy and consideration and Frank was relieved that the ice had been thoroughly broken. Soon Garnett was sifting through his short stories and offering advice:

I have read your stories with attention and am now returning them. They show you as a versatile talent with facility of touch and much responsive feeling but a bit simple in technique. The faults, such as they are, don't matter so much since the standard for short stories is by no means exacting and the 'market' seems such a chancy one.

Garnett was hinting his stories were not *that* good, so it was superfluous to rigorously polish them. This was not the sort of offhand appraisal an aspiring writer would welcome, and yet Frank was aware that, unless one regularly sold to the *New Yorker* or *Harpers*, short stories seldom commanded attention. If he wanted to be recognised as a writer, he would have to supply a substantial, exciting novel with a broad appeal. So he proceeded to push ahead with *The Twisted Tree*, realising that, if he did not finish it fast, the attention Garnett was presently giving him might lapse, leaving him devoid of a powerful metropolitan contact. Thus he single-mindedly immersed himself in the act of creation, hardly

noticing what was to prove an ultimately crucial change taking place close to him. Marcus had contracted an illness.

Because he was young and strong, Frank thought his friend would get over the flu or cold or whatever it was. While he worked furiously on his novel, Marcus's sickness grew worse until the Tippets decided to take him back to the Cott Valley. An ambulance was called and Marcus was driven to his family home. His parents called a doctor who diagnosed rheumatic fever. It was necessary to transfer Marcus to Penzance hospital and give him oxygen. But because of a delay in supplying the canisters, on a brilliant ice-cold day, Marcus died in the hospital ward, December 31st, 1933. Frank arrived there in a disbelieving trance of misery: "I could not believe it had happened and I had let it happen."

Crushed by the stark displacement of death, of which he'd never before taken measure, Frank sought assuagement of his grief by appealing to Canon Taylor. But the sole consolation the worthy churchman was able to eke out for the departed soul of Marcus was a spell in purgatory. Purgatory is usually evoked as a freezing cold, comfortless retreat that one may have to linger in for centuries. Frank found no hope in this, and he did not know to whom he could pour out his grief, for he could not help feeling the Tippets might be judging him. If he'd taken action earlier, would not Marcus have been cured?

Fortunately he was able to take comfort from a friend he'd met earlier that year, "a clumpy woman with a limp, wearing short scarlet Wellington boots, a blue beret and an old black sweater, and with cosmetics haphazardly daubed on a large round white moony face." This was his initial impression of Mary Butts, a distinguished writer to whose works George Manning-Sanders had drawn his attention. When Frank called on her, Mary listened intently, as he related the tragic tale of Marcus, actively sharing his grief and forging a bond of sympathy that was to prove of mutual help in years to come.

It was a painful duty for Frank, overseeing the funeral of Marcus whose companionship had proven formative in his making a break with London and putting down roots in Cornwall. Not only had Marcus played ambassador for the local community, he had transformed Frank's damp cottage into a home. Before the grim-faced congregation of the Tippets and their relatives, who probably thought Marcus should have stayed within the safety of the family farm rather than at a lonely cottage with an obscure young writer, for whom he had done most of the cooking and housework, Frank attended the ceremony, taking his place as organist, "playing the little handblown organ in St Just Church in a blind rage of inner despair, feeling my life was over, but following his body to the cold wind-riven graveyard high above St Just. I had been given the rarest friendship of my life; and that nothing remotely like this could ever come again I knew of a certainty."

Fortunately Frank had good, reliable friends, who offered comfort and succour during this time of mourning and adjustment. They bolstered his own natural reserves of pride, determination and inner strength. Being young, ambitious and not entirely able to swallow the enormity of his young friend's mortality, he was still able to cling to the thread of authorial ambition. However, first he needed to remove himself from the place of grief. So he packed his bags and left Boscean, staying with his friend John Raynor in the Isle of Wight, from where he sent the completed manuscript of *The Twisted Tree* to Garnett. Tense weeks followed, and then came back a masterful and detailed criticism:

I like and admire three-fourths of it. I think the general picture of the Family is excellently done, strong and fresh, with the brothers, sister, mother and father finely differentiated. Tansy is certainly a live heroine, individual, and she holds our attention... Arthur and the in-laws are admirably caught and the atmosphere of the place is (of course) convincingly real.

The quarter of the story I don't care for is (as you will guess) the ploy of Evil; but as it is essential to your purpose I will only say that you have arranged the structure & events cleverly, & made them natural, so far as Tansy is concerned. One suspects the artist-hero, Chailey, from the first to be a dilettante product of your fancy, (or perverted imagination), but, artificial as he is, you have done the scene in the Old Vicarage, & the Seduction scene, very cleverly. Where I damn and blast you is in Chailey turning out to be Jack-the-Ripper, which is a cheap sensation (cooked up as art); and I don't think you will persuade any woman that a mother could have pushed David down the shaft. You could and it is the force of yourself & imagination that have transformed Tansy into being your agent. It's very well done, that passage, but Tansy hasn't an obsession of Evil, and you've played with her nature for your obscene contrivance. However, there it must stay. My advice is send the MS to Messrs Chatto & Windus. I have a hunch they will take the book, & if they do, ask for £425 down on account of a royalty. If they refuse it try Faber & Faber, Peter Davies & Cassell, in this order. You see that for those who don't know you 'The Twisted Thorn' [*sic*] is a distinctly promising & clever novel, and if one of these publishers takes the book they will bind you to offer them the next two, and you must play up to them in a mysterious manner, implying that you have interesting literary irons up your sleeve. And God knows you may be a 'coming force' for all I know.

I don't think Cape would take the book unless I piled it on very thick & the 'Chailey-the-Ripper' episode sticks in my throat too much for that; but other readers may well think they have caught a very promising fish.

This criticism, although fair, had a sting. Were Frank to take it to heart, the plot and dramatic substance would be left hanging. The narrative was orchestrated towards a dramatic conclusion. The throbbing melodrama of the ending lifted it out of the realm of gloomy rural realism. Inferior novels had been successfully published and Frank thought he was ready to submit to the public for judgement.

THE NEW FOREST (1933)

Through the composer Christopher Le Fleming, Frank found a temporary home midway between Southampton and Salisbury. In a sense, he was still running away from the spectre of Marcus, but realised that he should try to work off his grief by sustained activity. It was on the estate of the Eyre family, who extended patronage to young and promising artists, that he was offered a home and an opportunity to earn a little money by teaching music and playing the organ at the local church. The family owned the publisher Eyre and Spottiswoode (to whom Graham Greene was elected a director in 1940) and later brought out three of Frank's novels, the first being *Miss Hargreaves*. Citations from the most notorious of their titles *The Protocols of the Elders of Zion* (a forgery positing a Jewish conspiracy to achieve world domination) still create an uneasy atmosphere.

Dorothy Crossthwaite-Eyre loaned him an estate cottage and also let him use a blue Morris Cowley called 'Susan' as a runabout; a genial chauffeur educated him in the rudiments of driving and thus induced him to go speeding down the lanes and mud tracks. Dorothy, known at 'Dio' to her friends, had dropped in on Frank at Boscean and she, being a skilled violinist, was delighted when Frank accompanied her on the piano, playing the violin sonatas of Brahms. Duly impressed, she mentally classed him as a suitable guest or resident artist on her estate.

Dio's family home, Warrens, was three miles from Bramshaw Church where Frank, again owing to her helping hand, was found a job as an organist. His instrument proved "the most cantankerous miniature organ I had yet encountered" and was pumped by "a squint-eyed primitive called Henbest whose permanent grin was always fixed on me when I presided over its yellowing and sinking ivories and its straight pedal-board." He also taught music to a large class of girls – a brimming, ebullient St Trinian-like brigade whom he presided over in an entirely ineffectual way. Their numbers and talents were too many to contain in a disciplined class and he was not a natural teacher who might have devised a vast group project. One hot summer afternoon, with a cry of exasperation, he dismissed the whole class and let them run wild.

Frank's home was an old red-bricked cottage lacking gas, electricity or running water, with crude beech beams and a deep thatch roof. He lived there with a cat called Micky and his own dog, Hilary, who tended to run off distractedly to pursue rabbits. But he did not take to the topography, claiming he suffered tree-phobia. Neither did the ambience of the place encourage his writing, but he did managed to bash out on his Corona typewriter a novel with

the unpromising title of *Multiply the Lord* that he later destroyed. To crown all this accruing unease, he was undergoing a crisis of faith:

Looking back to the New Forest days now it seems to me that I was only doing one thing thoroughly: demolishing God, and, because of the unhealing bitterness of my grief which continued to darken me, establishing my own image on a hand-made altar – an image I came more and more to worship and placate…

He finds himself detaching from the stolid Church of England – nor do his visits to the Catholic chapel of the Eyres provide comfort. Religion involves the regular *practising* of devotion, whether in the throes of grief or not. Faith requires a self-mastering feat of sustained worship rather than surrender to the cruel darts of fate and Frank simply lacked that pious fervour.

Thirty years later, recalling this emotional impasse in *I Follow But Myself*, FB consciously pulls his punches. He hints no church could console the *daimon* who provoked him and found no place among contented, ordinary types. Is he talking about a sexuality that renders him an outcast? If so, he prefers to translate it in pagan terms like the undifferentiated lust of the Great God Pan. Whatever his meaning, he does not find it amid the mushy leafmould of the New Forest, but in the open spaces of Cornwall where his heart is buried. Boscean is invoked – the home he made with Marcus.

Of course, he is recreating this inner turmoil as a middle-aged man with a family and social façade to maintain. To add more would be unnecessary. Did he want to make a confession that might prompt others to look at him strangely? Was he qualified to speak on behalf of that young man of whom he was now a mere projection? Even if he dared, of what use would it be? His secret had been so long hidden that darkness and silence had become its natural habitat.

Back in the quick of the situation, in the depths of the New Forest, spirit in turmoil, he prayed for a resolution from elsewhere to allay what was hurting. "Too much of me had been left in Cornwall," he declared. And then, as if in response to this cry, Bernard Walke wrote to him, inviting him to return to the duchy and take up the post of organist at St Hilary.

Frank was overjoyed yet at the same time realised Walke was no longer the vigorous man he had known three years back. Tuberculosis was leaching his stamina, although he still wanted St Hilary to be an exciting church with stirring art, music and spirituality. He thought Frank – a young musician and lover of Bach – would be able to teach the small choir the elements of plainchant and play the organ for Sunday Mass, Vespers and Benediction. Frank, who was locked in a phase of spiritual doubt, wrote back, saying he'd take the work but he didn't want to involve himself in the service and Father Walke wrote back, saying that he wasn't interested in the state of Frank's soul, only his musical ardour and ability to effect a reformation on the choir and congregation. Such an attitude disarmed Frank and made him feel more seriously religious.

THE TWISTED TREE (1935)

The publisher who finally took *The Twisted Tree* was Peter Davies. With his younger brother Nicholas, Peter ran a small, enterprising firm with an eye-catching, original list. The brothers were literally the 'golden children' of J.M. Barrie to whom the story of Peter Pan and Wendy was first told, a heritage that was to prove both a blessing and a branding. Old Etonians they might have been, yet their manner was light, friendly and devoid of snobbishness. The attribute of Frank's that drew their attention was an apple-green walking-stick made of ash which, in alliance with a dark brown beard, convinced the brothers they had landed "an interesting fish".

Peter and Nico treated Frank to lunch at Rules in Maiden Lane, not far from their office in Henrietta Street. Present in the restaurant was their third brother, Jack, whom they were delighted to see and yet also anxious that the conversation should not be stilted and literary. So, smiling at Jack, Peter Davies remarked, "So sorry we couldn't put this man off. But he's just written a remarkable novel we've accepted. You'd like it. All about fornicating in Cornwall."

When *The Twisted Tree* came out in 1935, sales were mildly encouraging, around 2000 copies, and it was saluted by critics for its realism, solid characterisation and psychological insight. Several literary influences were picked out. It was written, Peter Quennell remarked, "by the ghost of D.H. Lawrence seated on the grave of Mary Webb." It was also judged moderately daring, showing a healthy interest in sexual arousal, although one reviewer warned Baker against such masterly obscurities as, "A pantheistic nocturne flickered its orgiastic liturgy before her."

The Twisted Tree is constructed around the metaphor of a twisted or corrupted nature, exemplified in a branch of hawthorn secreted by the heroine, Tansy, after her liaison with the irresistible yet malevolent artist, Chailey, who seduces her in the ruins of the Old Vicarage where a terrible murder had earlier taken place. Independent-minded and free-spirited, Tansy is unashamed of her sexuality and rather grudging of her dogged fiancé, Arthur, as she is of the local menfolk if they lack courage or the happy sensuality of her handsome, easygoing brother Joe. Tansy is attractive if tart of tongue; men are drawn to her but cowed by her frank, challenging nature. She is aware of being drawn to weird, dominant males whose brains are slightly askew and capable of wreaking havoc with her life.

At the opening of the story, her mother Emmeline is gravely ill with a tumour of the breast. A power shift takes place in the family and Emmeline's sister, Janet, is called to help with the nursing. The household chores are shared among Nicholas, the father, and Tansy's older brother, Andrew, a dour,

dependable type who is contrasted with the handsome and light-spirited Joe, the brother to whom Tansy feels closest. Emmeline had always known Tansy possessed a wild side and might be drawn to the wrong type. In her physically enfeebled state, she is anxious her daughter should marry the dull, staid Arthur Stone, a former miner who worships her and will hopefully prove a supportive husband.

Emmeline dies and Tansy's marriage duly takes place. A son and daughter are born to her and Arthur, christened David and Alice. The boy turns out to be her favourite but she is sure that he is not the offspring of her rightful husband, but of the dark, tortured and morally corrupted Roger Chailey, who excited her passion but could never gain her trust, owing to his erratic, intractable and tightly selfish nature. David grows into a handsome teenager with a natural bodily grace. But he also has a devious and vicious side, expressed in the way he deliberately scares and taunts small children. He knows it to be wrong, but an uncontrollable urge compels him to behave in such a way.

Meanwhile Tansy is tiring of her marriage to Arthur who has lost his job and subsists on the dole. He is bitter, realising Tansy does not offer him the fulfilment of a physical relationship, but dominates and holds him at bay with her fierce tongue. He is being manipulated by his unquestioning love, and he also dislikes David who, he senses, is a queer one, an abnormal "child of the devil" drawn to reading dark gloomy poems and tales of murder and vengeance.

But her brother Andrew, who appears to have a furtive homosexual streak, likes David, finding him both personable and intelligent. He offers him work on his farm and eventually Tansy and Arthur agree to let their son go. But meanwhile, through reading the London papers, the couple have become aware of the arrest of Chailey who has been committing a series of Jack-the-Ripper-type killings in London. Reading of this, Tansy is both thrilled and mortified, believing the death-dealing seed of the father is secreted in her son, whom she loves with a fierce, jealous passion that at times borders on the incestuous. While taking David to Andrew's farm, where he is about to take up employment, they pass an old mine which David wishes to explore, and there, in the darkness, he drops heavy stones, and imagines bodies falling to their death there. Seizing the opportunity, Tansy denies his dark destructive side any possibility of fruition.

The novel demonstrates evil-doing as inherited – a view clashing with the idea of a child being born sinless. Most Christians maintain God would never consciously damn a life before it emerged from the womb. It is only later through personal choice that an individual may be drawn towards a particular destiny. But *The Twisted Tree* is informed by a more pagan outlook. Men and women are perceived as elemental beings in the wild, blasted westernmost peninsula of Cornwall in which the action takes place, a land that's seen much tragedy and horror, from mining accidents to shipwrecks and drownings. The natives of the region are instinctive creatures. They work the fields and mines much like ants

building their nests or bees their hive. Basically inartistic, it is their destiny to subsume their individuality in toil and become slaves to what they produce. Contrast these overburdened souls with the artist who not only holds the mirror up to himself, but may also lay claim to an aspect of nature, like Van Gogh did when he depicted sunflowers so arrestingly. Tansy knows her son, David, belongs to the latter breed, showing the freakishness and unpredictability of his father:

Sometimes she wanted to tell him that he inherited something richer, if more disturbing, than the sluggish blood of Arthur. But she could not part with her secret. Neither was she certain of what he had inherited from Roger Chailey. It was a power, that was certain. In all his gestures, so opposed to the lethargic movement of her own people, there was the compelling appeal of Chailey. The same bewildered anxiety that sometimes clouded his eyes. The same moodiness and impetuosity; the same reaction to lovely things. It was a strong flow of blood in him, a vital heritage if a frightening one.

(*The Twisted Tree*. P. 270)

Tansy is attracted to the villain because he has a sureness and grace of movement that place him at the centre of his own being. If he is wicked, it is because nature wills it. Here we find a savage sentimentalism of the kind permeating the didactic prose of D. H. Lawrence: the notion of the instinct or natural flow of blood triggering an act of sacrifice or murder. Elsewhere in *The Twisted Tree*, there is a hint of man being prey to nature and happenstance. The Spanish writer, Garcia Lorcá, (1898–1936), wrote of the *duende* or mischief-making pulse of life that propels families into blood-feuds as well as marriage, birth and feasting. For those who took a tragic view of human destiny, it was a popular theme that finds a precedent in philosophers like Schopenhauer and novelists like Thomas Hardy who maintain human beings are directed by a blind, selfish, invisible will that precipitates strife, desire and misery and renders earth a 'blighted' planet unless, through meditation or a conscious act of withdrawal, they are able to thwart it.

Technically speaking, *The Twisted Tree* is a polished piece of work, structured more like a steady-paced novel than the sensational story it turns out to be – a broody, brooding piece of writing with a startling conclusion. Chailey, the neurotic, unpredictable artist, to whom Tansy is irrationally attracted, is presented with operatic villainy. A hint of cliché informs his sneering manner and impetuous outbursts of perverse philosophy, but such touches are counterbalanced by the accurate observation with which characters like vulgar, friendly Auntie Janet are presented and the lacklustre, stolid husband of Tansy, Arthur Stone. Even the latter has Lawrentian moments, incidentally, which awaken Tansy's desire. Here he is (P.110) swimming:

In the water his body was a swift purity... The golden gleam of the sun fired him, so that he looked like one who had swum in a pool of gold dust. Tansy was thrilled by him. She had never seen a man's body before. The strong clean arch of his straddled legs, the firm

39

curve of his buttock, the glistening valley of his back, the stiff column of his neck – all this was Arthur, her lover, and she had never known. All she had seen, a masculine obtuseness in thick clothes. She had a sudden temptation to throw her clothes into the sea.

Although it is unlikely that Tansy, who had shared intimate space with her father and brothers in a close-knit Cornish farmhouse, "had never seen a man's body before", this evokes a comeliness and grace Arthur is broadly portrayed as lacking. In contrast with Roger Chailey, Arthur emanates "a strong fellowship with the earth..." The distinction is clear. There is the artist who fastens on to what is 'beautiful' and responds swiftly to unusual sights, combinations of form and colour in the countryside, and there is the native working man who takes the beauties around him for granted, and yet his knowledge of them strikes deeper, as he is instinctually and quintessentially part of them, more integrated than the poet or painter who holds nature up to the spotlight of his perception. The artist makes it his job to be a 'stranger', capturing details and instances as if for the first time, while the working man digs, plants and feeds off his garden, *utilising* rather than poeticising it.

In the copy of the novel studied by the present author, FB marked passages influenced by D.H. Lawrence as if that constituted a fault by definition. But these pastiches or 'tributes' are well done, a quick, light, sensuous prose coupled with vivid landscape painting and evocations of the pagan Celts (often thought of as Cornwall's aboriginal miners) and the sacrifices they performed amid the rocks and carns. The landscape is haunted by the savagery and suffering of what has gone before and the present occupants of the land are being disowned by the march of ages:

"All over the land was a sinister pride – a thievish spirit picking the bones of summer as a vulture on a lovely corpse. A buried voice of man rang through the hollow hills – a voice that uncovered decades of man's adventure with the world and revealed him as no purer a creature than the Celt who had squatted over his camp fire. All that had passed seemed to revile all that was passing. Because another summer had gone, the rock of time never swayed. And around those infrangible coasts where the beast of the sea leaped and fell back, man was no more than a trumpery marionette of God. Stripped of the comfortable vestments of what he called culture, he was driven back nakedly upon the fact that the final culture might disregard him altogether."

The notion that Penwith Peninsula is in thrall to a prowling, malign spirit is still very much alive. Notably the painter and sculptor, Sven Berlin, personified it in *The Dark Monarch* (1964), portraying the artists and workers of 'Cuckoo Town' (St Ives) as being at odds with a supernatural agency that plays havoc with their passions. Whatever the truth, it is an idea so firmly mythologised that nothing can budge it. Even the tourists think they've been taken over.

"Now for the stone," he said. "Listen."

But as he was about to release it upon its dark journey the siren pierced the air again.

"Darn!" he muttered. "Must wait for that, else we'll never hear it at all."

But Tansy did not want to hear it. Standing a little to one side of David, for a brief second she absorbed all the beauty of his eager, wild face. The note of the siren sank, grew louder and more compelling in her ears.

"Hurry!" it cried. *"Hurry... hurry ... hurry..."*

The word grew longer, more laboured and drawn-out, hung in the mine-pitted hillside.

"Hurry...hu-rry...hu-rry..."

The dynamic force of it broke in her head, generated to a blinding flash of fire in her head, so that her veins seemed to burst in her and her blood stream down blackly before her eyes. Her vision was streaked with blood, so that the smooth, sticky world around her became dead and unreal. She was driven forward. Her hands, cold and taut, like the steel girders of a great machine, were not her hands. She did not feel the pressure of his waist meeting her palms, as in one violent attack upon his crouched body, she sent him down his long home. The stone crashed after him. She did not hear him cry, heard nothing of the unending crashing down the shaft, of the little stones that rained upon his body. For thick in her ears were the last hollow echoes of the siren, a sound inexpressibly mournful, yet a sound she hoped might never stop. And when, after an infinity, the siren died away again and the place was silent; when she stood there above the long black mouth of the shaft, alone, where a moment before she bad stood with David, she could not believe that he had gone, that she had stamped finally and utterly upon the poor twisted devil of her son and sent him to the icy bosom of God.

A TERRIBLE TALE

The climax in the ruined mine is dramatically narrated, but here again an objection can be raised. David Garnett called the end an "obscene contrivance", meaning that it was devised to satisfy the story's demands rather than the natural desires and impulses of the characters. At times Tansy seems to be more out of control than David, truly obsessed, like the governess in *The Turn of the Screw* who, some critics claim, suffers from delusional frustration. The hints about David's so-called evil nature are shadowy. What's more, it's stressed that he's happy to take up new employment with Uncle Andrew, start a new life, not exactly a credible context for being pushed down a mine by his loving mother.

A contemporary critic would note the leisurely placement of dramatic links in the plot. Scenes build up character and family atmosphere rather than vibrate a thread of tension from chapter to chapter. One does not look forward to an approaching storm or point of illumination simply because FB prefers meticulous scene-setting to urgent pacing: Marcel Proust rather than John Buchan.

What does stand out is the degree of care taken in creating bold, arresting images and prose that is supple and of a sculptural strength. The breath of pagan Cornwall flutters through the pages and keeps them turning. The arm metaphor is used in connection with sky, headland and landscape, as if the scenery is actively engaging with human life, reaching out, grasping, taking, pointing. This potent, charged quality is often ascribed to Penwith, especially when a gale is combing the heathery pelt of the granite uplands.

No one disliked *The Twisted Tree* for its picture of Cornish life, save a weekly paper called *The Cornishman* which referred to it as "abominable filth", an enviable strapline in today's climate when no one worries overmuch about appearing respectable or – for that matter – literate. But back then it might have made some shy of purchasing the item. Frank's American admirer, Everett Bleiler, thought the novel treated Cornwall like William Faulkner portrayed the American South, dark, repressed and seething, but it was generally hailed as a promising debut. "A dark and terrible tale," thought Howard Spring in *The Evening Standard*, "told with a good deal of power and a one-eyed determination to allow no laughter to no lips and happiness to no heart." So generally the book was thought slightly menacing and overcast in tone, but exciting and readable enough to captivate.

A few reviewers, however, did poke fun at the passages of full-blown, rampant prose. This was to be expected as Frank was writing three years after that superb parody of the gothic vein in rural writing *Cold Comfort Farm* (1932) by Stella Gibbons had appeared. The hilarious skit on the Starkadder family who toiled, bred and brooded amid the cursed, bitter landscape of their inheritance, always in dread of 'something nasty in the woodshed', created gusts of laughter in the publishing world and tended to colour a reviewer's reception of pastoral novels that conveyed sexual heat by means of a throbbing, intrusive symbolism.

REVIEW – Compton Mackenzie in the *Daily Mail*

The Twisted Tree by Frank Baker is one of those half-fantastic tales about West Cornwall which demand a disciplined imagination and style to carry off successfully. Fortunately Mr Baker possesses both qualifications, and the result is a thoroughly interesting and often moving tale, the intrinsic probability of which is gradually made credible.

Having spent a great deal of my life in places which inspire novelists to create heroines like Tansy Rendell, I am a little shy of these wood-nymphs whom I never have the good fortune to meet myself. However, Mr Baker's accurate and easy reproduction of the Cornish speech, his equally accurate and often beautiful evocations of the Cornish scene, and his well-observed minor characters overcame my initial prejudice and gave me some most enjoyable reading.

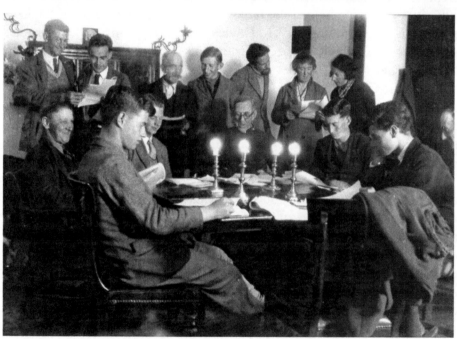

St Hilary (top) & players (below) in rehearsal (c.1935), FB bearded standing behind Bernard Walke seated at table in the centre.

St Hilary

After the tragedy of Marcus, Frank spent periods in London, the Isle of Wight and on the estate of the Eyre family in the New Forest, returning to Cornwall in 1935. He did not settle in St Just this time but in the parish of St Hilary, where the flamboyant and eccentric Bernard Walke had offered him work as an organist. With him on this occasion was the friend of his youth, the musician John Raynor, who was also attracted to the westernmost promontory of Britain.

To explain the sway Walke held over Frank, it is useful to know something of his early background. Walke's childhood years had been spent in the hamlet of Lover on the edge of the New Forest. As a child, he befriended the local craftsmen and absorbed their wisdom and folklore. It was a hunting area and, as a young man, he eagerly participated in the bloodsport until he glimpsed the suffering and courage of a stag who had outwitted a local hunt. This gave him a reverence for life that formed the basis of his pacifism. Such was his eloquence and authority that he summoned the famous and prominent to support the Cornish Peace Movement, including W. H. Davies the poet, Tom Attlee, brother of Clement Attlee, the Labour Prime Minister, and George Bernard Shaw, socialist and dramatist.

Being more a Catholic than an Anglican, Walke was a traditionalist like Frank's other favourite outlaw priest, Sandys Wason, who was briefly the curate at Gunwalloe and also a supporter and friend of Walke. The latter began his incumbency by affirming his allegiance with Rome, replacing the Prayer Book Mattins with the Tridentine Rite, verifying in 1935 that he "was convinced that the Catholic movement in the Church of England, which began in the discovery of the Church as a divine institution, could have no other end but a corporate union with the Apostolic See of Rome. Outside that unity there could be no assurance of the preservation of the faith and morals of the Christian revelation."

The Tridentine Mass, also known as the 'Old Mass' and 'The Latin Mass', is conducted in Latin with the priest reciting the liturgy facing east, leading the community who are behind him. Everything happens strictly according to the rubrics (instructions) and the congregation follows the Mass in private prayer and doesn't play an active part. By its nature the Mass is always a sacrifice, but its sacrificial character is stronger in the Tridentine version.

Anglo-Catholicism comprises a broad designation, encompassing a Protestant as well as a Catholic arm. In the past, this sparked friction and debate down the years in parishes up and down Britain, especially when a change of incumbents results in a switchback or innovation, the substitution of the Prayer Book Mattins with the Tridentine or vice versa.

44

With his flair for espousing causes beyond the confines of his parish, Bernard Walke achieved a national reputation. His broadcast of the Christmas play and other devout dramas written for local people strongly affected those susceptible to religious emotion. In addition he filled St Hilary's with statuary from Catholic shrines in Europe and commissioned artworks by such notaries of the Newlyn School as Dod and Ernest Procter, Harold Harvey, Harold Knight and Alethea Garstin. His wife, Annie Walke, provided a charming painting of Joan of Arc in the Pre-Raphaelite style and Roger Fry supplied a creepy – if magnetically arresting – portrait of St Francis of Assisi. The traditional parish church had become a devotional art gallery that sent out esoteric messages to those in the know. Some approved; many were indifferent; others were startled, resentful. Was he really a Cornish saint, they asked, or man so intent on impressing his personal tastes that he had overlooked the needs of those who preferred the church as it was before? Is it a parson's job to represent his congregation or persuade them to come around to his view?

While friends like Frank Baker stood by him, his curacy stirred an undercurrent of resentment from those who dubbed him a papist upstart. Despite his sway over intellectuals and purists, there was a side of Walke that provoked surliness and irritation. He was an intellectual, a *furriner* who did not behave as a parson should, being active rather than passive, a combative peacemaker, a flagrant internationalist who took in orphaned children and trotted from parish to parish on an ass as if he were Christ entering Jerusalem.

This animosity reached a climax in August 1932 when, in the best tradition of Henry VIII, a gang of Protestant diehards, headed by a local woman called Mrs King, launched an attack on the church at St Hilary. Carrying crowbars, they overpowered the verger and held Bernard Walke prisoner while they removed offending statuary and decorations from the building. The Kensitites, as this sect was called, prided themselves on defacing any Popish ornament that had been intruded into the Church of England. The siege of St Hilary was reported in the national press, creating a wave of sympathy for Walke. Almost everyone agreed his assailants had acted in a brutal, heavy-handed way and aroused the ire of the Anglican faction.

When living at Boscean with Marcus, Frank had admired Walke's steadfast faith and imaginative vision, but his friend's death had disrupted the harmonious atmosphere, prompting him to leave. Hence, now the pastor had contacted him, showing a sympathetic interest in his musical and literary ability, Frank saw it as a unique opportunity to get to know and learn from an exceptional man with a warmly curious disposition, blending a love of children, animals and working folk with an intellectual enthusiasm for art, music, drama, literature, theology and politics. Frank began to attend services at St Hilary and be drawn into a select, intriguing congregation that included the writer Mary Butts who was then living at a modern bungalow in Sennen.

HALAMANNING

After the interval of spiritual purgation in the New Forest, he felt ready to resume his Cornish mission and, what's more, this time he was accompanied by his best friend, John Raynor, who also volunteered his skills to aid the enterprise of Walke (although it was Frank who was officially employed by the parson) and rented a tall cottage at nearby Halamanning that had once been a mine counting-house, standing "solitary and angular, slanting in the middle of this straggling land where muddied paths met and merged into swamps." The building evoked Gothic fantasies in Frank of Peake-Land, a suburb of Gormenghast, a vast tradition-bound institution that blighted the lives of its masters and servants.

He found the gloom and moodiness of atmosphere bracing and enjoyed the local routes, "going inland from Prussia or Kenneggy, crossing the A394 at Rosudgeon and so to a lane by the Falmouth Packet." In those days Frank and John used to cycle back to the cottage at Halamanning after a day out. Having been close friends since meeting at Sydney Nicholson's School of English Church Music, they got on extremely well, sharing their slightly shadowy or borderline sexual dispositions as they did their dislike for the ecclesiastical coterie who dominated the academy.

Soon they found themselves lambasting the structure that had been put in place to contain them. "We were unpolitical," Frank recalled, "more pagan than Christian, dedicated to what we felt to be our work, often quarrelsome, fond of food, beer, wine and tobacco, proud, and very poor. Both of us had opted out from backgrounds whose true values we later came fully to recognise. It was the falseness in these backgrounds we had discarded. And I think we had one saving grace; we were not materialists. Moreover, we were able to see ourselves from outside and were certainly capable of self-mockery. I do not think we often took ourselves too seriously."

Both men admired the short story writer and countryman, A.E. Coppard, who wrote movingly about farmers, tinkers and outcasts and showed a touch of sensuality that reached its apogee in his short story *Dusky Ruth*. FB and John celebrated their apartness by calling themselves 'The Two Wretches' after another of Coppard's tales. They both had a penchant for what Frank called 'exhibitionism'. As that word has acquired affinities with bodily exposure, it would be clearer to say that they relished dramas and recitals, 'performing' or playing to audiences whether in a professional or amateur context. On impulse, they might occasionally dress strikingly or behave a little histrionically. This did not bother Ber Walke who noted how capable they were as musicians and made full use of their skills, allowing them to teach the small local choir of men and women the plainchant which so suited the Celtic lilt of the voices.

Eagerly they set about exploring the area and, believing themselves psychic, became fascinated by a bleak, untenanted cottage situated on a hill above Penberthy Cross, west of the Hayle River. The cottage was called Frythens which Frank associated with 'frightens' and devised a personal mythology around. He was not able to support his instinctive dread by unearthing a tragic or haunted history to the place, but states that for many years when he cycled past it he felt oppressed and daunted.

What did it give out? More than despair. More than remorse. Even more than hatred. It gave out a sense of annihilation, and of alienation. Moveless, sightless, a deaf mute on a crow-pecked hill, it sent out a dumb curse which enveloped the hump of ground in a cloak of blackness. One would labour up the hill, aware of its imminence, knowing one had to pass by and *through* it. I have known a few places where I have had to say aloud the Lord's Prayer. Frythens was one of them.

To him Cornwall was a 'haunted' place, yet he is unsure of how the word can be defined. He has sensed and seen ghosts himself, but the problem is what they represent, an optical phenomenon or the raising of some barrier between this world and the next. When he saw the ghost of his mother, he interpreted it as "a descaling of my eyes, for the space of one minute thus enabled to see outside the limitations of time. For she stood there, wearing the black clothes I had last seen her wear, on the border of the home in Cornwall which was later to become my family's home. She stood within the glass panel of a door. And neither my father nor my stepmother saw her nor was I even disturbed, even though I was emotionally stirred."

John and Frank shared this "psychic awareness" and from time to time experimented in an occult or vaguely spiritualist way. Frank claimed they possessed a powerful intuition of what was 'evil'. He went a little further by locating a malevolent, baneful quality in Roger Fry's painting of St Francis in St Hilary's. The saint's head portrayed "the blind thrust of a dedicated phallus" and was "horribly clever" in execution. "Sunday by Sunday," Frank recalled, "I would see it, reflected in the mirror above the organ console; and I would try to forget it existed. It is the one thing in the church that should have been removed; instead, the altars were hacked out. I often wondered if Bernard Walke could be aware of it. Certainly Roger Fry, the Bloomsbury unbeliever, who had offered to paint a picture for the church, knew what he was about. For it is deliberately obscene, in that it transforms a symbol of goodness into one of evil. For all I know, this picture may have had much to do with the troubles that overshadowed St Hilary, reducing it to the empty shell it became. And still it haunts the church with its impenitent darkness."

The painting is a little creepy, making the saint appear sly and guileful, but the phallic allusion is not that obvious and may reflect FB's state of mind at the time rather than any diabolical intention on the part of the artist.

'Halamanning in Retallack Bottoms' was translated as 'butter moor in a high place with many pits'. Appropriately the local farmer sold Frank and John his yellow, salty butter and they trudged back through the pits, "little holes to hell, traps for the unwary", to their desolate, comforting home smelling of damp and coal smoke. It was a sunken, timeless mode of existence, drawing water from the brackish well, taking walks to St Hilary and reviving past memories. The intense, dreaming trance of their time together was broken by the death of John's father, Reverend A.G.S. Raynor who, among other things, bequeathed to John over thirty bottles of fine wine, burgundy and claret, for celebrating the religious festivals, Christmas, Easter and of course any personal birthday. There was also delivered to the mine-house many cases from his impressive butterfly collection along with piles of ancient volumes of *Punch*.

"*Punch*, butterflies and wine," Frank recalled. "In my memory they merge into one unbroken winter's day – a day when there was always another bottle always another year of Punch to pore over, always one more butterfly, a very small one, a very insignificant one, who had not received proper attention earlier, one of those dreary oak-eggars perhaps, and always – another bottle."

MARY BUTTS: A LIGHT OF THE LOST GENERATION

As an organist and churchgoer, Frank took the opportunity to rekindle his friendship with Mary Butts, a fellow author and admirer of Ber Walke. A light of the lost generation of the 1920's, Mary had early rebelled against her country-house upbringing, plunging into bohemian life and taking up several disappointing or disastrous relationships with men who were predominantly homosexual, leaving her frustrated and unhappy. There was some consolation in her enjoying a period of butterfly celebrity when her stories were praised by Ezra Pound, Ford Madox Ford and May Sinclair.

Drawn to exotic cults and strange gods, in 1922 she studied Aleister Crowley's 'magick', staying at his Abbey of Thelema in Sicily along with her partner, Cecil Maitland, and watching scenes of bestiality and blood sacrifice that she later reported in a dry, cool manner. She witnessed Crowley in all his horror and glory and went "up the third to the fourth dimension". Now, after a decade dabbling in drugs, alcohol and occultism, she settled in Sennen and crept into the Anglican fold under the guidance of Ber Walke. But not in a stuffy, dogmatic way. Plenty of room remained in Mary's heart for the Holy Grail, intoxicating potions, ghosts and the nightside of things. Her great-grandfather had been a patron of William Blake and something like the mystic's fervour and visionary subtlety – urge to explore the unseen cracks of perception – pervades her prose.

Yet there lingered in Mary also an empathy with the scrupulously rational. For she knew the act of seeing was not synonymous with believing, and in that confusion foundered many a potential miracle. In her prose she wielded a

tentative, flickering precision of phrase that never quite vanished in a mist of unmeaning but remained not quite fixed or developed. She supplies a sentence hinting at the vacuum that lies behind character and motivation, as if she's keen to establish how little we really know about the 'others' who flit in and out of our life like insects alighting on a flower. What's more, she doubts the mind as an instrument of perception. "There is no head or tail to this story," she begins *Brightness Falls*, "except that it happened. On the other hand, how does one know anything happened. How does one know? How do I know that Max did not invent it?"

Mary was one of the 'elect' or close circle who, along with FB and a few others, would gather in Walke's study after the Sunday Morning Mass and enjoy a coffee and toast breakfast. "In that calm room," he recalled, "with its shelves of books and white walls and ash fire, we had a sense of unity which is rare, and a feeling too that we all had a unique role to play in the great adventure of living. Mary loved those Sundays as much as anybody. Perhaps, like the woman of Samaria to whom Bernard liked to compare her, she had come seeking the waters of truth."

Despite the closeness and camaraderie, the latter half of Walke's curacy proved testing and shadowed by physical decline. Following the besieging of the church in 1932, there was an interval of poor health when Ber was treated at the sanatorium in Tehidy for advanced TB. By the winter of 1936, mortally ill, he was forced to resign from the living of St Hilary and the Sunday Mass was taken over by anyone the Rural Dean could find to perform the ceremony.

THE FITZROVIANS ARE COMING

The departure of Bernard Walke from St Hilary left Frank rudderless. Not only had he lost his spiritual father-figure but his close companion, John Raynor, who had obligations to honour back in Sussex. Alone and spiritually disorientated, Frank decided to leave the mine-house and move into a house on Perran Downs. There, brooding on the spiritual anchorage that was no more, he toyed with ideas of chastity and the religious life. Did he have it in him to become a priest? Poverty, he believed, came easy and was to be his lot whether he wanted it or not. Obedience he was not *that* good at, as he always ended up doing what he liked. Temperance he found difficult but it was nevertheless a prospect he mulled over as he downed numerous beers in the Trevelyan Arms.

In this solitary state, half-drunk, sexually confused and filled with yearning for a safe haven amid the encircling causes and dogmas, he had a vision in an evening in late October. He had been sitting alone in the small, darkening church, kneeling up by the high altar whose tabernacle was curtained by a small piece of gold damask when the face of Christ the King Revealed Himself: staring fixedly at the gold veil, he saw it change into the crucified head of Christ

crowned with thorns "whose eyes looked at me stern and strong, whose voice commanded me to go on with what I had set myself to do at St Hilary. Not to complain, not to lose faith, not to turn back."

This is dramatically worded. But despite his instant of glory, Frank did not enter the Church – he lacked the narrow, fierce spirituality – but strove instead to keep the memory of Bernard Walke alive by forming a small protest group, headed by himself and Mary Butts, who tried to convince the clerical authorities how important it was the spirit of the former pastor be kept alive in whatever successor they chose, a request neither reasonable nor practicable.

Notwithstanding the departure of Ber, the year or so at Perran Downs was by no means a despairing period. There were compensations – flickers of activity that stirred gossip and rumour. The political situation may have been grim, what with Hitler's increasing territorial claims, but Frank acquired a Baby Austin and explored the towns and villages at his leisure. What's more, he noted how London's social world was infiltrating the scene. The duchy was drawing into its leafy clutches artists, poets and musicians. The lure of pagan sunshine, standing stones and dark blue seas had penetrated the nicotine mists of the Fitzroy Tavern, London. Several noted Fitzrovians – a loosely linked conclave of poets, artists and writers who frequented the pub – drifted down to the duchy and developed various projects there. Augustus John visited regularly with his wife and models; established artists and writers like the well-known couple, Oswell Blakeston and Max Chapman, dropped in on Mary Butts; Dylan Thomas, the Welsh Wonder, made an appearance several times, initially when having a fling with the socialite and art entrepreneur, Wyn Henderson, and later with his wife, Caitlin.

Frank often drove over to Newlyn or Mousehole to enjoy a drink and pick up the latest gossip. The company was abuzz one evening, announcing Dylan Thomas was coming to live in the duchy and everyone should contribute to his comfort. A primus stove was produced, pots, pans and blankets – anything to aid genius. Eventually Dylan and his radiant bride made an appearance at Mousehole and acolytes gathered in the local, hoping to garner a drip from the sacred spring. Asked his method of composition, Dylan said that he scribbled words or lines on bits of paper that he tossed into the air and picked up at random – a mode of construction more applicable to William Burroughs. Frank's account of Dylan Thomas is reserved, as if heard at second-hand, but he does state he was 'impressive' to listen to and looked like the curly haired cherub of Augustus John's famous portrait and that Caitlin was lovely to behold. Conversation-wise, there was little to report, save Dylan questioned Dod Procter on her reaction to the mention of women's periods – a remark met by a cold silence.

This was the period, after the death of Mary Butts, when Aleister Crowley was seen lunching with the glamorous Portuguese heiress, Greta Sequeira, at the Lobster Pot, Mousehole, and his fitful presence in the duchy, amid the woods and boulders of Trevelloe or enjoying the Shakespeare Festival at Fowey, stirred a

multitude of rumours that mingled with early hints of Black Magic and fused in a particular incident: the death of Ka Arnold-Forster at Carn Cottage in May 1938. The tenants of the cottage, the Vaughans, asked Ka to stay there during the night so that she might witness the poltergeist or ghost that haunted the property. She was found dead in a chair in the early hours and gossip connected Crowley's fitful presence in Cornwall with the fatality – as Ka, apparently, had been anxious to put a stop to sundry ritual activities that were taking place at Christian and pagan sites. The incident provided the basis of FB's thriller *Talk of the Devil*.

JOURNAL OF PERSONALITIES

Among the more interesting records kept by Frank is his 'Journal of Personalities' kept from July 1936 to the early 1940s. The entries comprise twenty-six pen-portraits of different people he met over the period, beginning with gentle, pompous and poetical, Father Lister Glover, who had composed a vast number of Christmas hymns, and ending with Lionel, a weedy young man who wanted to be an artist, drove a car with "careless skill" and whose companion was "a Pansy Anglo-Catholic Priest". Frank was only 28 when he drafted these pen-portraits: hence they are in places markedly judgmental and prejudiced – not how he would have put it as an older man – but they tell us much about the company he kept in different locations.

August 12, 1936: Antony Rousse

This youth called upon me this afternoon. Though not very pleasant in appearance, I came to like him more than I had expected. He is tall, fair with cerulean blue eyes and a tremendous nose, lodged in the middle. Smartly dressed though not well dressed, a tie with a dogs-toothed suit: a flamboyant watch, a signet ring. He is an actor, nineteen years of age (though he looks much older) and mentioned that he had aspired to Holy Orders, but 'something happened'. I gather he was homosexual but not intolerantly or intolerably so. There was something undefinedly 'common' about him which seemed to be a mistake. I could not fathom it. He said he was Cornish so I imagine he is really peasant stock risen.

August 25, 1936: Heseltine's Indian

I met this Indian gentleman at Mary Butt's House where I went to lunch today. Now I have never been able to feel myself in sympathy for coloured people, except coal black Negroes and Japanese, so I must guard against preliminary bias. Yet there appeared to be in his face – fat, twinkling, dimpled and yellow – all those qualities which I feel to be latent in the East. Cruelty that masquerades as independence: concupiscence that masquerades as gaiety: hedonism that masquerades as religion: cunning as intellect. He was a man of about 40, dressed smartly in European clothes. He spoke of Heseltine whom he had known well. He smoked a very foul blend of slate-grey cigarettes. He teased Mary as though she was a pet, amusing but also distasteful. He spoke of prewar frolics and one could imagine what sort of frolics they were. (Am I a Puritan at heart? Probably.) Camilla [Mary Butts's daughter] was also present. There was a very strained feeling in the air at Camilla being sent off to take the Indian to lunch and quite clearly she did not want to go. It was partly this which led me to make pronouncement against the gentleman. But no. East is East: and West is West. And when you get a chunk of East in so Westernmost a place as Sennen, the charm seems enormous.

September 1941: The Assyrian Strumpet

Annie Walke called her an Assyrian: anyone else would call her a strumpet. Age about 22 or 23. Met in The Ship [at Mevagissey] in company with a girl called Dorothy whom I had met at Oxford and completely forgotten. The Assyrian would, I imagine, have taken an impotent patriarch to her bed, drawn virility from a eunuch and reduced Don Juan to a piece of blotting paper. A truly frightening young woman with a set-square jaw and heavy bones and haunches. She made me sad. Nymphomania in one so young is not amusing.

I brought her and Tony Rousse (re-met after five years) up here (The Cliff) after The Ship had closed. She was a little drunk. We all wolfed blackberries and sugar and it was interesting to see how the Assyrian brought her sexual hunger to her food. Never had blackberries been so truly raped.

Then we talked of painting. Her manner completely changed and she became a simple child, eager to meet others who painted and easily enthralled by Joan's pictures. There was a garden interlude. We talked of nothing and every word was underlined. I wanted to lay my belt around her buttocks. (For her sake – or mine?) She slipped down the rocky wall, cut her ankle, which I bound with a clean hankerchief. A hard, cruel, savage face…

THE BIRDS (1936)

For his second novel, FB tried something more ambitiously speculative and futuristic after the manner of the early disaster narratives of H.G. Wells and his imitators. Although not learned in ornithology, he had always been interested in watching birds, attracted by their beauty, strangeness and the remote, inhuman gleam behind their eyes. His interest was amplified by his friendship at St Hilary with the naturalist, Robert Walmsley, who pointed out to Frank that "some birds have in their eyes a cruelty, a singletrack visual glitter, which can become quite terrifying if you are able to look closely enough into those rock-dark unreflecting pools."

Walmsley did not sentimentalise birds. He saw them as creatures with virtues and limitations yet possessed of the extraordinary ability to soar above human concerns. To become airborne, they did not need an aeroplane – a petrol-drinking device – that would disrupt the harmony of the spheres. The sky was their untainted, always available pasture. They moved through the realm of angels freely and confidently, and yet he sensed something threatening and destructive there.

"I have no regrets for seeing birds as monsters," Frank wrote in his autobiography, "capable of a fury of destruction possible to no other creature. I vividly remember the gloomy winter afternoon in the Halamanning Valley, a day with no sunset in the dusk, when I heard in the air too close to me the swishing of innumerable wings and looked up to see what is inappropriately called a great 'murmuration' of starlings. One part of a black sky was even blacker because of them. With an alarming and a deadly unity they all decided to drop into a wide rising field of dead nettles, feverfew and dried burdock. In less than a second the field was black and crawling with them. In the same second my nightmare was conceived. My hatred for all the rottenness of our civilization rose in me. I could see and hear the torments of people who might be the wrong side of that shrieking, whistling, hissing and ravaging world of starlings. Wings had no beauty now; but beaks and claws were working their damnedest. My macabre sense mounted in me. Hurrying to my hut in the gloomy light I lit a lamp and began to consider with unholy relish what one bird alone could do, if ever the devil got possession of it or man's domination of the beasts weakened. A black-backed gull could swoop down on a sheep and pluck out its living eyes. What could it do to a man if it chose? With a fiendish zest I began to map out my old world, the world of the City of London I would thus destroy, already seeing in my mind's eye many enemies who would become the victims of my harpies."

So Frank conceived a grandiose, metaphysical thriller that makes connections with writers like Charles Williams and C.S. Lewis, depicting a reversal of behaviour of an entire species that, possibly, was triggered by mankind not acting responsibly or taking proper measure of its moral obligation. Written during a threatening political climate, when Hitler dominated the political arena and the possibility of war in the air was imminent, *The Birds* (1936) has an unsettling, distinctive atmosphere. Some might call it a 'disaster' novel – not *a disaster of a novel* – with metaphysical overtones that uses an epistolary or autobiographical framework. It is likely that Frank had been affected by J.B. Priestley's *Rain Upon Godshill* (1929) that contains a phantasmagoric dream sequence involving a river of birds of all species flying against the backdrop of beating waves of white light; the creatures instantaneously breed, wither and die: sacrificial offspring caught up in the ever-replenishing crucible of creation.

When it appeared under the imprint of the Davies brothers, expectation ran high for a yarn that was noticeably different. It was not a dark romance like *The Twisted Tree* but nearer science fiction or bleak fantasy. Care had gone into the production and design, with Nico Davies writing the bird shoot chapter for Frank who had never wielded a gun in his life. As it turned out, the novel only caused a slight ripple in the pages of literary periodicals, but it did create a fresh wave of interest when it appeared as a paperback in 1964 after the phenomenally successful Hitchcock movie of the same name. The ominous blurb on the (somewhat abbreviated) Panther reprint provides an impression of its more hysterical passages: "On the day of the claw, the birds swooped down in a black cloud of beating, shrieking rage… Un-born babes were torn from their mother's wombs…men, women and children became helpless victims of the malicious and angry talons… No one was safe from the terrible vengeance of THE BIRDS."

Far more ambitious in scope than Daphne Du Maurier's short story, upon which the film was based, it has been called a "plume and doom novel" and "an unjustly neglected 'Ohmigod, we're living between two World Wars!' fable." Certainly it is a narrative of power and metaphysical depth, taking the form of a memoir of a survivor. The style swoops from the personal to the panoramic – from the narrator's story to his overview of London and its motley populace. The father-narrator writes to his daughter, Anna, about the 'Days Before the Birds Came' followed by the first attack on human beings in Trafalgar Square. Aside from the odd description of an eyeball or organ being plucked out, there is not much gratuitous gore. The dearth of the latter is more than compensated for by the amount of avian ordure that clogs certain chapters. Although ineffective as fertilizer, it turns out to be useful in expressing political disapproval. One of the birds flies over "a pathetic and universally pitied figure with a melancholy moustache and black hat" [Adolf Hitler at a Nazi rally] and pays the obligatory tribute, "casting his load with a gentle plop on to the carefully brushed black hair."

The tone is of slightly sanctimonious hindsight – God sending the birds to punish spiritually barren humanity. The civilization at the heart of the story (London 1935) is picked over with distaste: a sprawling metropolis brimming with money-grubbing clerks and underwriters, neurotic housewives, powder-caked streetwalkers, platitude-spouting priests and theologians, second-rate poets and novelists. Baker is passionate in condemnation – one feels he's at least half-convinced of what he's saying. Some of his denunciations of the leisure activities of working folk come close to the waffle of the hacks he decries. It is the slightly snobbish disdain of a troubled young man rather than anyone who has truly grown weary in the knowledge of moral lassitude, but there's a Shavian zeal there as well, notably in his valiant analysis of the plight of London's prostitutes.

Interesting are the sketches of acquaintances and well-known people like the songwriter Philip Heseltine or 'Peter Warlock'. Called Paul Weaver in *The Birds*, he is styled as a scholar of medieval poetry whose "early work had shown a sensitivity to musical cadences and aphoristic crystallization which bore a strong resemblance to the lyrics of the Elizabethans..." Then, changing his name, appearance and style of composition, he plunged into a savage, eccentric life, writing "furiously passionate verses, archaic drinking songs and vagabond love poems." Naturally his prodigal indulgence attracts the winged avengers.

Warlock was a mythic figure in Frank's musical pantheon. Coming from a privileged background, like a young, doomed god, he drank with the gusto and determination of one who wanted to go down taking the liquid wealth of the world with him. He was the *beau idéal* of the artist, switching between the hysterically happy and manically despairing. Huxley immortalised him as the incorrigibly loquacious Peter Coleman in *Antic Hay* – yet his best musical work is often bone-cold and tragic in feeling. People picked out his tall, lean figure in the fashionable locales of London. More than a whiff of madness and possession radiated from his lithe, nervous body and smiling eyes – indeed he tried out spells and conjurations with his fellow musician, Cecil Gray. FB had just arrived in Cornwall when Warlock's death was spread over the papers. In the midst of an unhappy love affair, he had gassed himself and solidified into legend.

Aside from those he admired and despised, Frank managed to confront personal devils in *The Birds* was. It was written at a time when he needed to empty out a lot of personal stuff, not the least his sexually divided nature, about which he wrote with sensitivity and honesty. He has a tendency to hook the reader and then break off to describe activities like cinema-going, listening to music and dancing in a lofty, disdainful manner, as if he is far above such nonsense. But the superiority of tone is a little forced and lacks the satirical ferocity of a Swift or a Wyndham Lewis. FB does *eventually* pick up the thread – he is by no means inept as a narrator – and then one is grateful. The birds and their impertinent antics are what matter to the reader and not the idea of London as a lesser Sodom.

The creatures are vividly and believably presented as attractive on first glance but possessing tiny, disquieting details that undermine the whole impression – that, in fact, convey they are appraising mankind more deeply than mankind is appraising them:

About as large as starlings, but different in every other respect, they were neither pink nor purple as the messenger had surmised, but an ambiguous shade of dark jade green. This colour, catching the bright sunlight, sometimes shone blue, sometimes purple. It was an almost fluid colour. Each one had a little ruff of pretty feathers round his neck which stuck like a hat above his head. The brightest part of their colouring was the breast, from the throat downwards, where the feathers were smooth and of a glossy sheen which seemed to reflect all colours. Their little beaks were curved, not unlike a parrot; they had sharp very lively eyes which gave them an inquisitive, impertinent expression. Their tail feathers were rather bedraggled, so that from behind they appeared to be dull, squalid creatures. Whereas from the front they were alive and full of colour. Their behaviour was most interesting. Lined in thick ranks up the steps, they did nothing but sit there, looking at the people who studied them, with almost critical intensity, as though they themselves were studying us. Indeed, the longer I watched them, the more I felt that it was ourselves rather than the birds, who had no place in this City. They showed no sign either of aggression or timidity. They twittered occasionally and sometimes ruffled their feathers; otherwise they were silent. The noise they made was not very pleasant; much of it would have been intensely irritating. And the longer I looked the more irritated I began to feel. That flamboyant colouring, that impudent little ruff which had first charmed me, began now to annoy me as would a person of great wealth who dressed in bad taste. Yet I was too fascinated to try and break away from the crowd.

Halfway through, a mystical interlude occurs that streams into a diagnosis of humanity's malaise. The narrator escapes to Wales, sharing the hospitality of a young shepherd and his family. Climbing Cader Idris, he is gripped by the insight that humanity, in pursuing shallow gratifications, has splintered into selfish parts forsaking the 'sensible' body and the soul: "For there was nothing done with the fire of the Soul that was not an act of creation. When I breathed and knew I breathed, I created…While I knew the Soul's inexhaustible powers of creation I need never fear death, for death was a word invented by one whose body had lost its Soul."

This fallen state is exploited by the birds who quaintly or savagely parody the attitudes and manners of men and women, utilising bizarre, aerial antics or grating mimicries of speech. They attach themselves to backs of priests' robes, creating a grotesque hunchback effect, or cheekily perch like a hat on someone's head. Other times they stare quizzically at select individuals, inspiring guilt and terror. And, although never seen eating, they drop vast amounts of dung, poisoning the water supply and fouling statues and buildings. After a while, it seems clear that the ordure they dump on mankind is not merely a matter of

excretion but of contempt, a profound social criticism echoed by the narrator's own diagnosis.

In their activities, a serves-you-bloody-well-right manifesto is evident that recalls the misogyny of a medieval sermon. A woman having an abortion has her innards plucked out; an elderly procuress is jabbed to death by beak and talon; a 'professional' cripple is pecked into running as fast as his hitherto maimed legs can carry him. Minor atrocities are counterbalanced by extravagant set pieces rendered with a Zola-like sense of the dramatic, such as the vivid, terrible, culminating chapter, in which the birds smash through the window of St Paul's Cathedral and flock inside, wreaking riot and bloodshed among the congregation. This is orchestrated with panache and has some deft touches:

I came into the chancel. Lying over the choir stalls with sheets of music and books scattered amongst them, were the senseless, priests and choirmen. I saw one fat old priest running round and round in insane circles up by the high altar, crying pitifully as a great bird darted above, playing with him as a cat with a mouse. On the altar the two massive candles had toppled sideways; from one of them the hot wax sent a noose of thin blue smoke into the air. I stood between the choir stalls, not knowing where to go or what to do. Some aldermen of the City came running towards me, and I drew aside to avoid them. Suddenly, as I stood there, not knowing what to do, I was startled by a mighty, cacophonous burst of sound from the organ, as if all the notes had been depressed at once with every stop drawn. The sound went on, a gasping and wheezing of a thousand pipes. I could not bear it. It seemed to me the most terrible noise of all. Even the shouting, the screaming, the wailing of the wind, and the cries of the birds were not so hopeless a sound as the last savage lament of this great organ. I thought of the organist, sounding his own death music with his lifeless body.

The central question: what do these birds stand for? Gradually one realises they are not physical creatures who can be dispatched with clouds of poison gas or bullets. They come and go as they please and evade destruction. Each person appears to have one attached to him and they are curiously different in colouring and movement, yet oddly similar, too. There is ambiguity enough about them (recalling Poe's raven or the reptiles of the Id) to make them resonate. Baker provides the rather Jesuitical hint that they are the corrupt emanations from the soul of man. The key chapter is entitled 'On the Heath' and the narrator is confronted by a huge grey blind bird that pursues him and reveals its secret:

For in one dreadful second, which seemed like all eternity, I saw in my Demon my own face; all that was me, all that had shrivelled to waste in me. Deep in the pits of those two dead eyes, I saw the soul I had driven out from me long ago. And it was hideous – I cannot tell you about that, Anna. Because to tell you what I saw then is to betray the living Soul which from that moment came to life in me, and still lives. I saw – and this is all I can tell you – I saw the corrupt emanation of the Soul of a man whom, as a great poet had said, '*God hath made to mar himself*!'

Biographical details should never be turned against a writer or masquerade as literary criticism. But it was the custom of Frank Baker to booby-trap his writings with small confessions and indignities that had burned into his memory. It was as if he carried around a phial to stain each of his fictions with a blob of bleeding authenticity. The Demon or blind bird in the passage is none other than the lapsed, lascivious Catholic monk, Alfred Rose, who befriended the young FB and subsequently felt let down when the latter broke off contact.

In desperation, Frank renewed his friendship with Rose who offered moral support and legal advice. Frank agreed to take the matter to court but later, fearing the publicity, fled to Cornwall, never to see Rose again.[1] In outrage against Frank's first betrayal, Rose had called him, "A man whom God hath made to mar himself" and the phrase stuck like a thorn. In late middle age, when Frank was reliant on alcohol and sensed his creative power faltering, he quoted this to himself with a relished bitterness. And yet, viewed objectively, Rose emerges as a gentlemanly, moderate old boy. In comparison with the obscenities and verbal cowpats one is liable to be assaulted with today, it was a subtle, high-minded rebuke that pin-pointed a self-harming trait that many of us possess.

A large measure of soul-searching and painful analysis is embedded in the narrative of *The Birds*. The climactic revelation of the creature's nature begs the question. If they are corrupt emanations from the souls of people – attacking their morally flawed progenitors – can they be construed as the agents of God's retribution? Are they akin to the plague Jehovah visited on Egypt or are they self-punishments man has brought into being by his selfishness, greed and aggression? Neither notion appeals to a contemporary, agnostic intelligence, both being too doctrinal. Wisely Frank hedges around this, avoiding too much specificity, lest the narrative plummet into the black pit of a hellfire sermon. Fortunately the birds also evoke more subtle anxieties: the previously mentioned Id or subconscious; man's reptile ancestors; the eternal, recurring predator; the angel of death who appears in the dusk.

Although *The Birds* was an unusual book, a *tour de force*, it sold about 350 copies on publication and received a mix of coolish and respectful reviews. "How much better H.G. Wells used to do this type of thing!" moaned the *Leeds Mercury* while the *Daily Sketch* robustly declared, "This book is as frightening as any chapter in the Apocalypse." There was also criticism of the author's displeasure with modern life, one reviewer pointing out that Frank even seemed to be annoyed over such eminently useful modern devices as the telephone.

[1] Rose's name appears under the pseudonym Rolf S. Reade in a bibliography he put together, listing the erotica in the British Library holdings with their press marks. In 1936, the year *The Birds* came out, he was at work on this but died not long after. When it was brought out, his editing was judged "a sorry affair". The scholar, Terry Little, hinted that his elaborate bureau, in which his secret papers were kept, may have contained pornography.

HEDSOR (1938)

Despite an attachment to the legacy of Parson Walke and the salt-soaked breezes of Penwith, an inner turbulence was agitating Frank. It was possible he felt lonely and thought he was missing out, especially after John Raynor had gone back. It was hardly a young man's life, pumping out hymns and rituals amid a forlorn community stuck at the toe-end of Britain when so many of his friends were elsewhere. There was always something of the performer, the strutting player and socialite about Frank, and that part was not finding expression. His private life had been paltry since the demise of Marcus and his pious side was taking a turn for the worse as well. It was as if the closer he got to God in the institutional sense, churches, organ-playing and ceremonial attire, the more detached he became from the religious experience itself. By 1938 he had become disenchanted with the situation he had initially found so attractive. "I longed to end my career as an organist," he wrote, "and pull out no more stops to the greater glory of God since it seemed his following was no longer worth the energy I had put into it; and I had begun to loathe church music and all to do with 'Choirs' and places where they sing."

The year of Munich saw Frank taking the drastic step of leaving St Hilary for Hedsor, Buckinghamshire, where he had been appointed organist at the local church in return for food and lodging. The offer came from Patrick Horton, a reliable, well-meaning cleric who had often attended mass at St Hilary. Oddly, only a month or so after his arrival, he found himself disliking the leafy lanes of the countryside, finding them stifling. Despite his avowed pantheistic leanings, he was no Robin Hood or Green Man. He actually stated that he "hated" trees, preferring the blue moods and self-shattering gestures of the Cornish sea. He disliked the stuffy Victorian atmosphere of his present church – finding the organ there "shocking and pretentious". Yet, in the midst of discontentment, are to be found clues, ways of escape and signposts for future initiatives.

Giving a small, pleasant, rather odd lady (who also happened to be a niece of the Duke of Westminster) advanced organ lessons was an added burden, but a burden that supplied him with an idea that he was to use to brilliant effect. By some unspecific metamorphosis, by way of this old lady and the wretched, cumbersome instrument, the seeds of what was to turn out to be his most successful novel, *Miss Hargreaves*, were planted. They required only the sunshine of a holiday in Ireland with an old friend, Jimmy Wardell, to warm into ripeness a strange, ultimately lucrative fantasy that has survived many reprintings and still attracts new readers.

The idea also allayed other thoughts throbbing in his brain – thoughts pertaining to an impending conflict and what duties he might be obliged to carry out for his country. How could be plunge himself into the selfishness of literary creation when a terrible offensive lay around the corner in which every able-bodied man would be asked to enlist and fight?

More easily than one might have thought, it seems. Absorption in story-making was a reflexive response to whatever external agitations were present. Putting the idea of the old lady playing the organ on the back-burner, he started to develop a curious plot with a hint of a parable in it, conceptually indebted to Stevenson's *The Strange Case of Dr Jeckyll and Mr Hyde*, but sufficiently different to command attention. He dreamed up a wholly unreal, monstrous character called Dylan Sedge whose qualities stood for the dual nature of man. While his left hand wreaked violence and murder, his right counterbalanced it by extending the balm of healing. How was this unfortunate creature to overcome this gruesome dilemma? If thy left hand offend thee, the Biblical injunction goes, cut it off, and this is what Sedge did, in a gruesome and graphic scene of self-mutilation that formed the climax to the novel which he called 'Strike Your Axe'.

This novel was finished within two weeks and was inevitably a wild, loosely bolted creation. Under the emotional pressure, a quantity of confessional stuff was bound to well up, pervading the plot and symbolism. Aside from the subconsciously pertinent notion that losing a hand or arm made one ineligible for military service, Freudian echoes resound. Frank was almost certainly influenced by Arthur Machen's *The Novel of the White Powder* in which a young man, after taking a nefarious concoction, indulges in all sorts of wicked doings, as a result of which his hand goes black and decays horribly. The hand stands for the male instrument of creation that offended morality if employed in too cavalier or indulgent a manner. The offence was the sin of Onan, masturbation, and Frank realised the proper cure for it was marriage which, in the words of Bernard Shaw, was popular because it contained the maximum of temptation with the maximum of opportunity. Except Frank had the additional problem of being attracted to men as much as women – even openly seeing himself as homosexual – a state of affairs conflicting with his religious leanings:

The truth is of course that what I was once forced to conceal, because of the stale laws which put the homosexual into a compound where he must sniff furtively for his own kind, is now a condition that is sickeningly discussed by everyone – and in a particularly stupid and insensitive manner by those proud to be called 'normal', who have never had to endure all that the condition implies. It is not easy to come to terms with one's nature when satisfaction of sexual needs brings the shadow of the law on the threshold; still more difficult when loyalties demand silence and Eros continues to clamour for recognition and ultimate appeasement. Harder yet, when the Church through its celibate priesthood wags an unyielding

finger at potency and damns all sexual pleasure except that enjoyed on the marriage-bed – and even then restricts its hard-driven children to activity which is ridiculously called the 'safe period'.

Fortunately Frank's stay at Hedsor did offer some spiritual nourishment to leaven the erotic and mental perturbation. It was lit up by the brief appearance of Sandys Wason who had a notion of founding a review for Catholic intellectuals to be called Phoenix. Frank was to be his ally in the venture. Laden with lists of addresses, notebooks, printers' estimates, specimen types and his battered, ash-smelling Remington, he arrived on the scene, muttering significant names and sizing them up as contributors. "Must get T.S. Eliot", he reminded himself, "and Wodehouse together for the first issue." This was rather like putting the Pope beside Just William, but regrettably this particular bird never managed to ignite itself let alone the literary world – despite Sandys devising the ringing slogan, "Buy Phoenix, buy Phoenix, and make Catholicism gay!" The diligent priest did try to rein in support from all quarters, pestering the rich and distinguished, but nothing came of it and Frank was finally warned off the idea by Ber Walke and Filson Young.

Both Walke and Filson were invalids, barely susceptible to the allure of thrilling new proposals. Aside from the sunburst provided by Sandys, Frank was in a state of emotional gloom. He partly confided his problems to Walke who told him to have patience and stay put in a place where basic comforts were available. Then, perhaps thinking it not a bad idea to set a troubled mind working for a charitable cause, Ber told him to visit the seriously ill Filson who was laid up in Kensington.

"I found him in bed", Frank recalled, "reading Middlemarch, working on the Times crossword, and daily making as a mental exercise translations of the Prayer Book collects into Latin." Thinner and sicker than he'd ever seen him before, he was living on rations of Scotch whisky and his conscience was bothering him too. Apparently he was thinking of all those people to whom he had been unkind and Frank assured him that he had been kind to him years back in Penzance, buying a meal for him and John Raynor as well as initiating them into the proper way to drink champagne. "It was easy enough to be kind to you," Filson told him, "I liked you. It was those I did not like I was unkind to. That is what weighs on me."

Little could be done to alleviate Filson's condition. Not long after he died, Frank attending his Requiem at St Mary's, Graham Street. This somewhat forlorn passing of a highly gifted author, allied to the tragedy of Marcus and his turbulent emotional needs, confirmed to Frank the decision he had taken to enter the Catholic Church which seemed to offer a more personal relationship with God.

Walke's kindliness and concern located another friend in need. The terminally ailing ornithologist, Robert Walmsley, was apparently seeking help with his manuscript on birds. Being a published author, Ber thought Frank might ease the submission and publication process. So Frank went down to Newlyn and called on Robert who was ghostly thin with red patches flaring on his gaunt cheeks. Yet still he refused to sit and addressed Frank from a standing position. He was diffident about publishing the notes he had put together, but became more fired when Frank told him how much he'd been inspired by what he had written, advising him to make it less scientific and more personal and anecdotal. The suggestion alarmed Robert who had poured his living soul into the birds and scarcely realised himself as a person apart. It was as if he had dissolved himself in rapt absorption. Frank went through Robert's foolscap pages and realised he was not only a man possessed, but a man blessed with the gift of communication, of precisely describing and making real the voices, plumage and feeding habits. In his hastily scribbled papers, he had unveiled a hidden world, trapped diverse species in a language that was rare and unique.

Frank set to work on the book, often in the company of Robert, whose bladed profile – long sharp nose, strong chin and long legs – resembled one of those miraculous waders he liked to observe. Frank began to conceive Robert as a heroic figure, strong-minded yet consumed by a sickness that was burning all his spiritual fire. He implies there was a watchfulness about Robert, a restless, haunted quality, as though he was not pursuing the birds, but they in some inconceivable way were watching and pursuing him, hunter and hunted. It was this bizarre, almost mythical quality that inspired Frank to conceive his friend as a fictional creation as much as a living truth.

Robert was grateful for Frank's help and anxious his labours should receive proper payment. "Here," he said, offering his collected notes. "Take all this. Done – what I could. Not very good, I fear. But I've put – a bit more of – myself in – as you wished. Find a publisher. If you can. Exceedingly grateful – take the whole thing over. But at your leisure. Kindly accept proper payment. You must not be the loser."

So Frank and Robert came to an agreement and, when it was time for him to go, he felt that he had indeed grown to love Robert for his decency and stoicism in the face of the approaching end. As they walked down the lane towards Robert's car, Frank remarked on the whitethroats sporting in the flowery hedges and Robert commented: "Playful creatures. Very happy. You could miss them. So much – a part – of spring and summer. By the time – the man with the scythe comes – they may have gone."

When Frank returned to see the Birdman months later, his condition had worsened. He was bedridden and Miss Back told him not to appear shocked by his appearance. Robert's head rested on the white mound of a deep pillow, and his eyes had sunk back into his head. He tried to speak but only managed a succession of gasps. Frank told him he had not yet found a publisher for the book, but was still confident it would find a taker.

Robert did not seem to care any more. As he lay sprawled in bed, Frank noticed a watercolour of an avocet beside him along with a variety of fresh-cut spring flowers. He asked whether he had yet managed to catch sight of one of those rare, elegant, waders with their long, slender legs and upcurved bills adapted for sideways sweeping across the estuary mud. Frank was under the impression the avocet had so-far evaded the sick ornithologist's gaze, but he learned that friends in the Norfolk Broads had reported back to Robert that some had returned there after an absence of years. Not knowing how ill he was, they urged him to come and see for himself.

In what little breath he could summon, he told Frank that he had indeed seen the bird: "Last week – at Hayle."

And so, slowly and painfully, he explained how the viewing had come about. Too sick to travel to Norfolk, he reasoned that, as avocets had arrived in East Anglia, there was a fair chance the Hayle estuary might also be hosting a few. So, with the help of his nurse, he had forced his emaciated body into gumboots and jacket and, slinging his field glasses over his shoulder, asked his chauffeur to drive the Daimler down to the water's edge at Hayle. When he looked over the estuary, he quickly saw an avocet, asleep amid a company of black-headed gulls and was able to watch it for an hour and for some time the next day and the next. By the time it had flown, his illness had returned with greater intensity and he had to resume an invalid's existence.

"I hope we will meet again – in happier circumstances," he said to Frank before he left.

NEWPORT (1939)

Unease with the situation in which he found himself prompted FB to make another move. In 1939 he shifted his few belongings to Rockfield Street, Newport, sharing a council house with Sandys Wason, nonsense poet, rebel priest and friend of young boys, who seemed to fascinate not only Frank – he portrayed him in *Allanayr* as Father Leighton – but Compton Mackenzie who deployed him fictionally three times. Sandys, though genial, was self-obsessed and crochety and would seem an odd choice of housemate for a young man. But Frank was not ordinary. He was essentially a seeker and men like Sandys, mystic, eccentric, at odds with society but creative too, were able to share his outlook and interest in music. Wason had been expelled from his curacy at Gunwalloe on the Lizard for his wilful papistical tendencies. A member of the Catholic League of Anglicans, who desired to reunite the Church of England with the Holy See of St Peter in Rome, he had been revered and despised by his parishioners. "Wason was a silly man held together by a childish faith" in the opinion of one; another referred to him as "A bloody curse to his parish and country." But Sandys could be inspirational as well as aggravating, a man with whom it was possible to share many a "mad, magenta minute" to quote from his least-forgotten poem.

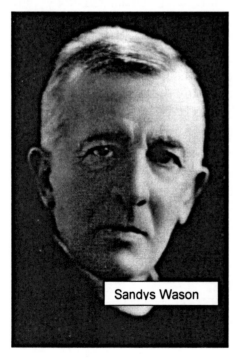

Sandys Wason

Sandys had earlier recorded a visit by Frank in a letter to Daisy Deas. "Frank Baker, ex-organist of St Hilary, has been staying here, Monday till Friday, and in that time wrote a short novel! Wonderful facility, isn't it, and the novel is astonishing to say quite readable...I enclose the parish paper of Hedsor where Frank Baker is now organist as the Rector has printed one of my poems..."

The novel referred to might have been *Sweet Chariot*, some of which already had been written at Mevagissey. If not, it might have been one of those short novels to which Frank occasionally refers that he later lost or destroyed.

In the land of Arthur Machen, Frank was able to find comfort in the countryside and its history. He took long walks, visiting Carleon-upon-Usk which stirred up images of its Roman past and the legend of the Holy Grail. But while images of romantic escape flared in his imagination, the appalling fact of war – of imminently being called up to fight – stirred his conscience and charged his prose with anxiety:

He was in the train to Middleport, passing flat, dyke-land country that had always bored him. He longed for the Severn Tunnel, and when they were rushing through it, he longed to be out of it. When they emerged, he wished with all his heart they were back in Cornwall. A hideous dread that he left an oil-lamp alight in his cottage, struck upon his nerves. He fidgeted and wrote vague notes in his diary; he struck innumerable matches over a pipe that would not draw; he counted his money: five-and-fourpence, and no expectations of any more for three weeks from the patron uncle who against his will, supported him in order not to "let down the family".

He read bits of the evening paper of the factory-worker opposite him. Conscription, he was told, was imminent; the militia waited, ready to launch itself forward when the government gave the word. The drums were being rolled; trumpets would sound the old fanfares; the savage was baring his teeth; the peacemaker sharpening his pen. Entrenched in their citadels of sub-undergraduate wit, the young communists were following Marx whithersoever he goeth; clothed in white robes, with palms in their hands, they approached the hammer and the sickle; the new Jerusalem, built labour-saving tenement flats, towered before them. Meanwhile, the veins stood out in Adolf's throat; the voices of lions whose fathers had murmured "Gruss Gott," now earned "Heil Hitler!" The monstrance was raised against the tired people of Spain; the Host offered and bread denied. Cardinal Pacelli had been trumpeted into St Peter's; sweating Italians clapped, cheered, spat and grovelled before the *sedes gestatoria*, and hoped for the best. Everyone, everywhere, hoped for the best and did the worst. Musso bawled, Hitler shrieked, Chamberlain purred, Roosevelt admonished, Daladier chattered, Stalin smiled: raise the voice of Bate in all this, thought Matthew, and who will hear it?

The rain poured down as they drew near Middleport. He saw the war memorial, a chunk of hollow-looking stone which might have been cardboard; the super-cinema; the ever-muddy Usk; the castle and the dun-coloured pigeons who always lodged in its crevices. In the streets the same people were still rushing, hesitating, loitering and mooning; the hills which encircled the town were swathed in sheets of rain. It was more a winter evening than a spring one.

Stonewood Street was a mile-and-a-half from the centre of the town. He hailed a taxi, not because there was much baggage but because he could not face waiting for a bus. He was a mass of irritability – and he hated himself for it – by the time the taxi drew up in the rain-rutted street where Leighton lived. He had been here once before for a few days, and his impression of Middleport was of a place outwardly vile, yet inwardly aware of its past and jealous of some romantic secret. A town with the mind of a village. But this evening it seemed merely dreary.

He carried his bag round to the back, knowing that Leighton would not want to be summoned from his fire to the front door. Passing the window of the kitchen he

noticed the chessboard leaning against the cracked pane; one of Leighton's buddies had broken it when last he had been here.

He knocked on the door, found it was open, and went in. On the draining-board in the scullery, were two scallops, Boulestin's cookery book, a bag of flour, a stale loaf and a grater. Matthew smiled, glad now that he had come.

Seen through FB's alter ego Matthew Farren, this passage from *Allanayr* (P.55) reproduces both his physical response to his surroundings and the political situation. It is a time of fear, retreat and creative ferment, and he smuggles in a tribute to Uncle Felix who assisted him in the same way Matthew's uncle did. More curiously, it anticipates aspects of the future lying in wait: the journey from Cornwall to Wales, from Kidderminster to Cardiff, the constant diving through the darkness of the Severn Tunnel and re-emerging into a Celtic land of lilting cadences and fuming slag heaps, was a journey he was to repeat many times during the course of his restless, varied career.

WINGED COMPANY

Not only was Frank working on a novel in the company of Sandys, he was also fulfilling an obligation inherited from Robert Walmsley by securing a publisher for his book on birds. Having reaped excellent sales for *Miss Hargreaves*, Eyre and Spottiswoode were better inclined towards Robert's manuscript than they might otherwise have been. They agreed to take it on under the title *Winged Company*. But Frank had to first lick it into shape, pointing, arranging and dovetailing the various chapters, slimming down some of the over-elaborate descriptions of plumage and skilfully blending his style with that of his friend. It came out in 1942, appearing with illustrations by Denys Watkins-Pitchford and fielding approving reviews but Robert was no longer alive to enjoy the applause or polite enthusiasm. After Frank had last seen him, he had lingered around for months and entered the New Year and then passed away. Depending on one's convictions, his soul was soaring on high with those winged beings whom he had always preferred or else lay still like a broken shell in a deserted nest.

Neither was Robert's book to enjoy an extended shelf life – an air raid on London destroyed all copies left in stock. A bird of war with metal wings had ravaged with flame a horde of books devoted to its living counterpart. But Frank mastered his initial desolation, for Robert's life presented a lesson in itself, telling us that what we seek in the depths of our hearts will be somehow given to us. We must pursue what we truly love with the fanatic, selfless passion with which he tracked down the avocet: "The task is simple; to make that final effort Robert Walmsley made. If we do that the Hunter who stalks us will depart; the 'naked fledgling' will discover himself as a bird of flight and song."

MISS HARGREAVES (1940)

Oddly enough, the one novel where Frank did not pluck his characters blatantly from life turned out to be his most successful. *Miss Hargreaves* (1940) appeared during the 'phony war' and was inspired by the elderly lady he briefly instructed in organ-playing at Hedsor. The book marked an elated phase in his career. He was coming into his own as a young writer although, politically speaking, the situation was ominous. The Treaty of Munich had been broken and Britain was officially at war with Germany. But the thought of becoming a fighting soldier – of physically killing and offering oneself to be killed – was so hateful to Frank that he preferred to bury himself in his imagination. Hence *Miss Hargreaves*, a skipping, bantering sleight of fancy in which death is no more than a rewritten memory.

There is a lightness and maturity of tone in the novel, coupled with a solidity of external detail, a Dickensian thoroughness of presentation. This satisfies the reader who recognises the author is in tune with his subject and operating the strings adroitly. The plot is fresh and appealing. Two young men, Norman Huntley and Henry Beddow, while holidaying in Ireland, visit a grim parish church and, to impress the over-zealous sexton, boast friendship with an elderly lady called Miss Hargreaves who was a friend of the late pastor. After congratulating each other on their invention, they end up in the local inn and start adding bits to the character they have made up, piling onto Miss Hargreaves as many batty fads and attributes as they can muster. To put a cherry on the jest, Norman actually writes a letter to her and then returns to his hometown, family and girlfriend, Marjorie, in order to resume his relatively carefree existence.

But his lackadaisical optimism is shattered when he receives a reply from Miss Hargreaves. She is dying to see her friend, dear Norman, and wishes to stay with him and his family. He is incredulous and aghast. At first he anticipates a joke – Henry perhaps intercepting the letter and forging a reply – but establishes that is not possible. He goes round to see Henry for moral support, but the latter is now rather anxious to back out of the situation he has partly contrived. It is left to Norman to meet the lady at the station.

When Connie Hargreaves appears, she is every bit as eccentric as Norman and Henry had imagined. She brings along the hip bath she sees as essential, her pet parrot, Dr Pepusch, and Sarah the dog. There is also the cumbersome harp which she plays every night. It transpires Miss Hargreaves is as irresistible as she is unbearable. Buoyant, autocratic, unpredictable, lyrical and intensely musical, she scythes a path of controversy through Cornford. At times Norman despises

her; other times he feels something like pride in his creation. He sees himself akin to God who has breathed life into a mental construct. Yet how could this be possible? Out of what context did she appear? At what point did he call her into existence? Norman is terrified to investigate further. For there is a blanketing sadness in Miss Hargreaves' situation, the pathos of an elderly lady who doggedly moves about on sticks, exuding tremendous vitality – yet her existence depends wholly upon the fancy of another. In that sense she reflects the tragedy and treachery of love: the need to 'create' an image who shall be adored yet also may eventually, allowing for time's vagaries, be taken for granted or dismissed out of existence. Unfortunately there is no one with whom Norman can discuss these matters. His girlfriend, Marjorie, deserts him for another, thinking his interest in the old lady morbid and mad. No one believes what he has done is possible. He experiences the awful loneliness of the Creator.

These strange goings-on are set against the background of the cathedral town of Cornford (based, one imagines, on Edwardian Winchester). It is a well-realised, ecclesiastical lunatic asylum of a place. Barbara Pym might have happily settled there and FB obviously loves it. The closeted atmosphere of cathedral life is convincingly presented. (Oddly enough, while Baker's secular novels have a tendency towards gloom, this 'churchy' piece is all slaphappy comedy – as if the structured, sacramental atmosphere teased out the clown in him.) Frank is familiar with all the regalia of ritual and the hierarchies of the cloth: choir, choirmaster, dean and bishop are all present and correct. He is also assured in the discussion and evocation of music; a professional performer's knowledge lights up the scenes of hymn-singing and recital.

While the staff of the cathedral are depicted vigorously, the Huntley family, on which much of the action is focussed, are like the amiable sketches found in old copies of Punch or a similar comic magazine. Norman is the storyteller and the prime viewpoint. Lively, sensitive and a little touchy, he has a blunter sister, Jim, and a blandly sensible stand-in mother. By contrast, the pipe-smoking father comes over as a genial buffer, absent-minded, proffering a fund of half-wise, half-crazy stories, usually excruciatingly irrelevant to what Norman has on his mind. His tone of opinionated unflappability can jar and become mere mannerism, but the unpredictability of his turns of thought and phrase usually lift a scene.

The first part of the book is neurotically ebullient, dominated by the comic ostentation of Connie Hargreaves, her outrageous hats, her quibbling demands and endless flow of dotty, lyrical effusions, but one can only take this so far. Baker realises the plot requires yet another preposterous attribute in order to reach a point of climactic fracture. Hence Norman, through another feat of imagination, effects the promotion of Miss Hargreaves' status to 'Lady Hargreaves'. Enabled by a mysterious fund of money, she moves out of her lodgings into a splendid detached house.

With her handsome new residence and aristocratic status, Lady Hargreaves becomes a person worth cultivating. The ecclesiastics of Cornford start fawning over her, vying for her attention and calling card. Owing to a misunderstanding, she no longer speaks to Norman, and he feels incensed knowing that, as he created her by imagination, he could also destroy her. But the thought of such power appals. A deeper, darker dimension lies behind his creation that he does not know how to handle. In vexation, Norman visits a Catholic priest, Father Toule, who is willing to consider the proposition that Connie Hargreaves is of supernatural origin without necessarily believing it. In an ominous interview, Father Toule suggests Norman should investigate the background of Connie, whether she had been once alive. If so, he might be able to trace her past and find her name inscribed on a tomb. In other words, has Norman called her up from the grave?

Naturally he baulks at such a startling suggestion and leaves in a dilemma. Knowing he has to vanquish Connie, he wants to do it kindly, naturally and, if possible, imperceptibly. After further frictions, Norman and his father appear at a musical evening that Connie has organised for the town notables. There Norman finally manages to instil in her an understanding of her fragile existential status; as he does, he senses the power shifting from the 'created' back to the 'creator'. Miss Hargreaves' energy is ebbing – she intuits she is "a thought, a piece of thistledown, a thing of naught, rocked in the cradle of a craftman's story..." By returning to Lusk in Ireland where he and Henry assembled her, by unravelling that strand of the past, he makes Connie silently vanish leaving a gap of sadness and wonder in his heart.

CRITICAL RECEPTION

Generally the critical reception of the story was enthusiastic, evoking plaudits from middlebrow reviewers – "a delicious fantasy", "the kind of novel that is badly needed at the moment", "it makes you forget about this troubled world", etc. Particularly gratifying to Frank was the praise of the anonymous reviewer in *The Times Literary Supplement* who commended him for writing "a ridiculous story...extremely well. It is as funny as it is tragic, as charming as it is pathetic, as plausible as it is incredible. One even closes the book wondering just where among its fantastic pages, truth may be uncomfortably lurking." The single discordant voice was George Orwell in the *New Statesman* who impatiently rapped down his gavel: "Miss Hargreaves is simply a few hundred pages of wasted talent."

For Orwell, a proponent of politically committed writing, a tale revolving around a wholly miraculous old spinster and comic churchmen was irrelevant, particularly amid a brewing world war. He preferred novels to grapple with political, sexual and economic realities at a grass-roots or factory-floor level.

Whimsy and the flagrant flouting of causal law was not his métier unless, as in *Animal Farm*, it had a didactic agenda.

*

Without being a flawless work of art, *Miss Hargreaves* invites comparison with H.G. Wells's *The Man Who Worked Miracles*, in which a small man almost destroys the world by dint of mind power. It also has a predecessor in the short story *Enoch Soames*, depicting a peeved, dilapidated poet of the 1890s who, vexed by the neglect into which his reputation had fallen, consults a literary reference work only to discover he is not an animate being but a wisp of satirical fancy penned by an author unknown to him called Max Beerbohm. A third, rather distant ancestor is Gogol's *The Nose* which has its main character socially spurned by his nose after it was sliced off him by a clumsy barber. He tries to recover it, but cannot locate it anywhere. When he does, he is infuriated by the fact that his nose, having risen to a more exalted position, literally looks down its nose at him. There is also a sensational antecedent: Stephen's King's *Misery* (1987) showing an author confronting a fan more horrific than any of the ghoul-ridden tales he perpetrates. Citing its literary ancestry, I should emphasise, does not diminish *Miss Hargreaves's* hardwearing integrity – indeed it has more than attained modern classic status (by Cyril Connolly's definition, a book in print half a century after its original appearance) being re-packaged this year (2009) by Britain's foremost suppliers of fantasy, Bloomsbury.

Creating a person through the imagination is what a novelist does best. *Miss Hargreaves* posits author-as-God, usurping the role of creator (a Luciferian concept that, if forcefully developed, might have punctured the gentle fantasy). A doppelganger motif is evident, too. Every author is 'haunted' by the characters he or she creates. They become implanted in the minds of various readers whose response flows back into the author who does not in a sense *live*, but rather 'breathes life' into the projections of his imagination. Frank Baker was definitely haunted by *Miss Hargreaves*. The success of the book smothered what he wrote subsequently. While art usually draws upon life, the reverse is also true – a brilliant fictional creation attracts its living counterpart. Margaret Rutherford, who took the role to the stage, would regularly write Baker long, lolloping and indecipherable letters in a strident, dramatic hand. She was warm, kind, troubled, magnificent and slightly mad, just like Miss Hargeaves – a coincidence as funny as it is eerie.

THE WAR EFFORT (1941)

"*Ichabod.* The Glory had departed. A great and good man had gone to live out his few remaining years at Mevagissey, his work at St Hilary done. For many months, I was left stranded…"

During the gloomy and disrupted periods of the late 1930s and early 1940s, partly because he was drawn to the fishing village and partly because Parson Walke was spending his last days there, FB revisited Mevagissey and settled there, either briefly or for a longer period of creative endeavour. After an interlude in London, he rented a cottage whose upper windows offered a view of the inner harbour and there, in relative comfort and solitude, started a new book, a light and loopy fantasy about a staid, stolid schoolmaster who changes places with his guardian angel; the result is confusion, comedy, identity crisis and ultimate defeat in that neither angel nor the man can altogether resolve their problems.

Using his Winchester background to supply some of the characters and educational details and the fishing port as the remote haven in which these strange notions take root, there is a slightly forced buoyancy about the novel which was to contain some remarkable descriptions of flying above the Cornish sea.

Frank would call on Ber Walke and his wife Annie, who had acquired a modern house on the clifftops, or meet them around the harbour. Almost every day Ber would visit *The Ship*, drinking a tot of rum with milk, talking to the fisherfolk and later enjoying a throw at skittles. In his black Spanish hat and pale blue smock, he would look romantic and conspicuous enough to command attention and respect. But these proved to be his last months among humankind. In 1941 he passed away quietly and unobtrusively in the quiet, workaday fishing-port, so far removed from the sophisticates and high churchmen of his intellectual bent, leaving a gap in Frank's life that was never quite filled.

The withdrawal from the world of Father Walke left Frank not a little troubled – for he was already in spiritual turmoil over another matter. Neither was he on the spot to commiserate with Annie Walke or his Cornish friends. To assist the war effort, he had already left Mevagissey for London, knowing his call-up papers were likely to come any day. He dreaded the thought of joining the army – for he had no stomach for fighting. At Shadwell he joined his friend, Colin Summerford, who introduced him to a group of pacifists and Quakers in the East End. Frank helped them, dishing out cocoa and comforting words to those in air-raid shelters. Despite this right-minded gesture, Frank realised that soon he would be forced to bow to military authority. Like many a patriotic Quaker or pacifist,

he had offered to serve in the Royal Army Medical Corps. But that did not mean a place for him would be inevitably found. So how was he to make it clear to them that there was no circumstance in which he'd be prepared to kill a fellow human?

Although the Quakers offered the benison of civilised, likeminded company, the desperate political situation was playing on Frank's nerves. He became fearfully, desperately unhappy, sensing he was caught up in the cogs of a remorseless, appalling mechanism. His emotional state reached its hysterical apogee when, walking in Aldgate on a hot summer's day lugging a burden of cheap cakes and buns obtained from a canteen, he saw a newspaper placard announcing 'Ten Thousand Germans Killed':

The insensate crowd of living people seemed to disappear; it was they who were dead, and only I was living. The streets seemed to be choked with blood, running dark and rich to the gutters under the blazing sun, coagulating and blocking the drains; the wretched remains of thousands who had died in agony *for no reason*. This hideous chaos, this seething mass of blood and brains, was here now, and nobody seemed to realise it. Suddenly I leapt into the air, screamed out something and ran howling like a madman through the throng of the living who were dead.

Something of this fear and trembling is detectable in the novel he was writing, *Sweet Chariot*, the main character of which, Mr Gregory Spillet, changes places with an angel, finding the process both inspiring and sobering. Like Icarus, the acquisition of wings spurs Spillet to aim high but inevitably he crashes down to earth. Spillet, the tall, eccentric, slightly dreamy schoolmaster, was based on a former teacher at Colebrook House, Percy Spillet, who resembled Gregory even to the detail of his expertise on flints. But Frank was also inspired by his memory of the sad, obsessed bird-man, Robert Walmsley, who had been blessed by a glimpse of the avocet in Hayle estuary.

It is an odd, nervous novel with an awkward pathos. Frank wanted to honour Robert's memory, translate him into a truly wild and zany fictional creation, but found himself chained by the desolate mortality of sentient things. Flight images infuse a narrative that is almost hysterically larky, but screams escape, escape, escape. From what? The shadow of the ever-rearing war? Thwarted desire? Middle-class conformity represented by his parents? The fear he might never find the love and approval he craved? The agitation and defeat of *Sweet Chariot* is masked by a facetious unease that creates an atmosphere some readers did not feel happy about.

It probably amounted to a fraught response to Frank's dilemma. For conscientious objectors were inevitably thought of as cowards, slackers or traitors. The best way forward for them was to define their agenda by making a positive contribution.

Hence Frank made up his mind to escape from the escapist literature he was writing and meet his obligation head-on. If he did not apply to join the army, specifying duties that would not involve armed fighting, he might be summarily posted anywhere. So, towards the end of 1941, he requested to join the Pioneer Corps, but when the call-up papers arrived, he was dismayed to learn that he had been assigned a combatant corps in Devon. The rail journey took up the greater part of the morning and, tentatively, he disembarked and made his way to the parade ground in Ilfracombe. But at first sight of the recruits, he was overcome by an appalling terror and depression. Thinking of the potential death of himself and the others assembled there, he was unable to proceed. Finally he retreated from the encampment and took the train back to London.

Fortunately, during these travails, he found a creditable ally in his uncle, Felix Baker, who had held a commission in the Great War and was presently in the Royal Observer Corps. He respected Frank's sensitivity and pacifism and helped him to prepare his case for exemption from military service with a firm precision that impressed the military authorities.

MEVAGISSEY IMAGES

(Above) The Barrons
at *The Ship (c.1938)*

(Below) Cottages above
the harbour (c.1938)

From *The Call of Cornwall*

ALLANAYR (1941)

With its piquant blend of supernatural and light comedy, *Miss Hargreaves* created enough of a ripple to interest film-makers who were quick to secure an option on the work. After the film rights were sold in 1941 for five hundred pounds, for the first time in his life Frank experienced a sense of stability, of inward confirmation that the slightly rash decisions he had so far taken were the right ones. He was now in a position to take things a little easier and enjoy an increased degree of material comfort instead of constantly scrimping and saving although, as every writer knows, few state pensions are awarded to artists and royalties soar and plunge according to reading fashions and the enterprise and distributive muscle of the publisher.

After the buoyant, chummy tone of *Miss Hargreaves*, what readers Frank had by now acquired might have been put out or disabused of their comic expectations by the resolutely serious follow-up novel *Allanayr*, a drama about shabby-genteel people with artistic passion who take great pains to supply food, board and domestic comfort to a grumpy monster of a musical genius who is self-obsessed and begrudging of their efforts.

Allanayr is a memorable novel, realist in conception yet ambitious in theme. The title is a placename, a rural idyll, a haven of happiness that beckons and haunts. It explores the role of music and musicians in a society that respects them only when they are commercially successful. In *I Follow but Myself*, Frank recalled the central character as being based on Sibelius, but Harrison Bates' situation also runs fairly close to that of the Bradford-born musician, Frederick Delius, who occasionally lived in drab provincial lodgings and produced his later compositions with the help of his transcriber and amanuensis, the young Yorkshire musician, Eric Fenby (who like Matthew in *Allanayr* was ferociously self-critical of his own work, often destroying his scores).

The novel pits genius against mediocrity, striving to establish through the conflicts and moral dilemmas of the Becker family what the relationship of one to the other should be. Are creative people, in their narrowness and self-obsession, deserving of special consideration? Does their 'special' gift bear divine or supernatural tidings, like a voice from the noumenon, or is this mere delusion? Does society need them or do they desperately need society for praise and patronage? The novel is set around the Usk Valley of South Wales, around Caerleon, where Frank's hero Arthur Machen lived, which is renamed Allanayr and is the spiritual symbol of the book, standing for the ideal home to which one can return, a home which doubles as a spiritual destiny.

Initially the Beckers feel honoured to rent a room to a distinguished but obscure composer called Harrison Bate. The latter is crusty, imperious and ill-mannered towards his rather craven hosts, Joe, and his caring, slightly downbeat

wife, Florence, who has a fine singing voice. A young, ascetic, technically brilliant if creatively arid young composer, Matthew Farren, presents himself to Bate, offering to transcribe, polish and, in certain instances, complete his fragmentary songs and unfinished symphonies. Bate agrees, allowing Matthew to call on him each morning and urge him into effort and application. Work *is* accomplished but the strain of unremitting concentration upturns Bate's already fragile health and he passes away.

Because he is cold, superior and sharp-tongued, Matthew (whose career, incidentally, is briefly resurrected in *Embers* as Dr Farren) is disliked by Kenneth, the Beckers' son, but is loved by their daughter, Stella, who is attractive and intuitive and hears the faraway music of Allanayr, the unseen source of artistic inspiration that beckons and inspires. Matthew is the book's most forceful character and an effective medium for the more perspicacious passages on musical history and the quirks and fortunes of an unacknowledged genius. He is realistic about his own abilities, having spent months on a Cornish moor intensely composing, not the masterpieces he hoped would startle the world, but clever, competent stuff that leaves him unmoved. And yet he does have an intuitive understanding of how to polish and smooth the rough bits of the brilliant scores of others. He is brought on the scene by the eccentric and intellectual Father Leighton. The manner in which Matthew analyses Bate's situation and musical corpus reflects FB's fascination with the gifted failure, the glow-worm who never enkindles a single lamp, the village Milton who dies unrecognised amid the obscurity of his birthplace:

Allanayr (P.50)

He found it hard to think clearly because of one picture that kept recurring in his brain: a genius at the mercy of the lower middle classes. An old man, he lies on a dirty bed while round him, on floor and coverlet, are scattered sheets of music paper. The figure groans, struggles to write, sinks back exhausted. The door opens upon a lubberly woman with a tray; on the tray a watery egg-custard, some prunes, scraped toast. This unpleasing food is left on a bamboo table by the composer's bed. The door closes again; the figure groans and tosses; the food is uneaten. Night comes; the fire goes out.

What Matthew imagined was a caricature, and he knew it; yet, he told himself, it was probably based on the truth. He did not know the people in whose house Bate lodged, but he could guess what they were like; he did not even know Bate. He knew a piano concerto published in Leipzig thirty years ago; a string quartet; two symphonies; and the scores of smaller works which he had obtained with some difficulty. But compared to these works, most contemporary music seemed to Matthew tin-can charivari played under the windows of a few bloodless critics. Bate's genius – massive, often undisciplined, yet always entirely underivative – had never been acknowledged in England; and in Germany his brief star had died in the darkness of the 1914 war. Matthew was aware of faults; chiefly a Teutonic overburdening of orchestral colour and

often a lack of cohesion; but they were the faults of a prodigal, compelled to spend what had been given to him. He was an artist who knew his power and had never been afraid to obey its voice; that he sometimes floundered was due, probably, to a lack of practical experience, for the numbers of performances of his works by first-class orchestras could be counted on the fingers. His first symphony was still occasionally revived at a Promenade Concert, where it was regarded as an old-fashioned curiosity, like one of Stanford's symphonies. Cader Idris, a rhapsody for string orchestras and two solo violins, had been conducted by old Cowen at the Cardiff Festival in 1902 and never repeated. But it was later works, which he had only seen in score, that so profoundly interested Matthew; as far as he could make out none of them had ever been performed in England. What sort of man was this, who wrote such incomparable music, who took no models and had no followers, and whom the world ignored? The question had filled Matthew's mind for a long time.

Cyril Daye, in his survey of modern composers, gave him a passing note: "a monodynamic composer who handles the orchestra like a piece of stone, hewing large chunks from it here and there in the hope that we shall recognise what is left. The result is grandiose and pleonastic; sometimes pitifully prosaic. There is more in one page of van Dieren – another overlooked composer – than in the whole of Harrison Bate. And yet there are signs of an original force here; for example, in the Coronach for wind instruments, where four horns and two trombones are handled in a remarkably macabre manner…"

This type of insight deepens the appeal of *Allanayr* which offers much to the musically literate reader. The figure of Matthew has been identified with the mad and dashing songwriter, Philip Heseltine, but they only have a certain asperity in common. Heseltine left a mark on English musical history unlike the restrained Matthew Farren who, with his hideaway in Cornwall and liking for eccentric characters, has more in common with the young FB, although Cyril Daye, the music critic, clearly deputises for the composer and historian of music, Cecil Gray, a boon companion of Philip Heseltine.

Superficially speaking, *Allanayr* is a powerful domestic drama about a poor, decent middle-class family whose life is disrupted and divided first by an unusual lodger and later by a financial legacy that stirs greed and dreams of grandeur. The modest but convincing narrative interest is well-served by the concise characterisation, shrewd psychological insight and passages of soaring lyricism.

SPLINTER OF ICE

Around the time of the publication of *Allanayr*, Frank reported how Graham Greene complained of his work, "Why does Frank Baker like his characters so much?" This is unkind if shrewd. There is a warm, participatory quality in Frank's depiction of the family in *Allanayr* that suggests a personal and emotional allegiance. He pushes them fairly fiercely, but not one goes over the edge or deserts their basic principles.

Even Matthew, the least humble or conventionally moral, has a fierce sense of honour so far as his musical integrity is concerned, but whether his stern and selfish devotion to his work will make him a good husband is rather doubtful. Where FB warmly flourishes his fellow feeling, Greene employs a tarter, more ironic technique. He will cheerfully feed his virtuous characters to the lions – only the mask of religion allows him to give way to sentiment. By contrast, although he disposed of large portions of humanity in *The Birds* and incinerated the major character in *Embers*, FB's attitude is generally more protective.

Dickens was the same. You are able to realise his loves and bugbears through his characters. Greene had a colder approach; he was a literary clinician, preferring to keep the splinter of ice securely lodged in his heart. Neither was he doctrinally conformist as a Catholic, being prepared to compromise his faith for the sake of a good story and turning out enjoyable, well-crafted novels, shot through with lust, murder and low tricks in high places.

There are advantages in both approaches. The author who loves his verbal offspring may invoke the same response in readers, thereby enticing them into the narrative. But if a reader dislikes a major character the author clearly loves, he may prefer to part company with the story rather than finish it. A colder approach is useful, too, in thrillers or novels which seek to heighten a hero's (or a villain's) sense of apartness. The tension quotient is increased; the world becomes a more menacing, threatening environment. Generally, it's true to say literary fiction has tended to shift more towards Greene's approach rather than FB's or, for that matter, J.B. Priestley's, who also had a chummy relationship with his fictional creations.

Frank's essential warmth is made apparent in the love scenes in *Allanayr* between Stella Becker and Matthew Farren; they are charming and idyllic, markedly unlike Frank's situation during the period of composition. In Newport, hemmed in by the benign but romantically hapless figure of Sandys Wason, who composed poems with the patient, mechanical application of someone solving a crossword, he would take days and afternoons off to explore the Usk Valley. In a state of uncertainty and stress, he tramped the dark, leafy windings of the enchanted realm of Gwent, marvelling at the wildlife and saw a kingfisher flash past over the water's surface. This savage dart of brilliance set his mind thinking of what he needed to make himself properly happy. He vowed that he'd find a woman to marry and then, in the same breath, dismissed the idea as folly. For the Bakers had made such wretched, miserable unions, he judged, on his mother's and father's sides. And the particular romantic collision that produced him two months too soon – "the bewildered introvert who stood tense and trembling and ashamed in the Usk Valley" – was especially blighted: "How could I dare to sow seed that seemed to be so cursed?"

MEDEA (1942)

Frank's stay in South Wales came to an end. Saying farewell to Sandys and the locals, he returned to his reliable anchorage, the small cottage in Mevagissey. There he was told by a helpful friend, Mrs Thelusson, that the Old Vic was looking for actors who had been exempted from military service. Frank did not think himself an actor, but he had always been half in love with the profession and derived pleasure from swaggering and declaiming before an audience. Another important consideration was that any bother he had with the military might subside after he was seen to be performing useful work for the war effort. Actors helped by inspiring and raising the level of cultural awareness, softening the impact of the gloomy years to come. In the winter of 1942, Frank wrote a letter to Tyrone Guthrie, the notable director, and was offered an interview at St Martin's Lane theatre. Frank went up to the city and met a tall, authoritative man who asked him whether he'd be willing to join a company headed by Sybil Thorndike and Lewis Casson. They apparently were about to take Euripides's classical drama *Medea* to the mining areas of South Wales and Durham. Frank's task would be to walk on as required, help the stage manager when needed and understudy Lewis Casson, who was to play Jason in the play.

While contemplating this new direction his career was about to take, he returned to Mevagissey and was struck down by fever. So convincingly sick did he look that he thought he might be able to stand in for one of the ghosts or wraiths that flit through classical drama. When his copy of *Medea* arrived, he set about studying it thoroughly, feeling both thrilled and terrified by the prospect of Jason's speeches, soaring and authoritative. What's more he only had ten days before joining the company in Tenby. Knowing avoidance is invariably the best solution, he thought of ways to duck his appalling obligation. Fortunately his friend Colin Summerford came around, telling him, "You can't run away from this one, Frankie!"

Although he desired and dreaded becoming an actor, he was better equipped for the task than most, possessing several advantages. One of the benefits of having attended the Cathedral Choir School, at which many actors, including Olivier, had received instruction, was that his voice had been very well trained. Frank knew how to employ it effectively, how to take a breath at the right place, how to modulate its rise and fall. Also he was a handsome, attractive man, slim, brown-haired and compact; in addition, he was musical, too, a skilful pianist and organist, with a fine singing voice, skills that might enliven and diversify a production.

Yet his initial appearance on the acting scene was awkward and painful. He presented himself to Mrs Clark, the business manager, who glanced at him

disinterestedly and pointed him in the direction of Lewis Casson's dressing-room. The actor was an imposing man with a growling, resonating voice that made the timid cower and Frank was timid on that day. Not long after, he found himself drifting awkwardly amid the hustle of the stage, getting in everyone's way, trying to help but not wanting to appear foolish and inexperienced. Nobody spoke until a young woman who was descending from a ladder smiled and, to his delight and astonishment, offered him a piece from a bar of chocolate. Was he the Frank Baker, she asked, to whom 'Clarkie' had been referring? Frank took the chocolate from Kate, as she was called, and with it the implicit offer of friendship, thus starting his days in the theatre by finding – although he did not know it at the time – the loving wife who was to support and sustain him through many long, happy years.

Because *Medea* was a foundation-stone of the classical pantheon, the company kept in mind they were performing before working folk who might find a few lines of explanation helpful. To provide this, Casson himself would appear on stage and address the audience, supplying a short history of the background and provenance of the play. This role was eventually passed to Frank who was embarrassed by having to deliver the speech in a black cassock with a belt around it. No one took much notice of his rather minor role, but Tyrone Guthrie, appraising him one day, said that it might be better if he spoke less like a clergyman. Frank reminded him that he had to appear in a cassock and maybe that was influencing his delivery, but he did take note of the criticism and adopt a more familiar, forthright tone. He also had a secondary role in the play, as a soldier or armed attendant who batters on the door of Jason and Medea's house after the latter goes to destroy her children. In black tights, long boots and a painted A.R.P. helmet, brandishing a spear, Frank must have looked a most poignant dramatic concoction, but he put his heart and soul into it.

Feverishly he studied the play until word-perfect, yet still he dreaded Lewis falling sick and his being asked to take over the role. There were three or four days when Lewis had a vile cold and he was on tenterhooks. Young Paul Scofield contracted mumps and Lewis was forced to play his role in addition which, by proxy, Frank was also obliged to rehearse. Then Ann Casson, who spoke the chorus line with Nancy Parsons, went down with mumps and Kate replaced her to Frank's envy and admiration.

The tour began in Wales and went on to Durham where the audience seemed to be made up of miners. If the applause was at times muted, he enjoyed the slightly neurotic camaraderie of actors and took to dressing up and making a display of himself with eagerness and energy. The younger members of the production he found entirely agreeable: Ann Casson, Douglas Campbell, Paul Scofield and Kathleen Lloyd, later to become his wife.

Shared disasters and triumphs helped to bond an enduring friendship and Kate Lloyd, Frank Baker and a red-haired young actor, artist and designer called

Douglas Campbell, formed a trio who went around together. Since he appeared on the scene, Kate had been quick to take Frank under her wing. He learned that she came from Worcestershire where her family lived, and that she'd been educated at Holy Trinity Convent, Kidderminster, from where she passed on to Homerton College, Cambridge, where she gained a full teaching diploma, specialising in English. After that, she went on to LAMDA (London Academy of Dramatic Art), gaining a diploma for verse and prose speaking and a gold medal for acting before acquiring professional experience at The Old Vic.

Douglas was a volatile, exciting companion, aged around eighteen and under the spell of a talented Glaswegian friend, a poet called 'Jock' or W.S. Graham (who was himself in thrall to the luxuriant poetics of Dylan Thomas until he developed a spare, gaunt style uniquely his own). Douglas was a pacifist of the combative, challenging kind and a committed vegetarian. In addition, he possessed considerable artistic skill and went on to marry Ann Casson and direct the Tyrone Guthrie Theatre in Minneapolis. "It is strange", Frank was to reflect, "that a play which presents the bitter tragedy of a woman who kills her own children should have brought four members of its cast so creatively together."

With the ending of the tour, the parties separated. Frank returned to his cottage in Mevagissey, thinking that marked the end of his acting career. But he did not feel grounded enough to resume his writing. An inner dryness, a vacancy, oppressed him. The life of the small port seemed routine after the excitement, tension and romance of the stage. He missed the thrill and sense of kinship. It had provided a much-needed respite from the drudgery of living by the pen. Besides, he needed new material to inspire him:

What tale cook up next? My experiences as No. 97005217 Pte F.E. Baker? Life in Shadwell Highway with the pacifists? My conversion to Rome from Anglo-Catholicism? I was not able to cope adequately with any of these bits of my life, nor could I face writing about myself.

He plunged into a gloom that he was yanked out of by an offer from the Old Vic to play three small parts in Shakespearian dramas which were to be toured before presentation at London's New Theatre. And so, seizing the offer, Frank went to Burnley, Bolton and Bradford where, on a Midsummer day, he met Kate again who was on tour with another company. After that enchanting reunion, he was transferred to Hull, Halifax, Norwich and Derby and finally back to the homeground of St Martin's Lane.

KATHLEEN LLOYD (1942)

Over twenty years after they had married, when Frank was working on *I Follow but Myself*, placed before him on his desk was an old green paperback of *Medea*, priced two shillings, on the cover of which was written in ink: Kathleen Lloyd.

"To anyone who is married," he reflected, "it must at times seem extraordinary that there was a period in earlier life when the partner who was to share some of the most beautiful and some of the most stormy passages in the long voyage, was not even within knowledge. Yet, while I held in my hand my own new copy of *Medea*, that Kathleen Lloyd of whose existence I knew nothing was in Tenby. She did not know either that the man called Frank Baker who should have joined the company but had influenza was at that moment toying with the idea of following some entirely different star."

Kathleen Lloyd

Entering the world of theatre dispelled the gloom and frustration of his previous self. Temporarily he had quitted the company of elderly priests and ritual pedants and entered into an easier, freer alliance with actors who adopted characters like hats and scarves, shed them and substituted them day after day, month after month, the tinsel and paste world of players whose most passionate declarations might be reversed a day or so later, an association of ever-hopefuls caught in a mesh of dissolving and re-forming allegiances, offering social variety as well as a welcome superficiality after the drudgery of duty and obligation.

During this period of strutting the boards and socialising, Frank had been drawing closer to the young woman who offered him some of her chocolate. At the time they met in the Vic, Kate Lloyd was also working in London at the Mercury Theatre. Their contact was intense if fitful. Many times he had been torn from her grasp, whether called away on tour, hiding in a study in Mevagissey or visiting friends elsewhere, but their gradual drawing together and decision to unite their destinies had an inevitability about it. Other men were interested in Kate; Frank had his admirers, too, male as well as female. But this knowledge only sharpened

their attraction. In the future, of course, a certain amount of antagonism and fury was to be vented on Kate's part against Frank's drinking and tendency to find work anywhere save the place where they were living. Hence, along the life-path of their infatuation, lay in wait the constant pulling-up of roots, with Kate maintaining the role of steadfast family anchor while Frank dreamed up ideas and plots, most of which were completed, yet none bringing in that always-hoped-for golden apple to permanently deliver them from financial stress.

By the autumn of 1942, Frank was earning an income mainly from music, not religious or classical, but playing old music-hall songs on the piano at the Players Theatre Club in Albermarle Street, mixing rowdily uplifting and soulfully sweet pieces like *Down at the Old Bull and Bush, Old Kent Road, Any Old Iron, Only a Bird in a Gilded Cage* and *Daddy Wouldn't Buy Me a Bow-wow*. He rehearsed with the singers most days from noon until six and, after a break for food, performed every evening save Sundays. Kate afterwards joined him for a meal. They'd watch the show and mix with the friends they'd made, earning a little extra by helping with the bookings or stage management. During this period, both found themselves working intensely hard, yet eager to return to the solace of each other. The intervals when they were parted were filled by little notes containing bits of gossip and reflection, Kate being a rambly, spontaneous letter writer, nakedly revealing her emotions, then moving on to lesser matters and Frank a rather more stately communicator. A genuine clash or tangle of emotions was active for a brief period, with Kate hovering between Douglas and Frank, as this letter from Onan Court, Hampstead, reveals:

Dearest –
I've left my writing paper at the theatre and must write to you so will have to collect scraps. I've just came in and its bedtime. I found your lovely letter waiting for me. Bless you – it made me so happy. Had a nice day really and stayed late to make the prompt copy of Way of the World…

Darling, I want to marry you so much. I want everything settled and clear too. You are going to have so much responsibility looking after me, my darling, as I am looking after you – and as for wanting to spend my life with you, isn't it quite obviously what I meant to do? I think so.

I know that you and Douglas are absolutely necessary parts of my life and I can't be happy without you. You say I can but I'd be quite lost and I can't imagine it. I also know that to marry Douglas would be the wrong thing for him and for me. The same instinct that made you write in your diary, "No, they will not marry". I waste a lot of time wondering what he'll feel about it and worrying about making him unhappy, but I'm sure he knows we are really not meant to marry. It would never be right however much we were in love.

How strange to write a letter to Frank and tell him about how much I love Douglas. How wonderful to know that you'll understand and not mind.

Dearest, your letter is full of questions, most of which answer themselves – "Do you really want to marry me?" In the next breath, "Where shall we live?" The answer to the first question is, "Yes please, darling, if you don't mind" and to the second "We'll go to Cornwall in the spring and live there."

I've finished *Sweet Chariot* and loved it. Very alive book. How sad about the landlady of the Five Pilchards, but how exciting about Bernard Miles [British character actor, writer and director, 1907–1991] and his music – black magic of course, and do you think he really believes he has magic powers? I mean, he's going to be fun and probably simply wonderful as Chalecoule – sorry, I can't spell his name…

Lots of kisses, Kate XXXX

These emotional convolutions were resolved when Kate married Frank on the morning of 9th January, 1943. The ceremony took place at the Dominican Priory with the musician Colin Summerford acting as best man. Later that night, Frank had to appear in a Christmas pantomime playing two roles, that of a duelling Turkish knight and the back end of a horse. Kate was in the audience with a friend to whom she confided the joyful news that she had married that morning, and her beloved was actually on stage at this moment: "He's the hindlegs."

The by-then venerable writer of horror stories, Arthur Machen, whom the couple had befriended, sent them a warm letter of congratulation, wishing them many long and happy years together and going on to praise *Sweet Chariot* for its "high imagination".

Kate's letter, although undated, was written in 1942 or 1943, not long before Frank and she married and set up home at Parliament Hill. It establishes how both he and Douglas loved Kate, and she in turn loved them, latterly preferring Frank, but the bond between the two men proved enduring and, after Douglas married Ann Casson, the friendship matured and was taken forward into old age.

To Frank, these friends were not only friends but 'characters' for stories he might write or was actually writing. Douglas Campbell appears in novels and autobiographical reflections, so do other friends, acquaintances and family members. Why Frank wrote so confidently and swiftly at times is because he literally *knew* the subjects whom he portrayed. Seldom does he jigsaw a portrait or fit together an assortment of menacing attributes like Bram Stoker did in *Dracula*. Instead he plucks people warm from life and places them in a dilemma which may or may not be entirely made up. Neither does he take pains to disrupt the geographical context: Sandys Wason appears in *Allanayr* in the very house in Newport in which he lived and his words are sometimes quoted verbatim. Similar names like Cornford pass over from book to book and old pals drop in and out like regulars in a bar.

This might be thought a risky process – it cost Somerset Maugham (*Cakes and Ale*) and John Cowper Powys (*A Glastonbury Romance*) dear and Graham Greene had a serious reprimand when J.B. Priestley protested at a mildly satiric guest appearance in *Stamboul Train* that was ultimately excised – but Frank got away with it. Perhaps because his handling of people was generally kind and inoffensive, he was never called to court to defend himself. Cornish locals, whose dialect proved so entertaining in *The Twisted Tree*, might have felt affronted at being portrayed as quaint, simple people, but they would hardly be the types to consult a libel lawyer, protesting their social standing had been diminished. You need to be self-important as well as rich before you can gainfully exploit the complexities of literary justice.

Each of us is simultaneously a perceiver and object of perception. We occupy a solipsism yet can never quite dismiss as illusion those who interact with us and apparently collaborate in our game of reality. Our best way to escape restricted consciousness is through the imagination. In other words, by a feat of will or sympathy, stepping outside of ourselves or adopting the viewpoint of those who observe us. This is what writers enjoy best of all. A favourite indulgence is to style themselves as a race apart who happen to be looser, wilder, more risqué, friendly or intriguingly hostile – more open to abstract ideas and tackling Great Questions. Does God exist and, if so, what should we do about it? Can Heaven on Earth ever be achieved? How can humankind end war and effect universal peace, free love, eternal life or whatever else? In such role-playing, FB was at ease and liked to write from a personal standpoint. After all, he had reflected a lot, analysed himself, drilling into the depths of his sexuality, craving for love and security, yearning for a compassionate, overmastering God-figure in addition to the desire to sing, perform and strut the stage, so it was only natural to place an *alter ego* in his fictions.

In *Before I Go Hence*, with a degree of palpable, speculative relish, Frank plunges into the mind of his landlady, Mrs Quinney, who observed the comings and goings of the fictional equivalents of himself, Kate, Douglas Campbell and his socialist friend. What follows strikes one as honest observation, maybe a bit prettied up in that the reader is obviously meant to favour the louche, likeable Hilliars over the staid, nosey, morally reproving Mrs Quinney. Purely from the viewpoint of a biographer, it is eminently quotable, conveying vividly the texture of their existence in that flat at Parliament Hill where so many significant things took place, even the visitation of that so-called "inky poltergeist" that Frank confided to Arthur Machen.

Before I Go Hence

When the Hilliars had first come to live above, a few months ago, they had seemed such very nice people. She had helped them. She had opened the door when they had been out; taken in furniture delivered from various dealers where they had bought their stuff; some of it was quite good stuff too. A pity that old oak sideboard of theirs had the worm; it would be all through the house soon, and of course they would do nothing about it. Then there was the question of the mice. She had offered them poison; he had taken the bottle and said in his usual vague polite way that he would put some down. But she had said (Mrs Quinney had heard her from their kitchen; it was not a question of trying to hear what they said; one could not help it when they would conduct long conversations in the kitchen with the door open. Decent people would have realised.) – she had said: "Poor little things! I can't bear the idea of their being poisoned. It hurts them. They die slowly. Besides that, the corpses only bung up the holes and then it's worse than ever. I'd rather have live mice about the house than dead ones." As though it *mattered* how mice died, so long as they died! Did the Hilliars know there was a war on?

Yes, it was all such a pity. They had seemed such very nice people, obviously of good family; and their parents (she had met both branches of the family) utterly respectable people. Of course, a young married couple were always trying in a way; there were bound to be "certain noises" above which one could forgive, remembering that youth would be youth. Mrs Quinney remembered Mr Quinney with a long sigh of satisfaction. What a man! His portrait hung up in the next room, over the fireplace; a fine photograph, enlarged, which brought out Herbert's reliability very satisfactorily. She had been married to him for forty-odd years and he had never once had a mood. Neither had she. That was the way to live.

Yes, nice people, the Hilliars had seemed; and for the first week there had been many pleasant interchanges of conversation and neighbourly pleasantries between them. He had offered to get up her coal from the yard; she had given them little bits of cake and pudding. Newly married people needed tiding over the first days, and Mrs Quinney realised that getting married now was not exactly a picnic. And yet they seemed to make it a picnic! An eternal picnic. They even had their meals on the floor – there was so little furniture. Still, there was a dining-table, quite a nice one; she had seen it in. In spite of that, they had breakfast on the floor in their bedroom. She was certain of that because she had heard him say to her: "Ruth, we must be careful of the marmalade on the carpet; it's made a hideous stain." Marmalade on the carpet. What could you do with people who behaved in such a slovenly way?

A picnic – an eternal picnic. A joke – a long joke. That was how they treated life. Then they would have a row. A good thing they did have rows, since those were the only times there was any peace upstairs. Sometimes for hours they would not talk to each other. Mrs Quinney would hold her breath and hope they would never make it up. But they always did; and then the noise would start again; laughing and joking up the stairs, all the doors open, all the windows open, hideous draughts through the entire house, eternal running up and down stairs with no stair-carpet, constant friends in and out, always company. Well, they seemed to be happy enough. But had people any right to be

happy in such days? Was this the way to win the war? Why wasn't he doing work of national importance? Discharged from the Army, she understood his father to have told her. Why? What was wrong, with him? A deserter, more likely. What did they do? What sort of a place was this club he went to every night? And those books of his, what were they like? A friend had told her about one, a horrible tale she had said, which no decent person could read. Mrs Quinney had tried to get it from her library; but it was always out.

Now they were coming down the stairs; the red-headed man and his wife, and that Scotsman who was old enough to know better than to consort with such an unruly crowd. She didn't trust him. She had heard he was a socialist, a pacifist, everything upsetting that a man could possibly be. She heard him whisper something as they passed her door. Then the siren wailed to its higher notes and she lost some remark from Dirk Sherwin that otherwise she might have heard. She sat up and fumbled about for her shawl. No use trying to get to sleep now. Even if there were no raid, the Hilliars would probably go on talking for hours in their bedroom. Then they would get up and go to the lavatory, clattering down the stairs heavily, probably getting something to eat from the larder on the way...

Now they were starting downstairs. First, carrying a tray of tea-things down to their kitchen. Was he going to wash-up? She waited anxiously, not really knowing whether she wanted him to, or not. If he did, she would have a double pleasure; the pleasure of complaining to the landlady about the noise he made in the kitchen long after midnight, and the more doubtful pleasure of having to admit that washing-up before you went to bed was the proper thing to do. If he did not wash-up, she would be robbed of her complaint; at the same time she would be able to say to her friends, "I never knew people live such an upside-down life. They don't even wash up before they go to bed."

Mrs Quinney is a portrait of the Baker's Hampstead landlady. The red-headed man and his wife, Malcolm and Fenella – he with idealistic views and she with complaints about ghastly juvenile leads and semi-drunk stage-hands – are based on a rampant Glaswegian called Ian, and his partner Ethel Campbell, mother of Douglas. The latter takes the guise of the engaging, good-natured artist Dirk, also red-haired, who enjoys a drink and maybe a bit of friction from time to time. It is apparent that Kate's first choice of partner had been Douglas, but problems arose between them that the appearance of Frank on the scene helped to smooth over. It seems that Frank, who was equally liked by both, was better tailored to Kate's temperament than the more belligerent Douglas. Jonathan Baker recalled his mother telling him that, after he was born, she received a telegram from Douglas enquiring, "Has he got red hair?" She had to admit that Jonathan had, but of the fact he was Frank's son she had no doubt.

SWEET CHARIOT (1942)

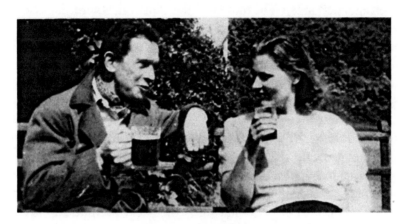

Frank Baker and Kathleen Lloyd.

Sweet Chariot was a favourite book of Frank's admirers after *Miss Hargreaves*. Kate was delighted with it and even the zealous critic, Derek Savage, confided to Frank he had a soft spot for it. After the steady seriousness of *Allanayr*, it was a reversion to that slightly mad flippancy to which Frank was prone. A fast and fluent piece of writing, it concerns the exchange of earthly and heavenly roles for the purpose of life-enhancement, but neither man nor angel benefits in the end.

Much of it had been conceived and written in Mevagissey where the early chapters are set. Dedicated to Annie Walke and the memory of her husband, Bernard, whose company Frank often sought while at the fishing port, *Sweet Chariot* handles its religious theme with a deftness some found delightful and others less satisfactory. "Yes," said Brenda Poynting, in a letter addressed to Frank at Cardiff, "probably a panel of judges would say that *Embers* is your best book. I agree it is in the very first rank. *The Twisted Tree* is, too, except that I find the ending after Tansy has pushed David down the shaft rather inconclusive. But for me the favourite is always the one with that wild dash of magic of otherwise and elsewhere...*Sweet Chariot*."

The novel is a record of what befell Mr Gregory Spillett on holiday in Cornwall. Mr Spillett is an English master at Cornford Cathedral Choir School, clearly based on Frank's old school, Colebrook House at Winchester. A bachelor, celibate, shy, conventional in his behaviour and opinions, he has no vices and little knowledge of the rough end of things, but he does possess imagination and a desire to break out. He finds an outlet for his wilder side when he swaps roles with his guardian angel, Melchior, who touches down in the Nansavallon Valley in Cornwall where Gregory is holidaying. They decide to swap roles. Hence the

story revolves around how a man may work out as an angel and how an angel may work out as a man. This involves a dual narrative which is weighted rather heavily on Gregory's side. To increase the tension, there is also a female schoolteacher, Vivien, trapped between the desires of man and angel as opposed to what she would like for herself. Melchior is purer and more refined than Gregory but prone to alternations of euphoria and depression. An angel out of heaven is like a fish out of water. Vivien's wants to be loved but seems to be caught up between the vacillations of a couple of reckless no-hopers who have become intimately interlinked.

It is a good thing for a novelist to have an original or zany idea but it can prove a challenge working out a rigorous logic to stabilise the fancy. Here the agency of character manipulation may falter. Intrinsic difficulties arise in novels whose main characters hail from the mythical or celestial menagerie. The superficial reaction is, "An *angel*, what fun!" or "How delightfully inventive!" as if the very notion automatically confers pleasure. Later, however, the novelist is forced to ask himself: "To what *especial* use can I put this angel in fictional terms? What circumstances can I create which will uniquely establish the rightness of this creature in this situation, a being who is, traditionally, defined as a messenger or representative of a divinity?"

This is definitely the awkward bit, obliging Frank to consider how an angel should differ from a human. A whole theological world-view is stirred. Confronting it raises questions pertaining to the machinery of God and the function of His minions. Unable to allow cynicism or temporal values a role in paradise, he decides to make the angel a naïve or unworldly being. Angels fly, are good-natured, idealistic and easily hurt or puzzled, in Frank's view, lending the novel a certain charm and sweetness but a lack of emotional authenticity.

Switching bodies with Gregory enables Melchior to take up with Vivien, who initially finds the change of character, the aureate innocence and enthusiasm, more attractive than Gregory's pedantry. Melchior does indeed deliver a bit of romance but he is rather too shy to make the grade as a lover. He tries hard to improve life on earth but ends up causing a dangerous fire in his place of employment, for which the identical-looking Gregory pays the price, namely a spell in prison.

The interchange is an exciting idea, but neither angel nor man are effectively 'transformed'; also key scenes are related in the past tense. Hence what we have is a pleasant read but one which does not develop thematically. The depths invoked by the novel would challenge the resources of a Thomas Mann who would no doubt dull down the fantasy element and intellectualise the design. FB opts for fun and whimsy which he manages with his usual skill and charm, maintaining a wary distance from God of whom the angel divulges nothing.

As with all of FB's novels, descriptive felicities abound, especially flight passages at which he excels. Conscious of his knowledge of birds being

superficial in his earlier treatment, this time he deals with the ornithological spectrum thoroughly, differentiating between species, their manner of flight and reaction to Gregory Spillet. There is a passage of attractive dottiness wherein Gregory appraises his avian friends and enemies. Celestially ambitious, he attempts to explore the limit of his extended reality:

Dense into the damp world of a great mass of cirro-stratus cloud soared Gregory James Spillett. Higher and higher, kicking out wildly with his legs, gasping for breath, he rose. Now he was above the cloud and saw it spread out below him, a pallium over the uneasy, half-sleeping village of Little Peter. Still higher. Four thousand, five thousand, to seven thousand, eight thousand feet. Clear and burning were the stars. Plough, Cassiopeia, Perseus, Orion and the Dragon, and down the great arch of the unending sky, the belt of the Milky Way, Spillett plunged toward the Square of Pegasus. On and on he went, and still further away seemed the mocking stars. Down the Milky Way a little laugh shivered. Voices resounded through the air; the wind whirled him round and round like a teetotum. It grew lighter; the air rarer. Was he in the Square of Pegasus? Did Pleiades light fresh lamps for him? He gasped and moaned, starved of air. His lungs were bursting. But on, beyond the Sidereal, lay that great world of light which blots out all the stars and holds all music in it; all the music he had ever heard held in one long, great chord; all the words he had ever spoken trembling in that chord. Yet a little, further – it could be done; it must be done. Now the light blinded his eyes and great shadowy winged forms choked and suffocated him. Was he before the outer walls of the country he had come to find? Was he to see the Shekinah? Was he to hear the Word? "Possibly; possibly not," he gasped.
 As he spoke those words a terrible thing happened. Down from the great firmament of light, a million mighty hands pressed upon him, forcing him back to his world. Laughter, wild and mocking, rang in his ears, dying, as he fell, to a far distant wail. Spinning round and round, he plunged into the black cloud of the east wind. The turbulent, wind-thrashed sea leapt up to claim him. So he was flung back to the world he had sought to leave.

The issue is of eligibility rather than aerial prowess. The greater powers reject Gregory and, in a sense, that's where the novel should end. But he has the obligation of completing the tale of Melchior who is recruited to play a stage angel in a ballet called *The Sons of Morning*. Quitting the show, the angel literally ascends to his celestial habitat, leaving the earthbound players to their dilemmas.
 The last section has an encounter between Gregory and Vivien in prison. She's in a state of perplexity, but Gregory will not explain how he'd literally 'not been himself' – for he has to secure the safety of Melchior. The solemnity of the conclusion is too dismal and disillusioned for the flossy fantasy that preceded it. If you start out a novel like Jerome K. Jerome, it's rather disarming to end it like Fyodor Dostoevsky. The religious side of FB considers angels glorious, august and lofty and the comic side as a subject for knockabout humour. Instead of opting for one or the other, he opts for both and leaves the reader perplexed.

SWEET CHARIOT

The larger birds were always his enemies. Once he was nearly forced to ground by a gannet which sailed out from the Dodman Head, with monster wings, murderous eyes and a bill like a javelin. Gregory, not caring for the expression in its face, swerved sharply downward; the gannet dived after him, and for a moment Gregory, feeling the rush of air caused by the flapping of those immense wings, felt sick and fainthearted. Suddenly, however, his panic left him; he could surprise his enemy, and he would. Opening his mouth wide, he let out a great roar which so took the gannet by surprise that Gregory had time to soar away inland. He felt thankful that he was not a fish; it must be unpleasant to have to pass one's life constantly under the shadow of so unmerciful an enemy.

Rooks were not kind to him; neither were crows. From afar they would mock him, and often rooks would drop sticks on his back as he flew beneath them; and worse than sticks; disgusting, untidy birds, he thought, with an inborn sense that the air belonged alone to them. Gregory bore these indignities with patience and tolerance. From their point of view it must be, he knew, excessively annoying; their air, their private air, invaded by a man who had not even the decency to come in a machine, thus warning them of his approach. Intolerable!

Magpies appeared to understand him. Sometimes they would flutter close to him, chatter some harsh words, laugh cynically and retire to a low hedge, where they would watch him. A pair, who kept flitting across the field above the barn, often stopped on a stump of an old oak near the door, and held long whispered conversations about him. They were not, Gregory felt certain, polite conversations; but they were not malicious. There were times when he imagined they were telling each other bawdy stories; close together would come their heads, their voices would sink, apart would draw their heads, a loud, impenitent laugh would fill the wood, and, with a sly wink at him, off they would fly…

Wren, stonechat, linnet, chaffinch, robin and yellowhammer – all accepted him as a friend. Once, while he was flying above the river shallows, a wren settled on his shoulder. Hardly daring to move, Gregory floated slowly on through interlacing branches. Still the little bird sat on his shoulder, trilling pleasurably. Rarely had Gregory been so flattered. Then a shotgun snapped through the silence of the Valley and the wren flew away, terrified.

AMERSHAM & ARTHUR MACHEN

Frank kept no direct account of the meetings he and Kate enjoyed with Arthur Machen and Purefoy but held dear the memory of the couple. He confirms they nearly always took place at the King's Arms, Amersham, lasting from the midsummer of 1942 until the autumn of the following year. Machen usually waited for them at a private table, glasses of gin and water set aside, Purefoy puffing at a cigarette she had hand-rolled and Arthur pouring out blue smoke from his sturdier pipe.

The chronicler of creepy tales and nefarious fairies was around eighty-one then, yet still lively, eager for drink, food, company, "an old man sunk in poverty and obscurity," as one writer put it, "but he talked as though the world was his oyster." In an old-fashioned Ulster cape worn over a black topcoat, he looked a plump, definitely corporeal figure, quite different from the gauzy wraiths and grey goblins that flit through his narratives. His bright blue eyes responded enthusiastically to any insight or suggestion. Others have evoked him less robustly: waxen hands, thick white hair and clouded blue eyes. Like many people fascinated by ritual, self-denial and ascetic issues, he ate and drank as much as he was able and put over the occasional racy anecdote. In his deep, sonorous voice, he would regale the Bakers with tales of yore. His literary recollections went back to Oscar Wilde, who had praised a story of his that appeared in a newspaper, and poets and artists of *fin de siècle* as well as Belloc and Chesterton and the celebrated actors and editors of the Edwardian era. He had also belonged to the Golden Dawn, the renowned mystical society whose ideas and ritual practices had briefly enticed figures like W.B. Yeats, Algernon Blackwood, Aleister Crowley, Florence Farr and Bram Stoker.

Although a staunch patriot, a despiser of the Hun who did not really take to pacifists either, Arthur never brought up the matter with Frank. Neither were at heart political creatures; their inclinations were essentially aesthetic and imaginative. Machen's work touched on Frank's preoccupations: religion, the supernatural and the sublimation and sanctification of the sexual urge. So, in essence, we have two writers, one young, the other old, both addicted to drink, tobacco and good food and also sharing a liking for shades, wraiths and faeries.

Machen himself is a curious contradiction. There is a clash of philosophies and attitudes in his writing. Early, slightly racy, mildly erotic tales conform to or parody French medieval models, spicing decorum with naughtiness. He also did a translation of Casanova's memoirs, along with books and articles celebrating smoking and drinking, mingled with criticisms of any puritan who belittled these diversions. Sometimes he presents the façade of John Bull, a roast-beef Englishman who distrusts foreigners and those who constantly seek change and innovation. This bluff front shielded a side ever ready to

luxuriate in a cerebral sensualism that is best embodied in his masterpiece *The Hill of Dreams*. The novel traces Lucian Taylor's downfall from adolescent girl-worship to romantic-daydreaming, thwarted literary enterprise and withdrawal from the world. A delicate literary fledgling, who pines for enlightened appreciation and a touch of love, he is reduced to a wretched, half-starved wreck, subsisting on little but reverie, tobacco and green tea. The hedonistic fantasy into which he escapes finally devours his soul. The dream returns to punish the dreamer as it does in *Miss Hargreaves*.

The punishments Machen devises for those who teeter on the borderline of conventional morality strike one as stern. When young men *do* show a bit of lechery or physical initiative in his stories, usually the Devil or Pan shows up, decomposing them on the spot or sending them rip-roaring mad. No wonder Frank Baker – a devotee of Machen's novels and stories – was visited by bouts of sexual trepidation. What manner of man was Machen? A rollicking Rabelaisian? A sanctimonious devil-worshipper? A fulminating puritan addicted to booze, tobacco and purple sins?

In *The Chronicle of Clemendy* he writes: "It is true that a girl does not object to being tickled, if you do it nicely, and choose the right places." This sounds cheery, broadminded, a bit of a tease in fact, but then a little later on you read *The Novel of the White Powder*, relating how a young man, Francis Leicester, goes out and does exactly that, only to discover the very appendage that enabled the impertinence has, after turning a horrible shade of black, burst into malevolent-smelling flames and is now reducing itself to a mass of slimy, boiling bubbles. This is none other than apt punishment for perpetuating the sin of Onan that Alfred Rose told Frank not to worry over. Later, under the influence of Machen, he wrung out more yet drops of inspiration from the theme by writing a Jekyll and Hyde tale in which a wicked arm is gruesomely amputated.

To be fair to Machen, he did not mind anyone being gastronomically or alcoholically lecherous – like Parson Woodforde, say – but he was wary of those who openly celebrate the procreative instinct like D.H. Lawrence. If you want to indulge in that sort of thing, at least have the decency to smother it in fragrant metaphors, Grail-light, chalices and brimming goblets. Some of his scary tales recall those horrific Victorian medical prophesies attached to various types of lubricious pursuit, gratifying for those who'd never dream of getting up to such things but disconcerting for those who err. However, Machen *is* a profound Celtic spellbinder who conveys better than anyone the lure of solemn, lonely places and stealthy spectres slithering out of the cracks in our minds. His evocations of Outer London in the Edwardian era are suffused in a golden haze of enchantment. Like Chesterton, he realised much of life is about getting lost rather than finding one's way with a map. The latter is a means of attaining a destination, but getting lost involves opening a dialogue with one's deepest anxieties.

PLAYING WITH PUNCH (1943)

An illustration from *Punch*.

When they were first married, Frank and Kate shared a top-floor flat at Parliament Hill, Hampstead, offering a breathtaking view over London. It was where their first son, Jonathan, was born (November 1943) and many troubling, uplifting and exciting things happened. Ethel Campbell was often there with her partner, Ian, and nearby was the famous actors' pub *The Magdala* where Ruth Ellis was to shoot her lover David Blakely. From here, after completing his period of touring, Frank was offered the chance to join the Old Vic Company. He accepted, hoping not only to fulfil his acting ambitions but to also find an outlet for his playwriting. The famous Old Vic Theatre in Waterloo Road had been bombed and the company's headquarters had been relocated to a new theatre in Brinley.

For Frank it was a period of intense creativity, but the conditions were far from ideal, being cramped and not particularly warm. They had entered the blitz period of the war and Frank was using the top room as his study, sketching out titles like *Playing With Punch*, *Mr Allenby Loses the Way* and *Before I Go Hence*. The latter he termed "a haunted book" that appeared to be drawing in its own familiar spirit, for Frank became aware of the presence of a poltergeist spattering ink on the walls and doing other mischiefs. He confided this in a letter to Machen who agreed an inky poltergeist "must be a nasty business" and then confusingly related a story about a drunken actor who had hallucinations from *delirium tremens*. The reference to drinking might hint Frank was slightly 'under the influence' when he perceived this, for he remarked he was not particularly frightened and therefore less than convinced of the phenomenon's genuineness. However, he roundly states that Kate *was* so perturbed by the supernatural irritant that he invited the young Dominican who had married them, Father Peter Paul Feeney, to come and bless the flat. He agreed and the 'trouble' seemed to fade away.

At this period, Frank's most effective play was taken on by Ann Casson's new company that had been formed to alleviate the privations of wartime Britain. A demand for a new type of cultural entertainment had arisen, one suitable to entertain audiences of service camps, civil defence workers and others engaged in the wartime effort. Bolstered by a guarantee of production, Frank was able to complete and launch his version of Punch. Always drawn to the theatre, when previously he'd tried his hand at playwriting, he'd never quite confined himself to the stringent demands of the medium, the results being too wordy, abstract or artificial. He was now determined to write a piece that acted well – for modern plays, he maintained, had lost contact with their audience:

The dramatist came to the conclusion that the modern theatre was, if not dead, so organically diseased that there was little hope for it. The unutterably dull three-act convention, the appalling box-set, the false realism and naturalism (for which the Master, Ibsen, must be – alas – blamed), had all produced a type of drama which lacked any true dramatic value. For this reason the cinema had, momentarily, won the day. Who would go to the theatre to witness insipid little comedies or pocket-tragedies when they could go to the cinema and see, from a much more comfortable seat, gargantuan feasts of the purest fantasy? Unless the theatre woke up to the primary desire of men and women for an art that magnified the *minutiae* of their lives and related them to the enormous scheme of creation; unless the theatre cast away the conventional – therefore devilish – works of darkness and put upon itself the armour of light; unless it was prepared to shock, bewilder, excite, horrify, inflame, an audience – it might as well go bury its head in the sand for evermore.

With this in mind, FB was asked to rewrite his *Punch* play for Ann's company, so that it might be taken on a long fit-up tour, mainly in Scotland and mainly to service camps. In order to suit the needs of the various units, the play should run for only an hour and should use a minimum of scenery. The backdrop would be provided mainly by screens which were to be carried around; lighting was to be confined to two spots on stands and one flood. Expenses having to be kept low, engaging only six actors, three men and three women, who were required to do their own stage-work and business management. A double bill of plays was required for the tour: *Fire at Callart* by Gordon Bottomley was *Punch's* companion piece.

TRAGICAL COMEDY

Punch and Judy originates in the old Italian puppet theatre. Usually Punch is derived from *pulcino*, a young chicken, and is traditionally attributed to Silvio Fiorillo (fl.1600). With his ineradicable grin and boathook nose, the most famous puppet of all time was first seen in England when Charles II came to the throne. His anarchic vitality was to inspire opera, ballet and punk rock. The time-honoured story tells how Mr Punch, in a fit of jealous rage, strangles his crying baby. His wife Judy sets upon him for this gross act of cruelty, and he turns on her and cudgels her to death. He flings the bodies of Judy and his child out into the street, but is arrested and thrown into prison. By means of a golden key, he manages to escape and overcome various temptations and oppressors. First he is besieged by Ennui, in the form of a dog, then Disease in the form of a Doctor, then Death who is vigorously beaten to death and, finally and most triumphantly, the Devil himself whom he knocks unconscious and hoists up to the audience.

FB's *The Tragical Comedy of Punch and Judy* was first presented in St Andrew's Church Hall in Grimsby, September 1948. Frank played Punch, Judy was played by Miss Freda Gay, Douglas Campbell played Scaramouch and Miss Ann Casson played the sexually flexible Dragoman or Stage Manager. The latter acts as a kind of chorus or commentator, so that the audience picks up the dramatist's intentions.

With its buoyant brutality that anticipates Artaud's 'theatre of cruelty', the original *Punch* is difficult to better, but Frank adds some ingenious developments, investing his adaptation with a contemporary resonance that touches an existentialist nerve here and there. Although wordy and in parts over-facetious, it makes for a spirited piece of theatre, blending the best from *commedia dell'arte* with modern angst, social satire and a dab of primal despair that anticipates the Samuel Beckett of *Waiting for Godot*. Starting slightly self-consciously and nervously like a Brecht or Pirandello, the actors remarking on the audience and arguing over what parts they're meant to play – that, yes, we're all actors in a show stuff – but once that's over, the play takes a clear, powerful shape. Punch is shown as both brutal and sympathetic, a modern Everyman who

at times seems to be representing the heavy-footed world of industrial progress, mashing up the world's resources. He is the indomitable trickster, the ever-rising, all-escaping spirit of survival that will not be quashed but constantly changes its ways and means:

DRAGOMAN

March, Punch! March to the end of the play. Pick no flowers on the way. Ignore the warbling of the thrush in the may-tree. Devour the lamb, hew down the young saplings. Dam the streams, destroy the dams. Power in your fingertips, power in your brain. Power in the wind, power in the rain. Gather the power, Punch! Gather the power! Store it! Hoard it! Gloat in the night! Here in your hump, Punch – here in your hump hoard the power, then march! march! march!

The Mayor is not individualised but projected as a dryly objective committee man, objecting to Pretty Polly soliciting for trade in the daytime hours. But the verses he declaims are witty and neat enough, recalling in their daring moments Auden and Isherwood's satiric fervour as reflected in *The Ascent of F6* and *The Dog Beneath the Skin*:

> My name is simple; William Brown.
> Forgive me if I seem to frown
> Upon this lady's occupation:
> Not so! We call it a vocation.
> Provided one takes the proper measure
> To neutralise the germs of pleasure
> We hold that people should be free
> To exercise their potency.
> A madman known as William Blake
> Once wrote (he made a great mistake)
> The harlot's cry from street to street
> Shall weave old England's winding-sheet.
> Alas! The prophet could not see
> That science would make us safe and free.
> The clock of progress cannot back tick –
> In short: be armed with prophylactic.

Giving the Mayor the name of Richmal Crompton's much-loved scholboy rebel sets up a ripple of surprise, and the topical hint concerning taking precautions to avoid venereal disease shows the play was mindful of the ways of its military audience.

Contrasting with Punch's blundering, violent dynamism, Scaramouch is a self-pitying, disgruntled artist-narcissist, trying to establish a bond between himself and Punch, so that what he does – make sunflowers, poeticise and chase straws – can be wrought into a political force. He wants power but his gifts are restricted to the solipsistic bubble that he inflates with his irritating prattle.

SCARAMOUCH

Oh, it takes more than a little thing like that to upset me. Poor Scaramouch! Giving and never taking. Making and never being. I am the tapes on the maypole, the mascara on the eyelid. When the people rise, they will kill me first. They will fling Scaramouch to the dogs, because to the dumb baby and its mother he could offer nothing but a painted sunflower.

Scaramouch is an outsider who dislikes seeing couples happily attached as it emphasises his isolation from the common stream. Punch's strength, he argues, lies in his narrowness of vision. If he was thoughtful and introspective, he would be as useless as Hamlet. It is, in fact, the old debate about the value of the dreamer as opposed to the realist, the poet as opposed to the plumber, the visionary as opposed to the valet, but it does appear to be saying – mainly through the character of the Dragoman who acts as a chorus – that brute force and get-up-and-go will always triumph because it creates motion and not reflection, and that is what excites people. It was the active violence of the dictators that created waves of thrilling shivers through the British intellectual establishment, inspiring them to re-align their ideological and moral sympathies, and FB, in his presentation of the murderous Mr Punch, might have been trying to catch an echo of the *Führer* whose devilment had by now surpassed that of Napoleon.

DRAGOMAN

Forget him. Think of the future. You are a changed man. You have used your power; and to use power is but to beget power. *As the Dragoman talks, Punch very slowly rises until he is standing full height in the dock.* Scaramouch thought he could create. But puppets cannot create. They can only twist matter into new shapes. Silk into a tunic; ink into arrangements of words; the walnut-tree into the escritoire; pig-skin into purse; gold into money; the wheat into bread. That is not creation. You are great because you knew you could not create. You are a rational puppet. Now you have found your destiny. Press forward, Punch! Think always of what you are going to do. Think often of what you have done. Think never of what you are doing. Press forward, Punch! Plan, plot, weigh, balance, strike!

The conclusion of the play is intensely dramatic. The ghosts of those he has slain confront Punch who naturally circumvents their intended revenge, determined to move on and outlive conscience, morality and self-examination. "If the blood of ten thousand innocent children was on my hands, I could still fight the Devil."

TOURING

Dresses and stage-settings of *Punch* were designed by Douglas Campbell, who was also stage manager, and the tour lasted from September to the end of the following January. From Grimsby the company went to Hebden Bridge, in Yorkshire, where a week was spent playing in the little theatre which was built by an enthusiastic group of local amateur actors. Three days were then spent at Leeds, playing at church halls in the suburbs, and three days at Ilkley. A week in the neighbourhood of Lancaster, playing at such places as Ulverston, Broughton-in-Furness, Grange, Northumberland, Berwick-on-Tweed and over the border to Edinburgh, Dunfermline, Haddington, Dunbar, Kirkcaldy, Gullane, Dunblane, Aberfoyle, Dollar and Alloa. November was spent in Orkney playing to military, naval and R.A.F. camps. December in the country around Aberdeen and Inverness. A week was spent in Thurso. During January the country near Glasgow was covered, including the Galloway area, Dumfries, and the border country.

Frank's impression was that *Punch* was "always exciting to play and always difficult." Few performances were given to the general public. The tour was intended for Y.M.C.A. halls, audiences of civil defence services, naval, military, and air-force camps, and schools. The intention was to visit places which had been little served by other travelling companies. The arduous effort involved was justified by the interest of small audiences, who had to use whatever quarters were on hand, Nissen huts on Orkney or remote church halls.

Punch was not invariably a success. On the Isle of Flotta in the Orkneys, in the garrison cinema before an audience of seven hundred sailors, with the admiral and his staff in the front row, it was a complete flop. But generally speaking, it was received with enthusiasm. It provoked pages of correspondence in the *Orkney Blast* and became for a time a major controversy on the Isles. Perhaps its strangest and toughest audience was one of Scandinavian sailors at the Seven Seas Club at Leith, where the actors had to use a corner of a right-angled room, which doubled up as a café, while the audience sat at tables, drinking beer and eating sandwiches. Although they understood hardly any English, they heartily applauded.

Towards the end of the tour the company looked bedraggled. All had incipient flu. The screens and the flat which had been bundled from lorry to train, from train to boat, from boat to drifter and back again to lorry, and in and out of halls of all sizes and shapes, were falling to pieces. If one made a sharp movement on the stage, there was always the danger of the screens toppling over and flattening the actors. The costumes were torn, dirty and creased. One of the wardrobe baskets was so eaten by rats that it was cast off in some obscure

Scottish village. The props were falling to bits and the make-up decomposing and mingling its shades and textures.

Yet on the whole the company remained in good spirits, saying "How amusing this will seem in a year's time." From quarrelling so much, they had grown increasingly fond of one another, arguing about evolution, religion, sex, politics, sociology, painting, literature, music, astronomy, mathematics, drama, education and cooking. Generally these dialogues took place in a lorry very late at night, when they were huddled together on an enormous black cloth in order to keep warm. Or sometimes they would argue in railway carriages or – as in Orkney – (where they lived royally at the Standing Stones Hotel), over the breakfast or late supper table.

Though he suffered tense moments during his playing of *Punch*, Frank was more than satisfied that taking so different and challenging a play to remote and often 'simple' audiences had proven worthwhile. He was convinced this form of drama had possibilities which could be taken further. "Was it possible," he thought, "that plays in one long movement (not merely one-act plays), which disregarded the unities, which broke the realistic convention and ignored the use of scenery or curtain, which used only stock characters and made no attempt at characterisation, which drew into itself certain topicalities and made use of song and dance – was it possible that this sort of play had come a little nearer to true drama than many plays now to be seen in the theatre?"

If this was so, as Frank acknowledged, there was nothing *new* in it. For what was *The Tragical Comedy of Punch & Judy* but a return to the conventions of the *commedia dell'arte*, a style of partly improvised comedy which flourished in Italy from the 16th to the mid 18th century? Actors worked around a scenario rather than a set text and worked into it whatever was topical, lively and amusing, not unlike the filmic experiments of Mike Leigh where the story develops from a situation rather than a script.

One might add that, were Frank alive today, he might go along to a local theatre and see Cornwall's premier touring company, Kneehigh, doing all and more of his stipulations, drawing in singing, dancing, acrobatics, contemporary reference, stunning visual effects, hilarious or emblematic costumes and generally taking forward the tradition by innovation and experiment.

THREE WARTIME NOVELS

——— MR ALLENBY LOSES THE WAY (1945)

Although it was published in the year the war ended, WW2 is very much with us in Frank's next novel, *Mr Allenby Loses the Way*. Much of the plot was pieced together and written 1943–1944 while touring Scotland and the Orkneys, entertaining troops and locals with *Punch*. He utilised the prehistoric landscape of the northernmost islands of Britain to dramatic effect along with the Parliament Hill area of his London flat that forms the setting for the greater part of the action. It is not incidental that the plot itself and so many of its characters smack of the theatre with their rotundities of phrasing and histrionics. The story is busy with intrigue, nervous with anticipation, a rushed, fretful atmosphere like bodies rubbing up in the wartime underground

It is also something of a curate's egg. A not especially smooth mix of realism and whimsy, it is easy to detect the influence of Dickens strained through the H.G. Wells of *The History of Mr Polly*. Undoubtedly *Mr Allenby* aims higher than its intellectual reach, a turbulent, troubled tract, alternatively over-fanciful and over-earnest, by someone critical of humanity and yet too romantic and emotional to deliver the hard analysis one finds in Thomas Mann or Robert Musil. A dash of the witty, questioning Aldous Huxley of the 1920s is also detectable, but Frank is not happy in the abstract realm of ideas, tending to get weighed down by sentimentality and superstition. Old locales are aired to give any faithful readers he may have acquired a sense of continuity. Government Hill, close to the flat of Maurice Hilliar, turns up in the story as does a bomb-blast similar to that in *Before I Go Hence*. Cornford is sentimentally invoked, the birthplace of Norman Huntley in *Miss Hargreaves*, and the setting of Gregory Spillet's school in *Sweet Chariot*. References to FB's beloved Cornwall occur, of course, in the person of the tedious if amiable Horace Minoprio.

The theme is the transformation of the life of a single man by a process of cruel and ruthless manipulation. At the centre of this modern fairy tale is Sergius Allenby, a plump little tobacconist whose life is violently upturned by the entry of a forceful magician-figure, Humphrey Nanson (based loosely on the psychologist John Layard), who offers to grant him five wishes. Allenby leaves his home and family to seek out his true identity. Is he truly an Orcadian fairy child – a foundling with a special purpose? The story explores his dilemma through a series of revelatory encounters, shot through with diagnostic dialogues and bursts of pessimistic social criticism. The shadow of World War Two stains each page. Along with a consciousness of the darkening political situation, there

is a fascination with the darker aspects of belief and the kinkier aspects of sexuality.

Humphrey Nanson is the master villain of this incredible tale. After seducing a virgin to win a bet for the sum of twenty-five pounds, he devises a life-experiment for the outcome of the liaison, namely Sergius Allenby. Nanson is presented with a flamboyance that creaks slightly. For a clinical psychologist, specialising in shell-shocked patients, he pontificates rather than dazzles, showing fluency and rhetorical swagger, but nothing truly incisive, varying between educated commonplaces and amusing eccentricities. If he rumbles impressively, he fails to deliver an earthquake.

A demonstration of his sexual orientation is found in Chapter Five: *Ballade in B Major*. Owen Steele (another of FB's alter egos) visits Nanson who shows him his pornography collection and expresses contempt for the war and foibles of mankind and then, quite unexpectedly, bends over a chair and invites young Owen to beat him with his belt. (Is Nanson, by requesting a beating, trying to pre-empt the possibility of true punishment for his wicked connivances?) The ritual precedes a claim of entrapment through complicity. Because Oven delivers the beating Nanson asked for, he has forged a mental bond with the older man, from which he can never extract himself. The beating is a kind of ritual corruption, disabling Steele's ability to provoke or criticise, previous to this disclosure:

He went through the door and Owen followed him slowly, pausing for a moment, to look for the last time at the room, wondering whether he would ever come back to it, a place so calm and wrapped in beauty. His eyes lingered on the black velvet curtains. What was the picture, he wondered? He would probably never know.

"I think you ought to have told me more about the Canute Club," he said. And he reflected how long ago it seemed since he had read that notice in *The Times*.

"The club? Oh – "Nanson chuckled. "I had in mind a small and select society of men welded together by one common belief – namely, that all men, as the psalmist says, are fools."

"It sounds very Chestertonian, or Stevensonian."

"Yes. They would both make good members."

"What would the members do?"

"Oh, apple-pie beds, my dear. A succession of practical jokes upon the fools. Each member to have his turn, the others assisting and observing the result."

"What sort of jokes, and how would you choose your victims?"

"There is the simple expedient of the telephone directory. Don't you adore the pin of fate? As for the joke, I would aim merely at the baffling and bewildering of the chosen victim. For example, Harold Finching, warehouse clerk, receives, every Tuesday morning, through the post, a parcel of boiled cod and bootlaces. Miss Pennyprim of Mon Abri discovers, every Sunday morning, a pair of bright scarlet bloomers hanging on her line. Mr Allenby, newsagent, is visited by a business-like fairy and told he may have five wishes."

The Canute Club recalls the frivolity and effrontery of Evelyn Waugh's black satires like *Vile Bodies*. Nanson comes over as a prankster, a practical joker rather like Horace Cole, the notorious hoaxer of the 1920s, a man almost maliciously dedicated to making fools of others, especially the law and politicians. Once he disguised himself to look like the prime minister Ramsay MacDonald and attended a meeting of the Labour Party, making a speech where he told the members to work more for less money. He also hosted a party in which the guests discovered that they all had the word 'bottom' in their surname. On another occasion, he gave theatre tickets to each of his bald friends, strategically placing them so that their heads spelled out an expletive when viewed from the balcony.

But FB is clearly trying to build Nanson into a bigger fish than Horace Cole. He dominates the book more than any other character, a Faust-figure who deceives humanity yet also ministers to shell-shocked soldiers, playing the dual role of healer and double-dealer. By P.169, when the reader is deeper into the story, Nanson has lost his impish streak and his pronouncements are beginning to sound grandiose. He has the temerity to suggest that many would prefer the fantastic scenario he constructs around them rather than the dull truth of their ordinariness:

"Why do I play with people? What do I get out of it? They are questions I have asked myself; and it is worth trying to answer them. I play with people because they invite it; because they cry aloud for the fingers of the modeller; because they want always, not to find themselves, but a dream-creature they build in their minds... Should I have been an actor? No, for acting gives the game away. I am a true actor, in that my audience never knows when I am acting. I am trying to be myself while I write this; and yet so easy has become the actor's guise I do not know whether I am parading a false self to my real self, if indeed such a real self has any longer any existence."

This is characterisation by resonant bluster rather than by action, understatement or subtlety. Like Edmund in *King Lear*, who histrionically preens himself on his villainy, Nanson is a narcissist, a power-crazed psychologist. He is playing what John Fowles in *The Magus* – a novel positing a similar connivance – called the 'Godgame', the main difference being that Fowles's magician-figure, Conchis, strives to instil from his theatrical enactments a lesson, an understanding of a situation that has so far-eluded the protagonist, but Nanson is unable to justify his rather grander design.

The credibility of Nanson's absurd tomfooleries jars in comparison with FB's soundly realistic portrayal of wartime London. The idea of a distinguished, salaried man entering into a deliberate seduction and then, after many years, preying on the offspring of his indiscretion by weaving a foundling plot and five magical wishes around him, all in the service of fulfilling a bizarre, selfish piece of manipulation, creaks far more than a plain, simple fairy tale. Small wonder the

author's strain is manifest as he strives to anchor the improbability by switching up the emotional pressure.

The grand finale takes place in the fairy ring on Orkney, by the massive stones of the Ring of Brodgar where Sergius was found as a baby. Allenby reproves Humphrey Nanson for his manipulative callousness in a tirade intended to make him identify with the piteous plight of his mother, Elissa, the maiden Nanson had seduced and deserted. Patiently he goes over the stages of his arrival in the world – from germination to manifestation – along with the torment of a young mother left alone at a time when a father-protector was essential. Nanson defends himself robustly but sparingly – "She knew perfectly well. She enjoyed those hours more than I did." He seems to have lost his bluster (not surprisingly, as there's nothing he can say for masterminding a project whose purpose is inscrutable even to himself) but Sergius continues to drive home the point, as if trying to breathe life into Ellissa by fulsome exhortation:

"But I want you to think of that, Father – I'll call you that to show you I acknowledge you, and honour you – I want you to think of that: all those months of labour and shame and loneliness, which should have been months of glory and companionship and great dignity – nobility, I could say, for a woman's nobler in labour than at any other time – all those months and it comes to this, that she doesn't want the child. Oh, yes, she loves it with all her instincts; but she's a true woman and she loves her man more. She loves the one who gave more than the gift itself. She's more lonely than any woman could be whose husband or lover had died. The wind howls up here – listen! You can hear it now. And great clouds gather in the sky and the winter seems long. It's getting dark now and only five o'clock. Then summer comes and she could have been happy up here; but summer is like a picture seen in a book, not real at all. So it comes to that. One day she leaves her home, carrying the baby with her she walks miles – never knowing or even caring where she is going – and somehow she finds her way here – and" – his words suddenly failed him. He asked, very quietly: "How could you do that to her, Father?"

NO NAME AND NO PLACE

The foregoing attempts to tug at the reader's heartstrings. But that is a difficult thing to achieve in view of the fact that Elissa, the mother, is not characterised so much as alluded to obliquely in flashbacks or snatches of reminiscence. It seems that FB was in a highly vulnerable emotional state during 1943-44, being a young father separated from his family by the exigencies of warfare, and sentimentally identified with what his own wife, Kathleen, must have felt, left on her own to do the wetnursing.

Allenby, of course, does not opt for a superficial contentment – he desires more than a father or family tree. Wishing to pursue some obscure destiny, he turns his back on hearth and home and decides to disappear. The muddle of his past has rendered him doubting and rootless: "I have no name and no place. I am

only a man whose home for a time is this great and wonderful universe in which we were meant to be happy and praise God."

However, if the foregoing appears critical, this may be only revealing of the present writer's angle on it. For it is quite possible to read the book as a plain story and relapse into whole-hearted enjoyment, for there is a brimming variety of characters, many amusing and moving scenes, passages of outstanding description and exaltation, striking settings such as the Ring of Brodgar and a plot that is pleasingly oddball.

EVERETT BLEILER ON MR ALLENBY

Sweet Chariot is clear enough, if weak, but *Mr Allenby Loses the Way* (1945) is perplexing. Baker seems to have tried a rather daring technical experiment: setting up mysterious situations, but explaining nothing, thereby letting the reader construct his or her own interpretation. The plot is simple enough – a man, abandoned as a baby, succeeds in identifying his parents – but the mechanisms that propel the search are far from simple.

In the subplot indicated by the title – other subplots being less relevant – Allenby, a small newsagent in London, is obsessed by the question of his identity. As a baby he was found abandoned in the Orkneys, and nothing is known of his parentage. One day, an old man enters the shop, and after verifying that Allenby believes in the old Celtic fairies, offers him five wishes. Allenby makes his wishes, and they come true. For his third wish, he asks to meet his father, and finds himself talking to the old man – who really is his father.

But, as is revealed early in the story, this is all wrong. It is all a hoax. The purported emissary of the fairies is an eccentric psychologist who plays elaborate tricks on others, partly as therapy, partly as cruel humour. The wishes were such a joke, devised on the basis of pub gossip, and small events that Allenby took to be supernatural were stage-managed. The situation thus anticipates John Fowles's *The Magus*.

Yet the wishes have come true, and some factor other than fraud, cruelty and irresponsibility must be at work, for the psychiatrist is caught in the same entanglement as Allenby. It is left to the reader to decide what this factor is, and thereby determine what the book is really about. It may be a take-off on wish fulfilment, with reference to psycho-analysis. It may be a statement about the power of faith, expounding a universe of justice. The forces vaguely termed "fairies" may exist, and may work with unwitting human tools. Perhaps a man who plays God may find himself to be a toy. The reader must decide.

(Above Left)
The mature John Layard,
practising pyschologist, who
accompanied W.H. Auden
and Christopher Isherwood
in their Berlin adventures.

(Below Right)
Derek Savage in old age.

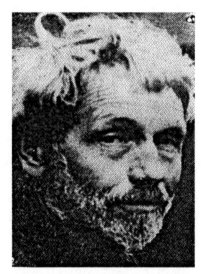

Nor does Baker tell us what "way" Allenby is lost. I am not sure how far one should push a religious allegory based on Christian dogma, probably not too far, but it seems safe to say that Allenby was alienated from life by his obsession. Despite, or because of, this fluidity of idea, *Mr Allenby Loses the Way* is very clever and entertaining with good characters, exuberant imagination, and flashes of bizarre humour. A purist could find some of its subplots extraneous, but they are still amusing. His end, off to war under an assumed identity, may have relevance to Baker's pacifism during the war.

——— BEFORE I GO HENCE (1946)

J.W. Dunne, the time theorist, at the seat of a biplane he designed himself. His ideas influenced both J.B. Priestley and Frank Baker.

Before I Go Hence is a calmer, far more disillusioned performance than its predecessor, the relatively jaunty *Mr Allenby*, an odd, troubling, dual viewpoint novel, mixing the suppressed violence of Dostoevsky with pietistic reflection, time theory and a hint of the supernatural. Today it might be classed as a meta-fiction or a story incorporating a sub-text that explores the paradoxes and problems of authorship by way of a plot that involves a narrative similar to what the reader is reading. Are we all actors in the drama of ourselves? This type of ploy can captivate the reader or, alternatively, drive him to the shredder. Indeed, it is a work that frustrates as much as it fascinates, drawing high praise from admirers of Frank's work. It was the first book in which Kate was closely involved. He read it to her from its first draft after a day's writing, many times. She helped him to be constructively self-critical, to ensure the finished work was reasonably well-knit, but did not go so far as interfering or altering the shape of the final draft. More importantly, she recalled being present on the walk when they were taken to the house that is the hub of the drama, Allways, as it was called, being as important as Allanayr in the eponymous novel.

The book is based on a religious text stating, "Before I go hence I am alone" and concerns an ageing clergyman, Fenner, stranded in an allegorical property – Allways – with his lonely, disgruntled yet loving daughter, Ellen. Their routine-bound existence is interrupted by an unannounced visit from the

black sheep of the family, Fenner's vagabonding, much-missed, favourite son, Robert, accompanied by his artistically gifted young friend, Dirk, for whom Robert feels a physical attraction he dare not express. Robert appears swaggering, warm, boastful, confident, a man of the world, while Ellen is bitter about having inherited the role of her father's keeper as well as having to take responsibility for her mentally backward brother Arthur. These worries have been ravaging her to the point of breakdown. To her Robert seems a vainglorious, selfish fool, strutting the world, trying his hand at this and that and seemingly attracting the lion's share of praise and admiration. There also is the problem of who, when the ageing Fenner dies, will look after poor Arthur, and Ellen gloomily assumes she will inherit the responsibility. Meanwhile Robert builds them all a splendidly functional tree-house, a perfect symbol for rising above their petty squabbles, which everyone pays a visit to and enjoys but which, more ominously, will turn out to be a scene of tragedy.

This story alternates with another narrative, set some twelve years in the future, that of Maurice and Ruth Hilliar, a married couple, deeply in love and yet with personal problems. Trying to decide where to live, they come across a ruined house – Allways – and speculate on its mystery and powerful atmosphere. Maurice, who is a struggling writer, is entranced by it; Ruth repelled by its gloom and sprawling strangeness. The memory of it burns into Maurice so deeply that, back in his London flat, he decides to write a novel around it.

The question this story poses in the reader's head: Is the novel Maurice is writing the novel I have before me? Yes, it is *in a manner of speaking*, despite the manuscript being consigned to the fire at the end. In terms of chronological narration, the brother and sister from Allways, Robert and Ellen, not long after Fenner has died, forsake the ominous property and end up in London where Dirk Sherwin has not only established a base, but an active friendship with Maurice, although Allways has never been aired as a topic of conversation. In a perplexing yet perfectly feasible way, life-paths cross in the war-torn capital. Hence the telepathic moments – if that is the right word – are not as chillingly illuminating as they might have been considering that the facts of the case might be available from a living relative only a few streets away.

So the line of development is consistent enough, narratively speaking, but a grim mystery lies at the core. Fenner, the old clergyman, hates the idea of Ellen, who has already wasted most of her life looking after him, inheriting the additional burden of poor, feeble-minded Arthur after his death. Did he thus, in a wild, misconceived flash of inspiration, push his own boy to death from the heights of the tree-house? Or is this the sick imagination of another, the controlling author, who will manipulate people's destinies for his cruel pleasure? A bizarre, impossible question to answer yet it is embedded in the text. For, in mystical instances of intensity, Fenner is able to look into the future and sense the presence of Maurice. He receives a tremor, an intimation perhaps of the other's

curiosity and sympathy with his plight. Thus Fenner and Maurice engage with each other while knowing nothing of the truth of each other's situation. Maurice writes a letter to his friend, explaining in detail the plot of the novel, with its disconcerting, reverberating time conundrum that admits of no steady state, only endless vibration, psychic transmission, the chain of causation shuttling from present to future, from future to present and back yet again, in all directions or literally 'ALLWAYS', so that it's scarcely possible to get a grip on what is definitively happening:

You will agree it is an interesting theme. And I cannot write it. I cannot begin to write it. Because, all the time, I hanker after the cold facts which, experience teaches me, with a little detection work I could soon discover. And yet, once given the actual facts in that house thirteen years ago, the dream is shattered; suppose, for example, I discover that the father killed the imbecile son, or the son killed the sister (you can imagine what you like); once such a fact is established, how is my interference possible? Unless, indeed (and here is horror), this merely proves I was the guiding power which led the hand to commit the murder; that there is no escape possible; that, in truth, I *am* responsible, and that it is this awareness that constitutes the actual thrill I derive from visiting the empty house years later.

In other words, the violence is mind-generated, a wave of possibility crystallising into a physical act – a heinous crime because the author has *willed it so*. The imagination, perfected through art, has cranked into motion what was only a *potential tragedy*. Hence the novel is much like Schrödinger's box, a possibility that turns into an actuality through the collaboration of another.

Beyond these metaphysical enormities can be located more approachable themes: personal responsibility, filial duty, sexual guilt through being attracted to one's own sex and separation from God as opposed to joy of being at one with God in eternity – all these themes, too large to resolve in a shortish novel, are aired and pondered.

In addition, there is a railing against the authority of the church, especially its cramped, restricted sexual mores. In a scene which obviously owes much to D.H. Lawrence, Ellen prepares a bath for the grubby soldier, Walter Bailey, and wahses his body clean. Frustrated she puts him to bed, later entering the bedroom to observe his sleeping form and he says: "Plenty of room for two, Ellen."

Perhaps she had not heard him; or perhaps she had heard him and been offended; at any rate she turned to the door and left the room sharply. He was glad, in a way. Yet the great bed seemed too large for his small body. He was almost asleep, when the door opened and Ellen came in. Slowly in the darkness, she drew back the bedclothes. "You said there was room for two, Walter Bailey," she murmured. "So I've come." He could not say anything. Slowly his arms found her, and her arms took his head and laid it on her thin bosom. She had scented herself and the beauty of this engulfed him and held him as though poised in a cloud. He did not feel as though he possessed any physical body. They

lay pressed tight to one another, sometimes her long fingers stroking his hair while his fingers would press into her shoulder-blades. Very soon he was asleep... Tenderly she stroked the head of the sleeping man who murmured sometimes and started in his sleep. It seemed to Ellen that, for the first time in her life, she understood why God had created the world. She felt as though she herself were creating, and the man too, held to her, creating; even though they never stirred, never by any touch inflamed each other to the desire for possession, she knew that she had performed, and he had performed, a most holy act of creation; that, to one another, they had given the benison of the purest love and, in that giving, in that so-unselfish act of the presentation of their two bodies to one another, they had clothed the feeble, wasting humanity of their bodies with the eternal mark that it must wear at the resurrection. Ellen knew in one great sudden flash of comprehension what the resurrection of the body meant; she knew that the identifying mark of the resurrected body was the mark made by the unselfish act of love; that no being who failed to achieve this had any part in the resurrection. There was only one way to go to Hell: to refuse to present the body as the creative force it was meant to be.

Seen through the eyes of a female character, this is a hymn to the bliss of communion rather than sexual activity proper (or improper). However, the prescriptive edge suggests an authorial voice breaking through. Definitely not that of an orthodox Catholic, for it suggests the resurrected body of Christ stands for togetherness. There's only one way to go to hell, the author stipulates, namely by refusing "to present the body as a creative force". (Surely there are more ways to get there than that?) Later, reneging on this, sex becomes "an eternal danger", fatal to those who do it merely to enjoy themselves; furthermore, the libertine and puritan are in danger of damnation. The passage is crafted with a fine sense of cadence and orchestration. A noble-sounding idea is aired and undergoes a few qualifications that are affirmatively resolved by the fusion of opposites.

The role of sexual passion, frustrated (Robert & Ellen) or satisfied (Maurice & Ruth), is only a subsidiary theme. What the novel is about is bridges between the dead and the living. Hence it is suffused with the sadness of those who can sympathise with the plight of others, but are helpless to involve themselves, as the subjects of their concern have been previously doomed to complete the cycle of their fates, like the young American who fell in love with a girl from the 18th century in the popular drama *Berkeley Square* which Frank must have surely known.

Through notes Kate supplied to the American scholar and critic, Everett F. Bleiler (who wrote an essay on Frank's supernatural fiction for a reference work), the source of the plot is outlined. Apparently Frank based the elderly priest, Fenner, and his daughter, Ellen, and their mentally feeble son, Arthur, suffering from "prolonged innocence", on former friends from St Just in Penwith, none other than the purgatorially inclined Canon Taylor, his daughter, Brogie, and her simple-minded brother of (inadvertently or carelessly) the same name as in the novel. "Arthur was not an imbecile," Kate explained, "but mentally

handicapped and like any child very dependent. Brogie, poor soul, in real life cared for Arthur until he died. Frank used to visit her when he could – in the early days when he was writing *The Twisted Tree* she would slip out of the vicarage at night and leave pies and whisky or cakes and wine at his cottage door. Small and dark like a bird she was. I bet she thought she was Tansy, bless her (not that FB gave her cause). All the bright girls who could read liked to think they were Tansy, I was told."

Kate interestingly added that J.W. Dunne's *An Experiment with Time* was a key text in the novel's construction: "Dunne's ideas had fascinated my mother & I long before I'd met Frank and played in 'Time and the Conways'. Frank also had read Ouspenksy. It filled out our own half-formed ideas and became part of our philosophy. We found it all expressed superbly by T.S. Eliot in *Four Quartets*. Frank's religious philosophy was too burdened with Christian symbols. It is at once a strength and a weakness, a weakness to rely on dogma, a strength in acquiring a personal vision."

FB wrote to Dunne (who was an aeronautical engineer as well as a time theorist) but the scientist declined to be drawn in, for he had set down all he wanted by then. He had proposed that evidence for displacement of time is found in precognitive dreams and visions (such as when Maurice Hilliar glimpses the previous owner of Allways and vice versa). By correlating dreams, Dunne argued, you establish how people frequently foresee a future event; therefore, logically, those in the past dream our present state of affairs or, at least, glimpse their own future. Hence dreams may both warn and anticipate. *Before I Go Hence* presents time as a recoverable dimension and has elements in common with J.B. Priestley's *An Inspector Calls* (first production, Moscow 1945) that employs flashbacks as well as flashforwards in time.

Ring of Brodgar: setting of final confrontation in *Mr Allenby*.

REVIEWS of *Before I Go Hence*

"The theme of *Before I Go Hence* exacts all the subtlety and adroitness, all the quiet fantastic plausibility of which Mr Baker is capable. No other living novelist would have attempted it or, having attempted it, could have succeeded. It is much easier to read than to review; of most novels the contrary is the case."

Daniel George, *Tribune.*

"Brilliantly contrived. As in the case of other Catholic writers, such as Mauriac, Graham Greene and Evelyn Waugh, Mr Baker's faith powerfully enhances his dramatic sense; good and evil are real antagonists, and in conflict."

Rosamond Lehmann, *The Listener,*

"It is a big Gothic theme. The impact of the no-longer and the not-yet is at half a dozen points felt with unnerving weight."

Rayner Heppenstall, *New Statesman.*

"Here is a fine book beautifully written with clarity and perception, planned and developed in a master's style. It has all the attributes of a lasting work. It will inevitably prompt contemplation on the value of the novel today.

Kathryn Byerly, *New York.*

"This is not a novel. It is the story of a novel which was begun but never finished. In less expert hands the consideration of this ancient and fundamental puzzle, would slip into scholasticism and pedantry. Mr Baker makes it as exciting as the bombs which fall on London during the course of the action. It provokes and stimulates the mind but purely as a yarn for a winter evening it stands with the best. Such a combination is rarely encountered."

Thomas Sugrue, *New York Herald Tribune.*

"Something which is beautiful and subtle, something which may... yes, it may contain a germ of truth. For all of us are continually hearing about people whose time sense gets mixed up."

Harold Morton, *Sydney Radio Station.*

"Of one thing you can be certain with Frank Baker: you are not going to be bored."

New York Times.

"The eerie is flattened by overmuch chattiness."

Norah Hoult, *John O'London's.*

EMBERS (1946)

*B*efore *I Go Hence* was followed in 1947 by another unusual novel, *Embers*, which might be called the last of the wartime trilogy, starting with *Mr Allenby*, set in the midst of bomb-blasted London, and ending with *Embers* that takes place in the calmer reaches of the countryside in the final year of the conflict. It is about an elderly musician, Thomas Trevelyan Embers, who is befriended by an impoverished musician and songwriter (partly based on the author and partly on the tragic composer Philip Heseltine), whose music affects him profoundly, but the friendship barely has time to ripen before tragedy overtakes it.

Embers captures the mood of a group of people living in a country town at the end of the Second World War, under the privations of rationing and regulations that are still active but beginning to loosen. We are moving towards Christmas, not exactly a Merry Christmas, but at least a Jovial Christmas. The enthusiasm and good cheer is a little forced. Mortality and the threat of sudden death haunts the atmosphere, with young servicemen dying and parents, lovers and wives anxious for news. Everyone talks of the coming peace but it is rather a dragged-out process. Aside from Thomas Trevelyan Embers and his coven of cats, who appears almost falsely hearty, there is a general atmosphere of stunted vitality and dogged compliance to the rule of law, making the younger element restless, dissatisfied and eager for the oxygen of opportunity.

The novel reaches an apogee in one of those slightly bitter house parties when people gather, intent on celebration, but old memories and rivalries erupt and explode, turning the festivity into the last act of a gloomy drama. Frank had undoubtedly seen Bernard Shaw's tormented Chekovian drama *Heartbreak House* with its impressively apocalyptic conclusion. Another plausible progenitor is James Barrie's *Dear Brutus*, a play disclosing the sadness of the past lives of a group of people along with the notion that tragedies are made through holding back love at the time when it should be freely offered.

Embers is a bit rheumatic in getting on its feet, taking around eighty-nine pages to establish the major players, let alone set them in action. Thomas Trevelyan Embers, a former musician, lives in a shambly cricket pavilion with six cats, all of whom are skilfully individualised, in the village of Monkton. The pavilion is owned by the gracious and generous Judge Penington and his kindly wife Alvina who, despite his eccentricities, indulge Thomas (who occupies himself writing to *The Times* and other papers on abstruse matters), extending to him many kindnesses including supplies of food and monetary support when needed as well as keeping a careful eye on his health. Other people living around and in the village, who befriend Thomas during the course of the novel, include the angry and edgy young songwriter, Martin Ward (who may have a little of

John Raynor in him), the millionaire industrialist, Macaulay, a crusty pair of Bloomsbury liberals, the Wallis Fosters, a dog-lover, Mrs Merryman, and young, handsome Charles Pennington, the son of the Judge, who is attracted to the ageing but mysteriously attractive Edna Chevasse, formerly the childhood sweetheart of Thomas, who is about to painfully and tragically re-enter his life.

The Wallis-Fosters, Harold and Myra, are a couple of painters, relics of a dying generation:

Harold Wallis-Foster, a man of about forty, was rotund and egg-bald, with a wearying smile and an endless flow of pleasant stories, always excellently told but always too long. His wife, Myra, was a tall, muscular woman with an encyclopaedic mind and a deadening passion for the absolute truth. Both were great arguers, great liberals, curiously certain that they represented the new age, which they had indeed done in 1920. Since they had forsaken both Bloomsbury and Chelsea (they never touched Hampstead) in favour of a village community where they read Bertrand Russell in much the same way as their forefathers would have read William Morris. They were heartily respected. The Judge was privately amused by them.

This is a pen sketch of William Arnold-Forster and Ka Cox in their mature years. Later they are presented more forcibly in *Talk of the Devil*. As a young writer, residing on the Penwith Peninsula in the 1930s, Frank had been entertained and impressed by this distinguished Liberal couple, the first a painter, gardener and politician, and the second an ex-mistress of Rupert Brooke and bosom friend of Virginia Woolf. He had been flattered to share their company and had found them likeable after their fashion and yet, whenever he portrayed them fictionally, he reverted to satire rather than present their full intellectual complexity. It also appears he had met the attractive Mallory girls who appeared fitfully on the Cornish scene after Will, following the death of Ka, married Ruth Mallory, the widow of the lost hero of Everest, George Mallory.

The first section of *Embers* is taken up with kick-starting the characters and their dilemmas, financial, vocational and emotional, while the second part brings them together and ignites the social fuse, so that they betray their weaknesses, strengths and emotions in different ways. In this second movement there is much first-class writing, virtuoso descriptive passages, renditions of music and powerful, stirred emotion. A climax is reached [P.117] when ancient, cantankerous Embers, to the surprise of all the guests, identifies the faded loveliness of Edna as that of his lost love of many years ago. But she denies the connection. "I am sorry, Mr Embers." Edna spoke very quietly, still looking at him, a smile on her lips but deadness in her eyes, "I am sorry, but I cannot recognise your claim."

Thomas, although hurt, shrugs off the incident and the party re-composes itself:

Now it was rapidly growing dark and the lanterns began to glow over the grey ice and the crackling brazier fire. From the stables a clock chimed half past four… the party was reassembling itself, but with a strange self-consciousness, people talking to each other as though they had newly met and were struggling to recognise one another in the veiled misty light. Martin, all this time silently aloof, watching Thomas, trying to capture the full significance of the meeting between Thomas and Edna, watched now the face of Charles, fired by the glow of the fire, a pool of witching beauty in the gathering darkness. He was tormented, in anguish, the unforgettable beauty of the scene locked in his mind with an unspeakable sadness, longing to communicate through music this unearthly moment and filled with a sense of his own inability to communicate anything.

Here FB presents a characteristic mix of sensitivity and sadness. A dramatic scene has taken place, but those who witnessed it are more curious than concerned. Quickly the atmosphere settles, the celebration re-establishes itself, but Martin draws back from the festive element and perceives underneath the tragedy of mankind's destiny, the landmarks of seasonal celebration lending ritual and dignity to something that may be cancelled out in a blink. For an artist like Martin, the breakage between Thomas and Edna may appear poetic or mildly thrilling, for he has this knack of 'rushing' things into art or converting grief into a structure, abstracting the human element. Artists, he understands, are not hungry for life so much as for an "unearthly moment" that can be tortured or tormented into a narrative or musical score.

Men and women were all thwarted, he thought, all reaching out to catch the hand of another in their toiling progress through life, and, if they caught the hand of friend or lover, holding it only for a brief moment… Yet it was Christmas Eve, and the shepherds tended their flocks, and a rose dawned in a stable; Christmas Eve and the earth lost under a mantle of the purest snow, the mother earth refusing her sustenance to her children, the waters stilled, time held stagnant, and hope burning like a little star. And there was the star. As he raised his head he saw, above the flamboyant light of the lanterns, faint and very distant, that one white star, the evening star upon which all men have fixed their hopes of immortality. What was the essence of this day? All these people gathered here, what meaning had they? He did not know. Each one seemed lost and alone, growing less and less tangible, less and less physical, as the evening drew down its cloak upon the world and geese flew, high up, with long outstretched necks toward their home. 'More geese than swans now live, more fools than wise…' I must set that, thought Martin.

What *Embers* abounds in are exquisite moments when the phrasing is perfectly pitched to the occasion. The letter in which the kindly judge, Noel Pennington, dissuades the censorious and priggish Wallis-Foster from further action against Embers, who has been falsely accused of making sexual approaches to local children, is a triumph of Jamesian subtlety and tactful rebuke:

My Dear Wallis-Foster,

I have received your letter and I am grateful that you should put this question before me. But it is not clear to me precisely what you desire me to do regarding my friend Thomas Embers. You suggest, it seems, that he is a danger to public security, and you base this belief upon a story which has circulated in connection with his behaviour. But you do not yourself make any definite accusation against him, and I must assume that you are not in a position to do so since, if you were, it would be your duty to ask the police to investigate, and you are, I know, a man who sets duty to the community above everything else. Indeed, I wonder, my dear fellow, whether you do not set it above charity, that most heavenly of the private virtues which rarely takes its guidance from public judgments…

Nevertheless, I do thank you for your warning, which reminds me once again of that instinct in human nature which I have, all my life, resisted. I mean, the natural instinct to Propagate reports. May I offer you an old Latin saying? "*Insita hominibus libidine alendi de industria rumores.*" All are eager to circulate reports which may have reached them, and, I may add, to give something of their own. But both the circulation and the embellishment will be avoided by the circumspect, to which company I am sure you prefer to belong.

My kindest regards to you and Mrs Wallis-Foster for 1945 –

Yours sincerely,
NOEL PENNINGTON

The description of Edna Chevasse watching her admirer, Charles Pennington, skating, is especially affecting. Youth and age are effectively contrasted, how the latter stands aghast before the miracle of the former, especially if possessed by grace and beauty, knowing that, however true their friendship, one will leave the other in order to journey into a future that will increasingly bear the load of those who have passed over.

She did not want to skate yet. She wanted to watch him. She wanted to take in to the full the sight of this young body so perfectly wedded to movement, so effortless and rare, the lovely physique of youth, resilient and graceful, manifesting the very essence of human spirituality. There was nothing she wanted, only to watch and to listen to the music, the calm waltz of age, accompanying the quick flow of youth. He came up to her, passed her like a scarf in the wind, touching her with his forefinger on her elbow, then laughing, throwing his head back, opening his mouth and playing his tongue on his lips. Where he had touched her glowed with voltaic force. Now she, too, wanted to be on the ice. She knew she had not forgotten how to skate. Quickly selecting a pair of skates she fixed them with her fingers that always trembled. She had no fear of falling. With no more thought she glided away on the ice, remembering the old tricks of youth, the figure-three turning, the serpentine, the figure eight, the pig's ears, the loop. She had been a lovely skater and still she was at ease, gliding calmly across the lake, with a gravity that Charles could not imitate. He watched her, wondering. "You're marvellous!" he exclaimed. He glided slowly toward her and took her hand and for some moments – they skated together, he leading carefully, aware now of her age, half afraid that he might go too fast

for her. But she grew impatient. "Faster!" she murmured. So he led faster and they skimmed the lake from end to end, then turned in the middle and came back on their own tracks till the ice was a pattern of their movements. The music had stopped. They heard that faint cracking in the ice which is the sign of its safety. Edna's blood flowed again freely in her body. Her face flushed and her hand, in Charles's, became warm and full of life. She began to pant a little. And she knew, she was warned, she could do no more. "We – must rest –" she gasped. More slowly they glided to the landing stage.

After reading such enchanted, crystalline prose, reverting to the central character, Thomas Trevelyan Embers, may seem a let-down. He's not as appealing as FB thinks he is, showing a verbosity and exuberance that dries on the page. He's like a comic sketch of the quintessential actor – he of the resonant voice and eloquent quotation. But for all that, he is far from a hollow man. His loquacity turns out to be a front, concealing a past tortured by the memory of a lost love with whom he is briefly and painfully reunited.

The end is symbolically appropriate: Embers goes up in flames in the manner of a whole generation. He effaces himself as abruptly as the young men who will never return. There is something forced about the sensational closure, but the book is haunting, poignant and written with considerable skill and subtlety. It contains some of FB's finest writing and demonstrates his ability to orchestrate group scenes and sympathise with men and women of all ages and types.

BACK TO MEVAGISSEY (1944)

Mevagissey, Heligan Mill.

Heligan Woods, retreat of the Mevagissey Bohemians.

After the success of *Miss Hargreaves* and sale of ancillary rights, FB's agent incautiously assured him that he was able to live by writing alone. So, thus heartened, in the spring of 1944, with their son Jonathan, the three left Parliament Hill, London, for Cornwall, setting up home first in Lupin Cottage, Perran Downs, and later in Mevagissey where they established deeper roots. It was a case of re-making one's new life in an old context or preserving the frame but updating the picture.

When he had first settled in the fishing port, just before the declaration of war, Frank had been an isolated young writer fretting over his future prospects, his emotional and literary status and the imminent delivery of his call-up papers, but now he was married and a father. He and Kate bought a cottage up Cliff Street, a little way down from the one Frank originally rented. It was awkwardly situated, on a hairpin bend halfway up the narrow street, very close to the cottage opposite where a local luminary called Jack the Devil lived. The cottage had no foundation on earth but was erected on stilts. The contract of sale stipulated that they had acquired the 'right of support', their ground floor consisting only of floor-boards over a yard which was not their property – presumably they only owned the wooden legs. Mr Pearce dried his fishing nets in the yard, so there could have been friction, but he finally came to accept the incomers.

Frank also acquired a smaller adjoining cottage in Cliff Street where he installed a splendid, borrowed Steinway grand pianoforte, worth more than the cottage itself. With such collateral, he hoped to gradually acquire more cottages, transforming himself into a speculator, but he could not raise the money from the bank and, more disastrously, the building he was interested in had been supposedly 'condemned' by the St Austell council, so the project went out with a whimper.

Counterbalancing this was the tribal atmosphere of banter and friendship of the port. Young artists whose families had merged into the community would call on each other; alcohol and tobacco would be shared; children played around the harbour and blended into each other; strong bonds were established; morning coffee would extend into a session of endless gossip and debate. Often as not, the weather was bright and fresh fish, pasties and vegetables were available for all. "The weather became Italian," Frank recalled, "the sun frizzled us all; the sea was like satin. I would swim from the harbour round to Polstreath in order to escape from the herd; but there I would find other friends and would have to swim back."

Amid all this delight a scholastic obstacle loomed: translating the Cornish language. The argot of the Mevagissey locals was a wonder in itself. An old tinner, Ebenezer Keast, used to regularly hail Frank, "Been up to Cap'n Friggens' locker, 'ave 'ee?" Frank was bewildered – to what could he be referring? – but after a while he concocted the response, "If I have, I'm not telling." This placated Ebenezer although Frank continued to have no idea whether 'Cap'n Friggens' locker' was a bar, a brothel or store of contraband. The other thing that caught him offguard was the touching interest in his nutrition shown by a local man if he was up and about in the early morning. "Had your breakfast, have 'ee?" he was asked. From the fellow's peculiar leering expression, Frank deduced something else was meant other than 'breakfast' – but what was it? After sustained reflection, he decided a de rigueur wink and nod was the proper response.

He also noted how the Cornish prefer to avoid direct statement. "Even the affirmative 'yes', he noted, "does not fall naturally from them but is spoken with a rising tilt, often followed by the word 'you': *Iss, you.*"

These were the halcyon days of Frank and Kate. Pacifist and vegetarian friends, who'd formed a little community of their own in Heligan Woods, were never far away. Poet, critic and conscientious objector, Derek Savage, took a cottage in Mevagissey along with his wife, Connie. There they lived frugally and rurally, growing their own vegetables and raising their children in a non-indulgent fashion. Other incomers who proved equally sympathetic were Geoffrey Gilbert and his wife, Molly, and their two small girls. Geoffrey was writing a novel that contained an element of social disaffection, but despite his embattled stance, he later succumbed to TV work. What locals thought about the artists and writers who did not fish or farm but dabbled on paper and canvas was

reflected in a remark of a local grocer to the writer and sculptor, A.R. Lamb: "They there Bohemians, they live in Heligan woods and, come Christmas, share out the children."

Drifting around with a shopping list, Frank would cross paths with the distinguished Arts & Crafts architect, John Archibald Campbell (1878-1947), whose three white houses at different levels can be seen on Chapel Point: "a small but burningly alert man, white-haired, with an endless flow of metaphysical talk peppered by quotations from Nietzsche given out with a prophetical fluency." John Archibald was not only intensely practical, but a Utopian visionary who had conceived a celestial city for the fishing village that would resolve many social problems. Such ideas he dissipated to his audience in *The Ship* along with Byzantine history, politics, sociology, religion and the Aristotelian music of the spheres. He longed to raise the spirit of man by creating harmonious, commodious buildings – a notion that would have brought forth instant applause from Prince Charles and Laurens van der Post. "There is a difference between a building and a machine," he observed. "A building is not an appliance or mobilisation. The building as architecture is born out of the heart of man; permanent consort to the ground, comrade to the trees, true reflection of man in the realm of his spirit."

Another contributor to these discussions, "carrying himself like a Regency buck", was the imposingly tall Charlie Bayzand, a geologist from Oxford, "a beautiful man who had invented an exterior self of squire-like authority that bore no relation to the quiet, shy and loving man inside." A witty, adroit talker, whose humour derived from the skilful inversions and paradoxes of Oscar Wilde, he referred to 'Nights that pass in The Ship' in memory of these encounters.

Up Polkirt, two benevolent and intellectual elderly ladies, former disciples of Eric Gill, Ann Pritchard and Faith Ashford, filled a gap in Mevagissey's devotional life by converting the old smithy's forge into a Catholic chapel. Before this innovation, Mass was said on most Sundays in Frank's cottage, usually by a priest from the Augustinian Priory at Bodmin. The room was very narrow and his old black Bord piano from the distant Boscean days had to double up as a table supporting the altar stone. Late on Saturday nights, Kate and Frank would prepare the room, placing flowers and candles on top of the piano and clearing the space.

The 1940s in Mevagissey were enriched and enlivened by Frank's old friend from his acting years, W.S. Graham, the Scots poet, who lived in a tottering cottage up the Green Steps, very near to the Bakers, and later moved to Madron, near Land's End. Jock gave Frank's sons, Jonathan and Sebastian, their first lessons in reading and writing. The boys loved going to his cottage to enjoy his lively, offhand, comical brand of instruction. If Jock had been working all night, often they'd find a note pinned to the door, a note with bold letters and little pictures informing them that he would not be available that morning. He had

the considerable gifts, including a memorable, beautifully controlled reading voice that won many people over to his verbal mastery. His poetry was a colloquial plainsong that transcended itself by its startling elisions and audacious post-Joycean coinages. In the cottage, he lined the walls with huge cardboard screens on which he pinned pages of his masterpiece, 'The Nightfishing', as it slowly surged up to the surface of his mind like a rising fish. It is one of the most original long poems of our times and will surely hold its place. "Jock knew the heart of Mevagissey," Frank affirmed, "for he had come closely to terms with it in the working company of those who fished for their living, and he had gone out in the boats with them."

Certainly few poets have managed to catch with exactitude the breaking and dispersion of waves on a fishing boat:

The long rollers
Quick on the crests and shirred with fine foam,
Surge down then sledge their green tons weighing down
On the shuddered deck-boards. And shook off
All that white arrival upon us back to falter
Into the waking spoil and to be lost in
The mingling world.

Towards the end of the decade, the character of the place altered. People who had down the years invested the port with a specific feeling, a palpable texture, died or drifted out of circulation. On Michaelmas Day in 1947, a figurehead of Mevagissey, the landlady of The Ship, Lily Barron, passed away. A long, stately cortege followed her coffin from the pub up the hill to the churchyard. Back at Cliff Street, after the funeral ceremony, Frank pounded out Beethoven with ferocious energy, the sonata *Les Adieux*, in which departure is the theme. Jock Graham was offered a lecture tour in America and he moved out, leaving his wife, Nessie, who remained close to Frank and Kate, playing poker on Saturday.

Yet more landmark deaths occurred that year for FB. Archibald Campbell, shortly before receiving permission to develop his utopian housing project on Chapel Point, fell over the cliff there and died – "walked into the City of his Mind", as Frank put it. Also his former mentor, Arthur Machen, passed away in December 1947, a few months after the demise of his wife, Purefoy. Frank went up to his funeral and, in accordance with the wishes of Machen's son, played Bach's *St Anne's Fugue* and Handel's Dead March in *Saul*. "I had no thought of Machen lying in his coffin as it came into Amersham church," he wrote. "Was it because of his great age? Not solely. Because, certainly, he had accomplished all he wanted to do… Therefore death came more as a host than an assailant…"

*

As for the political atmosphere, a massive, staining shadow had been thrown over human history and culture when in August 1945 atom bombs were dropped on Hiroshima and Nagasaki. There was an initial crude awe and excitement at such a terrible deed. It had been officially perpetrated after the Japanese had received a proper warning. So there was an appalling tingle of wonder in the air that quickly cooled as the terrible scale of devastation and ruin was absorbed. For the pacifists of Mevagissey, the politics of Armaggedon had become a reality and people began to fear for their future – for the future of history. With the devastation of Japan, a great unease rippled around the world. Would mankind survive the impact of such weapons?

People reacted by devising their own Utopias that required no armies or tanks to protect them. On this note, Frank met the celebrated Don Zeno, a racing-motorist priest, who had rescued war orphans in the Po Valley. In his Alfa-Romeo, he swooped down upon the Mevagissey conclave, spending an evening at the Gilberts' cottage in Heligan and spreading his idealism. There the group discussed the problems of communal living, finding themselves so much in accord that they nearly decided to go to Italy and become a part of Don Zeno's ideal city, built by children on a concentration camp and called Nomadelphia or 'The Town of Brotherhood'. Everyone present was fired by the idea but that is unfortunately what it remained, a glimmering bubble in the memory, a golden city awaiting materialisation.

With redevelopment and the spread of tourism, the tiny pacifist group lost their vim and dwindled to an irrelevance. The nuclear bomb was touted as the weapon ensuring the security of the Western World and protesters were eroded by the steady institutionalisation of such devastating weaponry. In place of rifle and bullet was a luminous mushroom with toxic spores capable of erasing a nation. What could the peacemakers do? It was as if they had been consigned to some desolate enclave of integrity while others acquiesced.

At the same time, Mevagissey lost much of its workaday status as fishing port. Visitors started to outnumber the locals. Trawlers gave way to pleasure craft and a slightly tawdry tourism infiltrated the traditional industries. A wishing-well was erected near the post office and a once-popular bakery closed. Tommie Rowse, the ironmonger, died. His shop now stocked a spangled array of postcards that were garnered by the charabanc loads streaming in daily. Gift Shoppes blossomed, mixing implement and ornament: shells, brooches, Joan the Wad piskies, shrimp nets, beach hats, beach balls and pebbles painted with stars, eyes and little grinning faces. And yet, through this bustle and upheaval, a solitary, stalwart hangover from the past lingered up at The Battery: Parson Walke's widow, Annie, alone, stone-deaf, writing poetry and sometimes working on her pictures. Frank and Kate would go up to visit her, talk of the old days and lament the steady, fatal scythe of time passing.

DEREK SAVAGE

In his critique of 20th-century poetry, *The Personal Principle* (1944), Derek Savage (1917–2007) defined literature as "our endeavour to realise the essential nature of our experience and to present that realisation to ourselves and others." Like Frank Baker but to a more vigorous extent, Savage believed the western world was in a state of cultural disintegration, an assertion for which he found evidence in contemporary writing. His critical work *The Withered Branch* (1950) argued that literature had forfeited its spiritual and moral core.

Born in Harlow, Essex, Savage spent his childhood in the Hertfordshire village of Cheshunt and was educated at Hertford Grammar and Latymer school, Edmonton. At school an injury on the football field placed him in hospital where he came across veterans of the First World War who confided their experiences. Though a boy of thirteen, Savage was appalled to learn the bloody, blundering history of the massive, wasteful conflict, its cynical use of disinformation and casual expenditure of men as cannon fodder. From then on, he became a combative pacifist, rebelling against his staid, kindly father, who owned two clothing shops and appeared to be politically and religiously complacent. He became a militant atheist and pacifist as well as a street-corner orator and pamphleteer.

After commercial college, he worked in a bookshop and then took a job in rural Sussex. There loneliness led him to rediscover his faith, and he was confirmed in St Paul's Cathedral. He married the ever-supportive Constance Kiernan (Connie) in 1938, and they lived at first in London, where he worked as a clerk for the Transport and General Workers Union. When war broke out, aiming for self-sufficiency, the couple moved to a condemned cottage without water, light or sanitation in Dry Drayton, Cambridgeshire. For a time, Derek worked as a hospital porter; later he and Connie decided to join a pacifist market gardening community near Ross-on-Wye.

Believing in tools rather than devices that obviated their use, early on Derek had formed an attachment to growing vegetables, walking and muddy boots. He cultivated a disdain for cities, massive, heartless concentrations of money and commerce. Despite or because of his uncompromising views, he found himself able to make his way in literature. Usually his writing was poetry or critical polemic upholding his adamant pacifism and Christian morality. His *Testament of a Conscientious Objector* appeared in a collection in 1965. It begins with the Cambridge Evening News report of his appearance at a tribunal in January 1940. He objected to war as legalised murder and conscription as subordination of the individual to the state as opposed to choosing for oneself. He left the court a free man but with the brand of CO on his forehead, generally

interpreted as coward and slacker. As a gesture of active disapproval, a neighbour pelted him with rubbish as he rode by on his bike.

His combative pacifism rubbed up against the combative patriotism of George Orwell. The latter styled pacifism as "objectively pro-fascist", resulting in 1942 in a heated exchange of letters. Savage thought Orwell was blurring the issue with terminology. So far as he was concerned, British democracy was nothing to crow about. Ideologically he was close to being an anarchist to whom political labels meant nothing. So-called democracies, fascist and communist states – all sought to manipulate and suppress the freedom of the individual. That was why it was important to stay reasonably poor. Corruption always took the form of a controlling agent who possessed greater power and funding.

"It is fashionable nowadays", he wrote, "to equate Fascism with Germany. Fascism is not a force confined to any one nation. We can just as soon get it here as anywhere else. The characteristic markings of Fascism are: curtailment of individual and minority liberties; abolition of private life and private values and substitution of state life and public values (patriotism); external imposition of discipline (militarism); prevalence of mass-values and mass-mentality; falsification of intellectual activity under State pressure. These are all tendencies of present-day Britain. The pacifist opposes every one of these, and might therefore be called the only genuine opponent of Fascism. Don't let us be misled by names. Fascism is quite capable of calling itself democracy or even Socialism. It's the reality under the name that matters. War demands totalitarian organization of society...Germans call it National Socialism. We call it democracy. The result is the same... The corruption and hollowness revealed in the prosecution of this war are too contemptible for words. Certainly I will accept my share of responsibility for them, but I won't fight in a war to extend that corruption and hollowness."

Orwell retorted that he was not interested in pacifism as a 'moral phenomenon', using ironising quote marks. He accused Savage of taking a pro-fascist stance. By not fighting for the rights of a democratic nation to stay democratic, Orwell argues, you are in effect co-operating with the bullies and inviting them to take over your country.

In point of fact, this is not a fair comment, and yet it does seem that Savage, who could be subtle and masterly in drawing distinctions between terms like 'classic' and 'romantic', seemed less than willing to concede a democratic regime allowed for vital individual liberties that the Nazis and Communists had scrapped. On the other hand, Orwell was wrong to angrily politicise what was basically a Christian stance. Savage believed 'Love Your Enemy' was a primary obligation that could not be reconciled with going to war. Christians were morally bound to be pacifists and, if they took up arms for patriotic motives, they were being traitors to their professed faith. Other intellectuals were less literal. Auden, for instance, used a phrase in his poem on Spain "the conscious

acceptance of the necessary murder." Later he amended this, but Orwell stifled his doubts concerning the degree to which violence could masquerade as political necessity, conceding: "There are some situations from which one can only escape by acting like a devil or a lunatic," meaning presumably a fight to the death.

But Savage was never able to fit his faith to a cause that required killing another human being. So far as he was concerned, murder was a mortal sin in the eyes of God. "The average man," he wrote, "forgets that there must *be* absolute principles, or human society will sink lower into depravity, cynicism and violence, and that since principles are nothing if left to float about in the atmosphere unattached there must be men and women who will at whatever cost embrace, incarnate and express those principles in their own lives."

There being no middle ground in this matter, from thenceforth Savage lived a life mainly amid his own kind, moving in 1944 to Bromsash to join a market-gardening community of pacifist views. By 1947, he was back in Mevagissey, joining fellow pacifist poet Louis Adeane in the cluster of cottages in Heligan woods. "You can get huge cooked crabs in the shops for 2/6d," he enthused to Connie in a letter. "The Cornish people seem decent on the whole. I saw the farmer Mr Pomeroy today and asked him about a horse and cart. Think it can be arranged. I did my review quite satisfactorily, thank goodness. Louis is also a fan of Mary Butts, and so is Frank Baker, so am in good company. Louis has been planning a Life, and interviewed relatives, etc. We are discussing some sort of collaboration. This should be a good place to write in. There are sea-going expeditions sometimes, sharing expenses. Vegetables will be a problem. Could you send me the ration books, etc., and I will see about them in St Austell."

*

For two years Derek Savage lived in the Heligan cottage with its primitive amenities. After that, he moved into 67 Church Street, Mevagissey, and later still Lawn House that Connie ran as a guest house. Local customs, such as men carrying the family dinner to be cooked at the bakery, recalled his childhood and put him at ease. He became a pillar of the village's art colony, counting among his friends Dick Kitto "who forsook playwriting for compost-making", the American novelist Mary Lee Settle, and the Scottish poets W.S. Graham and Nessie Dunsmuir. The circle extended to include FB, the painter Lionel Miskin and ceramicist Berny Moss and his wife Maureen, also a painter.

For someone who self-confessedly learned 'nothing' at school and had no ambition to make literature his career, Derek made a significant impact on the world of letters. The poet Michael Hamburger, in his memoir *A Mug's Game* (1973), recounts their meetings in the early 1950s, when he was impressed by Savage's generosity but disturbed by the doggedness of his insistence on the need for poverty. Hamburger respected his purism, enjoyed his polemical contributions to periodicals and felt "England hath need of thee, Mr Savage." He records

visiting him at his small, cramped cottage in Mevagissey in the Spring of 1950. He found his host generous, offering him dinner and lunch as well as giving him seven books by W.J. Turner.

Hamburger noted Derek had difficulty handling his four children – he tended to address them in long words and sarcasms while not listening to what they had to say back. He paraphrased their remarks in a reproachful way and singled out his daughter, Romer, for special attention. Hamburger agreed with Derek on the need for poverty, lack of money rendering one less greedy, but sensed a bitterness there. Derek *had* stuck to his principles, writing poems and essays of clarity and distinction. Surely by now a dogged integrity such as his should have reaped material reward, making the practicalities of living easier. "Poetry is not a career but a mug's game," wrote T.S. Eliot – hence the title of Hamburger's book – and Derek, who was always respectful of the high priest of English poetry, was paying the price of his calling.

A work of his aimed at the general public rather than the narrow, academic audience of his criticism was *The Cottage Companion*, a handbook containing sound, practical advice on economy subsistence. Certain dishes devised for times of scarcity challenge the valour of the tender-hearted: stewed dormouse, lark on toast and blackbird pie. Hedgehogs are recommended for their delicious taste (presumably the spines may be used as toothpicks) but some might find staying hungry preferable to digesting this appealing, diligent mammal. And, of course, there is the added snag that one has to first catch and do away with the victim. The work was styled as a sequel to Cobbett's *Cottage Economy*, linking Derek to Defoe and Mrs Beeton. "A feature article," he commented in a letter to FB, "was festooned with cartoons of a City Gent, lighting his cigar with a pound note, confronting a Yokel with a gardenia drooping from his stockings and surrounded with ducks, goats and pigs."

What was commendable about Derek was not his gastronomic agenda so much as his espousal of culture not as a snobbish enclave but as a perpetual dialogue that should be at the heart of the everyday life of the common man. In *The Personal Principle*, a critique of 20th-century poetry, he called for "the necessary unity of poetry, religion and politics in integrity. Politics needs to be ethically grounded and pacifism is the ethical ground of political action."

Generous in vision as he was, Derek's criticism was picky and prickly. Nearly all major modern poets he finds wanting, criticising the poetry of his former idol, D.H. Lawrence, for being rough and unfinished, not conceding those quick, sketchy, pen portraits of animals and insects are the equivalent, say, to Van Gogh's sketches, flashlit instants of perception, self-validating and natural as breath from the mouth.

FB was on cordial terms with Derek but sensed his disdain for many writers. Derek loaned him his contemporary critique of the novel, *The Withered Branch*, and before long received a long letter that probably made him smart:

It is *unfortunate* that you encumber yourself with such a clumsy use of the English language. Unfortunate, because none of the writers you examine were guilty of this. It is a fact, that every time one reaches one of the many long quotations in your book, one heaves a sigh of relief: here, at least, is a passage I can read with ease and, therefore, with pleasure. Reading should never be made difficult... For the purpose of the mission you have undertaken – and it is a very important *mission* as you realise – your style should be swift, incisive, as ironical as you wish, *if* you wish, but mellowed by a sense of humour without which true charity does not exist.

This is well-aimed and deflating, yet Derek Savage's vigilant critiques are not *that* cumbersome and impenetrable. There is subtlety to his sting as well as intellectual vigilance. Despite his disregard by the present cultural scene, he lived long enough to see an actor play him in the BBC centenary television documentary on George Orwell whose views he had eloquently opposed.

Perhaps the best tribute to Derek is found in Kenneth Rexroth's long poem *The Lion and the Unicorn*:

Over the hills and fields to
Derek Savage's thatched clay
Cottage in a narrow moist
Valley by a ruined mill.
Three days of hospitality
And passionate talk. How good
To meet someone in this world
With his own convictions and
Careless of gossip and fashion.
The only young English poet
Of working class extraction –
Barker is Irish, Thomas, Welsh –
But certainly by far the most
Distinguished both in appearance
And opinions.

Rexroth and Savage often disagreed in their literary judgements. Savage was possibly rather too religious and prudish for the American and Rexroth too let-it-all-hang-out for the Britisher. Both, however, benefited from sharpening their minds on the other's wits. Furthermore they shared the concept of people pooling their skills. An authentic community, they agreed, sanctions inner values and emphasises co-operation and sharing, placing it above economic and ideological difference. Capitalist or money-based values tend to create rifts between individuals that will end in class war and social division, tendencies that may increase the likelihood of war between nations.

JOHN LAYARD

Long Point, the cliffside house Frank rented, was owned by John Willoughby Layard. He was an internationally famous psychologist and anthropologist who had lectured widely in Britain and Europe, written highly respected papers, submitted himself for analysis to famous psychologists like Homer Lane and Jung, befriended major literary figures and exercised considerable sway over his patients and lovers. Whether he found him a stingy landlord or an affected bore is not clear, but Frank took a dislike to Layard, believing his dominance over people was obtrusive and deleterious:

There was also an unfortunate man, a flaccid psychiatrist, who had written one book on the significance of hair, unaware that he had done this because he possessed so much of it himself. These were days when beards and long hair were not in; but this man, foaming with red hair on head, chin, chest and, presumably, elsewhere, did not care about that. It was sad that nobody liked this clumsy yet highly intelligent man. Had he been able to talk of anything but hair he would have overcome his unpopularity. Like most psychologists he labelled everybody, and the labels were always wrong. Old Colonel Richardson, for example: according to Hair he was a frustrated pederast. Nothing could have been more wide of the mark, for Colonel Richardson adored women.

This is how he put it in *The Call of Cornwall*, but the description was distorted. Layard did not possess foaming red hair, nor was his outlook *that* simplistic. Obviously Frank knew more than he let on, for he had both corresponded with Layard and metamorphosed him as the sinister psychologist, Humphrey Nanson, in *Mr Allenby Loses the Way*. The book on Hair is none other than a disguised reference to Layard's celebrated Jungian case history *The Lady and the Hare* dealing with a family consultation, a dream analysis with a markedly Christian slant that culminates in an exhaustive, spiritually draining analysis of almost every hare legend in the world.

Neither was Frank the only author to depict Layard fictionally, for he had made a deep impression in many intellectual quarters. Layard profoundly infiltrated Auden's development during his Berlin period, especially in his long poem *The Orators*; Isherwood based one of the key characters of *The Memorial* (1932) on Layard; T. S. Eliot acknowledged his debt to the Malekulan material in his essay on 'Cultural forces in the human order' (1952) and Philip Larkin, having thrown off an early admiration, parodied him as John Barnyard in his lesbian girls-school pastiche *Trouble at Willow Gables*.

What was the reason for Frank's dislike? In his pen sketch, he makes Layard physically unappealing, but probably the feeling went deeper. Although Frank had never been a naïve Catholic – a through and through believer – he

favoured the vocabulary of religion above that of anthropology or psychology. Layard saw religion as a ritual procedure by which a tribe might commune with the greater force behind nature. Many years back, he had been admitted into the Catholic church, but what God he believed in was none too clear. Via Freud, he had recreated 'God the Father' as a spiritual projection of the family father. To a Christian, the notion might appear belittling (although God's fatherliness is often invoked in sermons). From Layard's standpoint, good and evil were not akin to white and black, two eternally struggling opposites, but constantly balancing and defining each other. The Devil's voice might actually turn out to be God's or a physical ailment needing attention. Hence, in Layard's view, ill-omens were always positive and could be used to facilitate healing. He knew all the double-decker words and could effortlessly analyse, conjure symbols, anecdotes and far-out connections, thus providing thrilling material for a visual artist like Lionel Miskin or a poet like Peter Redgrove.

But Frank thought Layard was spewing jabberwocky and overstepped the mark when overhauling the lives of others. His preferred mentor would have been Bernard Walke pointing out '*the* way' in the singular sense while Layard would probably say each individual should discover *his own* way. Despite a long liberation from the parental shadow, he retained much of his churchy Edwardian background and was wary of Layard who liked to fraternise with personal demons rather than cast them out. At one point, in a Mevagissey café, Frank communicated what he felt about Layard's theories by offering him the gift of a box that the other accepted gravely although it was empty, a frame of brown paper enclosing nothing.

John Willoughby Layard was born in 1891, second son of a distinguished barrister and author, and graduated in 1912 from King's College, Cambridge, with a degree in modern languages. There, after meeting the doctor and leading anthropologist, W.H.R. Rivers, he switched his interest to anthropology and psychology. In an expedition to make contact with the pristine tribes of the New Hebrides, Rivers deserted him on the island of Atchin, so that he might write up his notes in more amenable surroundings, leaving Layard initially alarmed, but he managed to apply himself to field-work. At first a certain shyness and hostility on the part of the natives was obvious, owing to the friction and suspicion created by an earlier visitor, an Irish trader. But after a while the Malekulans took a liking to affable 'Johnnie' from England whose vocal powers impressed them. Soon he was transliterating their native tongue and learning about their rites and customs. The next instant we find he has whipped off all his clothes, donned a penis-sheath (nambas) and started dancing as wildly and ecstatically as the rest of the young warriors. Even though their knowledge of English was non-existent, the natives knew a champion spouter when they saw one, dubbing Layard 'Lord of High Talk'. The cannibals turned out a jolly bunch, especially the young men, and

Johnnie started to join them at their feasts, celebrations and storytelling, probably finding it rather like the High Table at King's College.

Malekula was scattered with big stone monuments erected by the tribe's forefathers. Layard wanted to account for them and trace their patterns and carvings back to a definite source: hence the title of his famous book *The Stone Men of Malekula* that attempts to piece together the origins, myths and customs of the culture. Owing to depression and indecision, the publishing of the work was deferred to 1942. By then, Layard had become a thoroughgoing Jungian, overlaying his impressive ethnography with speculative and unorthodox psychological material.

When work on Atchin was complete, the First World War had started. Layard left for Australia where he offered himself for military service but was deemed unsuitable owing to flat feet. Shortly after, he plummeted into depression. From this vantage, it is not easy to establish the origin of the persistent misery that visited Layard, often rendering him helpless for weeks and months. He may have suffered from manic depression added to which was the problem of his emotional transparency. If he loved someone, man or woman, he would tell them frankly, and the declaration did not invariably receive the response he desired. He was more at ease with the cannibals of Malekula than many of his professional colleagues who regarded him as difficult or odd.

On returning to England, with the country at war, he was reunited with Rivers who offered him work treating shell-shocked soldiers. Rivers explained how his patients' condition involved the conflicting emotions of fear (of getting killed) and duty (to fight for one's country). Being employed by the military, he had to treat their dilemma as an abnormality when today it would simply be accepted that sane men do not want to be bludgeoned into conscription and risk being killed in armed combat. Fascinated by the challenge, Layard accepted but working close to his old mentor aroused his affectionate nature. When he told Rivers of his feelings – that were confessedly homosexual – he went white and left the room in an angry, flustered state. Rivers might have been a great psychologist, who required honesty from his patients, but he could not stomach this sort of thing from his colleagues. The subject was never raised again. Incidents like this imprinted on Layard how different he was and contributed to his misery and depression. If one has a spontaneous, expressive nature, it can be very harsh confronting a world perpetually at odds with it.

After the First World War, he submitted himself for treatment to the self-taught psychologist Homer Lane, who proved a massive influence in developing his own ideas. According to Lane-Layard, psychology was a morality drama in which God and the Devil had got their roles reversed. Owing to the constraints of Western civilisation, men and women were failing to differentiate between their positive and negative sides. Consequently, bad things that carried helpful information were invariably ignored. Diseases encoded vital statements about an

individual's attitude and outlook and, when conveyed in dream form, could be translated *positively* as warnings from God. Attempts to cure through pity and sympathy were an impertinence. "Wounds only hurt," he wrote, "if we try to cover them up and pretend they don't exist. If gone into, they prove to be doors opening into a deeper world of character… It is thus a mistake to eradicate a fault, or kill a disease."

Owing to suppression, God – or the good side – ceased to flow forth naturally from the personality. Spiritual uptightness generated anxiety and depression. What tainted the mind tainted the body. For each psychosis, a physical state would manifest. Hence, stifling one's creative powers gave rise to cancer. Being stubborn or unbending generated stiffness of joints or limbs. Less credibly, Stephen Spender was told that he had grown so tall because he aspired to Heaven. This sounds a simplification, but in the early days such arguments were bandied, more subtle touches being added later.

In the late 1920s, Layard teamed up with Auden and Isherwood in Berlin where he also practised as a psychologist. An intimate friend of the pair, he became Auden's sporadic lover and joined them in taking advantage of the city's homosexual facilities. Isherwood spoke of Layard X-ray eyes, admitting that he and Auden were in thrall to the shamanic figure who had explored the wildest corners of the globe and unearthed ancient wisdom pertaining to the family of man. But the spell did not last, for the young writers were too quick, too eclectic and intellectually impatient to bow before any one idol. Soon roles were reversed and Layard found himself deeply in love with Auden who did not reciprocate. Furthermore, to add to his distress, he had been deserted by one of his patients – a beautiful Italian girl called Elta. During the course of Elta's treatment, his master Homer Lane had died, and he interpreted the expiry as an act to undermine his authority. Lane's death alarmed Elta who abandoned the analysis, leaving Layard so despondent that he declared his intention to shoot himself. This announcement upset his friend, Margaret Gardiner, who told Auden of his plan. The poet responded: "If he wants to kill himself, you should let him. You've no right to interfere."

While Margaret pursued Elta in Paris, trying to persuade her to transmit some words of comfort to the angst-ridden analyst, Auden sent a telegram: *John shot himself but is alive.*

Margaret returned to Berlin and heard from Auden what had happened in her absence. In despair, Layard had tried to kill himself with a shot inside the mouth, intending presumably to blow out his brains, but the bullet had gone through and emerged from the brow without, apparently, damaging his mental faculties. On finding himself alive, though in a messy condition, Layard put on his hat to conceal the wound, pocketed his gun, went out and called a taxi to take him to Auden's apartment. Outside the door he collapsed and, when Auden answered, begged him to take the revolver and finish the task.

"I would if I dared," said Auden, "but I don't want to be hanged."

An ambulance was called and Layard taken to hospital where the bullet was removed. The analyst made a full recovery, wrote a paper on suicide (in which he was now practically qualified) and revived his faltering career. Back in London in 1936, he was introduced to Carl Jung, who offered him treatment and the invitation that they might collaborate. Hence Jung's knowledge and insight, his designation of archetypes and dream interpretation, flowed into the rich stream of Layard's learning, widening his already extensive knowledge of symbolism and arcana.

In post-war years, Layard preferred to live in Cornwall, at Mevagissey and Falmouth mainly, taking regular trips to Oxford. There he exerted considerable personal magnetism, though not everyone was impressed, Colin Wilson finding his conversation one long, monotonous, self-important drone and others finding him too highfalutin. And yet, undoubtedly, this was a period when he enjoyed a full blaze of authority, meeting, spellbinding and agitating the subconscious of local artistic luminaries like Lionel Miskin, W.S. Graham, Derek Savage and Francis Hewlett. In Falmouth a cluster of poets, including Peter Redgrove, Heathcote Williams and Malcolm Ritchie, made an idol of him. Calling him 'the old man', they would go and sit at his feet while he freed them from whatever psychic constraints were impeding them.

Holding court, Layard hammered home such dictums as "depression is withheld knowledge", hinting he was still peddling the notion that 'unawareness' was a voluntary act – gagging the inner voice to avoid the pains of growth. Peter Redgrove, who offered himself as a pupil during 1968-9, recalled a tall, commanding man in his late seventies. A cascade of snowy hair flowed down over his collar "like steam boiling from a pot" and he listened with an expression of reposeful concentration. In the centre of his forehead, Redgrove noted the cicatrix of a suicide attempt – "a small, round, skin-covered hole in the bone, like a third eye-socket." This bullet-mark would beat like a pulse when Layard's interest was stirred and he would salivate copiously, sometimes removing his denture to release the flow. "I am a sin-eater," he explained. The poet, finding this fantastical, invoked the spirit of common sense and Layard said, "We've had enough of that. What we need is uncommon sense."

Layard favoured Redgrove's responses whenever they involved the participation of the body. Like D.H. Lawrence, he was an absorbed, reflective man who, paradoxically, distrusted too much mental activity or knowledge paraded as in a shop-window display. Despite his many academic qualifications, to Layard a formally structured analysis was an anathema; in a sense, his procedure was a corrective to his own innate tendencies. Hence he liked to physicalise rather than intellectualise. Textures, tastes, sounds and colours were important even in dreams and he discouraged jargon-ridden interpretations. "Stop

trying to be so damn clever, Peter," he would advise. "Just tell me the dream. With feeling."

It was through Layard that Redgrove became aware of the invisible forces – weather, scents and sounds – that work on the bodies of men and women. Electrified by Layard's fluency and byways of knowledge, Redgrove developed a therapy based on awakening these influences, on teaching the mind to translate this tactile language; for Western man – the classical Oedipal figure – was top-heavy and controlled by will and ambition. Whether this was true or not, Layard did prove effective as a therapist and healer, and there are many alive today who are intensely grateful for the manner in which he helped and cured them.

The poet's wives or women played a subordinate role in the adulation of Layard. One recalled being commanded by her husband to repair Layard's silk dressing-gown – an item in an advanced state of fragility that caused her many tedious hours. She remembered a single occasion when Malcolm and Peter, left in charge of their respective babies, deserted their posts for a long drinking session. Later the wives returned to find the children unattended, nappies sodden, crying indignantly. Was that Layard's fault? She thought he urged them to act impulsively and selfishly, leaving them to literally hold the baby while they connected with their inner selves by boozing and running wild.

Certainly there was a dark, overbearing side to Layard, but in Lionel Miskin's view that was outweighed by the knowledge and insight he dispensed. In a letter to FB [11/4/67] he defends Layard, saying he is "not quite the monster you suppose him to be," but "tremendously gifted on some levels, infantile on others." Frank, apparently, disliked Layard's "dreadful spewing confessions" but Lionel maintained he had exceptional gifts, "amounting to genius." Hence Layard continued to received clients at Lionel's house and hold impressive analytical sessions:

I watched these two schizophrenics, a boy and girl (lovers) emerging from the really awful state they were in on arrival. His interpretation of dreams is inspired. And the way he applied it to them, but also to our own dreams, was just as astonishing – a new experience. But I owe most to the way he galvanized Derek with his enormous fund of information, discussing the most abstruse symbolism and tit-bits of anthropology and much else beside into the early hours, quite transforming Derek from a Just-William into an insatiable intellectual – almost boring in his mania for knowledge of every sort. For this alone I would put up with *healthy* for life.

Unlike FB, who tended to keep his social façade intact, the more liberated Lionel Miskin wanted to traverse every inch of his interior landscape, penetrate and analyse its horrors and the glories in the cause of artistic and emotional growth. It was he who introduced Layard into Cornwall's larger community of artists and intellectuals. Hence, in 1968-1969, he and his wife Pru took John Layard under

their wing and let him live with them in Ashfield House, Falmouth. "I had no understanding of the myth or Jung," he wrote, "till we later met John Layard, the anthropologist author of *Stone Men of Malekula* and celebrated dream analyst. He lived in our house for long periods in 1968 and 1969 and involved us in his analytical work with patients and invaluable knowledge of unconscious processes and dreams."

Lionel, who was Senior Lecturer in Art History and Liberal Studies at Falmouth, recognised Layard's learning and practical experience could be employed in education and invited the psychologist to talk to his students. Layard's knowledge was broad enough to fix creatively on any small aspect of life. When he learned that Lionel's friend, the artist Francis Hewlett, read the Beano and Dandy as a child, he asked what were these books and, on being shown the comics, he perused the Desperate Dan strip and immediately identifed the ancestry. "Ah, Hercules, I see you are well versed in ancient myth."

Here Layard comes over as genial, benevolently erudite, but his softness was deceptive. If mental health required scrapping a deep emotional attachment, he would spell out the cruel necessity. His psychoanalytical sessions might prove stressful, but the enlightenment and discussion they generated were gratifying. After the prolonged analysis, Lionel felt more confident about his powers and yearned for literary self-expression, to set down his fractured feelings about women, how they troubled, tantalised and stimulated him.

Taking inspiration from a story by Andreyev and drawing on revelations disclosed during sessions with Layard, he brought out an experimental novel, *The Pantechnicon*, that raised a few eyebrows among his friends. Appearing in a starkly effective black and white cover that he himself designed, it lacks a plot in the conventional sense, being a record of the horrific kidnap and rape of a young woman by three convicts that takes place in the back of a van. Her rather weedy boyfriend or 'lover' observes it all, as does the driver, Jules, both being more fascinated than appalled. Vividly written, the cold, flat tone recalls the precise visual style of Alain Robbe-Grillet, and the text ranges over erotic obsession, the relation of language to thought and action, and of art to life.

FB wrote a lengthy notice for it in *The Cornish Review*. One might imagine that, for a writer who admired Dickens and Gide, reading a clinical, emotionless tract about a distasteful subject cost him a great deal of patience. It was at odds with the warm, sympathetic style of writing he liked, and he must have been at least slightly astounded that the unappetising concept had been snapped up by the prestigious publisher, Weidenfeld and Nicolson. But Lionel was his friend and he produced a masterly, illuminating appraisal:

This outsider is the one character who comes to life in the book and, significantly, the only one to be named: Jules, the driver of the van, who is also the voyeur, sexually impotent because of damage inflicted on him in prison. The other characters, the convicts, the lover and his girl, are not named; and in their acts, which are looked at with

the microscopic eye of an artist to whom vision is imperative, we find nothing but the ghost-like functions of automata. But Jules is very much alive as he sits in the front of his van wondering how he can fix mirrors to give him a clearer view of the abominations going on in the back. He does not want harm to be done, he is anxious about that. At the same time he must see every precise movement, finger by fingernail, of the actions of his van, travelling in the South of France. (Significantly, the baked sundry Provençal world is also invoked as a kind of heartless and dumb conspirator with the conscienceless actors in the van.) Desperately, Jules struggles to extract more and finer detail from the bestialities in which the actors appear to be totally uninvolved in each other's emotions. No hearts break in this pantechnicon.

Lionel was grateful: "I do read the plot in synopsis and it chills me fearfully: such a terrible story. But I shall get no deeper, more interesting, more enquiring review than yours."

Meanwhle the psychoanalytical sessions continued. Layard was not a cold, remote psychologist. He did not give a damn about such issues as 'transference'. He had an outreaching feminine soul, involving himself with his patients in a manner that today would be thought highly unethical. This intimacy reached a sensational climax in 1970 when Layard was planning to establish an institution for 'third-world health' at Long Point, Mevagissey, while still being hosted by Lionel at Ashfield House. To phrase it delicately, Lionel burst in and discovered Layard giving Pru therapy of the kind that traditionally brings relief to both men and women but also, in special circumstances, arouses emotions of a violent, jealous nature.

Lionel biffed Layard for treating Pru so and there was a court case. This emotional shambles put an end to the third-world health project.

Excessive this may seem, but when you tot it all up, there's real value here. Dreams, tears, traumas, a boxing match, a police station and then, as a strawberry topping, the whole magic show climaxing in the dock. Here indeed was a comprehensive, dramatically satisfying therapeutic experience. By now, Lionel and Pru must have felt well and truly cured. She entered a relationship with a seriously ill artist, taking on the role of nurse rather than lover, while Lionel simmered in his misery until his energy and good spirits made a return.

Not surprisingly, there remained a bond between Lionel, Pru and John Layard. It had been tempered in a volatile smithy that, against odds, fused love, hatred and spiritual illumination. Lionel had more than a bit of the comedian about him. He became adept at serving up his bizarre forays into the human mind as a feast of laughter. Thus the shame and rage became externalised, transformed into comic spectacle, the private hurt turned inside out and made to dance for anecdotal display. After the fracas Layard returned to Oxford and set up home with his old lover, Doris Dingwall, and there remained until he died. During his last moments, Lionel and Pru, briefly reunited, knelt at his bedside and held his hand.

THE ROAD WAS FREE (1948)

Just before he moved out of Mevagissey, Frank had been working on three books, two novels: *The Downs So Free* and *My Friend the Enemy*, and one travelogue, *The Road Was Free*, all of which came out in 1948. Writing at this pace seemed to him a little desperate and, as he said, "like Sam Foote, my only way of managing money was to have two pockets: one for receiving, one for spending."

The Road Was Free is an account of a hitchhike he and Kate did, travelling from Mevagissey to the north of Scotland, stopping and veering off track in places like London, Newport and Glasgow. It has the merits of humour, lively observation and that bantering tone which FB had adopted as a mannerism; also, of course, he was drawn to comic writing as a relief from strife and emotional intensity. It is a rather ambling story that begins in Mevagissey with the couple discussing whether they can afford to look up their old friend Colin [Summerford] on the Isle of Barra. Broke or near broke, they cannot afford the fare to Scotland, but then Kate comes up with the idea that they should hitch-hike.

Naturally Frank considers it inappropriate for a married author of his standing, but straightway agrees. A few days later, off they go, leaving their son Jonathan of only two years and nine months, and Sebastian, his brother, only eighteen months, in the care of their young friend, Meg, a rather heavy responsibility for a young woman who must presumably stay with them during the night. So they take to the road, meeting characters like young Nick of Probus, a cattle dealer, a dreadful old man, Sandys Wason, Douglas Campbell and other drivers and opportunists. The prose is light, curious and determinedly flip and offhand, but there are places in which it succumbs to lyrical pressures such as first impressions of the island when they heard the seals singing, "neither animal nor human, of other beings, but beings with souls, or half-souls."

Kate responded instinctively to the seals' voices. It was a sound that touched her with its haunting melancholy, dissolving self-possession and making her yearn for some great, unreachable elsewhere. Frank quoted L. A. G. Strong's description of "the old, grey musicdoctors of the ocean". He would see Kate leaving the coastguard house on Greian Head where they were staying, and walking down the marshy rocky slopes to the sea. He grew anxious about the lure this strange music had for her: "Seals, like mermaids, have been known to steal away the human heart and lose it in the deeps. And half of the average human heart is always wanting to be lost…"

This is FB in the full tide of his romanticism. Faint, mysterious music on the wind, Tennyson's 'horns of elfland', the traceless song pervading the text of *Allanayr*, Yeats's 'glimmering girl' who lures mens' wits away, strains from an Orphean lute drawing the wayfarer through the portal into a radiant elsewhere – such agencies of revelation FB was never able to resist. The yearning acted both as reproof and challenge, making the artist feel cowardly for not throwing in his lot with such a spell, but also sensing enticement does not inevitably deliver what it promises. The irony of unseen melodies is that they possess no source and yet are more powerful for that. They may or may not be a delusion, but one thing is certain: that they will continue to be heard long after they have faded:

It was this music which greeted us within an hour of our first setting foot on Barra. Led by Colin we were walking slowly over sand-dunes and bog-land to the outlying western head of the island where the coastguard cottage stands, completely isolated, perhaps the most westerly house in the British Islands. Suddenly we stopped. "What is that?" we cried. "What is that?" For there, in the wind and the sea, a sound not of wind or of sea, but like both; a rising and falling undulation, of quarter-tones, like the music of the orient which falls so disturbingly upon ears accustomed to the western diatonic scale. Again, it reminded me of the whole-tone scale used so constantly by Debussy. And yet, not that; and we could never be quite sure that our ears weren't deceiving us. It might only be the sighing of the wind; or the drifting of the sea to the long sands.

The interval on Minch passes like a timeless trance. Frank appreciated how the working rhythms of the people of Barra blended with the enclosing land and water. Even the dead on their lonely promontory above the sea glide noiselessly into the bones of the living. The days passed swiftly until it was time for Frank and Kate to board the steamer *Lochearn* and leave behind his friends, Colin and Sydney. They are going from a peaceful, reflective place to a mainland that is still getting on its feet after the social upheaval of the Second World War. Still young German prisoners are stationed in remote places and a party of them are crossing back to the mainland.

The Road Was Free

All this I remember as though in the dim Delian past. And now it is all going, as the boat steams in from the grey Minch – we see it – we see it from the window and the women get up to look out and the records go on and the half bottle of gin is finished – it is all going, this most precious cargo of beautiful memories, it is all going aboard the *Lochearn* and soon we shall slide away into that dim grey sea and night will fall and we shall – but we are leaning over the rail watching Colin and Sydney disappearing along the road to their distant watchhouse with Lizzie and the seals to give them music. Till the last moment we watch them and wave to them and Kate murmurs *"Partir c'est mourir un peu,"* and we turn away from the rail and go down to the lower

deck where a crowd of very young Germans called "prisoners of war" are travelling with us to Uist. What must they think of this forlorn land, so bleak and bare and black now under this heavy grey sky? Boys of eighteen and twenty huddling together and talking in a language I can't understand. Once I knew some German. I meet one of them and try to stammer a phrase in his own language; but it is hopeless, I can do no more than mutter with a force of intensity which must have made him think I am mad, *"sehr kalt!"* That is all I can think of – that it is very cold. And, indeed, so it is, the air cold with farewell and the heart sad. It lights a spark in the German's soul merely to hear two words in his own language; and he nods eagerly, smiling like an old friend, as he agrees that it is *"sehr, sehr kalt."*

And now the engines have started and we are away and we stand again on the upper deck watching that black shape which is Barra and which can glitter with a million changing colours. On those black slopes grow small orchids, thousands of them close to the soil; and everywhere it is starred with small flowers. Yet now we see only blackness and the hulk of Ciosmaol standing like a huge grave-stone in the bay. How terrible it would be now in the empty rooms of Eoligary House. And how terrible the loneliness on that great beach, *Night's fall unlocks the dirge of the sea.* Hearing only the lament of the breakers on Eoligary sands, I am unprepared for the sudden burst of music which sounds from the lower deck. It is martial and dogmatic, a statement in the squarest fourpart harmony of man's challenging pride in his own being. But it is deathly music; too unyielding and brazen. The German lads sing because if they don't their hearts will break. They sing into this foreign sea with a bitter anger.

SANDYS WASON

In a less poetical tone is the visit Frank and Kate made to Sandys Wason in his house in Newport. Here he is on familiar ground – eccentric clerics and cranky old ladies are Frank's cup of tea – and the portrait of the self-absorbed if sociable priest has an offhand immediacy and humour:

Wandering about the huge room I vaguely examined the furniture; but all the time I was thinking of other days. Everything I touched seemed to be a part of Wason, properties of the figure who had become drama in my mind. Even the linen-basket. "I remember," I said, "fantastic shopping expeditions with Sandys in the very crowded streets of Newport. I used to clutch his arm, afraid that a car would finish him. And he would walk very slowly, close to the side of shops, slinking along as though he hoped to escape notice, his coat collar up, a Quixotic glint in his eyes. Then, without a second's warning, he would suddenly leap forward like a prodded cricket, plunging body and soul into a stream of traffic." I fingered the linen-basket, pleased by the pictures I was evoking, "Well, one day we were in the thick of a Newport lunch-hour scrum when he suddenly stopped, stared through his monocle, and pointed out into the street. 'Stop that boy!' he cried loudly. On a bicycle I saw an errand boy who was cleverly clutching a long, slender apple barrel with his one free hand, a dexterous bit of work. For goodness' sake, I asked, why impede the boy's difficult enough progress? 'Must find out where he gets those barrels,' muttered Wason. I sighed. Of what use to him, I asked, was an apple barrel? Prompt came the answer: 'Why, for a linen-basket, of course!' He was always

137

putting things to odd uses. One evening, while I was writing and he was doing *The Times* crossword puzzle over the fire, he asked me whether I had a good definition of an eccentric. Not being able to think of anything bright, I asked him whether he had. Yes, he said: an eccentric was one who used an article for a purpose other than that for which it had been intended. I did not think this very bright either; but, looking at him, I noticed that he was peeling a large dessert pear with a shoe-horn. And, of course, there was the time when he kept some supper guests waiting outside in the snow while he neatly converted pages of *The Times* into peak-hat table napkins."

To its credit, *The Road Was Free* conveys vividly the joys and perils of hitch-hiking. Frank wasn't above the low male strategy of using Kate as lift bait. The travelling salesman sees the lonely, mature female shivering beside the highway and his innate sense of chivalry prevails. Gallantly he stops and then, from a ditch, hedge or hole in the road, out crawls Frank with his ragged beard and bohemian visage. The driver has been deceived but he takes it well, shifting things around and making a space for the couple.

Even after securing the lift, the enterprise demands tact and sensitivity – for, as a hitch-hiker, you're no more than a roadside beggar. In view of this, how should you behave towards your host at the steering-wheel? Some drivers like to be amused with funny stories or ruminations on the state of the realm. Others prefer the offer of a cigarette while others stay sternly silent. What about visits to transport cafes? Should you repay your benefactor with a cup of coffee or a breakfast? What about calls of nature? Surely you'd better attend to those beforehand. Your unpaid chauffeur doesn't want to ram on the brakes and sit there seething while you relieve yourself behind a bush. Another consideration is that days spent lugging a rucksack or suitcase along a road can make you weary, and you should guard against sleep.

It can easily happen if, during the course of a cold morning's tramping, a lift presents itself. You place yourself in the seat beside the driver, exchange a few words and the vehicles starts and moves away. The combination of sun through the windscreen and the engine heat after the chill of the open road is liable to make you drowsy, and the last thing a driver wants is a mature male snoring on his shoulder while he's negotiating the gears. Such practical points, along with pen-portraits of the various Galahads of the asphalt ways, to whom they made successful appeals, make *The Road Was Free* an uplifting read as well as a diverting slab of social history. Few men or women go hitch-hiking today, but this book may well convert someone. However, as this is contemporary Britain and not the 1940s, it might be advisable to take along a stun-gun or some kind of pocket alarm just in case your solicitous carrier desires to dismember you or disembarrass you of your credit card.

MY FRIEND THE ENEMY (1948)

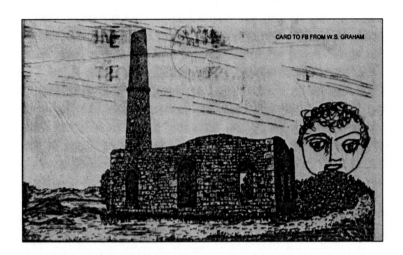

CARD TO FB FROM W.S. GRAHAM

If *The Road Was Free* possessed an aerial lightness, a novel that came out in the same year revealed the bubbling magma of resentment and self-division that lay beneath that genial suavity. Frank Baker was often a happy man, but he was also a highly frustrated man who wanted to make a deeper mark on the literary world than he so far had. Also he wanted to pick and choose what and how he wrote – a freedom only achieved by broad public demand.

My Friend the Enemy was an attempt to write a taut, intense, dramatic thriller with a satisfying roundness of plot and a tenacious, compelling villain. Its genesis dated back to the onset of the Great War when Frank's father had been called into the Royal Army Service Corps and he and his mother went to live with Aunty Betty and her husband, Reggie, in Stafford. There Frank became a weekly boarder at the Grammar School along with three other boys, "one of whom was a sadist of such hellish ingenuity that anything the Theatre of Cruelty cared to present now would probably seem quite homely to me." Memories of this Grammar School and the oppressor in question are to found in the tentative autobiography he started writing in Michaelmas 1937:

"There were only three other boarders. The school, which was one of the Edward VI Grammar Schools, did not actually take boarders, but an exception was made in our cases. The other three were much tougher than me and soon proceeded to initiate me into the mysteries of smoking, stealing and swearing. From which it was an obvious step to the soon-to-be dominating question of sex. One of the boys was called Fisher; the other two, Robins, brothers. Vernon Robins, the younger was always a friend, so was Fisher, though not so much so. But the three of us were banded together in a common resistance to Walter Robins, who was

two years older, and the most accomplished and fastidious bully who ever existed – or so I should say. Walter really bullied magnificently. He had a genius for inventing new tortures; wrist-screwing, thumb-pulling, ear-twisting – all these things were child's play to him. He bullied us all, but me more than anyone else, simply I suppose because I was obviously more bullyable. His lair was behind a piano. Here he would force me to the ground and fart in my face. That was only a beginning. What came later would be censored if I wrote it, so I shall not. In retrospect I feel grateful to Walter, and I am sure, if I had been him, I would have done the same. What I really admire is his thoroughness. He played cricket like a fiend, bowling deliberately for heads, balls that might have come from a machine gun. He now plays for Middlesex and has been several times in the Australian test-teams. I wish him well and hope that he has stopped biting his nails."

Fortunately, bitter memories may supply potent fictional ingredients, if you add them to your narrative in an artful enough manner and, some thirty years later, Frank was able to serve up these ancient scars and bruises in an astringent yet palatable dish that received high commendation from the critics. The publishers hoped for a breakthrough with this tale of love and loathing.

MY FRIEND THE ENEMY

'My Friend the Enemy' tells of the curious bond between Morgan Vale and Vincent Collins, a bond starting a boarding school where Collins was a leading athlete and, alas, a clever and persistent bully. His cruelty to young Vale marks the latter's character for life. After school days they do not meet again for some years during which Vale has become a successful playwright. They come together at a country house party. Vale is unwittingly responsible for costing Collins a job he desperately needs. The story develops from there, increasing in tenseness and suspense, to the strange and terrifying climax. Vale realises that his friend the enemy has been the only person he has ever really loved, (there is no hint of perversion) and that Collins' cruelty was part of the cruelty which is at the very heart of the universe. "But where is this heart to be found, where is the very core of the world's being, if it is not in ourselves?

The above blurb – almost certainly written by FB – draws attention to the 'doppelganger' aspect of the novel. *My Friend the Enemy* is a version of Wilde's *Dorian Gray* or even Frank's own flawed novel *Sweet Chariot*, for it – probably unconsciously – divides what is essentially one person into two different characters at war with each other and yet, contradictorily, in concord also. One is a peace-loving, successful playwright and the other a murderous cricketer, a demonically effective bowler. The theme is underlain by what appears to be a deeper emotional stratum that is hinted at rather than revealed. Is this because the author is exteriorising inner conflicts?

The epigraphs he has chosen for the novel are hauntingly apt, from Kafka and Maurois respectively. The first is from 'The Burrow', dealing with privacy and fear of exposure to the world, and the second – 'No man can bear a child's cross' – echoing the misery and ruthless isolation of early pain and suffering.

Let us now summarise the plot in more detail. Morgan Vale, a slight, sensitive schoolboy from the Potteries, is brutally bullied by a sturdy, handsome elder boy, an outstanding cricketer and sportsman. After they leave school, Morgan becomes a playwright of the Somerset Maughan type, portraying the upper classes with an edgy blend of sympathetic insight and sneering disdain, literally biting the hand that feeds, in that at least one of the families whom he parodies, the Wickhams, offers him unflagging support and hospitality during his prentice years as a writer. Meanwhile his old enemy Collins rises to a nationally famous cricketer – literally a demon bowler as well as a useful bat. At one of the Wickham's weekend gatherings, Morgan gets embroiled in an argument about God, morality and the cruelty of nature which prompts him to tell the tale of how he was remorselessly bullied at school by a man, presently a celebrated cricketer, whom he refuses to identify. His dinner table audience is riveted by the anecdote, but later, to Vale's acute unease, his ancient enemy arrives on the scene.

Apparently Collins, having giving up his cricketing career, is applying to become an engineer on the Wickham's yacht – an awkward, menacing reunion between him and Vale takes place, demonstrating the former has lost nothing of his violent edge. After a hair-raising scene when Collins confronts Vale in his bedroom, the latter quits the mainland for the islands of Skaltersay, and there, to his horror, Collins pursues him, confessing he is on the run for having murdered both his mistress and her husband. He accuses Vale of betraying him, thwarting his plans for escaping justice by inadvertently preventing him from getting the job as engineer on the Wickham's yacht. The family had been able to identify him without difficulty from Morgan's schooldays anecdote. Vale defends himself, explaining to Collins he knew nothing of his painful circumstances and would not have confided the story if he had been aware. But Collins continues to bully him, saying Vale alone is responsible, and they are obscurely bonded in crime, especially now when, possessed of the incriminating knowledge, Vale is an accessory to the fact.

After spending a night on the wild island with Vale, Collins breaks out of the cottage, leaving a suicide note. Deeply shaken, Vale returns to London and meets his mother, who is something of a Christian socialist, working with children in the community and trying to improve their general welfare. Meanwhile the case of the man and wife that Collins murdered has become a major issue in the press. Vale's mother gets so taken up with it that she urges her son to write a truly realistic play exploring the horror of the lonely murderer who is being hunted by the wolves of justice. "I want you to write the truth," she emphasises. "I want you to write about the poor hunted underdog; about the man

141

who's turned to the most horrible vices and reckons human life no higher than you or I reckon a blade of grass. Lower, in fact; for you and I love a blade of grass." But then, somewhat confusingly, she invokes the political situation that is at odds with the plight of a hunted murderer: "Morgan, there's a great brutality in the world: millions of men are stamping their jack-boots and sharpening their swords and oiling their guns. There'll be a terrible shedding of blood and a spewing out of lies and malice before long. It'll be the same as in 1914. And all for stupidity, for violence, for emptiness, for cruel heartbreaking promises that nobody'll be able to keep."

Presumably FB is trying to frame the intimate violence of Collins' private life against the larger historical frame and the pacifism of his mother.

Vale writes the play which proves successful in rehearsal only after he agrees to take the part of the murderer, but then during a public performance, he sees Collins in the audience and breaks down and walks out, drawing the whole thing to an standstill. Later he meets Collins again, who tells him how he faked his suicide and went into hiding, but now finds his position untenable. Too many police are looking for him for his arrest to be far off.

The novel is gripping and proves FB might have matched Patrick Hamilton, but there is a vacuum at its heart. Things are not made transparent in the text. In what sense, for instance, does Vale love the ostensibly horrific, bullying Collins? Is he hinting at the terrible closeness, the creepy intimacy, between torturer and victim? Surely not. Does his bisexual side leak into the dominant, dangerous figure of Collins? Does the latter stand for the mad beast who is liable to break out and run amok? Collins does not care what he does, unlike the reputation-conscious Vale. In fact, Collins goes so far as to have an affair with the leading actress, Perdita (who doubles as Vale's on-off girlfriend), showing a romantic pull that far exceeds his rival. Perdita loved the *true villain* rather than the surrogate; she thrilled to the role of his girlfriend in the play Vale authored: thus the identification in literary terms is complete.

In addition to the interior conflict, the novel explores the dilemma of the humanistic writer who, while rebuking the cruelty and violence of the world, does not baulk at manipulating it into a profitable narrative, a book or play that will make money. Vale is an eager, competitive author who knows nothing is more thrilling than a convincing master villain. Who would read the Old Testament if it did not have a Devil? Hence there's a deep hypocrisy about literature which feeds off the lowest while feigning to strive towards the highest.

Because the novel, concentrating on two protagonists, possessed a clear dramatic symmetry, FB thought it potentially filmic. Through a contact, he sent a copy to Dirk Bogarde whom he was hopefully lining up for the part of Vale. In his journal (March 7, 1967), he notes that he "heard from Dirk Bogarde, that he will read 'My Friend the Enemy'. I asked Panther to send the copy that I have. I

re-read much of the book. It is powerful and symbolically accurate: but it dates – and I was [surprised?] he wants to try to bring it up again."

Frank was right. The novel would make an effective black and white film in the noir genre. There are superb confrontations, claustrophobic bullying episodes contrasting with meetings on a remote island and the theatre passages, with their frantic, charged rehearsals tainted by guilt, treachery and morbid elation. There is the scene towards the end when Vale and Collins return to their old school, the music room, where all the bad memories hide, and compare their relative viewpoints. Collins reveals that he was a sensitive child himself and despises Vale in the way someone might despise his reflection.

My Friend the Enemy

We walked very slowly along the wide, deserted corridor. Through the tall barred windows the brilliant sun sent its rays. How strange the absolute quietness of the place – a place that I remembered as full of noise and quick running figures, tumbling in gangs out of the classrooms.

I shoved my hands in my pockets, leaned against a radiator, and whistled casually. I felt extraordinarily happy. Collins opened a door opposite to me. "Go in," he said. And I went into a small square bare room, overlooking the playing fields, and full of bright chestnut-coloured lockers with numbers on them. A trestle table and form stood under the window; on the wall was a map of the Midlands. I remembered the old chart of the musical keys. The walls had been distempered recently, a bright primrose yellow. It was very clean, almost too clean. I looked at a corner, a naked corner by the window.

"The poor old piano's gone," I remarked.

"Yes. They use this as a changing room now. There's a new extension, a music school, on the east wing."

"I don't like it so much without the piano." I stood in the corner, touching the wall with my hands, stroking it, feeling its hardness, and longing for that old piano to hide me as once it had done.

While I stood there Collins vaulted up onto the table and sat there, cross-legged, watching me, smiling a little.

"Come out, young Vale," he said.

I walked toward him. "Do you think there's anything extraordinary about me?" he asked.

"Yes, there is. You have murdered two people." I knew that had to be said, and it seemed no effort to say it. Neither was he offended.

"Is that really so extraordinary? Why do you look at me that way?"

"What way?"

"I don't know. A shifty sort of way. Do you know, you were never really under my power. I didn't want to hurt you."

"As a child," I asked, "did you ever know fear?"

"Yes. I did. I dreaded the dark. I used to scream for a light at home and they had to give way to me. I was terrified of what I couldn't see; and I hated that fear more than anything. I used to think about it in the day – I used to grow more and more afraid of

143

being afraid at night. I swore I'd kill it when I came here. Now, here's the odd thing. When I met you I recognised the same fear in you; I saw you were afraid of me. Instead of this making me like you, it made me hate you. It was like – it was exactly like meeting in the flesh what I'd known in the darkness. I still hate darkness. And you were like the darkness. I hated you. And I had to go for you. All my life, after that, I had to do everything, just to prove to myself that I wasn't afraid of anything people could do to me."

Suddenly I felt lost, desperate. "Collins," I asked, "why has it got to be like this?"

"Like what?"

"This awful tragedy hanging over us."

"Tragedy? Why is it a tragedy? Why look at it that way? Doesn't it seem to you that we're just beginning to learn something about each other? Is that a tragedy?"

THE VILLAIN

Walter Robins

Frank took few pains to conceal his feelings about the cricketer on whom the story was based. It was as if he hoped the living original would read the novel and experience a pang of shock or conscience. The real-life Collins was none other than Walter Vivian Robins who is classed as "one of the most dynamic all-round cricketers of his time" as well as being outstanding at football. While still at school, Robins made his first appearance for Middlesex, for whom he continued to play irregularly till 1950. He took part in 19 Test matches for England, being captain in the home series with New Zealand in 1937. His highest innings in a Test was 108, against South Africa at Old Trafford in 1935, and his best bowling analysis six wickets for 32 runs against the West Indies at Lord's in 1933.

"As a googly bowler," Wisden reported in 1930, "he still has something to learn, his fault being that he tries to bowl too fast, and as his trajectory is

consequently much lower than that of, say, Freeman, his flight is rarely deceptive. For his success he relies on his very powerful finger-spin which enables him to make the ball turn quickly and at a sharp angle. On his day, he is likely to run through any side but much of his good work is spoiled by erratic length."

His one major tour abroad was to Australia in 1936-37 when he was vice-captain under G. O. Allen. Unfortunately he broke a finger of the right hand at fielding practice in the first week of the tour with the result that he could not spin the ball and achieved small bowling success. It is possible that Frank read of this injury while writing *My Friend the Enemy* and incorporated something like it into the novel: "On the inner side, at the base of the palm, was a mass of septic discoloration, an inflamed furrow of pus and shell-pink skin."

One wonders if Robins ever read Frank's novel and was shaken or, more likely, cynically amused by the portrayal of himself? If he did, he must have realised it would not be feasible to sue, for that would draw attention to the nasty side of his character and perhaps boost the sales.

But it is obvious from the plainness of identification – a notable cricketer who attended a grammar school in the potteries – that Frank half-hoped the bully might pick up a book one day in a store or library and find himself pilloried in the pages. As for the truth of the depiction, although his ambition never reached the homicidal heights of *My Friend the Enemy*, it is notable that nearly all accounts of Robins emphasise his edge and aggressiveness on the field. His father brought him up to play with an unfaltering professionalism and, similarly, he urged his team to adopt a consistently fighting stance that occasionally made him unpopular. Robins does not seem to have been a very pleasant man but he did command respect.

A GRUESOME SUCCESS

The critical reception of *My Friend the Enemy* was generally favourable if not without the usual quibbles. Walter Allen, the novelist and critic, praised the book in the *New Statesman*, saying "Mr Baker handles his violent, almost Dostoevskian plot with great ingenuity and constant invention; and he is much more successful with his scenes of the theatre than is usual in fiction." The *New Statesman*'s rival, *The Spectator* thought it was "told in a flawless style" and exerted "an extraordinary fascination". In the *New York Times*, Orville Prescott, sounded similarly enthusiastic, conceding that the work was "touched with madness, but it is certainly a complete and gruesome success, a bravura performance."

THE DOWNS SO FREE (1948)

The title – *The Downs So Free* – has a ring of Sussex. You'd think it might be a poem by Hilaire Belloc. But it refers to a popular Edwardian air Frank had sung at many a recital:

O who will o'er the downs so free
O who will with me ride,
O who will up and follow me
To win a blooming bride?
Her father he has lock'd the door,
Her mother keeps the key,
But neither door nor bolt shall part
My own true love from me.

The open spaces in question are not the rolling chalk downs of the home counties, but the wilder Gongallow Downs in Cornwall, modelled on Perran Downs, near St Hilary, where Frank's father, Edgar, maintained the bungalow Claredene that was passed to his son and became part of his literary mythology or a sacred place. Interestingly the novel is dedicated to the architect, John Archibald Campbell, with whom Frank had many a fruitful discussion in his Mevagissey years and who himself was something of a philosopher and idealist, taking forward the ideas of Ruskin, Morris and the Arts and Craft Movement.

"I know all the people in it and am particularly fond of the book," Kate Baker told Everett Bleiler. "For three happy times we lived on Perran Downs and I see the people as characters not types. FB's mother, disguised as fat when she was thin and graceful, begins and ends the book. It is often so very funny too. Someone said, 'life is a comedy to those who think, a tragedy to those who feel.' If both are not present, we are seeing a half-truth which is more misleading than no truth at all."

Basically the novel is an ending-up story, dealing with a cross-section of ageing people who reflect either bitterly or positively – more frequently the former – on their lives and try to make their peace or compromise with God or fate. It is a novel about faith and yet it has all the restlessness of an unbeliever. A reflective, regretful tone dominates the story which does not lack wit or shafts of humour but articulates ideas through its characters rather than demonstrates them in action. It is a discursive novel in the sense that Aldous Huxley's novels are, but the tone is more subdued and genteel. It is as if Frank wanted to assemble the literary equivalent of a folly, a folly based on faith, an odd, fascinating structure that totters in places without collapsing entirely. The supernatural plays an

important part, but the ghosts are not palliative – rather they dole out tragic ironies, bitter knowledge.

Music is naturally important, a brilliant but failing pianist, Ralph Bardsley, being a major character who meets his end through a road accident, leaving his sister, Olive, rather stoically desolated. Fakelore and topography relating to Cornwall is integrated in the text, including a bizarre, apocryphal legend related by Olive Bardsley to Paul Keaton, concerning a beautiful anchorite, St Carow, who fell in love with a holy dwarf and was transformed by God into a shy stag, so that she would never break her maiden vows.

Within a short while, back he came to the Nanscarrow Valley and again he searched for his love. But all he found was a shy deer, who ran from him as he approached her. Sadly he addressed the creature. 'Here I shall stay in the place where my beloved has died.' In her cell he found bread and honey and a jar of pure spring water; and on her stone floor, covered only by sacking, he fell asleep to dream of her. In the night, as you would expect, Mr Keaton, she came to him in her true form, her coarse black robe discarded, naked and tender she came to him; and he groaned and stretched out his arms like Cupid towards Psyche. But she withdrew and would only touch his fevered forehead. Then she said to him: 'Lover, we have given ourselves to God and may not turn back. Here, if you remain, must I pass the rest of my days as a deer; for you must never see me again in human form. But it is not in my heart, nor perhaps in God's will, that I should turn you away. Love, let us do some useful work together.' In the morning, remembering his dream, he went out to the hillside where the deer grazed; and he knew from the soft blue eyes that it was his own true love who sprang so deftly from rock to rock and would stand, at night, on the highest rock of all, outlined against the sea and sky. Over there, Mr Keaton, jutting from the headland. And it is still called the Deer's Rock. A dangerous bit of coast.

This is a parable of sublimation, quelling desire in order to canalise it into a spiritual force. That's the theory, but the frustration suffered by the characters in *The Downs So Free* does not show much transcendent potential. It is more a burden they have to bear. This distance between them and fulfilment, physical or spiritual, is never quite breached, although Captain Mike and Amanda Evenlode succeed in establishing a relationship. The novel has a well-written blurb, very likely done by Frank himself, pointing out that the questions, 'Why am I here? Where am I going?' were questions predominating in his previous narratives and that they are all-important in this book, "distinguished for the brilliance of its characterisation" and exploration of human relationships:

All [characters] attempt different solutions to the ultimate problems; while they battle with staunch ironic determination to force dwindling larders to produce daily necessities, it is the contemplation of life and death that plays continually in their minds. Amanda Evenlode, spinster, turns to the Quaker mystics, good works and local folklore – yet never succeeds in convincing herself that the mystical life can give the answer to her human desires. Olive Bardsley, remote, rich, divorced, practises charity as a business

147

duty, deserts a brother who is a brilliant pianist, and falls back upon her Faith to receive her. Captain Mike Moody strides into amateur Yoga and sings his way with wheelbarrow and strong drink to an anchorite's cell in the cliffs. Osmond Venables, widower, antiquarian rationalist, comes to feeble grips with a poltergeist, sees his whole conception of an entirely material universe crumble under his nose, then blindly speaks with the voice of prophecy. All these, and many other characters, wander in and about the Gongollow Downs – that long peninsula jutting out into the western ocean, a place of peace and spiritual fortitude.

Frank's latent – if barely realised – Trollopian ambition, to make his novels into a self-referring corpus, so that they add weight and significance to each other, surfaces again in the reference to the cathedral town of Cornford; in the fact that Ralph, brother of Olive, plays the music of Harrison Bate, the crusty, semi-mobile composer who figured in *Allanayr*. The Gwent countryside is miniaturised in the garden of Olive Bardsley, a place where she felt free "to indulge a thousand wandering fantasies". The sad death of her brother does not affect her like it should; she appears only to feel a mournful nostalgia, but she makes a return journey to the sacred ground of their youth, Allanayr in South Wales, and scatters his ashes in the manner of someone sowing:

She stood up, emptied some of the ashes in her hand and dropped them on the air. How impossible it was to make of this a graceful act, even a significant act! Like sowing seed on the fields, nothing more. Then she stopped, realizing the profound adequacy of this symbolism. There was no other way to scatter these ashes. You could not throw them into the air. The wind would catch them, perhaps, and throw them back in your face. Only the traditional sweep of the sower could bring meaning to this act. So she held the urn in the crook of her left arm and, taking from it a handful of ashes, walked slowly in a circle round the Heath, scattering the ashes beside her, then dipping her hand into the urn for more. She remembered a picture she had seen in some old family Bible, of the sower casting seed on the Palestine field; and she tried to imitate his attitude. As the ashes fluttered to the ground, a verse from the Anglican Psalter came to her mind: *This shall be my rest forever. Here will I dwell, for I have a delight therein.*

After the reading of the will, there's an Evelyn Waugh-like touch of dark comedy (P. 247) when Olive drives past Ralph's flat and sees his male lover and chief beneficiary who, having instantly recovered from the bereavement, is shamelessly cavorting in "a red Turkish fez and a black silk dressing-gown, parted at the waist and revealing white velveteen shorts."

A BUBBLE BLOWN FROM A CLAY PIPE

The Downs So Free enables a reader to sink into an environment or setting, never skimping on description of habitat or habit. We linger amid the interiors of the characters' homes, share their thoughts, possessions, modes of eating and regrets. But these people reflect rather than propel themselves into open conflict. The

narrative is consumed by styles of brooding and matters relating to the afterlife or point of departure. What is a good life? What measures should one take to live it, especially today when fewer and fewer people believe in God? How can one find a spiritual anchorage in a material world? Osmond Venables, student of Lucretius, stands as the advocate of matter: that there is nothing in the world but bodies that in time decay, marking the end of personal existence. He is opposed by Olive Bardsley and Amanda Evenlode who possess a more or less steadfast faith, a belief in the immortality of the soul, but they are sympathetic to Venables whose passion for extinction appears to be grounded in a nervous instability: *materialism as a tenet of faith.*

Death dogs the narrative – even more so than in a Hardy novel when offset or diffused by the desires and passions of young lovers. There's a touch of over-egging the pudding when the author italicises 'transience' by echoing the Venerable Bede's image of a bird flitting through a shaft of light [P.127]. Contrasting with ego-centred time is the Buddhism of Captain Mike Moody who views physical phenomena as an illusory enticement that masks a more intense spiritual reality. Unlike the business man and frustrated painter, Paul Keaton, he has the courage to reject the routine and minutiae of a settled life. Gloriously he is portrayed against a sunset backdrop, preaching a mysticism similar to that of *The Birds* yet without the Christian slant:

Enormous, copper-coloured, growing pale and virgin as it ascended, the moon had risen from the sea. It now hung overhead in a clear, velvety sky wherein only a few stars could be seen. Far out to sea the Wolf lighthouse blinked its patient and watchful eye. The gentle waves splashed mildly on the pebbled coast. The Captain, wearing a long, black dressing-gown and a solar topee on his head, sat cross-legged on a flat stone over the embers of a fire of driftwood… 'You want,' he said [to Paul Keaton], 'a cosmological eye. You want to flow, my boy, flow, flow like the ocean. You're all things. You're the sun and the moon combined. You're the whole blasted planetary system moving round at amazing speed within the framework of flesh and bones. You're a fish in a pool; yes, and you're the pool around the fish. Grass, iron, fire, water, blood, earth, the cause and the effect – that's you, Keaton; that's me. *Homo* very *sapiens,* Keaton. I'll let you into a secret. The whole long game's one vast pretence. A bubble blown from a clay pipe.'

After reducing all religions to a series of preposterous relatives – "if you're an Arab you cover your women's faces; and if you're a Hottentot you drape 'em in beads" – Moody propounds the idea, familiar to students of Rilke, of escape from self by immersion in a simple craft or human duty, by subsuming personality in a role that transcends it. Although there's something exhibitionist and unreal about the Captain, he nevertheless has a historical context. Edwardian Britain counted a high proportion of army officers who had formerly served in India and become immersed in a philosophy that was quite alien to their Christian culture yet possessed the attraction of not being individual-centred or cluttered by ritual or

church attendance. Instead it offered practical exercises by which a religious experience could be cultivated.

Around the time *The Downs So Free* was composed, books on Yoga and meditation had started to achieve popularity. Frank's novel was written in Mevagissey from June 5, 1946 to November 9, 1947, not long after the appearance of Aldous Huxley's *The Perennial Philosophy* (1945). The title phrase was coined by Leibniz and refers to a metaphysic that recognises a divine reality behind or permeating the phenomenon of human existence. The personal soul is none other than a tiny part of the vast immortal soul of God. Hence man's end or spiritual completion lies in the knowledge of the immanent and transcendent ground of all being. Rudiments of the 'Perennial Philosophy' can be traced among many cultures and native peoples, providing a ground in which all faiths and convictions meet: "There is only one religion, though there are a hundred versions of it."

The climax of *The Downs So Free*, however, is less optimistic, employing the much-resorted-to device of a party or social gathering to unleash an apocalyptic revelation and drastic retribution that gravely disrupts the composure of the guests. In best theatrical style, with many a velvet trimming, the haunted, self-regarding Osmond Venables spells out the end:

"Look outside. Look at the mist. Already you are locked away from the rest of the world. Is it slowly dissolving? Is there a life a hundred yards away from this house?" Then he paused. And everybody listened. There was no sound. The curious, heavy silence which mist produces had indeed locked the house away from the rest of the world. Osmond laughed, "You are no longer certain that I was play-acting. And now I will be frank with you. Your lives have been passed under an illusion that you are immortal. Some of you believe this firmly; some of you don't know what you believe; but all of you hope it is so. You have lived your lives like children who watch a pantomime and think the curtain will never go down. But it will go down, it is coming down now, and the mist will pass over you and – all will pass into the immeasurable inane – away – forever. I want you to know this, to be convinced of it, so that you may die bravely with no foolish hopes or fears in your heart, and no undisciplined panic."

Among the guests this stirs a predictable hostility, but Amanda Evenlode's response is kindly and cautious. Apprehending the distress of her former close friend, Mr Venables, she tones down his slightly childish pessimism by substituting time-as-a-devourer for time-as-unfolding-potential, claiming what has been is eternally present and recoverable through the heart and mind:

"I must say to you all. I think Mrs. Keaton is right to be afraid. I think we all are afraid. I do not think it matters very much whether the end of the world comes about through man's devices, or God's; whether Mr Venables is right or wrong. But we owe a debt to him. We all know that he was subject to spiritual disorders in this house which bear no rational explanation. Are we then to dismiss his warning to us? We dare not. Suppose

then, for a moment, that it is true; suppose that we have indeed but a few moments of this earthly life before us – how do we employ the time left? I believe we should think only of this moment in which we still have air to breathe and hands with which to touch and eyes with which to see. God made us in His image and God cannot be destroyed. Death cannot touch us if we believe this. For once the Kingdom of Heaven is enthroned within us, we are above and beyond the physical laws of time and space which seem to govern us. Heaven is eternity; and eternity is the present we can never seem to hold. Hell is, I think, that nothingness which Mr Venables believes we go to; it is the negative result of thinking in terms of human time. Mr Venables, you know you are alive at this present moment?"

"I know, Miss Evenlode, that I was alive years ago and those years have been cut down like the summer grass." He spoke into himself, without looking up to her.

"But those years do not affect the present moment. When you travel in space, you do not assume that what is behind you ceases to exist. Why then, when you also travel in time, assume that what is behind you in time ceases to exist? I do not see any reason here. I do not believe that those years of yours, Mr Venables, are any further away from us than the light which swung from the high rocks of Nanscarrow Moor when the blessed St Carow lived here. And neither do I believe that St Carow is any further away from the strange works of men in our times, in their laboratories and cells, than we are."

The speech amounts to little more than a hopeful sentiment arising from a slippery analogy but it deeply affected Captain Moody, confirming Amanda as the twin soul to whom it is his destiny to draw closer.

Frank was familiar with J.B. Priestley's novels, dramas and discourses on time and his finale is the type of thing the Yorkshireman might have conceived. But there is a twist to it, anticipating Eugene Ionesco's absurdist play *The Chairs* (1952) when the marvellous messenger or 'emperor', elected to deliver a vital global message, turns out to be a mute who can only manage to scar a blackboard with meaningless chalky scrawls. Similarly Venables' message is pompous, a negative rant in which an angry vanity is detectable. Hence it fails to impress as an authentic oracle from beyond; it's as if he's taking too much delight in the notion that all the pageantry and bravura of existence will dissolve to nothing:

It was happening... The foundations of the earth were split at last, the rocks were flying in the face of the moon, the trees were thrashing the sea and the sea poured down into the open precipice made by the splitting of the bed of the ocean. It was like swimming under water. Here a huge fish bubbled towards him, gaping and oozing little crystal balls of milky light. And then he launched out and swam to the surface. A wave tossed him back. He was down again. A fish with the goggle eyes of Commander Ransom floated towards him.

Over the top as it is, Frank organises the climax with some dexterity. There is a clever build up, promising something terrifying that is circumvented by a solipsistic sleight of hand. Venables, whose adamant agnosticism has been undermined by poltergeist phenomena, is anxious everyone should accept the end

and die in a brave, open way, unsullied by foolish hopes, fears or expectations of an afterlife. But the great terror fails to descend from the sky. The world ends *metaphorically* for Venables only. He is stricken with insanity and thus denied the consensus reality he previously enjoyed with others. Is this the vengeance of the spiritual on the material or vice versa? There is a playful element in FB's doleing out of retribution that hints at black comedy rather than anything divine or karmic.

To conclude, in its blend of vivid detail, wild fancy and a certain staginess of presentation, there is an equivalency in *Mr Allenby Loses the Way*, a similarly flawed if animated narrative. The patchwork of viewpoints, conveyed in bitty sections, scatter the reader's sympathies and interrupt the flow. Some are of perfunctory interest but they do deepen the perspective. A semi-comical characterisation, lit up by mania, is allied to an adroit physical immediacy. Plants, gardens, food, dishes, ornaments and musical scores are conveyed with loving detail, but the overarching metaphysical theme is frustratingly left hanging. Rather than resolution, there is death and dispersion. Characters may reach a compromise with themselves but the great issues still hover like brooding clouds.

Below: architect Archibald Campbell whose discussions with FB inspired the intellectual musings in *The Downs So Free*. Right: his idealistic House at Chapel Point, Mevagissey.

Gate House

BLESSED ARE THEY (1951)

Frank's next book *Blessed Are They* was completed on the Feast of SS Philip and James, 1950, at Mevagissey. After the intensive bout of novel writing, it was very much an applied piece of writing, but informed by a worthy intensity and seriousness. The very title stirs the reader to humbly cross himself and mutter something meek and righteous. Published by the Newman Press, it is a collection of eight surprisingly attractive, varied short stories demonstrating the principal Christian virtues in a modern context.

Blessed Are They illustrates the Beatitudes or the eight declarations of blessedness from the Sermon on the Mount. First we have Mrs Jenner standing for 'Blessed Are the Poor in Spirit'. Overlooked by her children and close relatives, this dear old lady must give up her delightfully old-fashioned Cornish cottage with its spacious views and hoard of sentimental belongings in order to satisfy the demands of the local council for a new road. Next we meet the pious young Irishman, Patrick Maloney, typifying 'Blessed are the Patient', who elects to spend his life amid the catacombs of Rome, greeting and showing the visitors around the holes and burrows where hundreds of early Christians met their ends. Patrick is convinced this is his true calling, thus disappointing his old mother who wanted him to become a priest back in Ireland. After that, John Hayward's authentic and becoming grief for the loss of his wife spells out plainly 'Blessed are they who Mourn'.

'Blessed Are They Who Hunger' portrays the earnest, full-hearted dedication of an actress to achieve as near perfection as she can. 'Blessed Are the Peacemakers' reintroduces Olive Bardsley who initially made her appearance in *The Downs So Free*. Now she is esconced not in Cornwall, but in Machen country, near the valley of the Usk. But the same visitor looks her up, the young man who is distraught over his wife loving another, breaking up their marriage, and the comfort she offers is identical too.

In 'Blessed Are the Clean of Heart', sixty-six year old Lucy Barr, by dint of her inner purity, is awarded a glimpse of God: "Experience had seemed to pass her by until now, when, in the dawn of imagination, experience claimed her in one blinding second and the tortured and loving eyes of the crucified Christ blazed upon her in great glory. In the physical darkness that fell upon her, the world of light and colour merged into that faint pinpoint of yellow Richard had instructed her to put in the branches of the magnolia. And glowing from that point, rising like the sun over the sea, she saw the face of Christ – no longer crucified, but in His own divine nature, reunited to his Father and gathering to Himself all his beloved Creation with its sins and its sorrows, its joys and its triumphs." In 'They Shall Obtain Mercy', hard-pressed doctor, Hugh Waverly, in

between the demands of his sick wife, his son and his professional practice, steals a Tanagra image of a satyr from an elderly patient because he *needs* it while she merely *owns* it. Happily, through the connivance of objective but scrupulously fair, Dr Harvey, the matter is resolved and Hugh acquires the money to take his boy on the holiday they both need.

In the sections not recycled from novels, Frank put a deal of hard work into the writing which is fresh and affecting for a work of this kind, using metaphors that echo in the imagination: "In the dust he could now see the shape of his own mother, his brothers and sister, his friends in Dublin; and it seemed to him they had struggled as these early Christians had struggled to retain the bright, excellent coin of faith they had been taught as children."

BLESSED ARE THEY

As they walked slowly along the cobbled road, Patrick watched them from the steps. He had grown to like them, as he grew to like nearly all those who came to the catacomb. They are going back to the world, he thought; and for a moment he envied them. But not for long. As he returned to the garden and sat awhile on a stone seat by the entrance to the catacomb and felt the rush of cold, pure air from below, he experienced once again that reassurance which had fortified him earlier. A thousand voices seemed to surge up to him from the galleries where life had been so close to death and death no more than the pathway to life. "Patrick," they seemed to say, "you are our friend, and our home is yours: the home that all will inherit who love God." He blinked and touched his forehead with his hand. He longed for a cup of strong sweet tea and wondered whether be would be allowed to make it himself from the packet his mother had sent to him. "I am twenty-one," he thought; "I am a man; I have the years before me." Years in the darkness were tunnelled out before him, years stretching to cavernous depths, to the very centre of the universe where God's children worked out their bewildering days. But for him there was no bewilderment. "Lead Thou me on," he murmured. And, getting up, he walked very slowly towards the school buildings, pausing sometimes to gaze across the gently rising hills to the distant, muddled mass of the Eternal City, over which the rich and generous sun of autumn glowed in fiery grace. Patrick watched a peacock butterfly over a brilliant bed of zinnias; and as he looked at the beautiful coloured creature, a pang of despair rose in him.

(Blessed Are the Patient)

RAMSGATE & ASHTEAD (1952-57)

However many times they moved, a money problem arose. Almost inevitably, when bills accumulated and they were down on their luck, Frank believed a change of address would alter their fortunes. Sometimes it did supply a partial answer. They might acquire a larger house – more suited for a growing family – but that did not ease the debt, only shifted its location. And that was basically Frank's dilemma, of being a distinguished novelist who fielded approving reviews, but one who had not yet established a broad base of faithful readers. Yes, he wrote enticingly and often amusingly, but lacking the tart, filmic edge, the slightly bitter-tasting narrative pull, combined with a journalist's grip of the contemporary political scene, of Graham Greene or even Patrick Hamilton.

The latter pair, the first a Catholic and the second a Marxist, had grasped that the thriller form was the way ahead for any writer who wished to write serious novels. Quiet, domestic dramas, with a spicing of supernatural whimsy and an infusion of religion, were all right, but had a limited market compared with a potent combination of violence, sex and pursuit. In the context of their extended intellectual scope, thrillers now provided a foundation upon which to launch political, philosophical and even theological themes, so long as their was the requisite action, pacing and sexual interest.

In a gesture of rather desperate spontaneity, Frank and Kate broke with Mevagissey, selling their cottage near the quay in 1949 and returning to London. Frank assumed the capital would offer enhanced literary opportunities. However, once they'd actually moved, he became disillusioned, realising he was chasing an idea, a hope, a yearning. "A long process of deception set in," he wrote, "when I fooled myself into believing that it would be easier to make 'literary contacts' if I was nearer London." Steadily he was absorbing the bedrock truth: that success is not best pursued like a ball bouncing down the street. You should merely travel hopefully enjoying whatever comes your way.

Optimism was stoked by a holiday in Italy. In Rome, Frank and Kate were granted an audience with the Pope who asked whether they had children. Two boys, they replied, and he exclaimed, "What, no girls!" and, after conferring a blessing on them and their little ones, he sent them away suitably elated.

Returning, they found London hectic and unsoothing – no longer did they feel right there. Especially when Kate told him she was expecting another child. Cornwall had become so ingrained that they were soon back in Mevagissey, but no longer in the village, instead renting an isolated house high above the sea at Chapel Point. The landlord was "that extraordinary old hare", John Layard, a noted guru and analyst to many a famous figure of the 1930s, including W.H. Auden and Christopher Isherwood. It was the place where they'd spent their honeymoon, with steps leading down to a beach which was so silent and deserted

155

that they came to imagine they owned it. In this idyllic setting, Josephine Baker was born, February 18th 1950 and christened after the 'Queen of Paris'. Frank hoped the name might confer special talents on Josie who, indeed, did turn out to be an actress, singer of popular songs and poetry reader. Fortunately he had earlier been to Paris, performing English folk songs for the French radio, later allowing himself a bit of fun and frolics by slipping in a visit to the Folies Bergère where Josephine Baker was the star.

In January 1951 he made an entry in his journal:

> 'When our Lord falls in our Lady's lap
> England shall have a great mishap.'

Old prophecy – and this Easter falls on Lady Day. What? There are eruptions in Australia, avalanches in Switzerland, Europe is under the military dictatorship of America, General Eisenhower has the impertinence to rebuke the *Dutch* for not having enough divisions to go into battle, there is no coal, the lights of London are out, no paper, no meat – and the Festival of Britain is being set up. A year never started more badly. In Mevagissey everyone has had or is having the flu. Nobody has money at all. A grey half light over the sea. But I never felt more full of hope.

Unfortunately money from the earlier sale of the cottages was dwindling and royalties from books and articles had ceased to flow. The novels written since 1947 no longer brought in enough to maintain a growing family and the paperback market was pointlessly restricted. To aid the financial situation, Kate contemplated a temporary teaching post and Frank borrowed small sums of money, securing wood for fuel and practising Micawberish frugalities to conserve what they had. Things only looked up with the announcement of a family bereavement, blending shock, grief and loss with the guilty elation of being a beneficiary. Frank's mother Lillian passed away, providing a sum of cash that temporarily alleviated their difficulties.

But still the legacy was not sufficient to keep them going. What television and broadcasting work there was available was mainly London-based, needing on the spot decisions. Therefore, on 15th January 1952, the Bakers yet again left Cornwall, this time for Ramsgate in Kent. FB's journal noted: "Finished at Long Point. We depart for Ramsgate in 3 hrs time. These are the last words I shall ever write here…" Thus Frank, Kate and their three children, their furniture and possessions, were whisked away by a hired Rolls Royce to a home that had been offered to them by George More O'Ferrall. There followed a stay in Ireland that had an effect on Frank, turning him from a practising Catholic into a lapsed one. He was especially pained by seeing Catholic priests drawing excessive funding from the poor and oppressed.

In 1952 the tenure in Ramsgate ended. Again the Bakers found themselves transported, this time to a rented flat in an Edwardian house in Ashtead, Surrey. "With three children," he wrote, "mounting expenses, ideas not

selling, story options stalling, publishers hesitating, rent and rate demands never keeping abreast of bouncing cheques, and the liquor at the Leg streaming ever more menacingly, I was at last forced to seek some kind of a regular job." Fortuitously the BBC came to the rescue, offering Frank a job in the television drama department, necessitating he travel three or four times a week to the "friendly building" at Shepherd's Bush where there was a posse of similarly dispossessed and penurious scribes prepared to pool their ideas in the interest of national amusement.

At Ashtead, Frank worked intensely, writing a play 'Straw in the Wind' (about Amy Carr) which was produced on television and well-received by critics. Interest was expressed by a West End theatre, only they had reservations about the 'fantastic' ending. It seems Frank was unable to adjust the conclusion sufficiently to gain their approval or maybe interest simply petered out. As if to compensate, the following year (1953) delivered a grand theatrical event. Ann and Douglas Campbell had gone over to Canada, loaning the Bakers their Chelsea flat, so they had a place to stay for the staging of *Miss Hargreaves* at the Royal Court in Sloane Square. Thirteen years had passed since the novel's appearance and it may have been that theatregoers were overdosing on gentility and whimsy, but the adaptation, although well done, only received a lukewarm reception:

SPOOKY MARGARET

Eerie fantasy and farce do not mix easily, but up to a point Frank Baker's *Miss Hargreaves*, at the Royal Court Theatre, gets plenty out of an unusual idea – thanks to Margaret Rutherford. A mythical old lady invented by a young man as a joke, turns up with a bulldog, cockatoo, harp, hip-bath and many skittish affectations. Miss Rutherford's girlish antics are superb, but even these wear thin with the joke and its spooky climax. She is well supported by John Justin, George Curzon, Dorothy Turner, Pat Sandys and a good cast who provide almost enough fun to make the weirdness acceptable.

Inevitably Margaret Rutherford became a family friend. She and her husband, Stringer Davis, visited the Bakers for Christmas and were subject to the boys' somewhat disintoxicating practical jokes like placing a rubber dog turd beside their plates of turkey and creating a loud bang whenever a wine glass was raised.

Although he missed the peace of Cornwall, Frank's persistence in remaining at Ashtead was rewarded by the unexpected sale of a story which finally materialised as a novel: *Lease of Life* or *Nearer to Heaven* in the States. Unlike Miss Hargreaves, the film option for this novel was snapped up instantly and made into a moving film, starring Robert Donat as the Yorkshire parish priest who learns he has a fatal heart condition and only a year to live. Frank, delighted by the windfall, took a day return to Waterloo to celebrate the success of the sale. Another novel which he wrote at Ashtead was the mysterious and perplexing *Talk of the Devil*, calling it his attempt to "play the Aleister Crowley card".

Despite the intense literary output, Ashtead did not suit Frank or his family who continued to enjoy holiday breaks with friends in Cornwall. Often he was left on his own and knew exactly where to spend his time. Black, perilous days of drowning money in the Leg of Mutton and Cauliflower (two much resorted-to pubs) accumulated. Now Josephine had come along, the family amounted to five, and he felt compelled to maintain a slave-driving routine of mechanical writing, while the practical problems of managing the house and growing teenagers fell on Kate, who complained that Frank's depressions were partly self-inflicted by his physical dependence on so many alcoholic pick-me-ups. All this reached a breaking-point in 1956 when, after a ferocious row, Frank beat a retreat to London to look up Kate's younger sister Belle and her husband, Hans. The latter was a Buddhist who diffused an atmosphere of calm.

His state of mind is communicated in a letter he left for Kate, in which he asks to be forgiven and reflects on his anger and sense of worthlessness. "I have not asked for any of this," he declares. "Maybe I have deserved it, but I think I have had enough. But I must not war with you, the one person who means all life to me… But I am angry; I am very angry; I cannot find acceptance in my being. I watch the dustmen collecting our muck. At one time I was sorry for the dustman – now, I am not; for he is paid to do a job – and I do not seem to be paid to do mine. I have used what little 'art and craft' I have till I am almost dead – and this is the result, after 13 years marriage… Felix says to me – 'Don't lose confidence in yourself.' Fool! Of course I haven't lost that; I have lost confidence in everyone else – except you… You stopped me. You were right – but then I was suddenly forced back upon the room with the unwritten words on the wall. And the piano I can no longer play. I have drunk very little (a little gin) and left the remains for you down by the small bookcase by the door. Drink it and don't accuse me – of what? I have no word. I become more human when I drink; I find a common touch. My dear, draw out from yourself at this moment in our common venture – all that stamina you inherit from the Midlands. 'A bit of the old Worcester,' please. It is lifesaving. At this moment, while typing this to you, I want to break everything up. I won't… Destroy this when read. I could not bear Jonathan to read it. I am physically in good form. Spiritually – I am in a mess. 'The dark night of the soul has gone on for too long.' But all I ask is keep your faith in me alive and we will come through. Make some soup. I would like that when I come in, sure to be last train. God loves us if He exists which I doubt."

After the explosion of rage and insecurity, there creeps in, almost inadvertently, the sly note of confidence, assuming Kate will be there, holding out to him the steaming bowl of soup. For it seemed that, however fierce the eruption, the years had only increased and deepened their bond, their twining together like Baucis and Philemon.

LEASE OF LIFE (1954)

*L*ease of Life was the most successful novel of the second half of Frank's career. It was filmed with Robert Donat in the leading role and revived his optimism and sense of ambition much as the spectacular response to *Miss Hargreaves* had some fifteen years previously. Although written during a period of intense financial pressure, an ease and serenity infuses the prose that communicates the author's pleasure with the material he is handling. *Lease of Life* is an effectively understated story about a middle-aged vicar of a country parish, Lawrence Hearne, simultaneously zealous and modest, who is told by a doctor that he has only a year to live which, as Dr Johnson observed, "concentrates the mind wonderfully" and spurs him to reappraise his existence.

Spiritual questions bother him, especially what he sees as the Church's lack of engagement with the everyday problems of the 20th century. Given that man is a material being, he asks, is it not better for him while on earth in the flesh to attend to the physical needs of his flock, to involve himself to the utmost with their earthly life rather than fixate on a promised life to come? He also tries to confront paradoxes in the Bible, such awkward points as "Why did the Lord say to Judas, 'What thou hast to do, do quickly.' He was not warned not to do it; for him – the outer darkness and the noose. And without his place in the scheme, how could the redemption have been fulfilled?" Hearne, wisely, breaks off here,

for to follow the logic of Judas doing his duty by betraying Christ is akin to admitting sin as a functional necessity and not a case of man falling into error.

In addition, Hearne secretes a grief in the form of his son David who lost his life flying in the Second World War. He also feels that his job does not provide for his family. This situation is amplified when his wife wishes their daughter, Susan, to be funded for a musical scholarship. Lawrence simply has not the money and is too proud and principled to beg.

HONEST TO GOD

Although a low-key, apparently orthodox narrative, *Lease of Life* puts forward views that were progressive for the 1950s. Lawrence Hearne's sermons anticipate by a decade what Bishop John Robinson's argued in his dialectic *Honest to God* (1963). The book sets forth his ideas about God, the supernatural, religion, prayer and the duty of contemporary Christians. Citing theological existentialists like Paul Tillich and Dietrich Bonhoeffer, Robinson proposed a ground-based approach to Christianity as opposed to touting Heaven, Hell and the Afterlife. In his preface he stated, "I suspect that we stand on the brink of a period in which it is going to become increasingly difficult to know what the true defence of Christian truth requires... I am convinced that there is a growing gulf between the traditional orthodox supernaturalism in which our Faith has been framed and the categories which the 'lay' world finds meaningful today."

This message is anticipated by *Lease of Life*. The less than palpitating climax of the novel is Lawrence's Lenten sermon which, while losing him his post at an important church school, gains him a notoriety that turns out to be remunerative – an offer arrives for him to write controversial newspaper articles. To his young audience in the cathedral, he emphasises "The Kingdom of God is within you", encouraging them to pursue their aims with energy and zeal rather than bothering about the life thereafter or the role of dark forces. "Too much thought," he says, "of that sad lost figure we call the devil will only turn you away from your own true path. And does it ever strike you that it is we who create the devil anew every day, in the same way as we crucify Christ? Has it ever occurred to you that he has no real existence as an independent being – outside our own troubled natures? We all share bits of the devil – and you won't find him anymore outside yourselves than inside yourselves. If you live in fear of hell, and the darkness where the devil is supposed to reign supreme, as in the pages of Milton or Dante, you are really afraid of your own nature – of your own complexities and contradictions – and this fear will yield you no more happiness than will the forlorn expectation of heaven."

Frank, like Bishop Robinson after him, argues the church needs to be broader and more open in its approach by telling people enjoyment of life is a holy act. Being inhibited by the Devil or transgressing a moral boundary may interfere with the natural delight in things that God intended. Robinson went

further than FB, accepting Christianity was implicit in concepts like 'humanism'. Neither did he brand as beyond the pale non-believers or Christians who approve of Christ as a force for change or enhancing existence while doubting such concepts as Life Everlasting. In other words, he sought for a compromise between the two poles, not acknowledging what attracted many to Christianity was its amazing, charismatic and magical irrationality: immaculate conception, the raising of Lazarus, the feeding of the five thousand, rising from the dead and ascending into heaven.

Written in third person intimate or close-up, the viewpoint of the novel is mainly that of the central character, Lawrence Hearne, varied by short scenes in which his wife's angle is briefly explored or that of Martin Hood, the organist (who's also suffering doubts about his faith). The straight narrative is supplemented by sometimes lengthy entries from Hearne's journal, containing quotes, reflection and minutiae as well as dramatic tidbits that fill in small points of the plot or seal up doubts or confusions. Entries vary, dryly reposeful or piously speculative or showing an anxious urgency, depending on the mood of composition. Usually the prose is graceful and swiftly flowing and, despite the hackneyed format, does not strike the reader as contrived because the author is so manifestly at ease with it.

LAWRENCE HEARNE'S JOURNAL...

It seems to me that I look inside, truly, for the first time in my life, wondering what I shall find there. It is very much a state of wonderment... Nothing at all remarkable has happened to prompt these thoughts. I have merely been told by Dr Pember that I am suffering from an incurable disease of the heart and can expect at the most a year more of life. Now I repeat to myself – to you, Lawrence Hearne – there is nothing remarkable in this. Men this moment in their thousands are being born, thousands are dying, and all of us are caught midway between birth and death. We all know that death is inevitable; yet we live as though it did not exist. Comforted, or otherwise, by the Christian teaching of heaven or hell, we go on from day to day, getting better or getting worse, living and partly living. We are all fumbling, and I, a priest of God, struggle to see more daylight. To be told you soon have to die – what does it mean? Practically, it is of course a nuisance. I think of all that I wanted to do and it seems to me that I have done none of it. I think of S. and V. and what it will mean to them. And yet, so soon, one forgets the dead unless they were very close to you, as David was... O God, open my eyes wider; let me see more, if it is Thy will. If it is wrong for me at this moment to have no regrets about my life, I am sorry. But I do not feel them. I cannot now believe that 'acts' of contrition or faith or hope will avail us much. We are all here, our unique personalities intact at any given moment; we have some part to play, the meaning of which cannot now be made clear. This is all we know. And yet I pray, "Open my eyes wider." N.H. has just stumbled across the lawn, drunk again. He blames the devil, which, as always, irritates me. Is the devil the most clever of man's inventions – the great scapegoat upon whom all man's treacheries are loaded – so that it *is* even possible to

devise ghastly engines of destruction like the H-bomb – and blame the devil, either in terms of American capitalism or Russian Communism? Fear of this beguiling myth, this proud Lucifer, prince of' darkness, leads to that sort of negativity which men call virtue. And yet, even as I write, I feel the darkness around me – I feel the great monstrous burden of the world's accumulated evil rising like a hurricane to shatter our self-esteem…

LEASE OF LIFE

Lawrence Hearne, 52 years old, and vicar of a poor country parish, is told that he has not more than one year to live. His innermost thoughts, his reassessment of life's values, and his spiritual growth during that year are recorded in his journal – and woven into the narrative.

Here is the story of a man facing a situation which in itself is enough to test his courage and faith, complicated by the ambitions of his wife, Vera, for their musically talented daughter, Susan.

Vera Hearne has since resigned herself to the financial restriction of a vicar's wife but rebels when she sees their poverty destroying Susan's chance to study piano in London on a musical scholarship. And when a dying parishioner entrusts a large sum of money to the vicar to be held for his son, the temptation is too great for Mrs Hearne and she takes some of the money for Susan's musical training.

The vicar suspects what his wife has done, and into his already harassed mind comes the problem of how to remedy the matter without destroying Susan's newfound confidence. The situation is not eased when the vicar, being considered for a remunerative position as chaplain in a boy's school, tears up his carefully prepared "trial sermon" and gives the boys a heart-to-heart talk on life's real values… This loses him the position and alienates his wife, but brings him unexpected publicity and the chance to remedy his wife's theft by writing for a city paper.

The year is passing rapidly now, but the vicar goes on in his faithful, gentle, ungrudging way towards the end. The story of these last days, rich in memorable incidents, is permeated by a human, yet almost divine, love.

THE FILM DIRECTED BY CHARLES FREND (1954)

In his history of Ealing Studios, Charles Barr (Third Edition 1998) describes the film as "Frend's most impressive post-war film, his forte being certainly not comedy, not spectacular heroism, but the charting of modest, dutiful work. The film's attitude to authority is unusual for late Ealing. Reverend Thorne consciously offends both the local headmaster and his bishop, and thus sacrifices a promotion that is virtually settled, by preaching a sermon that ridicules the idea of a headmaster God."

The screenplay of *Lease of Life* was by Eric Ambler, the thriller writer who married Alfred Hitchcock's producer, Joan Harrison. Hearne's name was changed to Thorne to provide greater allegorical resonance. Robert Donat played the leading role with considerable dignity – earlier he had played the hero in *The 39 Steps* – and lent his hand in the promotion of the book. "From the first flowing sentence to the last," he enthused, "Frank Baker's narrative moves – clear as a crystal, like a stream borne gently from its first faint trickle in the hills, effortlessly and inevitably to the everlasting sea. The man in this story touches greatness. Calmly and serenely comes to realise the deathlessness of faith…And we who watch his journey come to realise there is a blessing of courage."

A man who claimed a special relationship with the film was Michael Walker, author of *Hitchcock's Motifs* (2005), who confided his reaction to fellow critic, Ken Mogg:

When you next watch LEASE OF LIFE, think of me. It's the only feature – to my knowledge – filmed in and around my home town, Beverley in East Yorkshire. The fictitious cathedral town of Gilchester in the movie is the real life Beverley, which has a famous minster, where the relevant cathedral scenes were, I'm pretty sure, filmed. The schoolboys are likewise from Beverley Grammar, which I did not attend, since my father insisted there was a better school in Hull – which he had been to! But when the film shows location shots of Beverley, I strain my eyes for a glimpse of someone I might remember – I would have been 12 when the film was made.

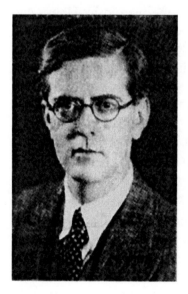

Left: A.L. Rowse – FB admired his poetry, arranging readings and radio broadcasts from Cardiff.

Right: Margaret Rutherford, actress, friend and correspondent of FB who brought *Miss Hargreaves* to the stage in 1953.

CLAREDENE (1957–62)

In 1954, Frank's father, Edgar Baker, died, leaving his son the sheltered bungalow Claredene, "the wood and asbestos shanty" at Perran Downs, earlier utilised as the setting for *The Downs So Free*. This was akin to a fortuitous tragedy for the Bakers, restoring part of their birthright. Although for years they had visited Claredene, they now owned it as a permanent retreat. During the Ashtead period, a longing to return to the duchy had been growing. Edgar Baker, who had remarried after the death of Lillian, spent his last, happiest years at Claredene. After his death, Edgar's widow, Freda, preferred to set up home elsewhere – hence the property passed to Frank. But he was cautious about uprooting himself and returning to Cornwall right away. Feeling that his writing was progressing, it was more convenient to be near the Television Centre and he did not want to revisit St Hilary, there being too many memories of his old mentor, Ber Walke, that might unsettle him.

But on one occasion, while his father was still alive, he broke this self-imposed taboo, going out one evening and taking with him bottles of beer from the Trevelyan Arms. Soon he was delighted that he had taken the short walk, for the rectory at St Hilary, Ber Walke's old home, was now lived in by Denys and Jess Val Baker who made him especially welcome. Soon he was sitting by the old fireplace with a plate on his lap and sharing with them a delicious meal. Afterwards they took him upstairs and showed him their children sleeping in six small beds and he thought how happy Bernard Walke would have been, a lover of children and animals, a protector of the rights of orphans, that such an empathic family was presently there. True, the Val Bakers were not Christians in a doctrinal sense, but like him they were dedicated pacifists, upholders of the arts and generous and hospitable in the way they used the old house.

WHEN I MADE SCONES

It was not until 1957 that the Bakers physically moved into Claredene from Ashtead. Previously they had sustained their allegiance to the duchy by spending regular holidays with the Gilberts in Heligan. The brothers, Jonathan and Sebastian, found the change not entirely agreeable, for they had by then made friends at Ashtead and Dorking. Jonathan recalls putting his possessions in store, including his collection of birds' eggs and 'Saint' books by Leslie Charteris.

Frank's 'Claredene Years' of the middle and late 1950s were alternately tranquil and tumultuous. Often he might be away, on broadcasting or television commissions, but Claredene was his domestic anchorage. For a while, when his

children were working towards 'O' and 'A' Levels and he had little work on hand, he found himself doing shopping, cleaning, cooking and other household chores. No longer the chief wage-earner, he was obliged to defer to the needs of Kate who, to staunch the cash flow problem, had obtained teaching work in Penzance. She left the bungalow early in the morning, enabling Frank to potter about and juggle ideas. Happily, through the knightly initiative of an American friend, Welford Inge (with whom he maintained a copious correspondence), he was able to sell an article entitled 'When I Made Scones' to *Harper's Magazine*. Delighted, he wrote a further twenty articles on similarly trivial accomplishments, but all were rejected, so he abandoned the idea of becoming a domestic oracle.

On the plus side, he was in a setting where he yielded to what he termed 'the call of Cornwall'. By himself walking, he'd hear the nightjar on summer nights in the pine branches and think of former days at St Hilary when he knew every member of the choir. The autumnal fondness that attends middle age was setting in and Frank would come back from the Trevelyan Arms and pause by the gate and admire the field of anemones. The next sight would be a ruined cottage, a former workhouse that generated a forlorn feeling. By contrast, back in the garden, things were looking up. Kate had laid shrubs and a friendly neighbour planted poplar trees to provide shade and privacy. They were basically happy years and yet those same changes that had affected Mevagissey were pervading Perran Downs. Building plots were taking over the empty spaces. New bungalows spread out in which retired people took residence and Claredene lost its solitariness. But the family was always able to retreat from development, cycling to Prussia Cove and cleansing their cares in the sea.

In an attempt to vary his output, he had tried his hand at cornering the younger reader, contributing in 1956 anonymously a story to Swift Annual 3, a boys' comic that enjoyed wide circulation. Set in Cornwall, it was a short colloquial piece called *Wild Honey* about a donkey-man called Joe who offers rides to children on the beach. Joe has a store of wild honey that he keeps to himself, so that he may gather and sell it to holiday-makers for a profit. The main problem is keeping his secret from over-curious children. The story portrays Joe through soliloquy and direct speech, using the native dialect: "I seed you and Master Larry last night," chuckled Joe. "I seed you, and I laughed to meself as I hid with Timothy in the scrub. I was in no hurry. I sez to meself, I sez, 'Timothy and me'll wait here till morning, if need be, till them young scamps give up looking.' And the place where he gets his wild honey would have stayed a secret if it hadn't been for those darn kids..."

*

The move to Claredene meant that Jonathan had to attend Penzance Grammar, attuning himself to a new school and environment. He also changed his course of study, dropping music and taking up German. After a period of acclimatisation,

things worked out satisfactorily. He made friends who shared his interests and daily would take the Grenville bus back to Perran Downs from the centre of Penzance at 4.15 pm. One Thursday, a market day when all the pubs were open, he was waiting by the bus stop with his school friends when Jock Graham appeared on the scene, heavily drunk but apparently feeling the pangs of hunger. With Jonathan watching, he entered a butcher's shop and came out holding a lump of raw liver. As the bus came along, Jock attempted to take a bite but the substance proved resistant to chewing. So he merely stuffed the whole big blob of it into his mouth. Jonathan's friends were horrified by this cannibal cabaret. "Who the hell is that?" By the time he had seated himself in the bus, Jonathan was just able to look back and feast his eyes on Jock "foaming at the mouth with blood, bulging eyes and other horrible things seeping out..."

Meanwhile FB was easing into life on Perran Downs splendidly. In nostalgic mood, he visited the places in Cornwall he had known as a young man: Mevagissey, haven of his dreams, where he'd holidayed, honeymooned and fled to for comfort; Penzance with the Morrab Library and diverting sprawl of bars; Prussia Cove, said to be named after the notable smuggler, John Carter, who resembled the King of Prussia; Sennen, where he had regularly called on Mary Butts, with whose daughter, Camilla, he was still in contact and, as ever, writing genial, informative letters and receiving warm replies.

There was another close friend he was able to look up from Claredene. A friend who was no longer alive, but the cottage they had shared at Boscean was still standing, although in a state of disrepair. Since Marcus's death, a generation had sprung up, young men and women surging towards a future that was still forming, but the close companion of his early manhood had been cut off, denied the opportunity to develop whatever was uniquely his. Frank would strike towards Land's End and visit the little valley where his affair with Cornwall had been nurtured many years ago:

I have often returned to Penwith in the last forty years; and to Boscean, although not within its doors, for they are padlocked as the cottage falls into decay. The farm is deserted. A pottery is worked at one of the cottages. But the hard landscape is unchanged; the passing of years has no meaning here. What I once saw as conflict I now see and hear as harmony. Winds that lash the sea to roar and batter at the granite cliffs are in fealty to a divine law beyond our thwarted measurements of time. To know West Penwith is to discover that one is, as Edward Thomas wrote in his strange poem *The Other*, 'an old inhabitant of earth'. Here one can find a unity of purpose with people who lived thousands of years ago, long before the little pages of recorded history. And what is this purpose? Not only to survive, but to extend the consciousness; to discover, however painfully, that one's own unique being is an essential part of the whole immense and unending drama we call life.

He put down his feelings in a letter to John Raynor, perhaps his oldest and dearest friend, who wrote back [14/11/57] clearly moved:

Dearest Frank,

Oh, how I wish I could have visited Boscean with you. I have been ceaselessly haunted by the past, my own and yours. You have the very greatest power, you know, to roll back and virtually annihilate Time. You lived a part of the legend of Lyonesse. Few people have ever done that. For that reason alone you will never "solve" anything, or know very much peace of mind. It's the same with me; though my identical experience did not really begin until I was 36. For five beautiful years I knew Paradisal joys and ecstasies. Twelve years later I am as painfully aware of them as you are of yours twenty-four years later. The world as we know it does not, therefore, any longer content us, and it never can and it never will. But I have got much music from being cast out, and you will get a great play. I wonder how it is going? I think of it (and of you) such a lot. To-day I found a picture of you as a chorister at Winchester, standing in front of a stained-glass window. Like early pictures of myself, the knowing little creature knows a bloody sight too much! What are we? I ask myself, you and I, I mean, and the answer comes sighing down corridors so long and dusty that it trips over its own echoes and remains on the far side of interpretation. Something garbles it on the way! But what – and why?

All my love (yes, to you both) J.

Llewellyn, Frank, Kate, Josie & Jonathan Baker at Claredene.

TALK OF THE DEVIL (1956)

During the composition of *Lease of Life*, Reverend Frank Baker had been cruising on pious overdrive, inserting sermons and texts in his fictions, brooding on moralities and amoralities and paying homage to his Creator. But his next novel was a departure from Christian orthodoxy, being more concerned with blasphemy and impiousness, with the world, the flesh and the Devil, after whom it takes its title.

Maybe it was his return to the Penwith region that gave rise to thoughts of early days in Cornwall when he had known a distinguished liberal couple, William and Ka Arnold-Forster, who counted among their friends Virginia Woolf, Rupert Brooke, George Mallory and other famous political and literary figures. They lived at the impressively named Eagle's Nest, a Victorian house with a splendid Mediterranean garden perched high on the rocks of Tremedda. He had used them before, this couple, in *Embers* when he had portrayed them as drab, burnt-out bores. But he knew they were better than that: Will was brilliant with a gimlet mind and Ka sensible and kindly, with a quacky, slightly imperious upper-class accent; she was also a local magistrate who put tremendous effort into helping the locals. And yet this woman had passed away in the most curious circumstances that now were rekindling in Frank's ever-fertile mind.

For *Talk of the Devil* is a thriller, after the manner of Graham Greene, playing with the notion of Satanism as a means of power and manipulation. For an explanation of the genesis of this unusual novel, I can only refer to my book, *The Tregerthen Horror* which lays bare the Aleister Crowley background and subsequent reverberations in detail. But rather than repeat or recycle old material, I will here insert information I subsequently gleaned from studying Frank's papers. This information backs up my researches and adds a few details that will be of interest to anyone curious about this bizarre West Cornwall mystery.

Set in Cornwall in the middle of the 1950s, Frank's novel is practically a *Roman à Clef* in which many of the characters are taken from real life. This is acknowledged by Kate Baker who confided a quantity of hitherto unavailable information to the American critic, E.F. Bleiler. The mystery it purports to solve harks back to the Year of the Munich Agreement, 1938, when Ka Arnold-Forster, *nee* Ka Cox, died in an allegedly haunted cottage high up on Zennor Carn.

"Talk of the Devil", Kate explained, "is based on a true happening which FB had wanted to write about for many years. He knew the whodunnit was not his kind of story but for him this was a real unsolved mystery. Ka Arnold-Forster, who died suddenly in a cottage on Zennor Moor, was a strong character. She had been very outspoken about Aleister Crowley, who'd been up to his usual

nonsense in West Penwith, covens and the like. Mary Butts, who lived at Sennen and was a friend of Frank's, thought him dangerous – she had stayed at his Abbey in Sicily. Frank had met and liked Ka who, in early youth, had been the sweetheart of Rupert Brooke. Her husband, Will Arnold-Forster, was political and intellectual and worked with the League of Nations. Although Ka had heart trouble, Frank's theory was that she died of fright in that cottage. The young couple who lived in it had literally lured her to spend the night there, complaining it was haunted which, Ka said, was ridiculous. She died in the night, sitting in a chair facing the window. Now FB knew a wood carver and artist who made masks. He had one from this person and he suspended it outside a window in his place. Light was arranged to play on this mask, so that a surprised visitor would see it and become uneasy until the joke was explained. FB wondered whether something like this was not employed to scare Ka to death – he was not alone in his belief that Ka was the victim of a plot that was intended to scare her for being derisive about the practice of so-called witchcraft. It was intended she should be frightened but not killed. Ka had been dead some time when the couple in the cottage gave the alarm and Edward Sackville-West, who was staying at the Eagle's Nest, went over and summoned help. Ka's death shocked everybody – she'd been sharply critical of the witchcraft nonsense Crowley had left behind. The lonely cottage, the standing stones, the youngish couple, Ka's confident scorn of superstition and then her all-night vigil trying not to doze off in the chair – what might not the practical jokers arrange to punish her?"

It might be added that the book was written in the mid 1950s, after the publication of *The Great Beast* by John Symonds, a biography of Aleister Crowley to which it is more than slightly indebted, and when newspaper reports were awash with sensational tales of witchery and occult antics. Headlines like BLACK MAGIC KILLER and WITCHES DEVIL-WORSHIP IN LONDON enlivened the breakfast table and Frank must have thought that such a topical subject would surely find an audience.

The plot of the novel may be summarised briefly. Middle-aged, barely successful novelist, Philip Hayes (Frank Baker), drives to St Zenac (Zennor) to look up old friends and see if he can solve a problem that has bothered him for almost two decades: who or what caused the unexpected death of Gladys Acton (Ka Arnold-Forster) in a lonely, supposedly 'haunted' cottage above the village? Did she die through natural causes or was she the victim of a sinister plot, masterminded by the Satanist, Nathaniel Sylvester (Aleister Crowley)? Philip Hayes seeks out old contacts and friends, asking them difficult, often painful questions. Some resent his enquiries, in particular a proprietress of a restaurant called The Scallop Shell [The Lobster Pot] that formerly served as the headquarters for Sylvester and his Black Magic sect.

This heady stuff proved too rich a concoction in the opinion of Kate. "I think FB", she said, "had too much material at hand – he needed a Garnett, a Hutton to urge him to 'Slay your Darlings!' and 'Boil that down to a column!'"

Though not waffly, there's quite a bit of 'circling round' posing as investigation, plus tense hints of blasphemy, devilry and debauchery. But then, abruptly, the diabolical colouration fades, and the plot transforms into a spy mystery, locating a conspiracy at the source of the tragedy. The villain turns out not to be Satan or Nathaniel Sylvester but the dependably despicable Nazis, for whom Paul Acton (William Arnold-Forster) is secretly working – he engineered the death of his wife who had uncovered his traitorous intentions.

Well-written if leisurely paced, *Talk of the Devil* has some successes in characterisation: Gladys and Paul Acton for example. But it does not quite perform what it promises, starting off on a metaphysical note and ending on a quizzical one. Save for a suggestion of foreign origins, there's little indication why Paul Acton turned traitor and the investigation peters out in an existential maze. Early disquisitions about morality, the nature of good and evil, become less relevant as the story shifts it central concern, leaving Philip Hayes at the end pursuing his own distorted shadow. Here criticism is irrelevant, for FB did the job himself, making Paul Acton remark to Hayes: "You throw idea after idea into your books, you've got a rich, perhaps slightly melodramatic mind, but you never seem to gather up the threads fully."

Actually FB is being hard on himself. Although *Talk of the Devil* turns into a different book than described by the blurb, the plotting and accountability of the characters are satisfactory. Paul Acton has rather more lives in him than a single man could manage in his brief span, but that is often the way with villains. Quite a few ideas are raised but they are timeless notions that do not jar or drift in the air superfluously. As for Philip Hayes, he appraises himself as a leftover artist with his best work behind him. He shows a mild irritability with the welfare policies of the post-war era, nostalgically harking back to the artistic conclaves of the late 1930s, when everyone drank harder and lived more recklessly. Hence, to anyone interested in that milieu and the strange rumours they generated, *Talk of the Devil* will prove a stimulating literary excursion.

Predictably Camilla, daughter of Mary Butts, was intrigued. "As for Aleister Crowley," she enquired, "did you write *Talk of the Devil* before or after Julian [John] Symonds' *The Great Beast*? Surely you must know his chapter on Mary Butts and Cecil Maitland, the man she left my father for a few weeks after I was born. But is my mother always to be a figure of fun in people's books? No, not in yours. I'm grateful to you for that. One of the most interesting parts of her diary is the time she spent in Cefalu."

By modern standards, the novel is restrained, hardly any violent, climactic or intimate instances. Many of the sexual practices of Crowley were not only prosecutable; to even mention or evoke them in the 1950s was liable to bring down an accusation of obscenity. While there's a sense of strangeness and unease brewing in the story, FB never plunges into the cauldron and reports from the depths; maybe that was sensible. If that sort of thing is not your forte, why force it on yourself?

Making up for this restraint are the alert, detailed observations, like Paul Acton disclosing the ornithological identity of prominent Parliamentarians: "Eden was a starling; Aneurin Bevan, a ruff looking for a reeve; Bessie Braddock, the reeve who would not be looked at; Edith Summerskill, the long-eared owl waiting to pounce on every tidbit; Attlee, the great crested grebe because on the approach of danger they sink lower and lower in the water, swallowing their tail feathers…"

Even the breathless gabble of the doomed Stella Coleman is mildly amusing:

Talk of the Devil (P.123)

Darling, please forgive me not writing. There never seems a moment. Terribly busy here – every night there's a gang in. Painters, writers, actors and the trippers who don't know what it's all about but like the food. I've told you about Nathaniel Sylvester, haven't I? He's fat, repulsive, and rather beastly – but amusing sometimes. He's a poet of sorts, but all his poems are done in private editions. Olive keeps them locked up and won't let me read them. Every time you meet him he fixes you with his eyes and says 'Do what thou wilt shall be the whole of the Law.' To which you're supposed to reply, 'Love is the Law, Love under Will.' But I usually giggle, which he doesn't like. He's in tonight, with a whole crowd upstairs, and they're making a hell of a noise, a sort of groaning sound. I wish Olive wouldn't have him here really – I suppose he's good business, but I don't know... Darling, I'm so tired, but I've just had a very large gin with something in it which Olive says will pick me up; and now I've thrown six omelettes across to the Crouch Enders. I don't quite know what I'm writing or feeling, but I don't care. I really must try to answer yours. Don't worry about little Clare, she's happy at Truro, I only thank God I managed to get her there, and that this job can pay the fees. Do you remember a phrase 'Beasts in Ephesus'? It's in the New Testament somewhere; that's what I feel the people upstairs really are, but it's worth going on for Clare's sake, it must be worth it. I'm hunched in a corner of the kitchen writing this on a high stool, and listening to the racket up above. What a lot of sillies they are! Just taken another sip of this hellish drink, and it's lovely. Wish I knew what was in it...darling, suddenly a rat ran across the floor and disappeared under the sink. Quite horrible, but it didn't seem to matter. Outside the sea is beating against the walls of the house. Darling, I'm frightened...there's a way you can go where you can't turn back…

TERESA (1960)

Living in Claredene – the holiday home of his parents – stimulated brooding on the history of his family. Their emotional frets and fevers down the years provided Frank with a dependable if forlorn source of inspiration. In particular, his organist grandfather fascinated him. He was drawn to his blend of musical brilliance and steadfast ordinariness allied to his slightly odd choice of bride, a spirited, wilful and unintentionally overbearing young woman called Teresa who deserted him at an advanced age and took to the road like the poet, W.H. Davies. Frank had known and loved his grandmother and pondered: What was she thinking about to act in such a brave, inspired and autocratic fashion? Some thought her merely mad or unutterably selfish. Others thought that she had got God on the brain, for she sought out churches and the religiously minded for charity and understanding.

Frank preferred to see her as more of a suffragette, a woman who had never been able to explore the freedoms she desired, held back by the tribal rigidities and tut-tutting respectabilities of Victorian and Edwardian manners. Above all, she wanted to establish a relationship with God on her own terms and young ladies back then were simply not designed to do things like that.

In a way, the idea of the novel was an original one. The subject matter had few competitors. But the risk element in the project was fairly high. Writing a longish novel about a batty old woman, who also happened to be a religious nut, was far from the most brazenly commercial of ideas. The whole theme obsessed and fascinated Frank and he determined to make it one of his crowning works, exploring the religious psyche against the background of family upheaval and disapproval.

The novel was called *Teresa* and it tells how the heroine – though that's hardly the right word – left her staid, apparently respectable husband at the age of sixty-five and went off wandering in search of a spiritual authenticity she felt her previous life had been lacking. "From the convent school where she ends her days," the blurb informs us, "Teresa Mary Bennet, almost forgotten by her family, looks back upon her long struggle to escape from a suburban domestic background she could never accept. A woman of impulsive religious conviction and creative fire, she has always retained an intense awareness of herself as a creature of God; yet she cannot find answer to the question *for what purpose was I made*?"

In relating this story of a high-strung, defiant elderly lady trying to find the meaning of life, Frank does not follow a conventional chronology. He is a skilful enough novelist to have learned the sequencing of events in a work of fiction becomes part of the meaning. If you end a book at the beginning or at a

dramatic threshold, you are making a different type of statement than if you use a consecutive pattern. Beginning with the grandson, Philip, visiting the graveyard of Teresa, the story flips backwards and forwards over seventy years, so that the natural developments will appear as a series of jumps and switchbacks, the ironies rubbing up against each other. The last two chapters, for instance, are set in 1920 and 1940 respectively, the earlier one showing the bitterness and disillusion that Teresa felt with her marriage and the later revealing the fact that she once truly loved her husband after all, so that there is a healing in the closure, a coming round to what mattered before the break with the pattern.

Teresa is a rounded if lost character. With her mixture of serious metaphysical questioning modified by surges of playful craziness and breakaway alcoholic binges, it seems a pity the narrative could not have driven her into yet more daring extremes of behaviour, but Frank prefers to tether himself to the biographical facts. The scandal she generates is no more than a light rattle of shabby-genteel teacups and her purloining of the candlesticks from her parish church, in order to acquire funds to support herself and her drinking habit, makes for one of the livelier outbursts:

"Yes," she mocked him in a shrill voice. "Stolen from the church! That makes it more wicked in your eyes, doesn't it? Just because I've stolen a pair of hideous candlesticks from that humbugging, hypocritical, cold great barn of a church. Church! Oh, I spit on it! It's nothing but God's kennel, where He waits to snarl like a mongrel dog. That's your precious church, you and your father so worshipped – God's kennel. Well, I left Him a beer bottle, and that's enough payment for that sort of God – your father's God – God of the Sunday joint!"

Her onslaught is representative of what some Victorians and Edwardians of a thoughtful or radical disposition felt. Frank's friend, Derek Savage, classed his father's Christianity as little more than a habitual rectitude, a declaration of conventional respectability. FB admired Teresa's spirit, literally portraying himself in the story as her grandson, Philip, who wrote "strange novels" from his Cornish hideout and, quite naturally, loved his grandmother:

Philip reminded himself why he had made this pilgrimage: because he had loved Teresa; because, of the few remaining members of his family, he alone understood her tempestuous nature; because, being by chance only a few miles from the place of her burial, it had seemed the proper thing to do. During her life he had never seen much of her. But he had corresponded with her a great deal, and she had always filled him with a sense of the urgency of life. She had not so much answered his questions; she had made him ask them. And now that she was dead, she came to full life in his mind, not merely as an old woman, which is how he could remember her, but at any point in her long journey.

Both in fact and fiction, Teresa Mary Bennet or, strictly speaking, Teresa Mary Baker', was dependent on drink, whisky and stout being among her favourites.

Late in life, when practically penniless, she had a tendency to take to the road and call on relatives and friends of an amenable disposition. Naturally her drinking occasionally triggered 'scenes', but some people can't brood on massive metaphysical issues like God or the Devil without a fixative of some sort. Such restoratives may prove deleterious in the long run, alcohol provoking eminently damnation-worthy sins. One recalls Graham Greene's whisky priest in *The Power and the Glory* who gulped down a sugar lump from the dead body of a child.

Speaking in purely fictional terms, Teresa is never quite able to sink to such impressive literary depths, but she does manage to steal, tell small lies and get persistently sozzled which is not too bad for an elderly Edwardian lady. In the hands of a Zola or Balzac, the drama would have been played out in more gruesome detail; dramatic declines and reversals of situation would socially strip the characters, reduce them to grovelling wrecks, and there would be a revelation of a tragic, desperate nature, mangling the reader's emotions. But in Frank's novel, all the major players maintain their façades, life potters on and Teresa quietly dies amid the 'Sisters of Mercy'. But the quietness of this, the denial of shuddering melodrama, is perhaps the point the author wants to make: respectability does carry on largely unaffected by the misdemeanours of others.

WHY IS IT SO DARK?

A theme of *Teresa* is that the vital conflicts in life are between man and his Creator. This sounds lofty if not easy to work out in dramatic terms. What God is up to *is* a mystery – nor does He reply to human implorations in a manner readily grasped. More convincing are Teresa's gripes against social circumstance and others' notions of how she should present herself. What with her ostensibly upright or 'uptight' husband secreting a mistress in Paris, her biological desires peter into misery and trauma, and she finally retreats from the muddle and stress by burying herself in a monastic order. The last chapter stands as an effective bravura passage, literally a stream of consciousness. Memories, visions and hallucinations intrude on her thoughts, drifting back to better times and then forward to her present plight, a haunted monologue combining blasphemy, terror, desire and regret:

Why is it so dark? Why does the wind wail about the church? Why aren't there beds for wayfarers here? Are we expected to doss down in the font? Or stretch out on that altar between the two dirty brass candlesticks, and that respectable naked cross? What's that? What's that noise! Somebody's opened the door, there's the light of a torch flashing up towards you. Lie still, Trot, very still. They'll bury you here if they have the chance. Lie still, don't betray yourself.

Like the famous soliloquy of Molly Bloom, Teresa's voice become franker and more self-surrendering. It seems a late stage in her life for erotic feelings to emerge, but emerge they do, perfectly appropriately, in a church, a temple that

some see as a sanctified model of the body. The sins of the flesh are merely the manner in which religion works through us: God made man and women to procreate and recreate the fall that originally took place in the Garden of Eden. With all her religious questing, Teresa is really proclaiming the most intense experiences are physical and personal. This harks back to the speech of the frustrated Ellen in *Before I Go Hence* although the physical detail is more daring:

Oh, where's the young body, where are the strong brown arms which held me, the hollow in the shoulder where my head lay, the warm sweet place between the downy thighs where my hand lay? Who has taken it all away and left me nothing but the agony of memory? Is it God who has done this treachery to me, who gave me riches and stripped me to poverty? Have I to be the bride of Christ? Touch me, then, touch me, Lord.

Her thoughts proceed to get blacker and bleaker:

You're buried alive, with only a drop of rum to warm you as the worms start to writhe over your face and body. And you're frightened, you know you are. You've always dreaded this and now it's come, and it isn't pretty, it isn't what they say it is, the smooth-voiced priests, the holy ones. There isn't a hope, I'm lost, I'm part of the dead stones of this horrible haunted place. One among the dead, Trot, one among the dead. Christ have mercy, Christ have mercy…

A dark, vigorous passage follows in which biblical and occult allusions occur, a piece of writing that harks back to the previous novel *Talk of the Devil*, with its invocation of the Whore and 666. Teresa is presumably guying the desertion of her by her own children who are holding her up as a great sinner for showing such independence of character as to desert them. Considerable verbal energy is at work here, including punning and wordplay, an aptitude Frank did not much exploit, although the talent was there, and "the immaculate deception" makes the grade.

I sink fast in the deep mire where no ground is. It's pitch dark, except for a cold lance of light spearing in through the north window and touching the dead squire's feet. Stone dogs, things of nothing. We have come to the place of bones. It is the Field of Blood, where Judas hanged himself. Take a walk, Trot; the world is yours. Pew after pew is before you. We're all quite alone, we have all been locked up, we only have ourselves to entertain ourselves. Stand before the lectern and flip over the pages of the Bible. Read the Lesson. Here beginneth the second verse of the eighth chapter of the forty-fifth section of the one hundred and nineteenth episode of the three thousandth and one hundred and seventy-third saga of the Book of Doom. Now it came to pass in those days that Hashish, the Queen of the Underworld, rose up and took with her Belial, Astoreth and Rumm, her three children by the mastery of Alcohol, Lord of the Wastes of Wind and Water. And when they had come into a far country, one by one her three children rose up and hewed off her head, and holding it aloft for all the Sons of Concupiscence to see, they cried with a loud voice, blessed be the great Mother of Aholibah, Lilith most

175

Lusty! Blessed be her holy and immaculate deception! Blessed be her infamous name, and the hem of her gutter skirt!

This passage represents more than Teresa's drunk and wandering mind but someone who is actively denying her God. The tone is hardly that of an elderly religious lady, even one who is something of a rebel. What is marked is the erosion of faith. One cannot imagine this passage implanted into FB's earlier works. It would have been unthinkable then: an Oirish combination of blarney and blasphemy that disfigures or enlivens the more jocular pages of *Ulysses*. As the Bible is the Word of the Law, it invokes the ultimate mockery, for its content is serious like no other work: omnipotently serious, in fact: thus it has attracted every type of detractor.

CRITICAL RECEPTION

Teresa is a favourite of several of FB's admirers and drew praise from Kenneth Young in the *Daily Telegraph*: "only the insensitive and stony-hearted will remain dry-eyed with Frank Baker's *Teresa*. The story itself is neither sentimental nor particularly pathetic; it is the manner of telling it that is so moving, a genuine poignancy emerges, an overwhelming sense of the sadness of youth inevitably becoming age. *Teresa* is a work of great skill and greater sympathy." Furthermore, in a letter to Nico Davies, John Connell compares it to Joyce Cary, only "steeped – as Cary's work isn't – by the sense of the presence of God."

This is perceptive – indeed it *is* a finely written novel that required a deal of planning and reflection. The book achieved a German translation, appealing to the slightly pietistic tradition of the nation, but it did not get the recognition that FB hoped for because the general public preferred a racier formula to the humdrum perturbations of a past generation. After the appearance of her last adult novel *The Inheritor* that came out in the year of *Teresa*, Richmal Crompton remarked to a friend, "There's not much call nowadays for quiet novels about families and village life – that's rather a vanquished world."

Underlying *Teresa* is another fascinating theme relevant to contemporary women's studies. The notion of a woman being punished or ostracised for giving expression to the fuller reaches of her character – being designated as a rebel and outcast – finds a distinct echo in *The Vanishing Act of Esme Lennox* by Maggie O'Farrell.

The novel tells the story of a strong-minded young woman, Esme Lennox, who refuses to conform to her social class, dress predictably or compromise her intellect. But such is her family's exaggerated horror of the social embarrassment they imagine her behaviour is creating, Esme's intelligent rebelliousness is diagnosed as madness or mental illness and, by the cruel connivance of her creepily conventional sister, she is incarcerated for life in a grim mental institution. Nothing so tragic happens to Teresa but a similar situation is set up: a woman who shows independence and disrespect for social status is demonised. Teresa flouts convention and convention freezes her out.

Demelza, Stephen, Josephine & Frank Baker, Denys, Gill, Kate, Genevieve, Martin, Jess, Alan (Gill's husband) aboard *Sanu* at St Peter Port, Guernsey (c.1965).

THE DEATH OF PETER PAN (1960)

On the morning of April 6, 1960, Frank Baker learned of the passing of an old friend. Not an obscure writer but a publisher – an "artist among editors" – who was able to create an international ripple. The *New York Times* announced: BARRIE'S PETER PAN KILLED BY A LONDON SUBWAY TRAIN. Newspapers around the English-speaking world reported the death of Peter Davies as though his mythical counterpart had been effaced. "Death must be an awfully great adventure," was a famous line from the play, but now the ageless child, who had survived trench warfare in the First World War, had flung himself under a train and the press rose to the occasion by emblazoning vulgarities like PETER PAN STOOD ALONE TO DIE and PETER PAN'S DEATH LEAP.

The *Daily Express* reported: "Until he died at 63, Peter Davies was Peter Pan. He was the Little Boy Who Never Grew Up; the boy who believed in fairies. The name was a gift to him from playwright Sir James Barrie, and Peter Davies hated it all his life. But he was never allowed to forget it until, as a shy, retiring publisher, he fell to his death on Tuesday night." The article went on to describe a life that was an unhappy struggle to shrug off the pirate-killer from Never Never Land. The coroner pronounced Davies' death a suicide, remarking "the balance of [his] mind was disturbed."

Peter Pan grew out of the stories devised by J.M. Barrie to entertain Peter and his brothers. His mother was Sylvia Llewellyn Davies, daughter of artist and novelist George du Maurier and aunt of Daphne du Maurier. Sylvia's maternal softness and glowing good captivated Barrie, as did her attractive, spirited children whom he charmed and cultivated. Arthur, her husband, was irritated by the admission into the family of a brilliant if diminutive Scot with an aura of 'faerie' about him. With his fanatic desire to put children under the thrall of his storytelling, Barrie came over as a little odd. In 1909 his wife, frustrated and disillusioned, began an affair with the writer Gilbert Cannan, and their marriage ended. With the deaths of Sylvia Llewellyn Davies and her husband, Barrie assumed unofficial guardianship of the sons, one of whom, George, died in WWI. Another brother, Michael, drowned himself with his boy friend in Oxford. Many years later, in 1946, Peter Davies hinted that he and his brothers were 'spirited away' by Barrie from their family circle: "The whole business…was almost unbelievably queer and pathetic and ludicrous and even macabre." It was indeed tragic that the golden boy, whose youth had been irradiated by the greatest fairy tale of modern times, should die unhappily and alone, leaving behind a personal history 'The Morgue' that records his family's inveiglement with Barrie.

CARDIFF (1962-1966)

Maintaining a steady income from Claredene was proving difficult. By 1962, Frank was unable to obtain advances for creative work and speculative ventures were extraordinarily risky. So, when an offer came from the BBC in Cardiff, he decided yet again to leave Cornwall for another Celtic land and seek what limited fortune was in the offing.

His job was Script Editor at Broadcasting House, Park Place. There he sorted through promising and less promising scripts for radio and television, floated ideas and contacted contributors and performers. Almost as soon as he arrived, he took a dislike to the city, accusing it of deadening the creativity in him. "I wish you hadn't to be in the hated Cardiff," sympathised his highbrow ladyfriend, Brenda Poynting. "Well, perhaps you will discover some compensating factors in time. Of course, I will pray that you'll be able to write a novel in Cardiff. It is quite ridiculous to imagine you have lost your capacity for expression…"

Although he made friends in Cardiff and enjoyed a stint of lecturing in an adult college at Abergavenny, he was not truly happy. When he arrived, he was bearing a luggage of psychological and physical problems. These he had to master if he was to hold down his job. Several times before, he had struggled to overcome his compulsive smoking and drinking, but decided he'd better try harder this time. He had a bad chest and the drinking caused behavioural as well as medical problems. So, between coughs and sips of alcohol, he wrote to a hypnotist at Torquay (January 9th, 1962), Mr Henry Blythe, a friend of the writer and broadcaster, Tom Salmon.

In big, bubbly handwriting that unfurled in vivid green ink, Mr Hythe wrote back, thanking Frank for his "long, interesting letter" and explained how he could supply tape recordings of himself persuading the patient to kick the habit, using voice mesmerism or mechanical hypnosis. He had enabled several other writers to give up tobacco, including William Hickey of the *Daily Express* (guyed in John Osborne's disastrous satire *The World of Paul Slickey*), so he understood the species to which FB belonged. Frank also wanted Mr Blythe to help him shake the drinking habit; that deep-rooted dependency in particular tended to get out of hand, flaring into rage and mental instability.

Eventually Claredene was sold, and Kate and Josie moved to Cardiff, joining Frank in a rented home. The brothers, Jonathan and Sebastian (who by now preferred the name 'Llewellyn') started to plan their further education. Jonathan left home for London University and Sebastian went to Bristol Old Vic to study stage design. Years later, when Josie left school, she worked as an actress in a children's theatre company and developed her musical skills.

Along with his plummeting health came the inevitable money problems that he tried to alleviate by little acts of opportunism. One day, in January 1963, he read in the *Evening Standard* that the distinguished author and biographer of Oscar Wilde, H. Montgomery Hyde, was also a devout collector of Wildeana. So he wrote to him, offering to sell a relic of the great aesthete that he owned: a menu card of the Restaurant Marguery in Paris, so framed that both sides of the menu were readable. On the back of the list of exotic foods were four signatures: Oscar Wilde, Frank Harris and R. Caton Woodville and W.H. Harris. Dated 29/10/91. A quote from Dorian Grey in Wilde's handwriting was placed above his signature: 'The only way to get rid of temptation is to yield to it.' Frank Harris was a celebrated lecher, editor and author of vigorous stories and unorthodox critiques of Shakespeare; Richard Caton Woodville was a superb artist and war reporter who did work for Vanity Fair and W.H. Harris remains obscure (unless related to Frank Harris).

FB and Montgomery Hyde agreed upon a mutually satisfactory figure and the money passed hands over lunch in the Garrick Club, January 21st, 1963.

<div align="center">*</div>

Cardiff initiated a vexing, demanding period of trauma and neurosis. He was not especially happy in his work and suffered dark days and nights of endurance. After reaching an age when he should have been able to freely develop his own talents, he had to work towards deadlines and schedules and cast aside personal aspirations. So he visited bleak bars and clubs and mixed with dubious types who privately disgusted him. He reached the lowest pitch of depression after a bout of particularly heavy drinking disrupted the balance of his mind. When he collapsed and started raving, he was confined to Whitchurch Hospital in Cardiff where they treated his condition. He had a bad time there as he had to mix with patients who were desperate and down-and-out. He became horrified by his own condition and the plight of his fellows.

One man who shielded him through this crisis was an authentic Christian called George Powell who offered Frank comfort, hospitality and practical aid. In addition, there were many messages of sympathy from friends, several of a charitable and pious disposition. "I just picked up your valiant letter," a devout lady admirer, Ruth Troward, wrote from Oxted [April 8, 1964], "and kissed it; and love you more and respect your spiritual honesty... I believe this present experience, together with your own great gifts, can bring others true help and hope. Some few of us 'go down into hell' as we are told Christ did and then comes, afterwards, this Rising from it, and only He knows what He experienced there, and returned for a short while. It is Love perfected, and understanding for every one of us all."

After discharge, he renounced drink and tried to turn around his addictive nature. He wrote [May 5, 1964] to the Registrar, Dr Eric Fine, telling him that he had been managing well since his leaving and intended to listen to a programme on alcoholism on the Home Service. "Finally," he admitted, "the melancholia you warned me of probably came in the form of a trilogy of dreams on three successive nights, all of interest to the psychiatrist, and the last devastatingly terrifying to me – though merely comic now when reported."

Side by side with his mental breakdown came family problems. These centred on his sons' discontentment with the educational courses they were pursuing. Both Jonathan and Llewellyn decided to drop out of formal education, a reaction not uncommon in 'creative' families who prefer work to correspond with their shifting impulses which, inevitably, it does not. With the solid instinct of a writer who grasped what was happening under his nose might be handled more confidently than material from elsewhere, Frank utilised this commotion in his family life to make a filming experiment on the Isle of Mull. *Just One Lobster*, as it was called, was an attempt by a family of four young people to break through the barriers of social convention and family wishes to create a new and satisfying way of life. The film was narrated by Frank himself who explained its provenance. "The film is about a period," he explained, "in the lives of my three children. Not long ago my first son Jonathan was reading classics at London University. Now he tries to make a living fishing for lobsters. Llewellyn, my second son, also closed the doors we had opened to him – his art school and his work as a stage designer. My daughter Josephine was training to be an actress."

Clearly this was an absorbing project, showing that working close to the steering-wheel of the BBC had a congenial aspect. With his wide range of skills as a novelist, composer, pianist, dramatist and performer, Frank was able to push to the fore any idea calling upon these resources. Obviously culture was his metier and he contacted poets and writers, encouraging them to read and perform.

Neither were the distinguished deceased overlooked. Once, sampling his bookshelves, he became excited by a poetry collection of Edward Thomas and decided it was timely to celebrate on air the life and writings of this under-appreciated major talent. So he contacted the poet's daughter, Myfanwy, and his nephew, Edward, who approved the idea. In planning the project, he gave minute attention to detail, drawing speculation from Edward about his uncle's private life and attitude to Oxford. "Fundamentally," the nephew confided, "while Edward [Thomas] always stuck to Helen out of love or loyalty (or some elusive mixture of both), he always resented the deprivations resulting from her seduction of him at Oxford. Mostly, he would have appeared to have regretted being deprived of the sort of company he enjoyed at Oxford where quite different aspects of his personality came to the fore than when he was shut up with his babies, his remorse, his penury – and the hack work that symbolised all these things."

Frank's appreciation of Edward Thomas's was so heartfelt it initiated a friendship between him and Myfanwy who was delighted by the programme. "I feel I cannot wait a moment to tell you," she wrote in March 1966, "how deeply moved I was by your talk about Edward and the reading of his poems. It was one of the loveliest programmes I have ever listened to… Your selection could not have been better…but I was particularly pleased to hear your daughter's sensitive and understanding reading of *The Lofty Sky* which I love particularly…"

Another topical, fitfully provocative literary figure was Frank's old friend, A. L. Rowse, who had sympathised with him over his grief at Marcus' death and responded to his praise of *A Cornish Childhood*. Frank contacted him (June 1966) about making a programme from Swansea on the poet, Alun Lewis, whom Rowse styled as the Edward Thomas of the Second World War. Frank had the not-so-bright idea of running the two poets together, Lewis and Rowse, with a linking commentary – after all they shared the same initials A.L. – but almost immediately thought better of it. Frank, a devotee of Rowse's poetry, had just read *A Cornishman at Oxford*. He told Alfred Leslie how much he'd enjoyed it, even the more unsympathetic parts. The latter replied that such a reaction was natural, for "some people are subtle enough to understand that the dark passages are a necessary offset to the light."

"Even unknown names", he added, "are not dead leaves to a historian: they bring back the past, recreate it and keep it alive, as those people who have that kind of sensibility can tell. You may not have it, but I can judge how they react from the letters they write me. Sitting in the midst of my spider's web I react to the slightest twitch upon the lines. You provide me one reaction, if not two, with your passion for music which I share and agree with you in responding to more intensely that to any other art. As you know, only music knocks me out."

Displaying a vulnerable, affected arrogance, the letter continues, touching on the merits of his poetry, third-rateness and fifth-rateness, the stupidity of critics and, finally, the nameless, aimless, non-literate masses. The latter, while envious of his wealth and achievement, are unable to take in the full measure of Rowse, an intensely complex, demoniacally hard-working, ultra-sensitive fellow who combines the talents of poet and historian:

But as to poetry, or what you say about my poetry, you may be glad to know that I have put together a fifth volume of poems, two thirds American (I live there much more now), one third Cornish. Spurred on by *The Poetry Review* – Derek Parker is kind enough to think my poetry disconsidered or at any rate under-estimated (as it is) and wants to devote a number of the Review to a batch of new poems as a main feature. (Look out for the inspissated stupidity of some people's response). I have also brought together a new volume of Cornish Stories for Macmillan. For, when so many other people have dried up – or their inspiration has dried up – I have never ceased to write poems and stories secretly, under the

immense mass of work accomplished. (In California I am halfway through a big book on The Cornish in America). So you see my way of life – though other people may not approve of it (what do they understand? But the fifth rate, or third rate rather, never understand, though they should have the humility, or at least the sense of humour about themselves and their place in the scheme of things, to *try*. I suppose I would be beyond them, even if they tried – though trying would be good for them, might help their intelligence just a shade. Well then, my way of life turns out to have been very propitious to achievement and to inspiration. Think of all those dead husks, who have dried up, while I go on. In my own way, of course, for I dearly don't need to be told how to live by people who achieve infinitely less... The hideous thing about the Welfare State society is the way it releases all the envy of the inferior – the people who cannot achieve themselves. So I think I'm well to hold aloof from them. I don't allow these people to know me. I couldn't support it, for you know, better than me, that under the hard appearance, the willed carapace, is someone abnormally sensitive. They wouldn't know that. And I waste no time in explaining to them. It would be lost on them, and besides it would be demeaning; one would feel smeared by contact with them. It is better to be fortified by contempt and go on with one's work. Of course, it would be nice if someone occasionally came to one's defence and took up the cudgels for one or even made an attempt to understand a complex phenomenon, perhaps a rather unique one, for there has only been one combination of poet and historian before [Macaulay]. But no one has come to my defence. I suppose they think I can well defend myself, as in many ways I can. Now old and rich, but still creative, who was once young and poor and full of compassion and good will.

THE EVE OF LOST SOULS

Putting on such programmes was fascinating, but it involved a great deal of concentration. He was giving his all to the work of others rather than pursuing his personal ends. To relieve the stress, he would refresh his thoughts in the greener parts of the city – in particular a large wide field to the west of city, lying above a little park called Syr David's Field. "Here I would go", he recalled, "in the autumn of 1965, evening after evening, and always be aware of some new aspect of life held inviolable with or around that little field; for a little while each evening I would sit on a bench and begin to write verses, return home with a line or two clear in my mind, and race back again the following evening to catch the last of the sun and to renew my relationship with the Field. It is this place I will think constantly of when I leave Cardiff."

Only in his late-fifties, Frank's confidence was faltering. With an autobiography in mind, he had started to dwell on time and mortality. Aside from Syr David's Field, he would take out the Riley he had bought – for escape as much as work – and drive into the wilder parts, especially the Rhondda Valley.

This was an upland, airy region that industry had spectacularly despoiled: cramped terraces, morose chapels, sentinel pit-heads and slag-strewn hillsides where the air carried a carbon taint.

One day, thinking of looking up George Powell of Ynyshir, he took a wrong turn and found himself high up, lost in mist, with an ominous mound of fallen rocks by the roadside. His initial sensation was fear but that gave way to brooding on the generations of men and their families who dwelt amid these valleys and mean streets. They had wracked their bodies by hacking out spoils from the earth while he lived by chiselling a few paragraphs a day. He thought of their kinship, their sharing of hardship and bonhomie, and then it occurred to him that his deepest feelings seldom related to the living. Those he had known who had passed on filled his mind, and his allegiance to them outweighed other claims on his compassion. He recalled his inscribed copy of Ber Walke's play *The Eve of All Souls* that tells of a couple of newlyweds, John and Mary, stealing into their parish church on the night when the dead come back. The returning ghosts speak of their old lives in the tiny Cornish community. The local blacksmith's imagery of fire and anvil is invoked, hinting the departed souls are being beaten and shaped into something greater, more brilliant, and yet it is their muted longing for what they have left behind that affects the spectator. Frank similarly reflects that bits of his character, too, are detained in the past – adrift with a flotilla of dead names to whom he has access only through dream or memory: "There is Bernard's inimitable handwriting, and he is gone. I see him on his horse in the St Hilary lanes, his long head sunk under his wide-brimmed hat, his sharp-cut features imposed on his own countryside; and I see rubicund old Filson purring along with Prudence on the A30 road for another broadcast."

Throughout the long Welsh interval, Frank and Kate took breaks, usually returning to Cornwall for their holidays. An appreciable time was spent aboard Denys Val Baker's motor yacht *Sanu*. Large enough to be a comfortable home, both families looked forward to sharing a summer sea voyage, adventuring from the Scottish Isles to the Isles of Greece. Frank was at his best on the water, Denys recalled. Although not skilled at handling ropes or repairing the engine, he was an adept cook and never sea-sick. As a companion, he was wise and funny, kind and attentive. Normally subject to heavy depression – a malaise difficult to dislodge and endured for hours or days by his long-suffering loved ones – aboard he was less prone to mood swings. At anchor he would rise at dawn and jump overboard to swim round the boat. Normally the graph of his emotions was a big dipper ride, thundering up to the heights and plunging to the depths, one month drunk and delightfully happy, the next still drunk but suicidally miserable. On a yacht in the Mediterranean, with his family and closest friend, he was more consistently benign and genial.

VENGEANCE OF THE BIRDS (1962–64)

Details of FB's breakdown during his stay in Cardiff have already been hinted at. However, a piece of news released in 1962 caused him more distress and anguish, more professional torment, than any other incident in his writing career, simply because it salted the wound of what he perceived was his lack of success and resultant financial instability, for it related to the triumph of a fellow writer whom he thought had stolen an idea from him and reaped a great deal of profit in the process.

To express the dilemma concisely, Frank announced that two friends had independently informed him that a film of *The Birds* was being made by the celebrated director, Alfred Hitchcock, adding they assumed he would benefit financially from the venture. But Frank knew nothing of the matter and, after making enquiries, learned to his dismay that the film was based upon a story with an identical name to his novel that appeared in Daphne du Maurier's short story collection *The Apple Tree*. Aghast, Frank acquired the book and read the piece eagerly, finding similarities combined with a striking difference. Where his novel provided a sweeping, panoramic overview of a winged offensive on London, Daphne du Maurier showed it from the viewpoint of an isolated Cornishman, Nat Hocken, who took practical measures to repel the ever-intensifying attacks of flocks of gulls and lesser species on his home and family.

The first person he informed (19/9/62) was his old friend, Nico Davies, brother of Peter, whose firm had originally issued the novel. After some genial pleasantries, he struck to the heart of the problem:

Two friends, independently, have written to me saying roughly, "I see that Alfred Hitchcock is doing 'The Birds'. I hope you get something out of it." I had heard nothing about this so I made some inquiries. I was told that he was making a film from Daphne du Maurier's short story of the same title; and that this story had recently been serialized in the Evening Standard. I borrowed a copy of her book of stories 'The Apple Tree' and read 'The Birds'. Although the Cornish background is completely different it bears such a strong resemblance to my book that I can hardly believe she had not read it when she wrote her tale. Now, the point is there is infinitely more material in my book for a film than there is in her story. Is Hitchcock aware of the existence of Frank Baker's 'The Birds'? It's not that I think that he should be and I am prepared to send him a copy stating that it has come to my notice that he is making a film called 'The Birds' and would no doubt like to read the book. Incidentally the two friends who wrote to me did not know Du Maurier's name in connection with the Hitchcock film. I do not know how far the film has gone, whether a script has been made. But I don't feel that I

can just stand back and do nothing, and wait for Miss du Maurier's short tale to be re-issued (as it will be) and sell in thousands when the film is released. It is my book that should be selling in these circumstances. Is there anything to prevent you doing a paperback edition and bringing it out quickly? Nothing that I can see! Incidentally (though most importantly) I am quite sure that my book appeared before her tale though I am not certain of the exact date of her publication.

Nico speedily and gallantly responded, replying to Frank on the same day that his letter arrived:

Dear Frank,
I am glad to think that at least a little bit of moolah will be coming your way for this new stint and I shall hope one day to be having a look at "Stand Clear of the Gates" (a wonderful title!), though with publishing in general as it is now I wouldn't like to guess what our reactions will be.

 You put me in a particularly difficult spot over the film of "The Birds": at least it's difficult from the point of view of Daphne being my first cousin, so that what loyalties I have are horribly jumbled up. I don't know Hitchcock at all. I can't help thinking that if you are to take any step at all, the first one should be to a lawyer – though I must admit I would be surprised if the right sort of answer will come your way.

 If you like I would be quite ready to write to Daphne giving her the gist of the news within your letter and asking her point blank if she had read your story (though I wouldn't guarantee the truth of her reply); I could at the same time ask her what she would do if she was in your position…and whether she would think it a sensible idea for me to send Hitchcock (getting from Daphne his address) your own copy of *The Birds* which we have here. Yet it might be the best conceivable possibility to wait till the film comes out, wait to see how much of your story is incorporated and, if legally advised there is sufficient, THEN would be the time for storming the Hitchcock gates. And I would say that THEN, if the film is a success, would be the time to revive a paperback interest.

Thinking it was surely better he approach Daphne direct rather than ask Nico to confront his cousin with an embarrassing charge, he wrote to her. Promptly she replied that, far from having read his novel, she did not have the slightest notion that it existed. But she did confirm that, yes, Hitchcock had bought the rights to her story, but she had no idea of the content of the film, whether it followed the line of her plot or owed anything to Frank's book. Perhaps he had better contact the director, and so Frank did:

Dear Mr. Hitchcock,
Two friends of mine recently wrote to me, independently, drawing my attention to the fact that you were making a film called 'The Birds.' And both assumed that

this film was based upon my novel, of the same title, which was published in 1936.

'My novel was a long horror story telling of the destruction of the human race by vast hordes of savage birds, who descended in malefic force upon London, and tore it to chaos. I believe that your film has a similar idea.

Had I known of your plans earlier I would immediately have sent you a copy of my book, knowing that here lies rich material for a film. As it is, it has been offered to nobody.

I have a copy.

Would you care to read it?

Yrs. sincerely, Frank Baker

Next he wrote to a solicitor friend, Claude Richardson, portraying what he saw as his impoverishment and what he thought might be possibly achieved.

My dear Claude, May 6th 1963, Cardiff

Awful to write to you after so long a silence and never seeing you and then ask for your professional advice. And perhaps you will not mind; and might even be amused. You see where I am now for my sins? A horrid town but some good country not far away. I like the Rhondda Valleys. Do you know this part at all? I have a temporary job as a scriptwriter here till the end of the year when it might or might not continue. Half the family (Kate and Josephine) are here with me in a small flat; and the boys? I never quite know where they are, Jonathan (19) goes to London University in the autumn to read for a classics degree; and wants to go to Greece somehow this summer. Llewellyn (18) is working as a stage designer far up in Scotland, Pitlochry. He is the one who should do the Greek text from – was it Thucydides? – for you, but perhaps somebody else has. I wish we could meet again but distance...

Here's my problem, Alfred Hitchcock has made a film called *The Birds*. (I believe you pointed this out to Molly Walford some time ago, and she wrote to me.) It is soon to be released. It is not based on my book (published 1936) which I assume he's not read, but it is basically the same idea. He took his story from a short story by that Daphne du Maurier who I always believe *pinched the idea from me*. Be that as it may, I feel I ought to try to get a sum of money out of him. I did nothing for ages, feeling it to be pretty hopeless. (I did, many months ago, write to Miss du M. a humorous letter and she replied – naturally – that she had never read my book.) However, to-day I wrote to Hitchcock (copy enclosed). And I have sent a copy of the book – with 23, 000 words cut out – to a paperback firm *Panther Books* asking if they would care to re-issue it and pointing out the Hitchcock situation. The point is Hitchcock might well be prepared to settle a sum of money on me to ward off any kind of action – though I frankly doubt if any action could be taken after so long a time. However, nothing like trying. I wonder, have you any wise comments to make? Is it something you could

possibly handle for me? In any way? I am certain that his film is basically the same story. And it is bound to be a big box-office success of course. I expect my letter to him is a hopeless mistake. Tell me if you think so.

I feel I ought to get at least five hundred if not a thousand out of this. I don't say I expect to. I am having a try because I am up against the wall with a loaded gun held at me from the Commissioners of Inland Revenue who demand at once 300 odd from me, back tax arrears which I have not disputed, as I have no accounts at all.

A letter from the Tax Collector at Redruth last week says "you must now face the consequences of your negligence". I fear a warrant and the loss of my small house (which we have let to a family for three months so it would be more than awkward). Not a cent to stave them off and a large bank overdraft, (£400). Do you think I can salvage anything via Mr Hitchcock?

Yes, it is awful to parade this before you after so long no news at all. But please say something – I feel there is some way out of the mess. I still have to keep the family, and can barely do it on this job. And I have sold nothing for ages – except a sound-radio play to Radio Eireann.

If you want fuller particulars of the Hitchcock story I will send them – copies of letters to and from Miss du Maurier. (But I don't feel she should come into it at all). The rights of my novel have long ago reverted back to me; so I am quite free to sell it anywhere. I don't want to lose some money if it could be got.

Forgive me if this is a very boring letter,

Love to you all, Frank

STATEMENT: *THE BIRDS*

In June 1936 Peter Davies Limited (now of 23 Bedford Square, London, W.C.1.) published a novel by myself called 'The Birds'. This story was the sensational account of the collapse of civilization under attacks of vast hordes of mysterious birds who appeared overnight as from nowhere and gradually, one by one, attached themselves to individual persons, finally pecking and clawing them to pieces, submitting them to agonized torments, until London was torn to chaos, and from all parts of the world similar catastrophes were reported. An essential part of my story was that the only persons who escaped death were those who submitted to their attacking bird, and allowed it to settle on their faces. Such non-resistance resulted in the evaporation of the avenging bird and the immunity of the sufferer. Only a very small minority of persons had the courage and imagination to make this submission; and from this widely scattered band of isolated individuals a new world was to emerge.

This book has for long been out of print. The rights, and all subsidiary rights (filming stage, television, etc.) have since reverted to me from the original publishers and I am free to dispose of the property as I wish.

Some sixteen years after my book was published, Miss Daphne du Maurier (of Menabilly, Par, Cornwall) published a book of short stories. (*The Apple Tree*: Victor Gollancz). One of these stories was called 'The Birds'. (Recently re-issued as a serial in the London 'Evening Standard', and about to be re-issued by Penguin Books Ltd with the same companion stories and now under the collective title, 'The Birds'.) In this story, which is localized in Cornwall, a small village community is attacked by hordes of birds which come over from the sea. A farmer locks himself in his farm, with his wife and children, prepared for a long siege. The birds come in force down the chimney and peck savagely at the boarded windows. There are wireless warnings from London telling householders the precautions they should take in a national emergency. (There were similar Government warnings of a national emergency in my novel). The story closes with radio reports of similar attacks taking place throughout the world. (Again, similar to my novel). But Miss du Maurier's novella leaves the tragic conclusion of the horror in the air; we are merely led to suppose that the bitter end is coming. Whereas my novel describes in full detail the complete breakdown of London, on a Day of National Prayer in St Paul's Cathedral.

Six months ago two friends of mine wrote to me independently having read in the press that Alfred Hitchcock was making a film called 'The Birds'. From descriptions of this horror film both my friends assumed it was based upon my book. In fact, this film is based upon Miss du Maurier's tale, from whom, presumably, Mr Hitchcock has bought the film rights.

I wrote to Miss du Maurier last September, pointing out this situation, and asking herself what she would do if she found herself in my circumstances. She replied promptly (by return of post) that she had never read or heard of my book. I answered courteously, and there left the matter, for the time being.

(I must here state that Miss du Maurier is a cousin of the Davies Brothers who originally published my novel. I find it a little hard to believe that she did not see a copy of my novel at the time of its publication, since she was then in close touch with her cousins, Peter and Nicholas Davies, who were very enthusiastic about my novel and were giving it wide publicity – both before and after publication).

So far as I can gather from an article in the London Daily Express Hitchcock's film is set in America. I do not suppose that Mr Hitchcock ever saw a copy of my book (which would have made admirable material for a large-scale terror film); and I have not seen a copy of his film-script.

To this letter I have so far had no reply.

The Hitchcock film is quite obviously built up upon exactly the same idea as my novel. How many incidents it contains which are similar in detail (apart

from those I have mentioned above which occur in Miss du Maurier's tale, and may or may not occur in the film) I am unable to say.

In a recent issue of a French magazine – ('Marie-France') – there is a French translation of Miss du Maurier's tale. Tabloided above this, pictures of Hitchcock and the star of the film, Miss Tippi Hedren.

Mr Hitchcock's film has recently been shown at the Cannes Film Festival, with much publicity; and it is due for release in London shortly. No doubt screen credit is given to Miss du Maurier.

Signed: Frank Baker, May 13th 1963

Finally, on May 29, 1963, Frank received a reply from Universal Pictures. Not from the distinguished director Alfred Hitchcock – he'd never get involved in writers' wrangles – but from Joseph S. Dubin, Chief Studio Counsel of the company, who told him that "an examination of Miss Du Maurier's work, as well as a viewing of the photoplay *The Birds*, which is now in general release, will clearly demonstrate to you that there is no actionable similarity between your work, the work of Miss Du Maurier, or the photoplay *The Birds*."

As Daphne had earlier pointed out, the big studios connived their affairs in a manner that ensured they were bullet-proof from allegations of this sort. They had purchased in good faith the rights for a specific work. Whatever likeness it had to other books was not their concern. They were in the business of making movies not playing referee in authors' squabbles.

Counsel's Opinion

On reading Dubin's tidy, collected response, Frank's hopes drained. There were no cracks through which his grievance could penetrate. His mind began to be haunted by the scavenging flocks of despair – literally he was the victim of *The Birds*. In a sick, unsleeping frenzy, over the weeks and months he absorbed the gossip and enthusiasm surrounding the much-vaunted movie and became tormented by imagined sums he would have reaped had only Hitchcock come across his version first. Du Maurier did not need those thousands, that harvest of profit, while he needed every penny. Daily he passed bookshops stocked with reprints of Du Maurier's story collection containing the star item and groaned inwardly and outwardly, later retiring to a pub where he downed beers and whiskies in generous measure. When morning came, he heard the screeching of birds and amplified their cries with his own. But he realized that he had to force himself round to reason. After all, he was an intelligent man and had read the poem *The Road* by Robert Frost: that told him how, in choosing one course in life, we have to exclude others that might have turned out more fruitful or more dreadful, but of those we can never speak, never know.

Naturally FB protested against the studio's verdict. He believed Daphne had earlier read the story through the Davies brothers who, knowing she'd be intrigued by such a fresh, alarming theme, posted her an advance copy. But he realised a few links and parallel strands were insufficient to establish a major breach of copyright: distinct stylistic likenesses had to be established, actual phrases and situations duplicated, but no evidence of this was found. Her version of how she came to write *The Birds* was that, living near the coast, she had often witnessed the threatening behaviour of gulls, especially when hungry or protecting their young. "I got the idea," she recalled, "from watching the farmer plough the field behind the farm, at Menabilly Barton; the seagulls chased the tractor, flying down, apparently trying to attack the farmer."

The evidence of both parties was submitted to Counsel for an unbiased opinion. The judgement [13/8/63] that arose from his reading was objective and scrupulous, intelligently differentiating the two works:

"Having read both Miss Du Maurier's story and Mr Baker's book, I am of the opinion that Miss Du Maurier has *not* infringed Mr Baker's copyright. It seems to me the only real similarity between the two lies in the general idea of mankind being attacked by birds, plus two fairly minor details – namely announcements being made on the wireless of a national emergency and of similar attacks throughout the world; and secondly attempts to combat the birds through aeroplanes. The former is only to be expected in a short story of this type and this is a common feature of all stories about mankind being attacked by some outside power, whether birds or flying saucers. The latter is a very minor detail in Mr Baker's book – so much so that I observe he does not mention it himself in his statement. It is also rather what one would expect to find in any book dealing with attacks by birds.

The treatment of the general idea of attacks by birds in the two works is as different as it could be. Miss Du Maurier's birds are ordinary birds – gulls, robins, finches, sparrows, rooks, cranes, etc. They attacked collectively all mankind indiscriminately and died by the hundred in doing so. Mr Baker's birds are supernatural; they cannot be killed or even have a feather removed; they do not attack collectively; from the vast flock, individual birds attach themselves to then attack individual people. Moreover Mr Baker's book seems to me allegorical. The birds represent men's soul's and those who are not prepared to look into the depth of their souls are killed or driven to suicide. The moral of the book thus improves on the oracle at Delphi: "…or perish". Miss Du Maurier's book has no moral and is not remotely allegorical. It is a short horror story. Accordingly even if Miss Du Maurier had read Mr Baker's book, I do not think she would be liable for infringement of copyright. The treatment of that idea is utterly different and, as I have pointed out, there can be no copyright merely on an idea. I consider that any claim against Miss Du Maurier would fail."

Counsel added he felt "considerable sympathy for Mr Baker – particularly as his book seems to me much more suitable material for a film than Miss Du Maurier's very short story…"

This was a crushing blow. Frank had little choice but to bow out as gracefully as he could. Even supposing the idea *did* occur to Daphne by way of reading his novel in 1936 and later forgetting it, the two works stand apart. To Frank, the thought of his idea being profitably pilfered by another was a horror, an abomination, but authors before him (e.g. *Our Feathered Friends* by Philip MacDonald in 1931) *had* tackled the theme if not in such depth and detail. Furthermore some *routinely* threatened to take studios to court to supplement their income. Whatever the subject, they would instantly claim the idea behind the film was plagiarised from a work of theirs in hope of a stirring a nervous reaction and a large cheque in the post. Approaching someone else's theme – retrying it by tilting the angle or perspective – is common among storywriters, but usually no friction is involved since it is the way of most stories to sink out of public recognition. What is unusual is that a rather clever reworking of Frank's theme by an already successful writer gave rise to a groundbreaking movie that was to thrust her into heights of acclaim only matched by his gloom, despair and sense of neglect. A tragic irony if ever there was: the rich get rich and the poor get nothing.

Plenteous sympathy was expressed by Daphne [19/8/63] who was very sorry he had been put to so much trouble and expense and sincerely wished that, for his own sake, Mr Hitchcock had bought his novel rather than her short story from which to adapt the film. "If you have ventured to read my tale," she noted, "you will see how brief it is, and from what I hear of the film it has been very 'freely' adapted. I do not believe it is about a part-time farm labourer and his family at all, but there is a love-story involved, and it all takes place in or off the American coast. I would very much like to read your novel, and if you can spare a copy, I will read it at once and return it to you."

Long after hope had died, Daphne continued to write to him in a sympathetic, confiding manner about their bond of synchronicity. Slightly flattered by the contact, Frank responded graciously and courteously, but actually he was bleeding from within. Compliments were sweet, but he had been paid with flattery before. What he wanted was a portion of the wealth and success that was owed to him but had always failed to arrive. When *The Birds* came to St Austell cinema, Daphne [15/9/63] eagerly informed him of its cinematic merits:

Well…from a technical point of view, it's pretty good. Fine photography, good acting, spectacular and amazing use of the actual birds, which I understand were trained for the purpose, or at least in close-ups too, but then so were the factual descriptions in both our stories.

As for Hitchcock's story, neither yours nor mine, and I still don't quite see why he put his scriptwriters on to inventing the particular tale that he did. Spoilt rich man's daughter (who had unhappy home and childhood) buys love-birds in a bird shop as form of practical joke on handsome young lawyer she meets in bird-shop, who intrigues and irritates her at the same time. Takes considerable time and trouble (and audience's patience) in taking love-birds in cage down to lawyer's home in small seaside town. Meets his ex-girlfriend, who is a school-teacher locally, also his family, consisting of suspicious widowed mother and small sister. For absolutely no reason as far as audience can tell, a seagull darts from sky and pecks at girl's head, after she had delivered love-birds, and from then on spasmodic attacks begin, working up to a crescendo, with attacks on school-children, school-teacher, some harmless male neighbour, etc, etc – finally into a tremendous attack on the lawyer's home itself, from where the film follows my story with the lawyer boarding up windows, etc, and family listening to attack from within. There is certainly no suggestion of birds being souls, as in your story, or merely turning against mankind, as in mine, but I feel Hitchcock intended some psychological interpretation, and that the purpose of the love-birds at the beginning is meant to be symbolic (these birds remain calm throughout) but symbolic of what?

The widowed mother appears to be frightened of loneliness, and resentful of any woman who attracts her son – but so what? No one else resents anything, though the spoilt rich man's girl seems determined 'to get her man' and does. Does this mean she is a bird of prey? But in the end she is violently attacked by the birds, and though bleeding one knows she will recover – reconciled to the suspicious widow mother, she is driven away to safety by lawyer, clasped in widowed mother's arms, and lawyer's small sister clutches love-birds in the cage.

She describes the abrupt end of the film and laments the movie that was lost by no one being perspicacious enough to base a screenplay on Frank's novel. There follows a discussion of "the devil in ourselves" and what mechanics and intrigues effected the raising of Jesus from the tomb. She also expressed pleasure in the fact that Panther is now poised to reprint Frank's version of the birds for which she hopes the best possible success.

After that enthralling summary, Frank provided Daphne with a copy of *The Birds* that she responded to enthusiastically:

I can hardly wait to tell you that I sat up late last night, and lay in bed late this morning, in order to finish your Birds. I have been absolutely fascinated. I had imagined, God knows why, that it was some sort of thriller, certainly not this really superb psychological, one might say metaphysical, drama. It's far deeper stuff than mine, and now I realise to the full how bitter you must have felt when there was all this stuff about the film in the papers, and how the idea was taken from a story of mine. What I cannot understand is why your story did not awaken

an instant clamour in everyone, and why it didn't become the book of the moment and be snapped up for film rights then and there. Unless it was that the reading public at that time did not appreciate this sort of book…

Daphne goes on to relate that she went to a well-known analyst (John Layard?) who questioned her about *The Birds*, asking why she had made every bird, not just birds of prey but sparrows, starlings, robins and swallows, attack humanity. "It could be because you saw yourself threatened," he explained, "by everyone, even your friends, there was no one you could trust, you had to shut yourself behind barricades to protect your family." Dismayed by this, she later conceded that she may have produced the story in response to an attack of paranoia. "I think he was possibly right and my Birds acted as a kind of spiritual purge…"

Ken Mogg on The Birds

Film buff and expert on Hitchcock, Ken Mogg, studied FB's novel and wrote an intriguing article for his website in 2006. Later he brought out 'The Day of the Claw: A Synoptic Account of *Alfred Hitchcock's The Birds*', published in the online film journal, *Senses of Cinema*, issue 51 (July 2009).

Ken suggested that, even if Daphne du Maurier hadn't read FB's novel, Hitchcock had been aware of it: "Frank Baker's novel 'The Birds' (1936; 1964)", he points out, "was almost certainly an influence on Hitchcock's and Evan Hunter's 1963 film of that name, even though the filmmakers claimed only to be (loosely) adapting Daphne du Maurier's short story, also called 'The Birds'. Having finished reading Baker's novel – which is a splendid piece of 'dystopian' fiction in its own right, a wise if misanthropic evocation of 1930s British society – I cannot do more than begin to convey here the qualities of the book. Baker has put much of himself into it: he was a bisexual man in a generally staid and uptight society, and the animus that drives the book is deeply-felt and cogent. It effectively poses to Hitchcockians whether their admired film isn't synthetic and shallow by comparison! (I am talking now of the other side of Hitchcock's exemplary detachment and vision of a humanity in which we all share that I have lately praised here!) The film 'borrows' a huge number of Baker's ideas and effects. I'll try and list the main ones. First and foremost, apart from the bird attacks themselves, both Baker's and Hitchcock's stories revolve around a grown-up man's relation to his widowed mother at a time of crisis, including the fact that he

has just met a woman whom he may eventually marry. The mother – Lillian in the novel, Lydia in the film – speaks of how she fears her son no longer cares for her. The novel's narrator comments: 'I denied it, but I knew it was half true.' (Panther edition, 1964, p.132.) We see the mother grow increasingly frail-looking and tired, though at the last minute she will be spared from the birds to join her son and his wife-to-be as together they flee the devastation all around them – which includes the death of a family friend named Annie – to a better life far away. The narrator, alerted by Olga, his future wife, finally sees that he must face up to what the birds mean to him personally, that is, he must learn to be his authentic self: a scene on Hampstead Heath in which he outfaces his 'Demon' bird (pp. 169-70) is the equivalent of Melanie's climactic ordeal in the attic in Hitchcock's film. He writes: 'I stood up. My ankles ached, my limbs were bruised, blood was dripping from my chin... [But now] I knew that the metempsychosis which touched and threatened the whole race of man no longer had the power to assault me.' The novel attaches various but related meanings to what the attacking birds represent, but these are distilled in the narrator's reference to [this] 'terrible story of the breakdown of men under the prey of their own voracious natures' (p. 141) – which I suggest is close to how Hitchcock's film shows its own avian predators turning universal Will back against humankind (cf. our 'Hitchcock and Schopenhauer' page on this website). Amongst scenes from the novel: a woman with a feathered hat pecked to death in a London phone booth (p. 29); the birds massing all over the figure of Admiral Nelson in Trafalgar Square (p. 48: cf the monument to Admiral Dewey in Union Square at the start of Hitchcock's film); military forays against the birds that end up as fiascos (pp. 55-57); a chattering or croaking sound emitted by the birds, 'like a blunt knife drawn over a slate' (p. 95); an out-of-control car without headlights crashes (pp. 136-37); a bird pecks and bursts the wares of an old lady balloon-seller (p. 163); a man preaching Judgement Day is pecked to death (pp. 180-81); the climactic scene in which the birds invade a packed St Paul's Cathedral – described by Baker with great power and skill – and whose first victim is the Archbishop of Canterbury, followed by the deaths of nearly everyone else present (pp. 202-07); the subsequent devastation throughout the country (p. 207ff); an ironic reference to how the fleeing narrator had stopped to eat cold roast chicken in an empty cafe in St Albans (p. 221). It's a splendid novel, as I say, and even has some additional Hitchcockian touches that the 1963 film didn't use: notably, a scene in which the birds invade a cinema showing a newsreel of their activities, and shred its screen (p.137)!"

A technical complexity of writing a biography is that the joys, disasters and conflicts of the subject's life tend to run along separate though parallel storylines. If, at the same time, he or she is engaged in a complicated love affair and an argument with a homicidal lunatic, it is often advisable to trace each strand separately rather than use the confusing technique of intertwining them in a single sequence. This may not be true to life, when problems swarm in from all sides, but a prose narrative cannot convey simultaneity – all needs to be set down with linear clarity. So far, assuming a literary priority, we have been paying close attention to FB's life as a novelist and actor, overlooking the background drama of his family. But obviously, with three growing children, other significant changes were taking place and, indeed, surged to the fore during the debacle over *The Birds*.

Frank's problem with Du Maurier and Hitchcock was compounded by the troubles of his offspring; their emotional attachments seemed to be shaking them apart rather than stabilising them. With no money and a boat in Scotland, Llewellyn had landed himself with a young wife and baby, going off on a crazy, perilous adventure. Jonathan jacked in his university Classics course and ended up in Spain, arrested by police on a cannabis charge and jailed for six months (that might, under less propitious circumstances, have been six years). Later he joined Llewellyn on the Isle of Mull, trying to live off the spoils of the land and sea. Sweet young Josie, apple of Frank's eye, on reaching the tender age of fifteen, formed a romantic relationship with a hopeless drug addict and villain called Derek Dodd. After she was spotted in London with him, Janet Gilbert conveyed the information to Jonathan in his Spanish prison. He in turn informed Frank and Kate, but they were unable to take control. On reaching sixteen, Josie decamped to Scotland with Derek, intending to marry him over the border, but the police were alerted and found her in Glasgow. "I was welcomed home with open arms," she recalled. "My boyfriend killed himself about a year later and not long after that dad took me on a little holiday to Winchester where he was attending a reunion. It was a magical father & daughter time. We explored Thomas Hardy country in Dorset. I shed many tears and he showed me great love and kindness. I have a manuscript of a fictional book he began to write about the time we were together, in which the young girl is an aspiring folk singer; it is left blank and incomplete. Perhaps I will try and finish it one day."

KIDDERMINSTER (1966 – 1976)

Gradually the knotty, troubling strands of their children's careers untangled, leaving Frank and Kate rather greyer and worse for wear. If anything marked the end of this painful, prolonged phase, it was their move in 1966 to a house called Kylesku in Kidderminster. Kate inherited the property from her family. After being stressed and pushed to the limits at Cardiff, FB welcomed the contrast. In the Upper Severn Valley, a place of canals, railways and soothing, umbrageous scenery, Kidderminster was agreeable if less stimulating than Cornwall, and he spent much time playing the piano and writing poetry.

Owning a handsome bungalow in Worcestershire was a boon to the family of five; also, Kate's favourite aunt, Margaret, was able to live with them. Having come from the area and been educated at Holy Trinity Convent, Kidderminster, it was not too daunting for Kate, after resettling her family, to apply for work at her old school. She was taken on and committed herself to at least two years teaching English, poetry and drama, with a special emphasis on transferring these skills to the stage. The town also provided useful access to the Midlands Television Centre at Birmingham which had offered Frank work on plays, documentaries and the cheaply produced but popular soap *Crossroads* launched by ATV in 1964.

Frequently the family returned to Cornwall for holidays and spasmodic visits. They no longer owned Claredene, so they had no regular place to stay, but friends like the Gilberts offered them hospitality. It was not an especially productive time for FB who was entering a 'looking back' phase. Save for the notable autobiographical achievements, *I Follow but Myself* and *The Call of Cornwall*, written mainly in Worcestershire, his published output was slight during the decade. But he was constantly working on articles, stories, poems, preparing radio and television features as well as replying to and initiating correspondence.

In his transitional journal covering July 23, 1966 to April 12, 1967, his slightly wayward routine is highlighted. Partly in Cardiff, partly in Kidderminster or cruising aboard *Sanu* in France with his friend, Denys Val Baker, a restless, impulsive itinerary is spelt out: musical events, book news, work on *I Follow but Myself*, walks around the Severn valley, trips to Arthur Machen country and the valleys of South Wales, dawdling in fascinating pubs and churches, family matters and the deaths of old friends. His first entry records a family dispute; apparently he likes to put part of the day aside for a walk, a custom to which his offspring are not always amenable, hence "what bores me to the teeth is the general laziness and sloppiness of the young…"

197

August 19, 1966. I drove to Trenarren and spent some hours with that curiously tormented historian and poet, A.L. Rowse. His beautiful old house – all to himself – his paintings, his books and ancient white cat and his ever querulous talk of other people which always comes back to his own isolation and was fascinating and disturbing – almost frightening – at times. He so much longs to be loved and shows much that is lovable even in his most lacerating moments. I could not mention the Arts Council Grant for writers scheme which was the ulterior reason for my visit. The day was again divine. I went on to Mevagissey and there met dear old Faith Ashford burrowing amid the trippers at Pentewan. I gave her a lift back to Mevagissey. The place is ruined and old memories were almost unbearable.

August 28, 1966. [After visiting the Miskins, Frank and Kate went aboard Denys Val Baker's yacht, *Sanu*] We chugged out of Falmouth harbour towards Finistère. A lovely sunset but bad weather was gathering up within a few hours. I was hopelessly sick and then began the most agonising sea voyage I have ever endured. SANU rocked, rolled, pitched, tossed. Climbed up and down; mountainous waves. Useless I groaned in the top bunk of our cabin while Denys and Alan [Ross] kept somehow at the wheel.

September 10, 1966. Last day in Brittany [aboard *Sanu* with Denys Val Baker]. No sun. Endless shopping for wine, cigarettes, etc. to take home. Kate and I were at odds and parted company in the afternoon and I walked about, first to the very ancient Norman church on the other side of the stinking river, then into Quimper looking for Kate and took a rest in the Cathedral Gardens. Fell asleep upright on a hard iron chair and woke to the sound of Breton voices. Then I went to the high ridge of beech woods above the city. From there the Cathedral spires can be seen as though they are one they are so exactly similar…

October 24, 1966. A disaster at Aberfan. At least 200 people, including many children, are killed as a colliery tip smashes down… It was through this village I came when I was 'lost' a fortnight ago in the Riley – a doomed place as I know and wrote of in my chapter on Filson Young. Looking this up on the map now, I can retrace the road I took up the mountains in the fog – why did I have to do it? The most extraordinary psychic experience stirs me in a way I don't understand.

October 31, 1966. All Hallows. I have finished 2nd draft of Mary Butts. Weekend at Kidderminster with the lonely Aunt Margaret – very touching. Last night broadcast of Havergal Brian's mammoth Gothic Symphony – really the second performance – the first being nearly 6 years ago. The composer, aged 92, was present and an encomium at the Albert Hall – audience stamped and yelled their plaudits. The only music I remember similar to his is Delius at the Queen's Hall when (Beecham?) appeared on the last night. The applause was greater and with more reason.

November I, 1966. Unexpected bit of bounce. £361 from Germany for 'Day After Tomorrow' and tie and socks.

February 2, 1967. Early morning. Great rain – flood. The Severn Bore rampaging. I read Richard Church's 'autobiography', his experiences similar to mine or rather his

influences: Keats, Church Music, Plato's Symposium, but he was more assured, being 14 years older. A beautiful writer.

February 18, 1967. Josie is sweet seventeen. We are beginning to pack for our exit from the prolonged Cardiff scene – thank God – and I am further revising 'I Follow'. A most courteous letter from Richard Church in response to query concerning W.H. Davies: he remembered well 'Allanayr' which I published years ago. Marvellous.

March 9, 1967. Drove to Winscombe. Ruth Troward's 'remains' cremated after burial service, with 3 hymns to harmonium accompaniment in a poor little village church. (Rowberrow) I don't think she would have cared much for this – but Angela meant it well. Eileen Baker – a newer friend of Ruth's – lunched with us. Later I was left with Angela who tried to talk about the Dilemma of Death, our mortality, etc. I was completely inadequate and could only use a sense of humour. "God the Father" seemed a joke to me and I said so. Yet Ruth believed in this to the end (or did she?). I came across the Severn Bridge in howling south-west gale – quite terrified, the car being nearly lifted into the air. No sign of the loving Father in all this except, I suppose, I was not blown to bits.

April 10, 1967. I began this play. Wrote a scene, but of course as usual cannot continue – my hand shakes and the same fears beset me – as if of work coming to no conclusion. It seems to me to be before me now. I read the beautiful prose of Richard Church and the power he has to express joy (that I never find) and to make words do that he would have them do.

*

Aside from keeping detailed, thorough journals, news trickled in to Frank from various contacts. Friend of his Mevagissey days, Lionel Miskin, wrote lively, intellectually engaged letters, decorated with crayon and ink drawings. Many of them plunge into psychological and religious depths pertaining to Frank's spiritual convictions that had taken a battering throughout the decade. By now, although by no means an atheist, he was erring towards doubt or a rather bleak scepticism. Lionel, of course, was not doctrinally religious. An adventurer in ideas, more interested in the symbols and images produced by faith rather than ontological issues, seemingly everything interested him: art, poetry, literature, anthropology, ecology, film, theatre, hallucinogens, shamanism and the ideas and therapeutic techniques of John Layard.

In a letter [8/10/69] he said that he was playing host to Derek Savage and his wife, Connie, who had given up their house in Mevagissey:

The Savages are likely to be with us through the Winter. We have fascinating arguments – Derek with his funny patriarchal evangelical ideas of religion and us with our heads full of dreams, myths, John-Layard-Jung-Shitkin. Such tilting & jousting. We are, of course impossible. Our language is depraved. Our behaviour

Bohemian. We never put saucers under cups. It is all very primitive and repulsive to the dear old Savages, but they take it with the sweetest good humour; stick up for themselves with fervour; enjoy my assaults on the boys for their disgraceful smoking and actually enforce their better behaviour as it shames them to be quite so vile to poor bearded old Dad in front of Derek or Connie. At least John Layard has been safely in London, which is a relief, while his patients down here seem to be all having what is called euphemistically dire negative transferences about him. You know it was him who nailed on us to the police – the potty old thing. Really some day! Derek is quite a character, while Connie emerges more and more. So it ought not at all to be a bad Winter.

While Lionel navigated his personal and artistic affairs, Frank was hard at work on the major project of this bustling, unsettled period: his autobiography. Conceived in Cardiff and physically written around the time of his move to the Midlands, he put a great deal of thought into the form of it. Realising he was not famous enough for his straight autobiography to stir commercial interest, he decided to tell his life story by way of nine pen–portraits of his friends, distinguished, moderately well-known, barely remembered, nearly forgotten and never-known, selecting one to stand for each successive phase of his development. It was a less-than-naked way of disclosing his strengths and weaknesses, cleverly avoiding the pitfall of sounding blatant or egocentric. He used Dean Hutton to stand in for Frank the timorous choirboy who attended Colebrook House, Alfred Rose to disclose Frank as a sexually divided and tragically lost soul, Mary Butts to recall the broken-hearted, religiously troubled Frank after the tragedy of Marcus Tippet, Edward Garnett to address Frank's prentice work as a novelist, Filson Young as an opportunity to divulge Frank's thoughts on musical technique and his warm memories of the Christmas broadcasts from St Hilary, Robert Walmsley to evoke his sinister fascination with birds and Arthur Machen to sketch in aspects of his early married life, when poised between theatre and literature. Curiously enough, he did not choose to portray Bernard Walke, the 'Cornish Saint', but wove him into the narrative through his involvement with figures like Mary Butts and Filson Young.

I FOLLOW BUT MYSELF (1968)

I *Follow But Myself* appeared in the year of the death of Walter Robins, the cricketer and footballer who'd bullied Frank so savagely at Stafford Grammar. The sportsman passed away at his home near Lords after a long illness. Aged sixty-two, only a couple of years older than Frank, his hushed exit probably caused the other to ponder the ironies of destiny, the implacable tormentor consigned to the dark pavilion while the little boy who was his victim flourished yet another work of prose for the public. Outliving one's enemies is one of the more mournful satisfactions of longevity, attrition masquerading as fate as it works through bodies.

A combination of autobiography and selective essays in portraiture, many think FB reached the high watermark of his prose in this very personal book. Novels date in a way autobiographies do not and several of the minor figures he singles out, like Alfred Rose and Robert Walmsley, were bubble reputations that spluttered out of existence. If he had not been there to freeze-frame them in carefully wrought, reflective paragraphs, they would have been permanently erased from the archives. It is a work in which he writes 'warm from the mind' and there is considerable skill and variation in the pacing, in the wavelike way that he will flow into the heart of the subject and then allow the tide to draw back into himself as he lays bare his own emotional state during the period of contact. He does not attempt literary estimates in the chapters on Mary Butts and Arthur Machen, but concentrates on personal points, their quirks and generosities.

In this toast to absent friends, as Roger Dobson put it, Frank produced "a minor classic that deserves to stand on the shelf alongside Jocelyn Brooke's *Orchid Trilogy* and Julian Maclaren Ross's *The Weeping and the Laughter*. Baker relates his story through the vivid portraits of those individuals who influenced him as a man and writer." The title derives from *Othello*: 'In following him, I follow but myself' and, oddly enough, Dobson was most affected by the portrait of the relatively insignificant Amy Carr, the hapless spinster who loved poetry but was never able to produce anything of worth. As there seems little point in rewriting prose that does the job perfectly, I will quote Roger's summary of the Amy Carr chapter:

The chapter in *I Follow But Myself* that impresses most (it is certainly the most poignant) is devoted to the humblest of all Baker's friends: an obscure elderly spinster Amy Carr, and many readers will think it a pity that Baker did not devote an entire book to her; though, as he says, he used her character in two unspecified novels and put her into a television play, after her death, where she was played by Margaret Rutherford. Miss Carr, 'prototype of all spinsters discovered in novels, of all ladies left forever on the shelf and growing dustier and dustier as time wore on, came from a solicitor's office somewhere in

south-east London, Catford, I think.' Baker meets her when he is a young man working as an assistant secretary at the school of English Church Music at Chislehurst in Kent. Miss Carr, of the 'funny crumpled hat', is the school stenographer: 'and when I first met her I saw in her no more than a fusty old female, whose sheer plainness of visage and dowdy clothes were only matched by her incompetence as a shorthand-typist.' Her top copies are marred by errors and blotches from erasures. Baker's employment at the school is abruptly terminated after a scandal, and after he leaves Miss Carr sends him a warm and supportive letter: 'I know that an injustice, a great injustice, has been done to you', she writes. A correspondence develops and a friendship over the years. Baker sends her his books as they appear and advises Amy on the little verse and prose pieces she submits to magazines. Baker provides a tender portrait of the lonely spinster who devoutly believes in Christian virtues yet has grave doubts as to whether God exists. She has a blind devotion to Shakespeare, collecting multiple editions of his works and on her bookcase is a tiny bust of the Bard with little candles in brass candlesticks, and these are religiously lit every 23 April: 'the only person I ever knew who set this day as high or perhaps higher in the calendar as Easter or Christmas'. During the war, terrified by air raids, Amy moves to Penzance at Baker's suggestion and he finds a flat for her there. As the years pass, Baker becomes an actor touring with the Old Vic company, marries a fellow actor Kathleen Lloyd, starts a family, moves about the countryside, drinks more than is good for him – by his own admission – has his novel *Lease of Life* (1954) filmed by Ealing Studios. Still Frank continues to visit Amy for tea feasts and talks on books and religion. She is becoming frailer and her sight is failing, but Baker walks with her in the nearby Morrab Gardens and then sees her to her door. He would 'not go up to her rooms again with her but, saddened by the thought of her loneliness, wave to her as she stood at the window, a misty figure through the pane, as she waved back to me. She would not stand right close to the window but a little withdrawn into the room, as though she did not wish anybody else to see her. I knew that she would soon go to bed, for early bed was best in order to save fuel and rest her eyes.' The inevitable happens. Her freedom is precious to her, but her doctor warns Amy that she can't remain living on her own. One day she is whisked off in a taxi to her last home, Benoni, Carallack Terrace, at St Just. 'Her possessions, even her books, were all sold, and she was given the money. But they fetched little and she would have been infinitely happier had she been allowed to give them away.' And it is in the home that Amy dies, but she has taught Baker an important lesson: 'the intrinsic value of such uncelebrated lives as hers'.

Roger Dobson's acclaim has the advantage of hindsight, but the original reviews of Frank's memoir had a touch of weariness or cool enthusiasm. Critics prefer a book to slide down like an oyster, so that they can expand a point or two and then take leave with a single snappy phrase. But that was not possible here. In order to treat *I Follow But Myself* fairly, they had to read pen sketches of nine different characters and the thought of such concentration left them anxious and drained, especially as their word allowance was tiny. Hence a few treated the work as a book written by an oddity about oddities – a bitty remembrance of a bunch of neglected nobodies dutifully resurrected by a little-known writer.

Others concentrated on Frank's interwoven life story, treating it as an odyssey of a tortured soul, a man who struggled with homosexuality, religious conviction, wartime pacifism, liquor and debt but somehow managed to raise a family and emerge as a respectable citizen. The quality of writing was usually praised although one reviewer, with a superior sniff, dubbed some of it "local literary society" standard. Richard Church surveyed his career approvingly, singling out *Allanayr*, the book he'd enjoyed many years ago, pointing out that Frank's search for an identity was no new affair – Rousseau had enacted a similar struggle two hundred years before. In the *Yorkshire Post*, Tom Bentley ran the headline 'Seam of Sadness' and referred to a "sensitive and strangely poignant experiment in autobiography" and noted many of Frank's friends were eccentrics with a touch of "Baroque grandeur". He concluded the book "has a deep underlying note of sadness…a bitter and unceasing struggle against the frailty of the flesh, with spiritual ecstasy and despair and, most of all, because of the growing realisation that the creative artist can never achieve lasting peace."

An excellent short notice, the pick of the bunch, appeared in a Cornish parish magazine: *St Just & Sancreed Church News and Views*, July 1968. It was written by the Vicar, S.W. Barrie, who briefly summarised Frank's career, noting how the book moves backwards and forwards, the chapters being "pegged onto the names of friends", and then selecting a collage of appropriate images: "William Holden Hutton carrying a wreath to the statue of King Charles the First; Edward Garnett dropping sheaves of typescript on the road; Marcus Tippet holding a great bunch of wild flowers; Bernard Walke letting his horse lead him where she will. All his best stories are Anglican ones. The mixture is Bohemian Catholic, not so easily come by in these days of National Health. The book is sparkling with a mystic haze on it. Above all, it is warm."

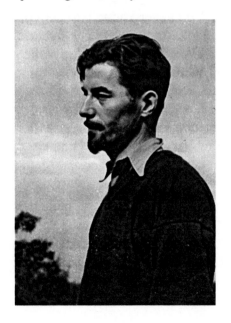

The critic Derek Savage as a young man at Bromsash. A friend of FB's (if not exactly an admirer of his novels), he was not included among the portraits in *I Follow But Myself* but is mentioned in the topographical memoir *The Call of Cornwall*.

OKLAHOMA (1969 –70)

IN 1969, while Kate was preparing her syllabus, an invitation came from Oklahoma for Frank to take up the post of artist in residence in the Central State College, division of language, arts and humanities, where his job was to teach creative writing. Though reluctant to leave Kate, he was delighted to take up the opportunity, thrilled at the prospect of seeing America but daunted too at his family being so far away. His friends responded encouragingly to the exciting new opening it represented. Lionel Miskin hoped the experience might extend the frontiers of his fantasising:

America must be INCREDIBLE. I should be very disappointed if I were wrong. Remember, Frank: lie as much as you like about it. Let yourself outdo Munchhausen himself. But don't tell me anything concerning geography, cooking, psychology and especially criminology of the place that I might be tempted to compare with our own provincial absurdities. Have you ever read a curious novel of Kafka's called America? It is nice because you realise he has no knowledge of the place and it is pure fantasy. I must have American fantasies: bigger still, impossibly grand and monstrous and wicked and sexual and depraved and all the rest you are free to give me and for which I shall pay you in kind – i.e. my own brand of provincial truths! But I wish I could join you in addressing your enthusiastic audiences on the glories of LITERATURE. Lucky people to have you!

As always, Denys Val Baker was ready with help and advice:

And do take some copies of your books with you. You never know, but that you can fix up some American publication. This could be an approach to Mr Huttner, of Pyramid, who writes friendly letters though I've never met him – of the others, Fowler is an ardent *Cornish Review* subscriber and sends good stories sometimes; August Derleth is a well-known writer of supernatural tales and also runs his own publishing house and is doing a book of my stories, sounds very friendly. James Wyckoff is the only one I know personally when he was like me a younger writer over here and met me down in Falmouth. We got on very well – he used to write for my old 'Voices' mag.

As soon as he arrived at the college, he had letters waiting for him from Kate to which he eagerly and commiseratively responded:

Oh that parting at Kidderminster – still I see you on that miserable station platform. So good of you to wait, but I couldn't have borne it if you hadn't. Of course, the tears streamed down your face. I did not weep, but sat in the train

stonefaced, feeling anonymous even to myself, a completely empty being, as though everything I loved and was and ever shall be had been taken in keeping by you. But now I have your letter, I feel myself returning. What I have shown to people hasn't been exactly myself. But then we all have to act. I think people like me all right. Anyway they're all very nice indeed.

Two weeks later, Frank is hard at work, planning his creative writing course, deciding to initially concentrate on 'Character', using a number of famous novels in illustration of this: *Madame Bovary*, *Sister Carrie*, *Emma*, *Howard's End*, *The Scarlet Letter*, *Antic Hay*, *Sons & Lovers*, *Bleak House* and *Miss Lonelyhearts*. "What I do", he explained to Kate, "is to try and bring in a bit of poetry every time, and always give one quotation from something not so well known... One young man wanted to know how to handle minor characters – a very good question which I'm trying to answer now."

He had been fixed up with a comfortable air-conditioned apartment, about sixteen feet square, with two bedrooms with a double-bed, a kitchen and bathroom. He had a television and enjoyed sitting up late and watching the chat shows, noting there was little news from Britain save bulletins from Ulster. But he was pleased to see Margaret [Rutherford] in Chaplin's film *A Countess from Hong Kong* with Marlon Brando and Sophia Loren – "A much better film than I remembered the first time I saw it, and a brilliant second-half appearance of Chaplin himself, as the ship's purser."

Cliff Warren, the tutor who supervised his welfare, formally introduced him to the students. He got most of the details right when he outlined his English guest's career, save for crediting Frank with being backed by the National Trust, an inscrutable observation never quite clarified.

CAMPUS NOVEL – THE MAGUS

One thing irked Frank while in Oklahoma: none of his novels was available in America. Nearly all were out of print – even the 1964 paperback reprint of *The Birds*. Therefore, while he might convincingly present himself as a former maestro, someone who knew the ropes and *had* achieved success, he was not able to promote himself as a vital component on the contemporary literary scene. He was also miffed when nearly all the literary students on the Oklahoma campus were engrossed by John Fowles' novel *The Magus*. Frank thought Fowles overvalued and judged *The Magus* phoney. His students were affronted by the dismissal. According to Kate, both she and Frank thought Fowles was eminently readable and eminently forgettable. Perhaps he found it painful seeing a younger writer, while avowedly producing a mystery novel, reflecting on philosophy, society and sex in an ingenious, thoroughly unembarrassed manner – things he might have done had attitudes been less censorious back then.

Fowles' spectacular success in America was bound to affect FB, but so far as *The Magus* was concerned, he might have credited himself for getting there first. Humphrey Nanson, in *Mr Allenby*, theatrically manipulates a man's life in order to teach him some kind of lesson, a contrived plot maybe, but more than an echo of it touches the character of Conchis, Fowles's Prospero-like protagonist who manipulates Urfe's life through a series of ritual humiliations so that he is unable to discriminate between reality and stage management or the 'Godgame'. Do I act the same when my audience is withdrawn? Am I in fact always acting for someone? Both *Mr Allenby* and *The Magus* revolve around notions of the unexamined life and the abnegation of responsibility. So far as clarity of intent goes and complexity of grasp, it must be said that Fowles is analytical where FB tends to be emotional.

But he found consolation for lack of evidence of his literary output in the Oklahoma Campus having an excellent library, including a collection of *Harper's Magazine*. Here he was able to look up his culinary *coup d'état* 'When I Made Scones' and explore old copies of the *New Statesman*, included one dated June 1935, featuring an advertisement for *The Twisted Tree*. It made him feel more secure when teaching hard-to-impress students, that a little bit of him was preserved in a massive educational resource.

FB and his family enjoyed regular sea voyages aboard Denys Val Baker's boat *Sanu* that featured in his many articles and volumes of autobiography.

GHOSTS (1970)

In January 1970, Frank was working feverishly at Oklahoma, preparing a lecture for his class, when he received a letter from Jonathan confiding personal things. Mood swings and an inner restlessness, fuelled by alcohol, were rebounding on his young family – he did not quite know how to salvage the situation. Frank could grasp more or less what was wrong as, throughout his life, he had fought with drink – a potion that offers a unique salve to those who cannot quite let themselves go or thoroughly immerse themselves in pleasure. It is ideal for writers and artists, who reflect and brood on their guilty deeds and later twist them into stories or symphonies, but it is not the prop of Apollonian man, he who has achieved a healthy, cultural balance.

Taking the Freudian line that traumas have a root or point of origin, Frank replied to Jonathan with a long letter, probing past circumstances that might have engendered such behaviour. The situation was urgent, he decided. It was time to unlock the floodgates and release material that had been troubling him but which he previously had thought better hidden from his children. So he makes a series of disclosures or 'exposures' about himself, his parents and his secret fear that what Jonathan was undergoing related to his family's past. Broaching the issue delicately, he mentions the death of Felix, his father's brother, the kindly, clear-thinking uncle who helped him through the wartime conscription crisis:

What shall I say first? Except, that, of course, as you know I fully understand everything that happened to you, does happen and has in the past. I think the first quite important thing to say is this: you in particular of all the family have been much in my mind lately, particularly since Felix died and left me with the feeling that now – well, what? That the very last of my 'props' had gone. For you know in an odd sense Felix was a kind of Father to me. But I won't go much into that. What arises from it though is this: before your letter came, thinking of you, I had a great desire to tell you all that I know about the family history. I feel it is your right to know (as it was mine and it has taken me years to ferret much of it out) and that only with all the knowledge I can give you can you be helped to live happily. I feel in a general sense: that one of the saddest things in life is – that sons never know enough about their parents, and vice versa. This is terribly wrong. I always wanted to talk to my own (very dear but bless him too 'reserved' in a sense) father about many things in my own life and his; but I never could – and then came his long illness, his inhuman stroke, and communication ceased. With my mother, alas, communication ceased long before she died. Now be patient; all this may sound a bore to you. I am slowly reaching my point. It is only just this – that if we as individual people know all that we can know about what we came from, we are more likely to make a good thing of our lives – and I

won't use the stupid word 'success' for who, in worldly terms, cares about it? Not I. Nor you I am sure. One wants to live well, fully and not to hurt people, any people, particularly those who love us and care for us.

After the sympathetic throat-clearing sounds and establishing the necessity for honest communication. Frank presents a remarkable theory concerning the medical problems of his family. Probably he was yet again recalling the rebuke of Alfred Rose, 'a man whom God hath made to mar himself', for it dealt with self-destructive patterns working through the family, a strain of alcoholism and madness that might have its origin in that most dreaded of ailments in the Victorian era:

I am therefore going to tell you what it has taken me nearly 62 years to find out – simply by putting two and two together and doing a lot of heart-searching and so on. I had always imagined that my Mother's Father died away on some exploration in the East. (I think she hardly ever saw him). He didn't. It was only a year or so ago I learned the truth, from Felix (the last of the Baker side of the family): 'Your Mother's Father, poor man, died in a lunatic asylum.' Don't let this shock or hurt you. Just look at it simply as I have to. How did this happen? Simple, my dear Watson. And I am (Christ! to think that fate made me a novelist) the only one to be able to put the facts together and to arrive at what I can't prove but know to be the truth. He was a victim of venereal disease. Now this means nothing much today. Try please to put your mind back to about 1885 – in a small highly respectable suburb of north London. Try to remember that there were certain 'facts' which amongst decent people were never mentionable. V.D. was top of the list, without a doubt. Realise also that in such days there was no proper treatment of any kind to cope with this prevalent disorder. And if you seek for proof of the attitude of those times to what is now again becoming very much a 'burning' (right adjective) 'issue' (right noun), then read Ibsen's play 'Ghosts' written in 1881 and suppressed by the censor in England till about 1926 because it deals seriously with a social evil – venereal disease. Why was it that, when I was sixteen, chance put 'Ghosts' into my hand; and that when I read this great and tragic play, I was deeply moved, hurt, bewildered and could not know why? That is the kind of question we cannot answer; but that is what happened. I have read it many times since, and have a copy here from the library (because I wish to discuss its brilliant technique with my class).

Frank pauses again before entering into a confession of what a struggle those years in Cardiff had proved to be, of the problems caused by bisexuality and addiction to drink:

Now, how do I put together these sad facts? Thus. Felix dropped out the news quite casually (in many ways he had a strange insensitivity). I asked him about

five years ago: 'Felix, what did happen to Lilian's Father?' 'Oh didn't you know? He died in a loony-bin.' In a flash, the whole of my mother's tragic life was explained. We reach ourselves. We inherit a weakness. Put it simply as that. There is no physical trouble whatsoever; there is an imbalance of mind which in me (and it must in you too) has been compensated for by creativity; in other words – as all artists know, the artist is sick and it is his sickness which makes his art perdurable. This is a kind of law – the rose and the worm and so on. (Blake).

Whatever Frank was hinting at, modern medical evidence styles neither syphilis nor gonorrhoea as hereditary; the former may pass from an infected mother to her baby before birth, in which case it is called congenital syphilis. If the mother is given proper and adequate treatment during early pregnancy, the problem can be avoided. But it is almost certain that neither Lilian, Edgar, Frank, Kate nor their children had been infected by anything. What problems they had were the luck of the draw rather than being born under a dark moon or cackling star of madness. But it can be *almost as bad* if anyone in the family is convinced by such a notion.

It is fatally easy to mock here, but many families have laboured under similar delusions, whether imagined or real. For whatever doctors say to the contrary, the idea persists that problems and dispositions pass from parent to child genetically rather than environmentally. Lord Russell of Liverpool lived in constant fear of going mad and, when his grand-daughter committed suicide, thought it was the crazy strain in the Russells expressing itself. And it is likely FB had convinced himself that his bisexual streak was conveyed to him by way of a hereditary disease. He reflects on those tortured middle years in the Welsh capital when problems surged to the fore:

As I grow older all the strands or threads in the pattern of my life begin to come together and I begin to see the whole. I ask only for enough of life in order to be able to see more and set down more. The conflict in me was terrifying very often. You, at the most impressionable age in your life (those troubled Claredene years when I was at Cardiff drinking myself into the grave) when you were in the middle of your adolescence and all your fine brain concentrated on work you had set yourself to do because (as you once reminded me): 'Well, you taught me the bloody Greek alphabet!' (Which I'd even forgotten I had time I think for a laugh here) – at that time you were a victim of my troubles at their worst. My early days in Cardiff were the sheerest hell I've ever had to endure. As to alcohol, I'm not sure at all about 'alcoholism'. There is always a cause. (Anything I say you can, I think, apply to yourself). I drank, it seemed, in order to escape from reality; but the result was – reality came back and struck me flat – and I too went screaming mad, as you have. The reality was, to put it at its dullest, (and to justify yourself also) very often the stark fact of having to earn money. But it was of course more than that. There was in me also my sexual ambivalence. I have – never did – discuss this with you, it has been too hard. I tried to rat on as much of myself as I

could in 'I Follow But Myself' but it wasn't enough; it is a partially honest book. I don't think I now want to publish anything more honest – it is too painful. My homosexual side battled endlessly with my hetero. I was a bit of a monster really. (But thank God I never did fall in humour, and this is the saving grace you know). Ma had hell from me, very often; I too had hell from her (as you know). How did we hold together? There is only one word in answer to that: love. We did love each other, and we do. Moreover, we respected each other's sheer individuality, and did not want to change one another. Kate and I have what my parents never could approach – and this is partly because of the times in which they lived (dreadful times – for the hypocrisy then amongst the middle and lower classes – not the aristocracy at all – was frightful). As to the sad inheritance: I am quite assured (if that can be the right word for so disturbing a truth) that the 'brain storms' – can't think of the right terms – the schizoid condition is a result of VD. So long as we understand it, so long as we trust and have faith, and face it all – all will be well. Of that I am dead sure – I know it. More than ever far away and night by night alone here in these strange States.

This is fearful stuff, darkly riveting as *Ghosts* to which apt reference has been made. Obviously Frank was suffering an attack of the gothic horrors, implying hereditary madness was the reason for 'The Fall of the House of Baker' and that it manifested in the disordered nature of his creativity. He analyses his drinking bouts in depth, how they shook his faith, in that he found no balm or consolation through religion. Then, surprisingly, he advances to Jonathan the very argument Lionel Miskin suggested to him earlier, that dualism is not the answer but relativism, the ability not to offhandedly classify things as 'evil' or 'good' but as manifestations of nature, of basic human impulses, some of which outrage the moral law and should be punished, others that are simply weaknesses needing to be better understood:

These demoniacal drink bouts that you now only occasionally get – this sense of good and evil struggling in one: yes, it is all so. I know it. It is dreadful. For you there is no way but to give up drink or at least (I'd say) to give up whisky (which I know you have). For me there was no possible middle way. Never in my life in Cardiff those dark days was anything more startlingly clear: I could either drink my way to a mental home or to the lockup; or I could throw it up and try at that late stage to take care of those I loved and for whom I was responsible (and, do you know, at some sad moments even now, pause and think, the devil says to me: wouldn't it have been nobler to have gone to the gutter FB?). I do not know the answer to this age-old problem of good/evil, except that I begin to think that we have thought (mankind) too long in terms of dualism. There is no absolute good, maybe; no absolute evil. (There is not in nature). Baffled by such a great mystery, what can we do? I turned to the Church again in 1938 and accepted Rome; I accepted Rome for one reason only – my book I think states it. I knew I needed

the authority (spiritual) which only Rome (in the western world) seemed able to give. In the last ten years we have seen that very authority split. The Church as an organised body is dying rapidly. I ceased to be a practising Catholic when we all returned from Holy Oireland years ago (and I saw there what the Church did to its sick and sad sons and daughters – what money is extracted from them – how its seminars and priests were well fed and its people sick). I withdrew completely at Ashtead when it came to getting you all ready for Sunday Mass…The Church did not help me one whit over the final solving of the drink problem; nor did it other than hinder me over the deeper more difficult sexual ambiguities I was faced with. In fact, on the latter counts they failed me terribly. Nobody, no confessor…really helped me over the final solution of the drink problems once the first decision was made in my mind. Then I went straight for medical help (through the kindness of George Powell of Ynyshir) and got it. And then began nearly seven years ago the slow waking up at the Cardiff Hospital when (how strange) I was at first put in a ward with lunatics, absolutely batty, all of them. (One was a murderer). (You know, it took my poor Mother two doses of being 'put inside' at Bodmin to realise she wasn't mad. But then the fucking fools went and gave her that terrible ECT – and this finished her finally. The same way they have finished poor Margaret Rutherford – and she has a similar sad background).

Once you've achieved mental clarity, he explains, you must be patient and let your talent gradually grow. The friends you make as you develop are vitally important; if they are of lesser ability, they may drag you down while finer minds, on the other hand, might pass on some of their wisdom and serenity:

It is only when I grasp that I begin to see myself clearly. It may not take you nearly so long because of what I've told you. But once you know it can be done, then it can be done. I do not believe in self-judging. I used to get (and still do get) cross with you for constantly saying 'sorry.' Try to get that out of your system. You and I have far too much to give to say sorry to anyone unless we happen to have knocked them over as it were by mistake because we were in such a bloody hurry. (Impatience is our cursed inheritance also.) And let me remind you that Felix's and my father's sister, Beatrice, prophesied for me: 'your best work will be done when you are over fifty, Francis.' How did she know that? Because she was a woman of great intuitive powers, who could have no children of her own, who loved me as a son – I was so lucky in so many ways – and probably knew all the history she could not tell me but dared not at that early age in my life: and knew that it would take me a long time to live through – one cannot exist without the other. I have always felt you (and even more so Llewellyn needed this). I have always felt that both of you, in your desire to shake off the hooks of 'respectability' – to live 'in the rough' as you might say – to kick ordinariness up the pants and moreover in your real desire to help others – chose over and over again the wrong set of friends. Oddly enough, as you know, in my youth most of

211

my real friends were much older. Friends of my own generation were mostly homosexual or at any rate sexually ill-adjusted. So, in a sense, I did the same silly thing – I found people of lesser mental capacity (of my own age) which was stupid. But I did also find people, older and of finer mental capacity such as Mary Butts, Ber Walke, Arthur Machen and many many others. From these people I literally fed. You should be on the watch for anyone whose knowledge of life is longer than your own, whose wisdom is clearer and outlook more serene. You need that serenity – only art perhaps finally can hold it. Your music is your salvation too. (Would to God I had forced the technique of music on you as a small boy – but I believed it to be wrong to force anything over any of you, and in a way I was right).

He then goes on to damn ordinary people and those who are sexually irregular (as he was from time to time) and, more importantly, not to mix cider with beer:

I think it is when one is with the very square people that *one is* in the worst danger. Don't go drinking with squares; almost as bad as drinking with queers. (Title: QUEERSQUARE) On the night you tell me about: you were I expect so bloody fed up with them all – you went straight for the very worst mixture you can make – cider upon beer. And it's true – one remembers nothing, only a dreadful dim blur, and that horror of realisation that you have hurt those you love.

This is followed by a heartfelt address on personal integrity, seeking out the hidden goodness within, bracing oneself for pitfalls and passing sorrows and learning to temper and wear them like armour:

Now please dearest Jon: will you take a good look at yourself in an absolutely positive way? Will you resolutely accept the challenge of your better self which will give you no peace should you fail? For that's the bloody truth my son. We are, as you know, very much alike. (This was the cause of our bitter conflict about eight years ago, or less). To me – if it can be comfort to you, and it must be – to read in your letter just that one line: 'thank God that I have you as a father' – to read just that is the greatest single blessing that you could confer on me. For I never feel I have been a 'good' father and in most worldly ways I *haven't*. I shall probably have not a penny to leave you. I can only pass on to you what I have discovered about life which is: that...*but* no, I am incapable of finding the right words, and I think I must quote that great solitary and misunderstood master Henry James, who wrote thus in a letter to a friend, when he was about 60: 'We help each other – even unconsciously, each in our own effort, we lighten the effort of others, we contribute to the sum of success, make it possible for others to live. Sorrow comes in great waves – no one can know that better than you – but it rolls over us, and though it may also smother us, it leaves us on the spot and we know that, if it is strong, we are stronger, inasmuch as *it* passes and we

remain. It wears us, uses us, but we wear and use it in return; and it is blind whereas we after a manner see.' As to one's inner thoughts: do you know what Dostoevsky said once? He was walking along a country road and he saw a small boy walking ahead of him: he wrote of the moment – that he felt as though he dare not pass the boy because at that moment his thoughts were so evil, and they night be given out in waves to the innocent one ahead.

Urgent, kind and exhortatory, the letter stands as an attempt on Frank's part to communicate an insight before it is too late. After perpetrating what he sees as so many good and bad decisions of his own, the father desires to arm his son with vital knowledge. But even as he writes, he is aware of the inherent problem of trying to instil a wisdom that has taken a lifetime in the growing. Often you only grasp what people are saying after you have endured something similar. Receiving advice is different from *understanding* it. The old always want to say, don't rush, be cautious, are you sure of what you're doing, stop and think about this – advice that invariably militates against the current of youthful impetuousness and may delay or negate a brilliant opportunity. As Proust wrote, "We cannot be taught wisdom, we have to discover it for ourselves by a journey no one can undertake for us, an effort which no one can spare us." There may also be an element of futility about the enterprise. Are you, as an elder, 'advising' or merely assuming what has happened to you applies to another? Hegel spoke of the Owl of Minerva (symbol of wisdom) flying through the dusk, meaning the vital secrets of survival – the methods and wherewithal to avoid an impending crisis – arrive when night has already started to fall: hence nothing can delay the onset of darkness. Illumination alights when it is too late. This is, of course, a pessimistic view and not invariably true, but it is always easier to overlook painful knowledge rather than *act* upon it.

TAPERS ON THE CAMPUS (1970)

FB – the mature novelist.

lthough the atmosphere of Frank's Oklahoma campus was restrained and civilised, America was going through a period of protest, mainly over the war in Vietnam. This was an issue students raised with Frank. They wanted to hear what was the average liberal Brit's attitude to their military intervention. Some took the government's line, believing American troops were halting the spread of the 'Red Peril' but others saw the invasion of the so-called 'buffer state' as needlessly interfering in the politics of a faraway place, theoretically championing the cause of freedom but wreaking so much bloodshed and catastrophe in the process as to undermine the whole initiative. If napalm bombing innocent villagers in remote places represented a democratic obligation, then some rethinking was urgently required. Even President Kennedy, no slouch on the threat that Communism posed, decided it was best to extract himself from a needlessly messy war. But he died before he could see through his policy of withdrawal and Lyndon Johnson seemed to want to intensify the campaign: hence the hostilities against the Vietcong continued, becoming progressively more brutal and pointless.

There came a dark day, May 4, 1970, when America woke up in horror to hear that four young people who had been protesting against America's involvement in the Vietnam War were killed and nine wounded by National Guard troops who had been called to a campus to quell them.

It took place at Kent State University and Jeffrey Miller was one of the four students killed. Bob Carpenter, who was news director at the student radio station, told his listeners how the guardsmen opened fire on the students, claiming their lives were in danger. Apparently Miller was 85 yards from the guardsmen when he was shot. The other victims of the shooting were Allison Krause, William Schroeder and Sandy Scheuer, who kept at an even greater distance from the troops.

"There isn't a day in my life," recalled Carpenter, "that goes by that I don't wake up without some conscious thought of this. I was in Vietnam twice before. I didn't have the fear that I had on this campus – helicopters swooping down, tear gas, bullets. It was a scary thing. I get goosebumps talking about it right at this moment."

"I like to call it murder," said John Darnell, a student at the time. "I see no justification and no justice."

After the shootings, the students were enraged and wanted to fight back. Faculty members were warned by the National Guard commander that they must disperse immediately. To avert further bloodshed, the late Professor Glenn Frank made a speech to the students. "I don't care if you've never listened to anybody before in your life," he said. "I am begging you right now, if you don't disperse *right now*, they're going to move in. It will only be a slaughter. Please, listen to me. Jesus Christ, I don't want to be part of this. Listen to me."

The protesters, including the nine who were wounded, left the area. Alan Frank, son of Glenn Frank, was also in the crowd that day. "He absolutely saved my life and hundreds of others," he said of his father.

Liberal America was stricken by the needless killing of young people who wished to express their dissatisfaction with government policy. Both Democrats and Republicans were horrified by the response of the military. It became the talk of educational establishments and places of learning, including the college at which Frank was teaching in Oklahoma. Rashly he attributed it to America's gun culture, the right of every man to shoot if under threat, although in this case the violence was state-endorsed. The incident inspired him to write a novel in which the tragedy was aired and analysed. It was called *Tapers on the Campus* and was never published, though attempts were made to market it in the States.

My Old Friend (1970 – 76)

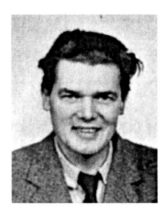

Denys Val Baker

Returning to Britain, Frank was plunged into the celebration of Josephine's wedding to David Hughes, a young theatrical organiser. "When we met him off the plane," Josie recalled, "it was obvious that he was drunk. The seven years of abstinence was over. Our wedding was on 11th July 1970 and was a happy, wild, drunken party with generous amounts of champagne for everyone. Margaret Rutherford, hobbling on sticks, was guest of honour as well as numerous crazy friends of my parents. Colin Summerford – a gay friend of Frank's who my mother disliked – exclaimed drunkenly. 'I've kissed the bride and I've kissed the groom and I don't know who tasted the sweetest.'

After the revels, he resumed life in Kidderminster, which was reasonably varied, embracing broadcasts on neglected poets, sporadic trips to London, appraisals of music and folk song and attempts to relaunch or revive – by TV or film adaptation – some of his previous books and stories. As the new generation's antics became more combative and outlandish, he sensed his best work was probably behind him and his writing no longer touched the contemporary pulse, being not especially taken up with sexual openness, pop music, ethnic or urban culture. Certain attitudes and changes heralded by the 1960s rebuked the modest outbursts of his literary creations. He had always preferred mild rebels like Mr Allenby, Thomas Trevelyan Embers and Gregory Spillet, men who dutifully bore the burden of their limitations, while much of what was going on involved the baiting of the class enemy and the tearing down of social partitions. The new hero was not a mild-mannered eccentric but a figure like John Osborne's Jimmy Porter who ranted and raged at all and sundry, even the wife who loved him, expressing an open hatred of Britain and the institutions that held it in place.

A faithful friend and correspondent during the decade in the Midlands was Denys Val Baker. Sailor, pacifist, novelist, short-story writer, memoirist and small magazine editor, Denys had forged a bond with FB down the years. Although they'd met during the early 1950s, when the Val Bakers moved into the old rectory at St Hilary, they got to know each other rather better after Denys's mother had died in 1964, bequeathing her house in Surbiton. Not long after, the Val Bakers moved from St Christopher's, St Ives, to the Sawmills, Golant, a wonderful old building partly cut off by the tide.

Since his early novel *White Rock* – a grim psychological tale about an elder sister leading her younger brother to death – Denys Val Baker showed a dogged creative stamina, climaxing in his amusing, best-selling autobiography *The Sea's In the Kitchen* (1962), a getting-away-from-it-all classic, presenting life in Cornwall as a testing if enjoyably off-the-wall adventure. Stories, novels and anthologies had poured out of him. He was Cornish literature's popular front even though he was actually born in Poppleton, Yorkshire, and raised in Wales and Sussex.

With Denys acquiring the Sawmills near Fowey, it was easier for Frank and Kate to visit him and Jess, despite the property being accessible only by boat. Their friendship was cemented when Denys's star was rising and Frank's starting to decline, but nevertheless the two men supported and advised each other, confiding their successes and setbacks and trying to devise joint ventures for their mutual profit. In addition, both were to go through family problems. Several of their children were reaching the difficult age and, being sons and daughters of artists, tended to be overly experimental and wayward, trying their hands at this and that rather than settling for a definite career; also, as was the fashion in the 60s and 70s, experimenting with soft drugs such as cannabis that climaxed in Val Baker being involved in a highly publicised court case. There was also the problem of the men's relationship with their wives. Though their marriage was a happy one, Jess Val Baker was not invariably in accord with Denys and, in later life, decided to pursue an academic career. Similarly Kate Baker would become impatient with Frank's deep-seated attachment to alcohol.

However, when Frank and Denys drew together, the latter was taking on the mantle of literary and artistic spokesman for Cornwall, making approaches to London editors, drumming up support for worthy regional ventures, constantly throwing out ideas for William Kimber's anthologies and compilations, and then, if commissioned, soliciting his many talented friends to provide memoirs, sketches, stories and cover designs. Apart from editing *The Cornish Review*, he brought out two Penguin Anthologies of Cornish Ghost stories, both of which featured stories by Frank.

But now the situation had changed. No longer was his friend and helpmate on hand. Frank was exiled in a venerable carpet-making town, far away from the boisterous, windswept shores of the duchy, from the salubrious vantage

of which Denys lightly chided and updated him on his family problems: Jess feeling tired and run-down and wanting to return to college; himself, smitten with depression mentally and stomach trouble physically, pondering the prospect of selling his beloved yacht *Sanu*, presently stranded and damaged at Bilbao, a shared symbol of a youthful, vagabonding existence that was presently weighing the family down:

Our last days on the boat were somewhat traumatic: Stephen had a flaming row with me, declared he wouldn't bear to ever come on the boat with me, etc…Jess ditto…must sell, etc. etc. Of course she is right in many ways. I don't think I have ever felt as shattered as I did after this year's trip (have once again lost over a stone in weight), as because of my very nature (bad thing) I tend to round in circles… And so as Jack once pertinently (for him) said, I am shortening my life by several years… All the same Sanu is one of the loves of my life, has given such untold pleasure; anyway, if we could sell her at a reasonable price, we will; if not we would try and bring her back – and (the last Great Romantic Dream) I am inquiring into the vague but not impossible scheme of could she be brought back across Europe by the River Danube, canals and the River Rhine, it is now an immense waterway, from Black Sea to North Sea. Wouldn't that be something? But I've got it at the back of my naughty little mind… But I didn't set out to tell you about my elderly mistress from Looe…

Denys affirms his loyalty to Frank, "even though we see each other so seldom", adding how much *The Call of Cornwall* stirred memories:

I thought (this is honest not flattery) the whole book was very professionally done as a travel book, but of course I took most pleasure in things like Mevagissey where your heart was…how it brings back (though we never knew each other really and were living on different parallels). I imagine in the drink days you were a real b----- pretty often. And now you are the kindest and gentlest of creatures (subject to the odd moments like the one I have never forgotten at Embiez where you disappeared to jump over a cliff…) We all have these. My favourite fantasy when I feel despairing, and I hit rock bottom, is getting in the car and driving straight over a Cornish cliff…then my mind travels forward a little and I imagine the really excruciating discomfort of it really…

Owing to his attachment to his so-called 100-year-old typewriter, Denys Val Baker's messages often have an acrobatic look, letters vaulting and jerking out of alignment as if emulating those concrete poems that hopped across the stapled pages of small poetry magazines of the period. Sometimes he provided the object a treat, by supplying it with a new ribbon, as in the boldly printed letter [18/9/72] from the port of Calvi relating how, in Ajaccio, he and Jess clinked wineglasses with two major players in the world of theatre and cinema:

A few hundred yards away from us was indeed that same British yacht, all lit up – not a gin palace, quite a nice boat, but definitely in the rich class. Went to bed; in the morning were having breakfast when suddenly heard voices in the water and saw heads bobbing, and four of the youngish people on the other boat had obviously swum over to take a look. 'Come and have a coffee,' we called and a very pleasant woman's voice called back, 'We'd love to,' and then added, 'I hope no one minds, I'm bra-less' – or something to that effect. There then stepped on to the deck (eagerly helped by a shining-eyed Stephen) a very beautiful dark-haired woman of about 30, followed by a pretty younger dark girl, and two young men. All were very pleasant, but the first (topless and exquisite) was quite something, absolutely down to earth and delightful. We all got on famously; it turned out they had chartered their boat (from Antibes) and done much the same trip… There were eight of them, and three crew, including a girl who cooked for them all. Time passed, and regretfully they decided to swim back. Just before they all dived in we exchanged addresses, and were at once intrigued to find that the woman had a place at Veryan, Cornwall, as well as a London address. Then we looked at the name…Sarah Miles. Who, of course, is now married to Robert Bolt…who along with Jess and I was on the famous Committee of 100 who sat down [protesting against the nuclear bomb] and spent the night in jail, though we never met. Off they went; about ten minutes later a lone figure came swimming over, and climbed up our ladder, a dripping Robert Bolt, slightly rotund, very jovial and friendly. Hardly was he aboard when he and Jess were having an argument about Marxism…all went so well that I brought forward our three bottles of wine for the evening meal, whereupon one of their boys was sent back in a dinghy to fetch some of their wine. There had now assembled on Sanu's deck a vast Bolt family, two pretty daughters by an earlier marriage, I suppose, also a son, plus husband, the older daughter, and then finally a really lovely 5-year old boy, son of the Robert and Sarah marriage. We all drank and had a very lively time – halfway through a huge game of water polo began around our famous 'raft' which consisted of the jolly Mr Bolt parrying shots with the orange ball…really liked him very much, and in particular liked his wife, she was a real honey, you and Kate would have loved the encounter…

*

The 1970s were for FB a decade of travel, reflection and taking the longer perspective. There was an added *gravitas* as well as a wavering of religious conviction. "I saw the light once," he confided to Josie, "but now my religion only brings me darkness." He started to think it probable that life is only once for the tasting, for there are millions waiting in the wings to be born and fulfilled, each in their particular way, and if all humans were allowed a second bite of the apple or ghostly finale, what a muddle it would make.

This darkening of prospect was intensified by John Raynor, who was only a year younger than Frank, being run over by a car on Easter Eve 1970. He was crossing the road after playing the organ for the Easter Vigil ceremonies at the church opposite his home. He remained unconscious in hospital and died on Ascension Day. Aside from a legacy of enchanting songs, he left behind an autobiography that was passed on to Frank who conscientiously edited it and prepared it for posthumous publication with Cassells. *A Westminster Childhood* came out in 1973 and elicited high praise from critics because it so delicately captured Raynor's childhood and London background. For a relatively obscure musician whose ultra-English type of song-writing, after the musical revolution of the 1960s, was no longer fashionable, some of these accolades would have been literally "music to his ears", so let us hope he somehow picked up an echo of them in the world beyond with which he had thought himself at various times in communication. The vivid and intensely atmospheric blurb was probably written by Frank:

"When John Raynor, composer of nearly seven hundred song settings, died so tragically, he left behind not only his lifetime's musical work, but the manuscript of this enchanting account of the years of his childhood. His father was Arthur Guy Sandars Raynor, a famous Master of the King's Scholars at Westminster School, and the young John spent his earliest years in the grey presence of London's great Abbey. History and tradition were the day-long companions of the perceptive, sensitive child, who indeed was born at No. 3, Little Dean's Yard, 'that inmost court of an inner court, the quietest and dreamiest place in London'. But there were sounds and colours and images that were to stay with him all his life and which he recorded so evocatively in this book: the brilliant-hued flowers of Westminster's secluded gardens; the magic of first hearing the Abbey's glorious organ; the clocks of London that became a lifelong passion; nursery fires and braziers; his mother's jewel case and his father's butterfly case, full of dazzling, glittering, shimmering things to feast a child's eyes. Terror and sadness also cast their shadows, to persist into later life: a haunted bedroom which drove the five-year-old boy to the brink of a nervous breakdown; the nameless, primitive horror borne on the wind from a tannery; the dreaded church door which proved to have had human skin nailed to it; the death of a brother, killed in the holocaust of 1918. This is a quiet, gentle book, written by a gentle man whose love for the England that he knew shines as surely in these 'recollections in tranquillity' of a happy, complete childhood at the beginning of the century as it does in the songs by which he has so greatly enriched English music."

W.S. GRAHAM

At this point, nudging towards the finale, I am going to slip in a section on FB and his old friend 'Jock' or Sydney Graham, because they were in regular contact during Frank's last years, each providing a solid support to each other during this crepuscular phase, sharing memories and dwelling on the grace notes and felicities of things long-gone rather than what the future was likely to bring.

The relationship of Frank and Sydney Graham was empathic. Both were cultured, vulnerable, sensitive and shared a craving for alcohol. Drink supplied occasion for the drowning and celebrating of their minuscule earnings along with much wordplay and mournful, nostalgic reflection. Their bond dated back to Frank's friendship with Douglas Campbell, the enterprising young Glaswegian who eventually took his skills to Canada and was in awe of Sydney's lyrical talent. Being an up-and-coming novelist with a bestseller behind him, Frank was able to laud over the company, talking about prayer and worship, denouncing politics and defending faith.

It seemed that Sydney might gracefully fade into lyrical extinction. Indeed, he himself was asking for this, shrugging off gainful employment, living by poetry alone, straining the hospitality of friends and strangers, scrabbling for subsistence, wearing cast-off clothes, walking in second-hand shoes, living in huts, hutches and caravans, but always with a pen and paper at hand, always with poetry beside him, Eliot, Wallace Stevens and Dylan Thomas and, in a patchy way, philosophy too, Plato and Martin Heidegger, keeping up a perpetual filtration game with words. In his early poems he spread out his leaves thickly and gaudily, so the second stage of his writing was the effort to gain control, to simplify, strip away the flab and touch the bare bone of human utterance, so that each syllable should stand cold, clear and static like standing stones in moonlight. He wanted to shape phrases only one remove from silence, using plain sturdy, pit-pony words carrying meanings never before expressed.

Dear F.
Poem Which Wont Begin

28 5 76

1

Lost in the rainy night above
I try to see and see the lit
Farms are not allowed to call
Me down off the Zennor Moor.

I think the verb which I am called
Is leaning out toofar for steep
Communication's good. Wow Wow
My beauties lost in the dark over
The rainy table of Zennor Moor.

Where shall we meet? Shall we in storm
Encounter through the others each
Other across the rainy dark
Of Zennor Moor? Wow Wow the dogs
Are loose out of the town to bark.

Where shall we meet? Who would you like to be?
Anywhere suits me. Or if suddenly
A fork of lightning tunes us ito white *-into*
Two people standing om a granite table,

Madron, Penzance, Cornwall. 29 5 76 A letter from my
table . The kernal of der nacht of circling ghosts.

Dear Frank, I'm sorry our respective manics missed us. I
long for you now with your sweetness and tears and galloping
consumption. (Spelling to hell tonight as if it ever...)

I have been trying to woo the Muse since the afternoon and
I must not have been trying hard enough. Rhetoric and lines
too vague and isolated. Me being too self-conscious.
A laboured slog. It never took off.

 When are we drinking up each other again?

I am a heavy, sad cat dog or whater beast I am, tonight . We
fall down darkness in a line of words. I hope we meet before
it is time to go down into the burny-burny. My dear Baker
of the best ovens in the world, knead me into a loaf of a
happy crust. May you be gladed round by self-rising flowers
rare. Be better than me. Write a note soon.

Good stars above you, night-pedestrian.

Yours truly, Wlimsy Graham
love Sydney X X

Letter/Poem from Sydney to Frank (28/5/76)

Through poverty, hangover, illness and depression, he sustained his obsession and eventually the struggling, preposterous, comical-drunk visionary was to be acclaimed by the likes of T.S. Eliot and Harold Pinter and receive the Atlantic Prize for poetry. His name is presently embossed on the covers of numerous theses and critical monographs as his poetry is intellectually challenging as well as charming.

Graham was born in Greenock in 1918. His father, Alexander, was a shipyard engineer in whose footsteps he intended to follow. But while training at Glasgow University, he took evening classes in literature and philosophy which overwhelmed any orthodox ambitions he might have nurtured. Interest in elusive, impalpable things – the noumenal realm which could not be seen or felt as opposed to the phenomenal realm of perception – began to occupy his mind. He sought to devise a technique by which language – poetry – might translate the panoply of shapes, sensations and thoughts that bewilder human existence. By remarkable sleights of phrasing, he manages to transform himself into a cloud, a gap of light, a rearing wave, a running-down watch. So total was his commitment that he preferred to take employment in snatches, subsisting on toast, pancakes, soup and scrapings off bone. To keep his thought processes swift and sleek, he swallowed Benzedrine and other boosters. His first collection *Cage Without Grievance* was published in 1942 when he was twenty-four. By then, he had met his future wife Nessie Dunsmuir (nicknamed 'Noisy Dancemore') who grasped what he was trying to do in his poetry and protected his devotion to it. After they settled in Madron, near Land's End, she never faltered as his "dear camp-follower", doing seasonal hotel work to supplement his paltry income. With him being so often drunk, naturally she was under a great strain, and it seemed she had a short, inconsequential fling with FB who kept a photograph of her in his wallet that he concealed from Kate.

Frank and Sydney exchanged letters and cards in the later phases of their careers. Anyone owning a letter from Sydney is likely to be the possessor of a literary artefact that wheedles, cajoles, proffers love and kisses, throws up its arms in lost, hopeless fashion or sings for its supper in a most appealing way. Often his scraps of cards or scrolls are more poems than his poems. Nearly always there is Joycean wordplay, sometimes stumbling and awkward, but more often the punning and linguistic contortions are a delight, depending on his lucidity at the time. Using a bare, stark syntax, he subtly disorganises it or tilts it on its side with dramatic results. In a postcard to Frank and Kate, he writes – "Here we are entering another Tear, may good things happen to us both together and respectively secret not to be known." By substituting Tear for Year, blandness is vanquished and greeting-card sentiments extend their reach into a private sadness, what we hide from others and ourselves. Sydney's contortions and coinages make haunting reverberations as he replaces the expected or predictable word with something near-sounding that overturns or reverses the meaning. It can

even contain sly bits of literary criticism. "I think you are entertaining yourself a wee bit," he writes to Frank, "calling the flowers 'sultry wicked flowers'. Such talk will get you nowhere. Also you should put a comma after 'sultry'. Let that be an illustration of how the merry plowboy can become a self-mad pedagogue."

On another occasion Frank is having problems with his writing. His language is beginning to sound stale and mechanical. He cannot think of a way to express things in a fresh, exciting manner. Sydney, of course, understands. He may be drunk but he has imbibed a great number of words as well. A verbal mechanic, he knows the weight and balance of each syllable he fits in place; knows when to pause and stab to the heart with a phrase.

"Frank," he begins in a letter [21/7/68] on thin blue airmail paper, "let me say this (no matter how smug it sounds). First of all write good exact thought about one person, two persons, three, as they enter the place you make. You needn't worry about what consciously you say. You are older and different and richer and you will be in it. Don't try to make another novel with your past novels as models. What you will write now will probably be very different and that is right and as it should be. You are such an alive man, Frank. Start some words and tease it out. Forgive me. I know in one way I don't know but I am always a greedy old didactic bugger avid to have his say. Courage, my tarry-trousered friend. Porridge, brother do not stumble. God! I'm frozen. It is just half past four. The time when the dying die. O the world is a cold cold place. I am not well, no, I am not sleepy. Well only a little maybe."

Sydney then unreels the latest news, mainly personal and domestic. Gradually he loses his grasp or interest and surges into absurdism and Cartesian basics:

I am older. Nessie (up there in her wee bawbaw) is older.
Buying dried butter beans is more difficult.
McBryde is dead awhile.
I have a good, brave, trusting wee cat.
I tried hemp and found it uninteresting.
I have a new pressure cooker on which I am a virtuoso.
I have no new (really new) friends.
I am writing a long poem for the Third to be with music
and how the marriage to the music will be achieved I don't know.
I don't get on with people any better than I ever did.
I love them or maybe I don't like them I never know.
I have never seen one, alas. I mean – an AVOCET.
I have only twice encountered MONTGOMERY'S FOLLICLES.
I mostly am myself. I am more alone than I have been
but I am learning to deal with that.
Nessie has to get some sort of part-time job.

A is dead. X is dying. Y is married. ? is born. I am here.

My dears my dears. I've put on the fire and unleashed the window.
No sign of the rosyfingered yet.
And it's too early to wake Nessie.
Please write me even a note soon and let me know how things are going.

Frank. Kate. My dears. BY. BY.

Sometimes Sydney's spirits sink to rock bottom. The lyrical branch withers to a naked, sad utterance:

I am at my lowest.

There is nothing to say.

WSG

Practical, anchored letters from Sydney arrive, too. Frank is arranging a poetry reading for him and he has to make a selection that will go down well with the audience. Frank is also preparing a broadcast on Edward Thomas for whom Sydney summons a mild enthusiasm:

I have always had a warm bit towards his poetry and I think him underrated generally. He has a very special quality and is not at all to be lumped with the pastoral choir of his time. He was not an over-sweetener of the countryside. His poems were usually delicately balanced and considerately coloured and kept the essential mystery which a poem is. I think of milkmaids lacing up their boots on farms and him giving his daughters the presents.

Illness crops up in these letters. Sydney was suffering from colitis. He worried it might be cancer (that did eventually visit him) and Frank had a lung problem that was developing into a malignancy. A feeling that time is running out seeps into the correspondence. Frank and Sydney's Last Tape winds on and seems about to run down leaving a trail of silence. But suddenly something happens. Frank is about to cross the Atlantic and take up a lectureship in Oklahoma:

[14/10/70] – Madron

Dear my old friend untwisted tree dear Frank,
 Sometimes I write when I have nothing to say and no information to impart. 'I hope to become a very spiteful madman. I really come from the beyond and bring no messages.' RIMBAUD. I don't mean that is me talking. It is nothing and the Dunsmuir chutney is pappling in the pan and the cat is on the mat being unfair to its famous master. Alack alack what is to become of us sweet all.

Well, you old devil, how pleasant to find your letter in through the letter box saying your always-a-wee-bit-actorish voice. Any time you write there is always a good brave love in your letters. ENOUGH.

Terrible – and the poem and the wrong dedication. As you will know it was not out of evil that that happened. At the last moment when Penguin needed the MSS I was so rushed and disorganised it finished up like that. There is no Isbel. It is me at the last minute putting a child's name down. But do not pierce me too much. I wasn't being against anybody. Judge me how you will. I am in your Jesuit hands. O GOD. I will certainly change it back in the next edition. Certainly change.

Frank, you (or the memory of you) have always been an addition to my life. Doubtful energetic times, angry joys, shouts and songs and Kate's omlettes. Are you there hearing your Celtic frrrrriend?

HO HO imagine you away there doing your bit in Oklahoma. Is that where the Musicals come from? Did you not get taken on? You and Mary? Mary Husband? Maybe Kate should have married Douglas. Maybe Nessie should have married you. Maybe I should have married Vivienne. Maybe we should have all lived together in a domestic/sexual soup? I stretch my two arms across the plains and shires of England to hug you both tight to my curly grey-haired bosom.

Frank, it must have been great for you out there in America doing that, with your kind of sense of the comic and also the serious man you always are underneath. I wish you had come in when you were so near. I hope you have a piano up there. My dear, I am very sorry to hear that or OFF-TO-AMERIKA songs wherever they are made. I mean no flippancy. I wish I had met him, Frank. He sounds like the pure, lonely creator. Maybe his songs can still be got out.

In Sydney's letters, each must play his allocated, stylised part. Frank is the literary gent in coat and tails with maybe a bit of theatrical fur around the collar. Sydney is the hapless, brilliant jester, the naked fool who trails behind him an icy ribbon of truth. As the years advance, both men find themselves oddly isolated. Sydney had been rediscovered as a poet but his drinking is out of hand and he soaks and composes deep into the small hours and finds himself moving around the room in restless self-dialogue, expelling words from his system in hectic, spraygun fashion. Then the tone will change and his notes to Frank appear to physically tremble with authentic feeling or grow soft and playfully inventive. Even when he states his Muse has deserted him, he discovers poetry in his very incapacity, making inertia lyrical:

[29/5/76]

A letter from my table. The kernal of the nacht of circling ghosts.

226

Dear Frank, I'm sorry our respective manics missed us. I long for you now with your sweetness and tears and galloping consumption. (Spelling to hell tonight as ever…) I have been trying to woo the Muse since the afternoon and I must not have been trying hard enough. Rhetoric and lines too vague and isolated. Me being too self-conscious. A laboured slog. It never took off.

Where are we drinking each other up again? I am a heavy, sad cat or dog or whatever beast I am. We fell down darkness in a line of words. I hope we meet before it is time to go into the burny-burny. My dear Baker of the best oven in the world, knead me into a loaf of happy crust. May you be gladed round by self-rising flowers rare. Be better than me. Write a note soon.

Good stars above you, night pedestrian.

Yours Truly,
Whimsy Graham.

On other occasions a letter will establish the time of night and prevailing weather, followed by expression of affection and a bravura flourish of lyrical absurdism:

[1/4/77] – Madron

As you see, I am up. As you hear, there is a good old storm wrapping the house and I am up. I am up. I mean I am up. I am up and not in bed and it is half past four in the mourning, the hour supposed to be, when we slip away to see what is really happening.

What was it I wanted to say? O yes, that I love you always in my life. I think we should stay around for a while yet. At least only to see what's cooking. Another omelette, Kate?

The Leith Police dismisseth us.

I'll be looking out for THE FIRE. Do I see your elding choirboy face? Where will I see your horror story? I hope you are alright after it. It takes a frightened man to write a frightening story.

What was your dream, my lord, I pray you, tell me.

Ness is asleep. My cat's in his red light district. I am in neither, which both are not adverse. Shakespeare is catching on. The point is are you trying to be a better man. Breathe deeply. Put the words down and place them all in the best order. Mortality shakes the windows. God! I wish the morning would come. Kate, I send you an omlette hug.

Love to you both, Sydney XX

This is bright and breezy, a Spike Milligan style rant. Opposed to it are those soliloquies carried by the wind that blows from nowhere and salted by the brine of mortality where the language is as solemn as the evoked cloud moving through

dark and light intensities. Laden with unease, trapped by transience, Sydney inclines toward solitude (though he's living perfectly happily with Nessie) and seeks to encompass the potential of non-existence. Enclosed by home comforts, he seeks the consolement of desolation, an outcast life-sentenced by poetry into which he pours his all. Like Kafka, he's little else but language and damned to suffer through a relationship that takes him deeper into abstraction and the concomitant craving for reprieve:

Mister Frank B

I realise. You are not here.

I cannot hear you but I heard your Time-glass running the time out to all of us. Come The Boy There? I am only writing to you to hear myself going out. Yet not speaking at all. The word's not near me. Today, Nessie is more near you and I'm writing to you for her. I will not show her this. She will not show me hers. Slowly the first of the clouds are making their way across the sky. Where else would they make their way across? The time is the present. And I am not any time. I suddenly realise, not being able to get my identity straight. O what is to become of me us you they them who???

I have to finish and this is not a letter. Ness made me do this and the edge of my life is shaking.

In a biography, there is a limit to how much one can justify quotation, but these letters from Sydney are works of such originality that it is difficult not to be drawn in and, whenever readers do respond, they may well experience something of the feeling of gladness and gratitude of Frank Baker when he first opened them.

Ink sketch by W.S. Graham retrieved from a letter to FB.

LAST DAYS (1976-82)

The appearance of Frank's last significant book *The Call of Cornwall* (1976) coincided with his return to the duchy from Kidderminster and his settling at Bay Ridge, Porthleven. Published by Robert Hale – a family firm renowned for their probity rather than dynamic marketing or large advances – the book was one from which Frank derived considerable satisfaction. There was the pleasure of communicating his enthusiasm for the duchy and anchoring it to stages of his personal development. Places like Mevagissey, St Hilary, Perran Downs and the Penwith Peninsula, in which he had lived, left and renewed his acquaintanceship with several times, are conveyed with a personal passion and enthusiasm. The author recalls his younger self in these settings, making the travel book double as an autobiography of his 'golden days' and counterpointing the fitful darkness and self-questioning of *I Follow but Myself*.

When the Cornwall book came out, he was 68, spiritually resilient – although not in excellent health – but had reached an understanding with himself, an acceptance of what there was left for him to enjoy. He had almost left behind ambition or the thought that, should he make one last massive creative effort, things might dramatically pick up and the doors of success fly open. He had reached the plateau in which writers cease to write in the sense of undertaking mighty projects but instead philosophise, reflect on the past and whatever meanings can be drawn from the whole experience.

The reception of *The Call of Cornwall* was broadly encouraging, deservedly so, for it is a good book, an eloquent commendation from a lover of Cornwall who had seen and lived through change and reported on it. But there were, however, letters that challenged Frank's opinions if not his facts. One local pointed out that the way in which he viewed Mevagissey was contrary to how he – a native of the fishing-village – saw it. Frank's emphasis was very much on "they Bohemians" or writers, artists and eccentric incomers who barely touched the lives of the day-to-day tradespeople and fisherfolk. A note of genial bewilderment is struck. Who are these characters? I never met them. How were they of any importance to the community?

Another correspondent engaged him on the same issue:

For there are two Mevagisseys. Yours was the Grahams, the Gilberts, Ber [Walke], Lil Barron, Man Fred and George Pearce and all the other favourites of Lil's who gathered at the Ship. Quite different from mine. I always disliked the Grahams – I looked at them with Scottish eyes, remember – and I am not being socially snobbish. I could and can see nothing in his poetry. The Gilberts were only passing acquaintances in the street. Although our Mevagisseys met at The Ship, I was just as much a Fountain man. And my village was very much the fishing and the fishermen, the Swimming Club and Water Polo and village families... Do you see the kind of difference I am pointing out? Of

course, your Mevagissey is dead, for your people have gone. It is alive for me because my people – and their sons – are very much there and alive and kicking.

Frank is accused of selling modern Mevagissey short, styling it as 'dead' just because it no longer engages him in the way it had when his friends were there. In point of fact, fishing was presently doing well, there was folk singing in the pubs, Saturday night dances and a strong community spirit. However, his detractor does climb down a little and acknowledge that, all in all, "the book is a wonderful achievement."

<center>*</center>

Frank liked Porthleven, a huddled, close-knit little town, with a massive harbour assailed by unruly tides. He was drawn to its dark solidity and the fact that it was a working-place rather than a tourist trinket. He sank into a regime comfortably, though he no longer swam and walked as he used to. Nor could he summon the energy to write a novel; that was all behind him. He had bequeathed his corpus to posterity and the common reader. Instead of literary toil, he absorbed the gentle rhythm of the seasons and whatever good was in the offing. His manner was mild and accepting and Kate found more time to cook than she had previously. Living on their own now, they devised a stately, soothing routine, Frank playing the piano in short bursts in his study and attending to a few letters, followed by a well-prepared meal. Frank was a slow-trotting eater while Kate was a thoroughbred racer, almost finishing the course before her husband had crossed the starter.

There was also a pleasant social side to their life. People called on Frank for the wisdom and warmth he was able to supply. Friends from his Chislehurst days; from Winchester; from the theatre; from Oklahoma and Canada; from Cardiff; from Abergavenny – all renewed their contact with a man they'd always considered special. Young sea-faring men and women, the crews of the Green Peace ships *Fri* (a yacht that led protest voyages against nuclear tests) and Rainbow Warrior (a ship that was eventually bombed in Auckland Harbour by French government agents), dropped in for talk, baths and home comforts. Jonathan recalled these exotic visitors as being greeted more enthusiastically by Kate than Frank who, while appreciating their passion and devotion to ecological matters, found their constant presences wearying, for they interrupted his eating routine and filled the house, endlessly using the bathroom and kitchen. "Oh Jon, I do long for some peace and quiet," he complained

Into his early seventies, Frank continued to compose letters, notes and reflections and receive visits from old friends. Denys Val Baker looked him up there, though he felt less than warm about Porthleven, or, alternatively, Frank and Kate drove to the Mill House and called on him and Jess. Both families were country lovers and Denys was always gladdened by the sight of Frank's "trim and

elegant form coming up the drive…" If unable to visit Frank – for he was no longer a well man – he might respond to a letter:

[9/2/82] Lovely to hear from you; better to meet. I think of you (and Kate) often tucked away in your grey-black wilderness of Porthleven, where surely no birds sing save baleful seagulls watching for some foolish entrance through that torturous winding harbour – not, as you will have gathered, my favourite place…

Denys complimented Frank on ageing gracefully, a face "almost blue-printed, ready for it all, that grave and distinguished countenance benignly staring up at me from the family photograph album." He harks back to past expeditions on *Sanu*, their shared holidays, "you and Kate with us, at Epidaurus, at a dozen magical little Greek havens – what wonderful times we had, old comrade" and wonders whether the present owner of the vessel will be aware of his ghostly if benevolent presence overseeing him in the wheelhouse.

Late into their careers, both short of money, they devised the idea of a book based upon an exchange of letters that was to be entitled *Dear Frank, Dear Denys*. "We had agreed that we should be quite frank in these letters," Denys explained, "and that was how I came to know of what was in effect the beginning of Frank's terminal illness."

But the project did not get anywhere. Once the idea of publication had been aired, the letters were bound to become a little more showy and self-conscious. Despite attempts to flatteringly appraise each other's talents, they were unable to make the cake rise. Quickly they grasped the idea was unlikely to be a money-spinner for, masterly communicators as they were, neither had achieved that classic status in which their personal letters would be deemed of public interest. In an effort to stopper his leaky finances, Frank applied for a writer's grant to the Society of Authors, asking Daphne du Maurier if she would appear as a signatory for his cause, to which she graciously assented.

"Times are hard, I know," she added, "especially as we writers get older, hardbacks go out of print, and paperbacks sell the Jaws of this world, not up to the standard of your *Birds* or mine!"

*

More serious than money problems, the sad fact of mortality intruded when Frank, always a fairly heavy smoker, started to experience chest trouble. He went to the doctor who recommended an X-ray. A tumour was discovered and a regime of treatment prescribed.

Later he sent a letter to Denys explaining the prognosis:

Don't ask me what they did nor what my right lung has been doing, but it seems I was determined it was TB. 'No, cancer.' It's strange how the word alone contains a shock. Only a slight shock I hasten to add. They have caught it in time and I've since had much

radiotherapy at Treliske, which unlike you I like. A sweetie of a girl called Chrissie administered this.

On Christmas Day she and I seemed to be the only people in the whole department. The lung responds well, I'm told. One clings to one's lung, hung on the edge of a precipice and flung to the crows having rung the death bell and stung one's conscience and sung one's requiem and bunged up every hole in the house to keep out the draughts and offered one's dung as a sacrifice to the birds and flung far afield all unnecessary impediments or excrescences which we carry through life and re-read Jung to see what he has to say about it all (incidentally have you read all that gossip about Freud, I always thought he was an annoyance and his dream theories absurdly restricted, but Jung is another tongue) and then find oneself among so many sufferers from this wrung-out disease.

Enough. One goes a little mad with the word lung. I tap my very narrow chest and listen. There doesn't seem to be much inside but ribs. As one grows older don't you feel that the dear old body gets odder and odder? One bears it about so warily and tenderly and then crashes into a chair at three in the morning and immediately dark little maps of blood appear under the surface of the skin. All these organs we carry around…

In another letter, after Denys himself had been in hospital with gastric problems, Frank tried to cheer him up, musing:

I'm sorry that you found Penzance Hospital so bleak and felt you got no benefit from it. Oddly enough we differ here. I rather like hospitals, although I wouldn't care to be in one for very long. But the general camaraderie and the sense of being in an enclosed world which has nothing to do with our normal outside world pleases me. And I always like it when the encroaching visitors leave after their inane mumblings at various bedsides – that lovely order returning, faces you know coming round again even if it is only to bring tea which might be coffee, cocoa, Horlicks or heated urine. I've often thought I'd like to work in a hospital. One day I'll tell you about the only operation I ever witnessed, on an enormously fat female septuagenarian whose stomach was displayed for me. God, when you see what we carry about inside us it makes you marvel that we can function at all!

Unfortunately, even as he was worrying over Frank's condition, Denys' own health was breaking down. At times he even felt lonely and ill at ease in his own home. His children had left to seek their individual destinies, Jess was restless and he was suffering from stomach pains. When his hospital treatment finished, Frank and Kate visited him, but the occasion turned out so muted he found himself apologising for being insufficiently convivial:

[20/3/82] My dear old friend: Alas I feel I gave you a very poor welcome yesterday and I feel I must write this quick line to tell you underneath it all in my heart was great love for you both, it's just that nearly all the time you were here I felt incredibly sick and was trying to control it so I could hardly think – and I probably never said how much I appreciated you both making such a noble effort to come all this way. It was good to see you both, even under such miserable circumstances. Oh how I long to be able to put the clock back, to those marvellous old sunny days in Greece…ah, Frank, they were the

days. I think of them longingly... I feel so terribly *depleted*, worn out, unable to cope, always alone (and in the night, the terrible night, the house totally empty, sweet daughters blissfully asleep far away, how could one wish to disturb their innocence, anyway)... I am sure you know the feeling, you have suffered so much. I can only for the moment send you my salutations, dear old Incentives Officer. Let us hope for some silver lining somehow...

Things were actually getting worse for Frank who was by far the older. In 1981, with his health failing, rather than face a tempestuous Cornish winter, he decided to take a long holiday with Kate in Spain. There he was surprised to receive a letter that took him back to the time when he was a heedless choirboy at Colebrook House exploring the ruts and ramparts around St Catherine's Hill, Winchester. It was from Dr John Crook who was writing a short history of the place. Frank wrote back, saying some of his memories of the school (1919-24) were "unprintable"; he regarded Teddy Hone, the headmaster, as a bully and oppressor of small children, but he retained his love for 'Spilly' or Percy Spillet whom he portrayed in *Sweet Chariot*. Towards the end, Frank styled himself as practically "boss of the odd, little school", lauding it over the small boys and openly smoking Russian cigarettes in the presence of Spilly who was amused by the affectation.

After returning from abroad, he was able to ease into the welcome monotony of life at Bay Ridge varied by obligations and reunions. Knowing of his old friend's faltering condition, later that year Douglas Campbell wrote from Canada, demanding Frank visit him – he would arrange and pay for the tickets and fares. Apparently Douglas was the star of the season in Stratford, Ontario, and anxious to seize this last chance to see his old friend. Frank drove from Cornwall on the familiar A30 and Camille, Mary Butts' daughter, provided hospitality *en route*, meeting him and helping him catch the plane. Frank thoroughly enjoyed seeing Douglas again and seeing a little of Canada and, once back in familiar territory, he set up a poetry reading for his old friend, A.L. Rowse, for the BBC. He talked of the historian's life and ALR read his own poetry.

The following year offered Frank yet more literary diversions. He compiled a selection of poetry and prose on the time theme, 'Time and Time Again', performed at Stratford-on-Avon. Afterwards, the actors Richard Pasco and Barbara Leigh Hunt led Frank firmly on to the stage where he enjoyed a standing ovation. J.B. Priestley, who hardly ever left his Stratford home, was there, supported by Jacquetta. He thanked FB warmly; two old-timers brought together by a shared obsession. "The wonderful year rolled on," recalled Kate, "and in late autumn, quite quickly, he burnt out, November 6th 1982, he caught the boat at 9 o'clock on a calm evening – and we were all left wondering."

In November 1982, Denys Val Baker received a phone call. When he answered, an unfamiliar voice said, "I'm sorry to be the bearer of bad news..."

233

FB's death plunged Denys into gloom. It had been a depressing, disastrous year, in which money and health problems combined, and now he had the added blow of the loss of a fellow writer with whom he had shared sailing trips, laughter and literary endeavours. Both had been pacifists and supporters of nuclear disarmament whose friends and families mingled. Both had felt briefly the mild glare of public approval followed by a steady overshadowing of their reputations. Hence, with FB's passing, Denys knew a boundary had been crossed and there was nothing for him to do save add a tribute:

Frank was one of nature's true gentlemen. This was brought home to us all very forcefully, I think, when a month or two after his death a memorial gathering was held in St Hilary church, where all those long years ago he had been the organist, under Father Bernard Walke. It was a cold January afternoon, but the sun shone and the church looked very beautiful, colourfully alive with many paintings of old time Newlyn painters. There must have been nearly fifty people there, when Frank's son-in-law, David Hughes, a professional theatre producer who had for some years past run the Shiva Theatre, introduced the programme. There was haunting guitar music by his son Jonathan, who studied in Spain under Segovia, and equally haunting ballads by his folk-singing daughter Josie, as well as some sweet singing by a tenor from Winchester College, where Frank had once been a choirboy. Above all there were readings from Frank's works by the famous Shakespearean actor Richard Pasco, an old friend who came down from Stratford for the occasion. Richard read the extracts beautifully, and as they had been chosen chronologically to cover Frank's whole writing life, they could not but move us all tremendously. What a gifted writer he was – how beautifully he wrote about Cornwall and what it meant to him – how deftly he brought to life so many fascinating incidents in his richly varied life.

Denys supplies a last recollection:

Everyone here will have their own memories of Frank and I have mine, which is perhaps a little unusual. We were on a long voyage to Sardinia and I had been alone at the wheel through most of a long, dark night, and now dawn was beginning to lighten the sky ahead. Thoughtfully, but as usual most discreetly, Frank had roused himself and come up to stand beside me in the rather lonely wheelhouse, lending me that silent companionship so valuable on such occasions. There the two of us stood, alone in the vast ocean, watching the outlines of our landfall looming majestically in the dawn light – two elderly men approaching yet another new day, another new world, another new experience.
'Ah, Denys,' my dear,' said Frank quietly, 'how fortunate we are to know such moments – isn't it marvellous?'
That was surely the secret of Frank's whole approach – for seventy-five years he was possessed, and lifted up by a sense of eternal wonderment at the marvels of life. Such a man does not need mourning but should be celebrated joyously as we do today – for he lived a full life, and we are all the beneficiaries.

"There is one thing about Frank I have never told anyone," Roger Tomlinson wrote in letter (that was, alas, left out in the garden so that its contents got

drenched and faded in the rain) from which I retrieved the suggestion that, during the last days of his life in Porthleven, Frank Baker slipped sideways and sustained a sprain. He was consigned to bed and one of his last requests was that the curtain should be drawn so that he could see the ships in the harbour.

After anecdotal tributes, from his old friend, Sydney Graham [10/11/82], came a brief, eloquent epitaph:

My Dear Kate
He was a good man at the loving and the organs, and the writing and the drinking and the flesh and God.
I miss the expelled boy already.

Jonathan recalled how, days earlier, he had called on Jock to tell him of Frank's passing. Nessie said he was upstairs and the doctor had forbidden him to touch alcohol. He went up and found him "laid out magnificently in bed with long white hair, and long white beard." Jonathan broke the news. "Oh no, dear Frankie!" he said and, after a few seconds silence, he asked, "Ye haven't got a wee dram?" Fortunately Jonathan had brought a half bottle of whisky which they managed to finish, after which he was sent down to buy another.

A few years after Frank's death, the American critic, Everett Bleiler, was compiling an entry for an encyclopaedia or reference work pertaining to supernatural fiction. Being an admirer of Frank's novels, he wrote to Kate Baker. She provided information on her late husband's life and work, emphasising the dimension of Frank that was non-materialistic and based upon shared culture and true friendship: "Frank never judged by money value himself or others," she observed. "And poverty is a comparitive state. We always lived a rich and full life. I sit here now, in my own house in Frank Baker's study, a beautiful room full of his personality. Furniture, books, pictures and the exquisite little Bord piano make it uniquely his place and, through the open window, the scent of flowers – brilliantly coloured against the blue Atlantic. The roofs of the houses are below us; the horizon is a vast curve – a semicircle: beyond, Lizard Point to the east and Land's End to the west, the world is visibly round. We have always lived in beautiful places in Cornwall, nearly always with the sea near or around us: Sennen, last village in England, there the sea almost encircled us; in Mevagissey it was just round the corner; at Long Point we went down our own cliff path to our own beach – well, beaches are not privately owned in England but it could only be approached from the sea or by our path, and there was a long point of rock to negotiate before beaching a boat."

The lady on whom the character of Tansy was modelled, Mercia, sent a magnificent sheaf of dark roses when FB died.

POSTHUMOUS PUBLICATIONS

Frank's passing took place at a time when his books had ceased to attract attention. Kate was keen to promote the titles of her unjustly forgotten husband and an attempt was made to market his unpublished American novel dealing with the tragic events at Kent University *Tapers on the Campus*. The novel was sent to Michael Finch, a literary friend of Frank's who returned the manuscript after a month or so, saying rather confusingly that it was one of Frank's best novels, "a work of the inner soul that must have cost him a price that he was more than willing to pay for the effort." He goes on to say that the title would have to be changed for the American market, as they do not use the word 'tapers'. Frank was always with him in spirit, he added, "and I have a little lane not far away that he and I used to walk where we can still be together and where it really counts."

A book that did get through and was published shortly after his demise was *Stories of the Strange and Sinister*, a collection with an interesting genesis. For Frank's settling at Porthleven had coincided with an initiative in niche publishing that introduced several interesting Cornish authors to a wider audience. Since the early 1970s, William Kimber & Co. had started to bring out books promoting Cornwall as a land of mystery and fascination. Their choice of title was partly guided by Denys Val Baker who played editorial overseer, introducing new authors to the scene and helping establish a fiction list as well as bringing out his own novels, reminiscences, short stories and creepy tales. Amy Myers was his editor and recalled a quiet, almost withdrawn man who warmed up on further acquaintance. Few authors reaped a sizeable sum from Kimber who preferred to distribute to libraries and set his print runs low to avoid storage costs, but it turned out a lively, attractive project, using a lyrical, strongly drawn style of dust jacket that still attracts book collectors. Solid, established talents like James Turner, A.L. Rowse and Ronald Chetwynd-Hayes mingled on their lists with newcomers like Kenneth Moss and Mary Williams. Frank's last book was a late addition to their considerable oeuvre, published posthumously in 1983, *Stories of the Strange and Sinister*, featuring a cover by Donald S. Swan depicting flaming sheets of music.

EVERETT BLEILER on Stories Of The Strange and Sinister

Stories of the Strange and Sinister (1983) contains ten short stories, some of which had previously appeared in anthologies. It would be overstating to say that the book has a central theme, but time and its variations play an important part in several of the stories.

Five of these stories are outstanding. *Coombe Morwen* describes a restored old Devon farmhouse which in the eighteenth century was the scene of brother-sister incest and attempted murder. The house had been waiting for the right person to come along, so that the pattern could be repeated. A time-tie causes 'possession' and another attempted murder. Perhaps there will be a third. The theme of the story is, of course, threadbare, but Baker has reworked it, what with a novel psychological interpretation, a triple-frame situation and an open ending, into a very thought-provoking story. *In the Steam Room* is minimally supernatural, with a vision of murder, but extraordinarily vivid. *Art Thou Languid?* describes a haunting as two men who operate a music shop in a small town are faced with death. Baker handles very well the linked love and hatred between the two men. *Tyme Tryeth Troth* is a symbolic statement of the identity of the individual person through different stages of time. Told on almost a fabular level, it posits a familial scene, a profound human experience, as the central focus for past, present and future. It is probably Baker's best short story, and is a very fine piece of work.

Somewhat atypical of the author's work, which is usually realistic within the established limits of a fantasy, is *Quintin Claribel*, a fable based on figures of speech. When Quintin insults his governess, she utters two platitudes: she wonders that his words do not freeze in the air as a permanent reproach, and prophesies he will eat his words. Both statements come literally true and dominate Quintin's life. A very amusing story.

A NOTE ON 'THE OTHER'

Edward Thomas's poem *The Other* intrigued FB. It is a vivid piece about a man, emerging from a wood and going into an inn, only to be told by the landlady that he was there the day before. It was not him, he explains, but this "other" whom he starts to obsessively pursue. The poem turns into a complicated quest, the man questioning himself at every stop, yet persisting with this seemingly pointless journey from inn to inn, meeting people on the way, but always arriving after the other has left. The reader becomes convinced that he is, in fact, chasing himself, his doppelganger or whatever. But then, at an inn, the pursuer actually meets the pursued. The other confronts the man and tells him he is tired of being hounded – cannot he pursue his own life? So the man, with a strong sense of shame, pretends to give up the chase and yet is compelled to carry it on, more wearily now, keeping at a greater distance from his quarry. Why? Does he love him in some way? Or is he actually seeking himself, like the soul seeking the departed body. It is brilliant, puzzling metaphor, an excellent ghost story with a painful, confusing dilemma at the core that might be called Kafkaesque had it been written at a later period. Underlying the fretful story is a yawning sense of unfulfilment allied to the illusion that finding a particular person could better it. This poem, I would suggest, is the key to FB's novel *My Friend the Enemy*, about the bully constantly hounding his victim in the manner almost of an attraction and the victim ending up, perversely, by needing him. 'The Other' has a pub setting, making one think of solitary drinkers pursuing one another's company, the lovelorn life of the defeated bar-fly (a favourite character in Patrick Hamilton's fictions). One thinks too of the heavy drinker, Philip Hayes, in *Talk of the Devil*, left chasing a shadow "like a giant sponge sprawled across the road and drifting towards Brompton Oratory" that turns out to be his own. A person not taken up with these matters might ask: "What on earth is bothering him?" The image is spaciously elusive, standing for something small and personal and also for man as a species, a genre, never contented, chasing the illusion of progress, god, love, happiness or whatever other melting goal temporarily bedazzles his appearance on earth:

And now I dare not follow after
Too close. I try to keep in sight,
Dreading his frown and worse his laughter.
I steal out of the wood to light;
I see the swift shoot from the rafter
By the inn door: ere I alight
I wait and hear the starlings wheeze
And nibble like ducks: I wait his flight.
He goes: I follow: no release
Until he ceases. Then I also shall cease.

PAUL NEWMAN

Born in Bristol, England, Paul Newman turned to full-time writing in the 1970s, since when he has published various titles on history, symbolism, literature and topography as well as short stories and poetry. His novel *Galahad* (2003) won the Peninsula Prize and his most recent books are *Haunted Cornwall, The Tregerthen Horror, The Man Who Unleashed the Birds: Frank Baker & his Circle* and *Under the Shadow of Meon Hill.*

PRESS OPINIONS

The Hill of the Dragon (1979)
People who set out to write well-researched books on unexplained phenomena without an axe to grind deserve an award for heroism. Mr Newman's neat and witty book is a great treat for the romantic zoologist, exploring the world-wide dragon myths with a thoroughness that would have delighted the late Willy Ley and Rupert Gould.
> (Elizabeth Hogg – *The Daily Telegraph*)

Somerset Villages (1986)
In this delightful impressionistic guide, Paul Newman takes us through the many villages of Somerset, paying dues to the virtues of Cheddar Cheese, Taunton Cider and Hamstone. With a sharp eye and easy, evocative style, he opens our eyes to things we would otherwise overlook or ignore.
> (*The Countryman*)

The Meads of Love: a biography of John Harris (1994)
This biography, the first since the poet's son wrote an idealised portrait following Harris's death, is written with wit and style; it sets the homespun life against the great events of the time, and uses the poems to make intelligent guesses about Harris's character.
> (D.M. Thomas – *The Guardian*)

Lost Gods of Albion (1998)
The delight of this book is that it is a well-read and wry survey of the extraordinary variety of response and interpretation the hill-figures have evoked down the centuries.
> (Richard Mabey – *Daily Telegraph*)

A History of Terror (2000)
In this elegantly written, engagingly conversational and superbly informative book, Paul Newman charts the shapes and sizes our fear has taken, from the rustic 'panic' of ancient herdsmen suddenly confronted with the Great God of the wild, to postmodern websurfers, overwhelmed by the glut of useless facts on the 'information superhighway'.
> (Gary Lachman – *Fortean Times*)

Lightning Source UK Ltd.
Milton Keynes UK
07 January 2011

165294UK00001B/49/P